The Corporate Eye

STUDIES IN INDUSTRY AND SOCIETY
Philip B. Scranton, Series Editor

Published with the assistance of the
Hagley Museum and Library

RELATED TITLES IN THE SERIES:

Clark Davis, *Company Men: White-Collar Life
and Corporate Cultures in Los Angeles, 1892–1941*

Pamela Walker Laird, *Advertising Progress:
American Business and the Rise of Consumer Marketing*

JoAnne Yates, *Control Through Communication:
The Rise of System in American Management*

JoAnne Yates, *Structuring the Information Age:
Life Insurance and Technology in the Twentieth Century*

THE CORPORATE EYE

Photography and the
Rationalization of American Commercial Culture

1884-1929

Elspeth H. Brown

The Johns Hopkins University Press
Baltimore & London

2 4 6 8 9 7 5 3 1

The Johns Hopkins University Press
2715 North Charles Street
Baltimore, Maryland 21218-4363
www.press.jhu.edu

Library of Congress Cataloging-in-Publication Data

Brown, Elspeth H., 1961–
The corporate eye : photography and the
rationalization of American commercial culture,
1884–1929 / Elspeth H. Brown.
p. cm. — (Studies in industry and society).
Includes bibliographical references and index.
ISBN 0-8018-8099-8 (hc. : alk. paper)
1. Photography—United States—Business methods.
2. Commercial photography—United States—History.
I. Title. II. Series.
TR581.B76 2005
338.6—dc22 2004022999

A catalog record for this book is available from the
British Library.

Contents

Acknowledgments

Although readers read acknowledgments first, writers usually write them last. I am no exception, humbled by the generosity of all who have helped me on this project. My dissertation codirectors, Nancy Cott and Alan Trachtenberg, provided a rare combination of high standards, encouragement, and intellectual acuity, which helped to make this project stronger than it might otherwise have been. My deep thanks to Jean-Christophe Agnew for his complex, thoughtful suggestions, as well as for his ongoing support of a number of his students' investigations into the relationships between commerce and culture. Laura Wexler's photography seminar, as well as numerous coffee meetings, helped refine my thinking about this project, while Jules Prown gave me the tools to attend to photography's visual and material dimensions. A seminar on the history of industrialization with David Montgomery helped remind me of the importance of grounding my questions concerning visual representation in the social and economic history of an industrializing nation.

My research and writing of first a dissertation and then a book manuscript, in many locations over many years, has been sustained by the richness of my intellectual community. For comments on various chapters and presentations, I thank Robert Allen, Ardis Cameron, Patricia Johnston, John Kasson, Juliet Koss, Jane Lancaster, Thomas Laqueur, Jackson Lears, Joanne Meyerowitz, Katherine Ott, and David Serlin. Special thanks to my graduate school colleagues, especially Cathy Gudis, Jeff Hardwick, Marina Moskowitz, and Lori Rotskoff. Scott McCarney and Keith Smith provided gracious and tasteful hospitality for my stays in Rochester, as did Bill Johnson and Susie Cohen. My life in Portland, Maine, continued to ground much of my early work on this project, and for their ongoing support I wish to thank Ardis Cameron, John Kramer, and Daniel McCusker. Special thanks to Rose Marasco, whose photography and companionship nurtured my budding interest in visuality and American culture. I owe thanks to the wonderful Marta Braun in Toronto, whose intellectual companionship and hospitality have helped to make Toronto a rich place in which to work and live. Special thanks to my colleagues in the University of Toronto history department, including Ritu Burla, Sean Hawkins, Malavika Kasturi,

Michelle Murphy, Melanie Newton, Matt Price, and Lynne Viola, as well as my colleagues at the Institute for Communication and Culture, especially Jill Caskey and Bill Thompson.

My project benefited from the enthusiasm and ongoing guidance of Peter Liebhold, of the National Museum of American History. Many thanks as well to my other advisers at the NMAH, both formal and informal, including Pete Daniel, Steve Lubar, Charlie McGovern, Katherine Ott, and Mary Panzer. Michelle Delaney and Shannon Perlich, of the Division of Photographic History, always made me welcome and graciously involved me in numerous exhibition and curatorial projects.

Many librarians and archivists made materials available to me. I wish to thank Katherine Markee, of the Purdue University Special Collections Library; Becky Simmons, Joe Struble, and David Wooters, of the International Museum of Photography at George Eastman House; David Haberstitch, Peggy Kidwell, Fath Ruffins, and Wendy Shay, of the National Museum of American History; Bill Johnson and Nathan Lyons, of the Visual Studies Workshop; Barb Hall, Roger Horowitz, and Jon Williams, of the Hagley Museum and Library; Michael Hargraves, of the Getty Museum; and the library staff of the Getty Research Institute, especially Richenda Brim and Aimee Merritt. I deeply appreciate the help of Brian Beaton, Liviya Mendelsohn, Acacia Warwick, and Kate Witwicki, who skillfully pursued innumerable arcane documents.

I was fortunate to receive a number of grants for this project, as well as for my course of study at Yale. In particular I wish to thank the Getty Research Institute for my two-year stay as a Getty Fellow; the National Museum of American History for graduate and predoctoral fellowships; and the Hagley Museum and Library, the American Historical Association, the history and American studies departments, and the Yale Enders committee for a series of shorter-term research grants. Much of my course work and early research was supported by a series of fellowships from Yale sources, for which I am very grateful. Special thanks to the funders of the Elizabeth Deering Hanscom Fellowship, the Richard J. Franke Fellowship, and the Marcia Brady Tucker Fellowship in American Decorative Arts.

My pursuit of learning would never have developed without the love and intellectual examples set by my parents, John and Susan Brown, to whom this work is dedicated. Finally, my deepest thanks to my partner, Angie Blake, whose love, intelligence, and sense of humor have sustained this project from its earliest stages.

The Corporate Eye

INTRODUCTION

In a 1923 article exploring the impact of photography upon modern life, Edwin E. Slosson, head of the Science Service, in Washington, DC, pondered the relationship between mass-produced photographic imagery and American subjectivity. "This seeing of the same pictures and reading the same magazines at the same time by the greater part of the one hundred million people of the United States tends toward conformity in tastes and ideas, towards the standardization of the American," he argued. For Slosson, the proliferation of photographic imagery seemed to augur the standardization of the subjective through photographic technology. "Whether this is a good or bad tendency, it is outside of my province to consider," he demurred.[1]

For a generation of managers central to the second industrial revolution, the promise of standardization through photography seemed very much a "good tendency." By 1923, the year of Slosson's article, standardization, along with system, had come to define the increased efficiency and productivity of a national economy that many corporate managers increasingly viewed as predicated on mass production and mass consumption. The defeat of industrial unions that might have successfully challenged capitalist hegemony in the industrialized workplace, such as the Knights of Labor and the Industrial Workers of the World, was accompanied by the growth of a professional-managerial class composed in part of newly credentialed engineers and planners, who turned American bulk and mass-production workplaces away from

an older model of artisanal production and toward a standardized work regime, culminating in the assembly line.

The most useful instrument for this major restructuring of American capitalism was the *corporation*. The term defines a group of individuals bound together, through law, into a body *(corpus)* and given the authority to conduct business on behalf of a larger group of usually unrelated stockholders.[2] The corporation emerged as a flexible means for raising capital, merging business concerns, and making decisions regarding the business direction of ever larger corporate enterprises. As Alfred D. Chandler Jr. has argued, the growth of the corporation in the late nineteenth century sparked a major transformation in American industry, as a new class of professional managers changed how business was conducted within the large firm.[3]

Despite the public focus on "big business," the early twentieth century's expanding industrial production was characterized by a diversity of productive capacities and organization forms. As Philip Scranton has argued, four broad approaches defined the making of goods in years 1870–1930: custom, batch, bulk, and mass production. Whereas in custom work the item was individually created for the client, in batch processing goods were created in lots of various sizes in response to grouped advance orders. Custom or batch processing techniques were used to produce many of the products central to the second industrial revolution, including most machinery and machine tools, locomotives, turbines, household furniture, silver, china, and other goods integral to an emerging consumer economy. Scranton characterizes custom and batch work as "flexible" or "specialty" formats for production in part to highlight the nimble means by which manufacturers met fluctuating demand. Although systemization of production and accounting methods was important to this group of manufacturers, standardization, the rallying cry of the scientific managers, proved in most cases antithetical to the flexible approach required by custom and batch producers. In Scranton's view, despite the historical visibility of the assembly lines and mass production, in fact about half of American manufacturing was characterized by custom or batch (flexible) production during this period.[4] The scale of flexible-production companies could range from a two-person custom furniture shop to large, often very complex multiplant companies such as General Electric.

The other half of American manufacturing was dominated by bulk and mass production and by tremendous volume. Bulk manufacturers

produced wholesale staple goods, such as screws, rivets, and linoleum, relying on simple technologies and lower-skilled workers. Mass production, the area of the industrial economy that has received the most attention from business and labor historians, relied on tremendous capital investment, a large work force, and technical innovation in order to produce standardized goods such as cars, sewing machines, and typewriters in huge numbers.[5] Although these large firms, epitomized by Ford, have garnered tremendous attention from both contemporary observers and historians, the nation's several hundred largest firms accounted for only a modest fraction of manufacturing employment as the second industrial revolution unfolded.[6] A new generation of business and labor historians is now reconstructing the complexity of America's economic past, as new studies of small business, consumption, and entrepreneurialism help complicate an older generation's focus on big business.[7] As the historian Wendy Gamber has explained, this new work, much of it concerning gender and business, is "increasingly abandoning a perspective that emphasizes a linear development from family firm to corporate enterprise for one that acknowledges continuity as well as change."[8]

Although the historical record reveals a great complexity among manufacturing approaches actually pursued in business practice, the spectacular productive capacities of the nation's largest corporations, as well as the managerial and technological innovations that accompanied this massive increase in production scale, nonetheless drew tremendous attention. The emergence of these large corporations coincided with, and helped legitimize, an emphasis on economic efficiency that had become, by the second decade of the twentieth century, a nationwide enthusiasm for the efficient rationalization of all aspects of American social and economic life. Whether or not managers were able to institute the actual efficiencies of, for example, greater productivity or reduced labor turnover, it became imperative that they *promise* the efficient rationalization of American economic life through innovative, personal "systems" and technologies. In some instances, such as in trying to win contracts as efficiency consultants, the promise of rationalization became as important as actual changes in work processes; photography emerged as an important evidentiary tool for workplace rationalization schemes. Rationalization as a historical phenomenon is made meaningful through social and cultural interpretations. As the business historians Kenneth Lipartito and Kevin S. Reilly have reminded us, culture is

integral to business behavior, and rational decision making is a contingent process that is legitimized and naturalized through, in part, representational practices.[9]

As corporate engineers and planners were reconceptualizing their relationship to the industrial workplace in the late nineteenth century, the photographic image began to exert a more compelling influence on contemporary culture. Eadweard Muybridge's locomotion studies, Etienne-Jules Marey's chronophotographic work in France, Jacob Riis's documentary realism, and the development of the halftone all combined with scientific positivism to offer the photograph as an objective document of transparent "truth." In the desire to map the mechanics of the working(-class) body in industrial production, efficiency experts and managers turned to emerging visual technologies. Photography and industrialization came together in the years 1884–1929 as engineers, efficiency experts, and industrial psychologists looked to the realist promise of the photograph to anchor truth claims about individual character and efficiency through an analysis of workers' subjectivities, both corporeal and psychological. Through photographs and, later, film the body's fluid and organic movements could be frozen, broken down, and reassembled into a more efficient combination of individual movements. In the photographic image workers' heads and hands could be read for character and workplace loyalty, a physiognomic rhetoric that dovetailed with scientific racism to shore up racialized classifications of appropriate work for various ethnic and racial populations. Through a carefully staged relationship between viewer and image, both workers' and consumers' subjective relationships to the workplace and to finished goods could be manufactured and directed toward managed efficiency.

While industrial psychologists and personnel managers used photography to naturalize vocational assignments, advertisers and merchandisers increasingly turned to photography as a means of stimulating consumer desire. As the rationalization of work processes and machinery dramatically increased the production of consumer goods, manufacturers and retailers faced a new problem of rationalizing consumption. During the first decades of the century, as Roland Marchand, William Leach, and Jackson Lears have shown, manufacturers and retailers turned to a new set of merchandising professionals, primarily advertising, publicity, and display experts, to market new consumer "wants."[10] Manufacturers, advertisers, and retailers agreed on the central

place of the image, increasingly the photographic image, in persuading consumers to buy goods and services. Increasingly, industrialists and advertisers relied upon the newly professionalized strata of commercial photographers to produce the visual representations central to modern consumer culture.

Photographs cannot offer unmediated access to the material world. Instead, the meanings we construct through photographs are as determined by history as interpretations of any other representation. The promise that photography seemed to offer late-nineteenth-century industrialists and engineers for knowing the individual body, for creating illusions of the real, was predicated upon a politics of interpretation. For social scientists working in industry, the discourse of scientific objectivity was undergirded by the seemingly self-evident transparency of the photograph; by the early years of the century, advertisers were taking advantage of this faith in photographic realism to promote consumer products. Thus, the years 1884–1929 saw an ironic contradiction: increased efficiency, rationalization, and systematic selling precariously anchored not by photography's transparent truth but by interpretation—an interpretation that was inflected by the era's class, race, and gender politics.

This book investigates a set of questions concerning industrialization, the working body, the commercialization of subjectivity, and the role of visual culture in an emerging modern America. What is the relationship between the standardization of work processes, visuality, and subjectivity, both corporeal and psychological, in the modern period? How does the seemingly increased rationalization of the individual subject help us to understand how Progressives negotiated anxieties about differences in ethnicity, race, and gender? And in what ways did the visual articulation of these negotiations help usher in modern American consumer culture? On a less abstract level, what role did photography play in engineering the industrial workplace's shift to rationalization? How was photography used in the workplace? Who were the persons who put this new visual regime into place? How does the logic of rationalization translate into the production of consumer imagery?

In this book I follow the broad shift from Taylorism (standardization of work processes through the analysis of the working body) to Fordism (high wages and consumer goods as a means of renewing what Antonio Gramsci has called the "human complex" in the service of capitalism) in an effort to bridge the historiographic divide between

the mechanisms of production, distribution, and consumption. Several historians have researched aspects of this transformation, exploring not only the social and economic history of industrialization but also the cultural transformations of a nation enthralled with efficiency and the utopian promises of the machine.[11] Yet these changes in production and consumption technology were accompanied by, and indeed instituted by, new visual technologies as well. My goal is to make a contribution toward understanding how the American science of work (whose European expression Anson Rabinbach has explored) dovetailed with what Terry Smith has called the "visual order of modernity."[12] In analyzing industrialization's (photographic) visual culture between 1884 and 1929 I seek to understand the political work performed by these visual technologies during a period of intensified work standardization and an emerging mass consumer culture.

Time, Motion, and the Photography of the Working Body

Frederick Winslow Taylor has been widely understood to be the founder of what Louis Brandeis dubbed "scientific management," an industrial and managerial movement that became known as Taylorism, and in some arenas rationalization, in the first decades of the twentieth century. Beginning in the 1880s Taylor introduced a number of innovations into the organization of work and materials within the factory, and his promotional work after 1901 successfully linked the idea of systematic management with his name.[13] Unlike those labor reformers who focused on the working conditions and home life of the factory operative, Taylor initially focused on production methods and the reorganization of supervisory authority within the factory. At Philadelphia's Midvale Steel Company, which he joined in 1878, Taylor set about increasing the productivity of the shop's machinists.

Taylor's greatest obstacle to increased output was what he later called "systematic soldiering," the "careful study on the part of the workmen of what they think will promote their best interests," which resulted in the workers' success in "keeping their employers ignorant of how fast work can be done."[14] As David Montgomery has argued, this soldiering was a collective effort on the part of workers to maintain a comfortable work pace, one that could accommodate all workers and would maintain the existing wage structure, which was increasingly determined by piece rate rather than by day wages.[15] Taylor recognized that his bid for

control over the pace of work would precipitate a "war," and he used his connections to the Midvale management to bolster his position in the ensuing battle.[16] From the beginning Taylor did what he could to shatter the machinists' work culture: he increased their productivity on the lathes by raising piece rates, fired recalcitrant machinists, and hired and personally trained new workers. Meanwhile, the machinists resisted, pressuring new workers, breaking machinery, and when all else failed, quitting.[17] After three years of such struggle, Taylor reported, he won: he had succeeded in dramatically increasing productivity and was promoted to shop foreman.

This struggle marked the beginning of Taylor's evolving conceptualization of systematic management. He realized that in order to control the meaning of a "fair day's work," he needed to shift the power from the machinists to the realm of science: time study emerged as a critical element in "objectively" defining the time it took to perform discrete tasks within the factory. In 1883 Taylor devised stopwatch time study as a means of setting the piece rates in the machine shop. With the aid of the stopwatch, Taylor divided each task into its component parts, timed each part separately, and then reconfigured the parts to arrive at a piece rate for the entire task.[18] These years also mark the introduction of several key elements of Taylor's system: the use of written orders, or instruction cards detailing the work to be performed by each machinist; the introduction of additional foremen, who were responsible for specific aspects of the work, such as inspection (these supervisors later became known as "functional foremen"); a reorganized tool room equipped with standardized tools that Taylor himself had devised through his metal-cutting experiments, begun at Midvale in 1880–81;[19] and the differential piece rate. At Midvale, Taylor's ability to shift control of production from the machinist to the manager was predicated on detailed information concerning the maximum possible output from any given worker. As he recognized, his "efforts to get the men to increase their output was blocked by the fact that his [Taylor's] knowledge of just what combination of depth of cut, feed, and cutting speed would in each case do the work in the shortest time, was much less accurate than that of the machinists who were combined against him."[20] In addition to numerous experiments on belting, tool design, tool pressure, and other variables in the industry, Taylor's work led to the development of the slide rule and the discovery of high-speed metal, both of which radically altered the pace of production. Carl G. Barth, a

Taylor assistant who was to become one of his most orthodox followers, developed the slide rule while he was involved with Bethlehem Steel metal experiments from 1898 to 1902; this tool, which replaced the accumulated skill of the master machinist, enabled the machine tender to determine proper settings based upon the management's instruction cards.[21] The shapes of tools, speed, and the rate of feed were to be figured out by a "trained mechanic with the aid of a slide rule" ahead of time rather than by each individual machinist. In 1906 Taylor considered the development of the slide rule to be his most important accomplishment to date, as "it accomplishes the original object, for which in 1880 the experiments were started; i.e., that of taking the control of the machine shop out of the hands of the many workmen, and placing it completely in the hands of management, thus superseding 'rule of thumb' by scientific control."[22] "A slide rule," he observed, "enables a good mechanic to double the output of the machine."[23]

The slide rule, the stopwatch, and the instruction card were instrumental technologies designed to remove workers' control from the processes of work and further rationalize the production process. Photography, which Siegfried Kracauer called "a secretion of the capitalist mode of production," would seem to be another logical tool.[24] But Taylor's relationship to visual technologies was an awkward one. Though his methods of rationalization depended upon visual empiricism, his tool was the naked eye rather than the camera. Taylor's approach to documenting the time and motion of machinists did not seem to benefit from the visual and mechanical curiosity of his employer's relative and fellow engineer Coleman Sellers, who patented a motion-picture device called the Kinematoscope in 1861.[25] The few halftones that illustrate Taylor's influential 1906 treatise, *On the Art of Cutting Metals*, suggest the limitations of photographic technology in the rationalized U.S. workplace.

The photographs in *On the Art of Cutting Metals* illustrate the steel tools whose performance is the subject of much of the work. Three pullout folders show the process of tool forging; closeups of tool noses; and closeups detailing the wear on high-speed tools after various experiments. The images are notable in part for what they do not show: labor. This silence, broken only by a whispered reference to the "best method" for forging steel tools in folder 2, is remarkable in a treatise whose insistent managerial subtext is concerned with "forcing the men to do a fair day's work."[26]

Fig. I.1. Frederick Taylor's use of photography suggests both the promise and the limitations of documenting motion. (Frederick W. Taylor, *On the Art of Cutting Metals* [New York: American Society of Mechanical Engineers, 1906], folder 1, p. 4, detail.)

Folder 1, entitled "Process of Forging a Standard Tool," is a sequence of six halftones, presented with the background dropped out, illustrating steps in the forging of a round-nose roughing tool (fig. I.1). Four of the six images feature the smith's anvil, with the metal bar in various stages of being bent and cut into its final shape; the remaining two images include the blacksmith at work at the steam hammer and checking the finished tool's angle with a cone gauge. The images present seemingly static moments in tool production, with the exception of figures 4 and 5, which endeavor to document the smith's work in cutting the tool angle. The effort to illustrate motion photographically is hardly convincing in this sequence of images; as the figure reveals, the moving tool escaped representation, requiring the printer to redraw the detail lost owing to the camera's slow shutter speed. The viewer is meant to understand this series of photographs as a sequence of images made in a discrete time frame, documenting a single tool's production from raw steel to finished product, but this interpretation is countermanded by the limits of the plant camera in documenting motion, as well as by the realization that the sequence includes two different blacksmiths.[27] The series of images hovers between a description of a process and a documentation of a specific tool's production from beginning to end.

The sequence represents an important step in the use of photography to document the labor process. Here we see a shift in representation from the photography of machinery and tools (not a new development in 1906, after decades of industrial fairs) to a tentative glance at the process of making tools: photography's documentary promise shifts here from the noun to the verb, from the static to the kinetic, from the machine to the man. Yet how does one photographically represent efficiency? Since efficiency is predicated on time, how can one show a man working efficiently via still photographs? Frustrated with what he saw as the limitations inherent in visually recording time and workplace efficiency, Taylor soon turned his energies elsewhere, but his forays into the use of photography in further rationalizing the industrial workplace were forcefully explored by succeeding generations of corporate managers.

In 1883, the year Taylor introduced the stopwatch to his analysis of workers' movements, the photographer Eadweard Muybridge was invited to undertake a massive project devoted to the visual documentation and analysis of the body in motion. In many ways, Muybridge's work at the University of Pennsylvania (1883–87) is the visual analogue of Taylor's functionalizing logic. Both projects sought to break the continuity of individual movement into component parts that could then be analyzed and reorganized. For Taylor, the goal of reorganization of discrete motions was narrowly instrumental: he sought increased corporeal efficiency, and the reorganization of the working body's movements promised greater productivity in the industrial workplace. Muybridge's project harbored a set of overlapping aims ranging from the scientific, to the artistic, to the popular, to the personal, reflecting the diverse composition of the university-sponsoring team as well as Muybridge's own complex personality. Though Muybridge's work lacked the specific approach of Taylor's investigations, Muybridge's accomplishments in using photography to capture the body's movements provided the visual ground for later investigations of American industrial efficiency.

Eadweard Muybridge, a British photographer who spent most of his working life in the United States, was the first to photograph fast motion, in 1872. In a much-celebrated commission for former California governor Leland Stanford, Muybridge successfully demonstrated, through a shadowy and since-lost photograph, that at some point during a trotting horse's stride all four feet were off the ground. This initial collaboration was followed by a more involved set of investigations

in 1877–79, when Muybridge made the first set of serial photographs of a horse in motion. Using twelve cameras and an electrically controlled mechanism for releasing the shutters, Muybridge documented successive motions of Stanford's horses, Abe Edgington and Sallie Gardner, as they moved around an outdoor track. In the summer of 1879 Muybridge added an additional twelve cameras, as well as a series of auxiliary cameras set at different angles to the tracks, allowing the simultaneous documentation of a moving figure from a series of angles. Also in this final summer of the Stanford project, Muybridge introduced the human figure to his investigations: members of the San Francisco Olympic club performed a series of athletic movements, while Muybridge himself chopped wood.[28]

Muybridge's interest in documenting the human body in motion likely stemmed from his introduction to the work of the French physiologist Etienne-Jules Marey, whose *Animal Mechanism*, translated into English in 1874, both Muybridge and Stanford had read during the course of their collaboration.[29] In 1881, after an extraordinarily successful European tour publicizing his photographic accomplishments and an irrevocable split with Stanford, Muybridge's plans for another set of experiments began to take shape. The recent invention of the gelatin dry-plate process allowed Muybridge to consider a more ambitious project of larger, more distinct images documenting ever-faster motions. In 1883 he issued a prospectus for the project, entitled *The Attitudes of Man, the Horse, and Other Animals in Motion*, which would be of use to both scientists and artists, as well as being of general interest. Four months later, in August 1883, Muybridge found an institutional sponsor in the University of Pennsylvania.

In 1884 a nine-member university commission was formed to supervise Muybridge's work, including six professors of scientific studies and two members from the Academy of Fine Arts, one of whom was the painter and photographer Thomas Eakins. From the summer of 1884 through May 1886 Muybridge made more than 20,000 sequenced photographs of 1,540 subjects, both human and animal (fig. I.2). This project has been the subject of substantial scholarly investigation. Historians of film have explored the relationship between Muybridge's work, including the semipornographic gestures of some of the female models, and the development of motion pictures.[30] Marta Braun has conclusively demonstrated the numerous ways in which Muybridge's methodology strayed rather significantly from the "thoroughly sci-

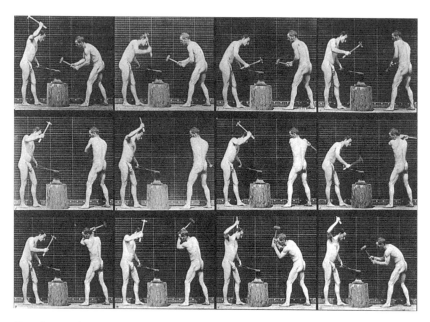

FIG. I.2. Eadweard Muybridge, still image of two blacksmiths hammering on
an anvil. Muybridge's locomotion projects in California and Pennsylvania rep-
resent groundbreaking attempts to analyze motion by means of still photogra-
phy. (Eadweard Muybridge, collotype, Human and Animal Locomotion series,
plate 374, 1885. Courtesy Muybridge Collection, Division of Photographic
History, National Museum of American History, Behring Center, Smithson-
ian Institution.)

entific character" sought by the university's supervisory committee.[31]
Recent scholarship concerned with visual culture and the history of
medicine has explored the pathological locomotion studies made with
patient-models from the Philadelphia Hospital.[32]

Few of these studies, with the exception of Braun's, have discussed
the relationship between Muybridge's project and the American use
of photography as an instrumental technology in analyzing the work-
ing body. As Braun has shown, Marey took up the camera after he saw
Muybridge's photographs of Stanford's horses, which were published
in the French scientific journal *La Nature* in 1878. While Muybridge
sought to gain sponsors for the project that culminated in the Univer-
sity of Pennsylvania studies, Marey applied his evolving graphic tech-
nologies to the analysis of the physiological laws that govern human
movement. The growth of the physiological and biological sciences at

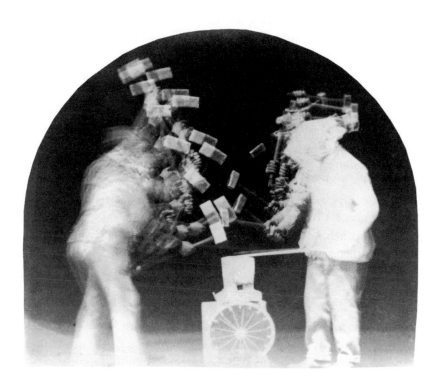

FIG. I.3. Etienne-Jules Marey and Charles Fremont, fixed-plate chronophotograph of a blacksmith hitting hot metal, 1894. Marey used photographic technologies to understand the mechanics of the working body as part of the European "science of work." (Courtesy Metropolitan Museum of Art, New York. Purchase, the Horace W. Goldsmith Foundation Gift and Rogers Fund, 1987.)

the end of the nineteenth century had dovetailed with the imperatives of industrialization, generating a new model of the human body as an animated machine that was driven by an internal dynamic principle that converted energy into movement and was limited only by the baffling persistence of fatigue. By the 1890s Marey's efforts to map the mechanics of human movement were being used by Marey and others as part of the effort to understand the mechanics and limitations of the working body, what historian Anson Rabinbach has called the European "science of work."[33] In 1894, for example, Marey and the engineer Charles Fremont used graphic technologies (film and fixed-plate chronophotography) to analyze the working motions of a skilled black-

smith (fig. I.3). Fremont, who, like his American counterparts Frederick W. Taylor and Frank and Lillian Gilbreth, was interested in both tool production and the influence of skill, adopted chronophotography and cinematography for his subsequent studies in filing, hammering, and riveting.[34]

The use of photographic technologies in industrializing the working body as part of a larger project of economic rationalization has been explored in the European context, most compellingly by Braun and Rabinbach, but it has yet to be fully explored in the United States, the birthplace of Taylorism and scientific management. The present study takes Taylor and Muybridge as starting points. These nineteenth-century figures, working in the same city during the same years, independently contributed key elements to what was to become a much broader effort to use photographic technologies to rationalize both mass production and mass consumption.

Photographic Meaning

Photographs are elusive objects, capable of an epistemological multiplicity that belies their seemingly nonchalant offer to index the material world. A project about the instrumental uses of photographic technology requires an early, albeit brief, meditation on the interpretation of photographs. Photographic meaning operates on two overlapping planes. The first level of meaning stems from the photograph's status as, in Roland Barthes's famous formulation, a message without a code. The content of the photographic message is, he argued, at first instance "the scene itself, the literal reality." Though the photograph is not "reality," it is, he argues, its perfect *analogon*, and it is precisely this analogical relationship between reality and representation that gives photography its "special credibility."[35] The photograph's privileged relationship to the real provided corporate managers with a persuasive medium of legitimization as they sought to naturalize new methods of work and consumption through various uses of photographic evidence. Just as in other emerging, professionalizing fields, such as anthropology, the still camera was appropriated as a "truth machine" to legitimate new forms of knowledge about the body.[36]

But as Barthes discussed, the photograph's denotative meanings are always joined by other, socially produced meanings. These "connotative" meanings are structured by the image's style and its mode of transmission—text and captions—as well as by how the image is read

by a public that consumes the image as part of a greater vocabulary of cultural signs. With even the most mundane transcriptions of material reality, as David Nye has argued in relation to industrial photography, connotative meanings accrue, quietly directing how the photograph is to be understood and interpreted. Within industrialization and scientific management, in particular, the photograph's denotative meaning is often coded as scientific "objectivity," a mask that enables managers to cloak the photograph's contingent, connotative meanings. Managers promoted and profited from the slippage that occurred when culturally managed interpretations (connotative meanings) were misread as simple transcriptions, or analogies, of material reality (denotative meanings).

Within the past few decades, photographic criticism has focused on the cultural elements of connotative meaning. As Barthes noted, the code of connotation is "neither 'natural' nor 'artificial' but historical" in nature.[37] Photographic signification is a historical process, dependent upon the specific choices of cultural producers and the historically specific sign vocabulary of particular readers. The challenge to the cultural historian is both to reconstruct the photograph's connotative codes and to situate these codes within a larger historical context, a context that can help explain the mechanisms through which photographic meaning was produced.

As a generation of photographic critics has argued, the history of photographic meaning is necessarily a history of institutions and of structures of power, relations of dominance and subordination that have specific histories and that shape the ways in which photographic meaning is produced. John Tagg, working within an Althusserian and Foucauldian framework, has argued that photography has no intrinsic identity, that what is real is not just the material item but also, and more importantly, "the discursive system of which the image it bears is part."[38] Allan Sekula, asserting that "photographic meaning depends largely on context," seeks to understand how photography "serves to legitimate and normalize existing power relationships."[39] They have been joined by a generation of cultural and photographic historians who have become suspicious of modernism's allegiance to "the thing itself" (the term is from John Szarkowski, former curator of photography at the Museum of Modern Art), instead focusing on how the photograph has been made subject, in Abigail Solomon-Godeau's formulation, to the "grids of meaning imposed upon it by culture, history, language."[40]

The present study shares the goal of turning to history to under-
stand how photographic meaning is constructed. I seek to understand
how photography is structured by the economic, while at the same time
working to naturalize capitalism at the level of ideology. Following the
work of Alan Trachtenberg,[41] my goal is to avoid the barren dichoto-
mies of object versus ideology and instead attend to the specificity of
photographic production in its historical dimension while examining
the structures of meaning through which photographic representation
has been made intelligible. Photographic representation has been cen-
tral, I argue, to the ways in which corporate managers have sought to
secure the consent of workers, managers, and consumers in the un-
evenly successful project of rationalizing American capitalism.

A "Morally Pink Complexion"

Rationalization is a slippery term, one whose meanings eluded even the
industrial managers who promoted the activities gathered beneath its
banner. In May 1927 the League of Nations assembled a World Eco-
nomic Conference, producing a series of resolutions under the head-
ing "Rationalisation." But while the attendees discussed numerous
industrial initiatives designed to promote the idea of rationalization,
including standardization, industrial psychology, and welfare work, it
nonetheless became clear that, as Lyndall Urwick, the director of the
International Management Institute in Geneva noted, "a great deal of
misunderstanding existed both as to the scope and significance of the
term Rationalisation itself."[42]

By 1929, the year Urwick's monograph on rationalization was is-
sued to help clarify the term, the application of "scientific" methods to
industrial questions had an international history of many decades' du-
ration. In the United States, the most frequently used term after 1911
was *scientific management*, a phrase that replaced the older *Taylor System*
but failed to adequately incorporate the increasingly sophisticated tech-
nologies of applied psychology. The influence of American managerial
innovations upon European economies was pronounced, especially in
the wake of World War I, despite a proliferation of terms that none-
theless described a common managerial ideal. The French lacked a
word equivalent to *management*, so French engineers and Taylor advo-
cates such as Henri Le Chatelier and Charles de Freminville translated
the American name for the movement as "l'organisation scientifique
du travail." In the wake of what industrial managers saw as the irra-

tional frenzy of the French labor opposition to scientific management, French engineers replaced the adjective *scientifique* with *rationnel*, so that the scientific organization of work became, instead, "l'organisation rationnel du travail."

In Germany, the term *Rationaliezerung* (rationalization) was coined to describe the postwar economic solutions to inflation, unemployment, and industrial inefficiency. At the economic level, rationalization concerned the methods and techniques designed to increase productivity, ensure distribution, and increase the standard of living by providing better and cheaper goods in larger quantities. One of the delegates to the 1927 World Economic Conference described rationalization as "the method of technique and organization designed to secure a minimum amount of waste of effort and material, together with scientific organization of labor, careful standardization of materials and products, and simplification of processes, and, finally, improvement in the system of transport and marketing."[43] These methods included many aspects of scientific management, as well as techniques of personnel management and marketing elaborated after Taylor's influential work in the prewar years. Such a broad definition profitably gathered together a variety of managerial undertakings, including the application of physiology and psychology to the working life of the individual, both at work and at home; welfare-capitalist programs such as profit-sharing and wage-payment systems; the application of the physical sciences to techniques of production; the management of transport, accounting, routing, marketing, and other aspects of the business enterprise; and intercorporate efforts to eliminate waste, simplify procedures, standardize parts, and integrate aspects of production, distribution, and consumption.[44]

During the 1920s the term *rationalization* became international and came to refer not only to the specific policies of particular factories but also to the more general application of system and technology designed to increase both industrial productivity and the consumer's standard of living.[45] At the 1927 World Economic Conference *rationalization* was chosen to encompass the various international experiments in industrial organization precisely because it reflected the belief that the world's economic problems could be solved by the scientific method. Unlike *scientific management*, which in the United States continues to suggest the reorganization of material processes more than the reorganization of the subjective (despite Taylor's claim for a "mental revolution"), *rationalization* promised "a complete reversal of traditional mental atti-

tudes on the part of all those who are engaged in economic life," touching on "every form of activity in which that life is manifested." Rationalization, in other words, promised the reorganization of the material and of the subjective both inside and outside the factory.[46] *Rationalization* was a utopian term, offering managers the promise of international productive efficiency, the elimination of waste, a progressive rise in the standard of living, and the eradication of class conflict through the intelligent guidance of a technocratic elite. Rationalization promised the thorough engineering of both materiality and subjectivity.

I use *rationalization* rather than *scientific management* because it connotes a range of engineering objects, including the material, the corporeal, and the psychological. Although the latter term has been used as a synonym for former, especially among European engineers familiar with Taylor's work, I avoid using *scientific management* except when describing specific Taylor-based innovations in the reorganization of industry. *Rationalization* more flexibly describes the myriad ways in which the imperatives of industrial reorganization sought to reengineer the physical and subjective worlds of a modern, industrial citizenry, at sites of both production and consumption.

In his 1930 investigation into the new urban salaried proletariat, Siegfried Kracauer set out to understand the "imperceptible dreadfulness" of everyday life among a new class of workers, the "salaried masses" who made up the employee population of the large corporation. Although his idiosyncratic ethnography was based in Berlin, the processes of rationalization were modeled, as he frequently noted, after "the American pattern"; the developments he observed were international in scope, relevant to the urban life of any of the West's advanced industrial nations. Following the corporate worker through the processes of employee selection, the development of welfare-capitalist programs, and the rationalization of pleasure through the development of amusement palaces ("shelters for the homeless"), Kracauer sought to understand the relationship between economic rationalization and the production of a new type of modern subject.

This new subject, the product of rationalization, could be recognized on sight by the employee manager. A personnel manager who described his system as modeled on the "American pattern" told Kracauer that he was seeking applicants with a particular countenance, a countenance he nonetheless found difficult to describe until, pressed by his interlocutor, he exclaimed: "Not exactly pretty. What's far more

crucial is . . . oh, you know, a morally pink complexion." As Kracauer observed,

> The same system that requires the aptitude test also produces this nice, friendly mixture; and the more rationalization progresses, the more the morally pink appearance gains ground. It is scarcely too hazardous to assert that in Berlin a salaried type is developing, standardized in the direction of the desired complexion. Speech, clothes, gestures, and countenances become assimilated and the result of the process is that very same pleasant appearance, which with the help of photographs can be widely reproduced. A selective breeding that is carried out under the pressure of social relations, and that is necessarily supported through the arousal of corresponding consumer needs.[47]

The new citizen's "morally pink complexion" worked, for Kracauer, as a shorthand description for the processes of rationalization that were reengineering not only industrial production but also the "salaried masses" that were the subject of his inquiry. I am interested in similar questions, though my emphasis on the instrumental uses of photographic technology requires a somewhat different organizational structure. I seek to understand how corporate managers used photography in an effort to produce a standard, modern American subject, efficiently available in both its productive and consuming capacities. Unlike Kracauer, I am reluctant to claim that processes of rationalization actually produced historically standardized subjects. Although this was certainly a goal, one that was later aestheticized in the cultural realm through, for example, precision dance, my research concerns the producers of visual texts rather than the consumers.[48] My subject is the cultural history of those photographers and corporate managers who sought to produce industrial and consumption communities through strategies of visual representation structured by gendered, racialized, and class-based ways of seeing. I am interested, therefore, in cultural production rather than reception, power rather than resistance. I have less to say here about how these visual regimes were contested, appropriated, or reinvented, especially by workers and consumers. While these questions are of course important, it is my contention that we have much to learn about the production and use of visual imagery as a means of consolidating corporate power and naturalizing what was a relatively new model of economic life whose reach has since extended to every element of modern experience. In this line of inquiry, I follow

the important route mapped by David Nye in his work on General Electric photography, and more recently joined by Roland Marchand through his monumental study of corporate imagery, *Creating the Corporate Soul*.[49]

I trace the movement of workers from the employment office to the work process within the company and finally to the dissemination of work and product imagery to a consuming public through advertising. Although the chapters are organized roughly chronologically, several also overlap in significant ways, as I take up various aspects of my argument in relationship to developments in personnel management, applied psychology, public relations, advertising, and other related areas. I am less concerned throughout this book with how managers successfully "rationalized" American corporate workplaces than I am with how they borrowed the truth claims of photographic objectivity to promise rationalization for purely instrumental reasons: to secure contracts, build reputations, win loyalty, and sell products. The historiography on the second industrial revolution has clearly demonstrated that systems of rationalization, whether introduced under the aegis of Frederick Taylor, Frank and Lillian Gilbreth, Harrington Emerson, or the Ford Sociological Department, were often deeply contested by workers and managers, and even the most successfully installed new rationalization schemes often (though not always) began to falter soon after the managerial consultants left the company to take up new contracts.[50] Taylorism, in other words, has been a deeply contested and uneven project.

Managers, consultants, art directors, and photographers drew upon photography's realist discourse to legitimize corporate aims in two ways. First, borrowing the rhetoric of science implied by photography's indexical relationship to the real, managers offered photographic technologies as impartial, unmediated scientific tools for rationalizing both employment procedures and the discrete motions of industrial and clerical production workers. Second, still drawing on photography's perceived privileged relationship to the real, personnel managers, photographers, and art directors used labor iconography and pictorialist aesthetics to engineer emotional responses to photographic representations, which, in turn, they sought to harness on behalf of managerial goals, including the rationalization of labor-management relations and consumer desire. This book deals less with the rationalization of American commercial culture than it does with the many uses of photogra-

phy in visualizing an ideology of rationalization in order to further the instrumental goals of managers, consultants, art directors, and other brokers of American commercial culture.

The first chapter begins with the introduction of potential workers to the large corporation as they are screened by the employment manager in the new profession's effort to rationalize employment hiring practices in the years before World War I. Here, the focus is on the relationship between photography and the early stages of what became known as industrial psychology as I describe the role of the applied social sciences in rationalizing not only the body (the focus of the following chapter) but also the mind and, in particular, emotion. The chapter is organized around the work of an early personnel consultant, Dr. Katherine Blackford, who serves as a representative example of a school of "character analysts" who used the still photograph as a means of selecting appropriate employees for a variety of vocations. A popularizer of classical and modern scientific assumptions concerning the relationship between external features and character, Blackford offered a peculiar recipe of neophysiognomic faith in the body as an index to employee fitness. Her influence as an employment consultant to large corporations was challenged and eventually displaced by the competing claims of university-trained applied psychologists, who offered mental testing as a more reliable index.

Chapter 2 picks up the trail of the employee after he or she has made it through the application process and is at work folding handkerchiefs, drilling metal latches, packing soap, or doing any one of myriad other repetitive physical tasks that became the object of motion study in the Progressive Era. I discuss the industrial consultants Frank and Lillian Gilbreth, who photographed and filmed industrial workers in order to isolate individual movements, which could then be reconfigured to model the "one best way" to perform a given task. In applying the logic of Taylor to the industrial worker, the Gilbreths sought to industrialize the final frontier of scientific management, the working body.

Chapter 3 picks up on Blackford's use of the portrait as an instrumental technology within personnel management to explore another use of employee portraiture. Lewis W. Hine's 1920s photographic "work portraits" were featured in the pages of corporate employee magazines, where their photographic meanings were overdetermined by a postwar managerial rhetoric that privileged industrial "togetherness" and corporate family harmony over independent union organiz-

ing. Hine's photographs represent an early articulation of corporate public relations designed for an audience internal to the corporation, the employees.

In the final chapter I turn to another type of advertising photography in order to explore the role of the photographic image within the new consumer landscape. I investigate commercial photographic practices in order to understand photography's role in negotiating the implicit cultural tension caused by increased rationalization of work, the standardization of consumer goods, and the psychology of "individual" desire. The major figure in this chapter is Lejaren à Hiller, a photographer and illustrator who, in the World War I years, invented photographic illustration for print advertising in its modern form. At a time when corporate managers, psychologists, and advertisers were moving from a model of "rational" man to "irrational" women, or a consumer motivated by emotional appeals and behavioral stimuli, Hiller created complex social tableaux, softening photography's realist edge with pictorialist sophistication.

These figures—photographers, efficiency experts, employment and personnel managers—were all technocratic utopians. Like other Progressive Era reformers, they believed that science and system could solve the myriad problems of inefficiency, inequality, and poverty that plagued the United States' transition to urbanization. They believed that their expertise gave them a privileged voice in addressing social and economic problems. Photography, which at the time was understood by most Americans as a transparent, objective technology, emerged as an important methodology for these technocratic utopians. As historians have argued, the Progressives were not without their own marked biases; their political motivations, though often sincere, were hardly immune from middle-class, white assumptions concerning race, gender, and class hierarchies.[51] Rather, as we shall see, managers, consultants, and photographers used photography's truth claims in order to naturalize racial and class hierarchies in a period of tremendous social and political change.

THE PHYSIOGNOMY
OF AMERICAN LABOR
Photography and
Employee Rationalization

In 1913 a contributor to the *Scientific American* decried the "wasteful and expensive" manner in which contemporary employers hired workers. The old hire-and-fire method, in which employers hired as many as five times the needed number of employees annually in order to maintain the necessary force of trained workers, represented a staggering annual cost to business.[1] Bemoaning the continued reliance upon the hire-and-fire method, the writer plaintively asked, "Is there anything better? Is there any way of standardizing men as machines and materials are standardized?"[2] Thirty-five years after Frederick Winslow Taylor was hired at Midvale Steel Company, eventually launching what came to be known as scientific management, progressive companies had (in their ideals if not in their practice) "standardized everything under the sun": machine parts, tools, work stations, materials delivery, wage systems, even chair heights.[3] Mass and bulk production were predicated upon such standardization. Yet the "human element" of the second industrial revolution—the employee—continued to frustrate Taylorism's advocates. If standardization produced efficiency and economy in the production process, could it not produce the same results if applied to labor?

The rationalization of vocational selection promised to bring the cost efficiencies claimed by scientific management to the disorderly process of hiring. The unprecedented demand for labor that marked the second decade of the twentieth century, combined with the greatest strike wave yet seen in the United States, riveted managerial attention

23

on the applicant pool, where, as the employment consultant Katherine Blackford enthused, "every man [was] a bundle of possibilities."[4] However, these possibilities, which proliferated during immigration's high water mark before the war, also included unwelcome labor organizing and corporeal inefficiency, both of which Progressive managers sought to avoid.

The financial costs of labor turnover and work stoppages combined with the contemporary interest in scientific management to establish a new professional type, the employment manager.[5] Avid students of Taylor's success in functionalizing production processes, these managers sought to systematize haphazard hiring and firing practices by concentrating responsibilities for these functions in one department. Expanded employment departments would take responsibility for any aspect of employment designed to increase efficiency, including transfers and promotions, medical examinations, Americanization programs, and welfare work. Employment management joined other new occupation fields, such as psychology, vocational guidance, and welfare work, to emerge as personnel management, a term that came into widespread use after the war.[6]

Not surprisingly, the area of hiring procedures was one of the first to be addressed by employment managers, who noted the "growing need for the specialization of employment methods and the hiring of help" and sought to standardize every aspect of the selection process. Applicants who had made their way to a company's employment office through vocational placement or in response to word of mouth or advertising were increasingly likely to fill out a standardized application form. Ideally, the applicant would be personally interviewed by someone who had been trained in the "modern art" of interviewing, a professional trained to judge quickly and accurately the applicant's character.[7] Interviewers were especially attuned to the "socially disgruntled" applicant, who, once hired, might channel "querulous" energies in the direction of union organizing.[8] Especially after the war, applicants were asked to take a series of trade tests to determine, for example, reaction time, dexterity, reasoning ability, or other qualities tied to the job opening. Finally, references were checked, and the applicant was either hired, placed upon a waiting list, or turned down.

The chaotic early years of personnel management saw a number of competing methodologies for standardizing the human element through scientific selection. As Sharon Hartman Strom has shown, the

new field combined the Progressive Era belief in system and efficiency as a route to equality, as well as increased productivity, a higher standard of living, and an end to labor-management acrimony. The new field merged the "feminine" occupation of corporate-welfare secretary with the "masculine" legitimizing discourse of scientific management, combining aspects of the prewar vocational-guidance movement with early work in applied psychology. After World War I the field became further professionalized and masculinized, as the contributions of Progressive Era professional women were pushed to the margins of the field, now subsumed under "business administration."[9] We are today perhaps more familiar with the extensive mental and trade tests that flooded the new profession with the rise of industrial psychology, especially after the war. Less familiar to historians, however, is the established practice of visual-based "character-reading" in selecting appropriate applicants in the second and third decades of the twentieth century, a methodology that vocational testing eventually replaced, but only after a lengthy effort.

In this chapter I describe the protracted battle between "character analysts" and industrial psychologists over the proper methodology for rationalizing American labor. Using a methodology based upon the analysis of individual physiognomies and steeped in the ideologies of scientific racism, the prominent Dr. Katherine Blackford read the photograph and the face for employee fitness. Blackford's project, which was widely influential from 1913 through the mid-1920s, reflected and reinscribed an industrialized way of seeing characteristic of scientific managers early in the century, a Taylorist optics of fragmentation, standardization, and interchangeabilty. But whereas most of her managerial colleagues analyzed, standardized, and reordered the inorganic materials of industrial production, Blackford's vocational selection reveals a similar visual empiricism applied to the body, especially the head and face. This analytical way of seeing, though not new to the early twentieth century, acquired renewed credibility within the Progressive Era as industry and business turned to new methodologies to rationalize employment practices. Although the testing methodologies of vocational-guidance experts and applied psychologists eventually emerged as the victors in the late 1920s, character analysis, an inventive blend of scientific racism and popular understandings of scientific management, proved compelling for a class of business owners seeking any solution to the complexities of staffing the modern corporation.

Industrial psychologists, whose discipline was founded and gained professional credibility during the same years, sought to discredit the character analysts' somatic readings in favor of mental tests designed to gauge the hidden, subjective aspects of individual capacity. This shift from the external to the internal, from the visible to the invisible, also suggests the waning appeal of biological determinism in the early twentieth century. As Social Darwinist assumptions about the inevitability of inherited genetic traits made room for a renewed faith in individual adaptability, most clearly expressed through the ascendancy of behaviorism after 1913, character analysis seemed increasingly out of step with both scientific and popular thought.

While psychologists speculated about the effect of the environment, rather than heredity, on individual behavior, scientific managers faced the limitations of their own discipline's rendering of industrial labor. Frederick Winslow Taylor's efforts to increase workers' efficiency had been based upon an understanding of the human as machine, an industrial engine needing only minimal physiological care. Increasingly, however, scientific managers and industrial psychologists began to see the workers' emotions, what prior generations had called the "passions," as the central unknown element of both industrial unrest and sluggish production. As the industrial physiologist Richard Dana argued, "The comparison of man to machine, while very suggestive in some respects, is not quite parallel in others mainly because of two characteristic differences. A machine has no emotions, and is not subject to fatigue, whereas in these two respects mankind is singularly frail."[10]

With the rediscovery of emotion's disruptive relationship to industrial efficiency, the worker's subjective life, both emotional and psychological, became the final frontier of employee rationalization. This shift to emotion within scientific management, psychology, and business meant that the ability to read and render the expressions of human emotion were increasingly investigated and sometimes manipulated. The new emphasis on what became known as the human element was central to progressive managerial concerns after Taylor's death in 1915. The new methodologies designed to map and direct workers' subjective lives were a result of a long-term effort by applied psychologists, corporate-welfare personnel, and vocational-guidance advocates to replace Taylor's ruthless drive system with a more enlightened appreciation for the complexity of worker motivation and productivity. But while this group's battle against the hard-line Taylorites of the first

generation has been explored by historians, the group's simultaneous battle against the character analysts and their competing "system" for rationalizing labor is less well known.

The Blackford Employment Plan

Katherine M. H. Blackford claimed to have received her M.D. in 1898 from the College of Physicians and Surgeons in Keokuk, Iowa. After several years of medical practice in Rochester, New York, she quit to make a trip around the world in order to study "racial types," a trip sparked by her "inability to understand people, to know what types they were and why they succeeded or failed."[11] In 1912 she settled in New York City, married Arthur Newcomb, and began work as an employment consultant to large corporations. She also worked as a consultant to Harrington Emerson, who employed her to develop scientific selection techniques for some of his efficiency contracts. The Emerson Efficiency Engineers developed a more flexible approach to scientific management to compete with Taylor and his approved systematizers; the firm eventually specialized in labor-recruitment issues and was retained by nearly two hundred companies in the years 1907–24.[12]

The first step of the Blackford Employment Plan, developed in 1912, was to organize an employment department in the firm under the supervision of an employment supervisor selected and trained by Blackford. The arguments for such centralization were identical to those used by Taylorists seeking to "functionalize" other aspects of industrial production: uniformity of policy and methods; adherence to company efficiency standards; elimination of duplication of foremen's efforts; the creation of a central archive of uniform and standard records; the advantage of having a scientifically trained expert in charge.[13] In addition to taking charge of hiring, firing, transfers, and promotions, Blackford argued, the employment department would be perfectly positioned to direct other aspects of employment activity, such as welfare work, should the company decide to expand in this direction.[14]

Once the employment department had been set up, the next task was to analyze the position through a process known to employment managers generally as job analysis. Did the position require physical or mental work? mechanical, artistic, or commercial ability? Blackford's job-analysis chart listed 131 physical and mental characteristics that the manager would consider in analyzing the requirements necessary for each position. Once the job had been properly analyzed according

to the chart, the applicant was similarly analyzed and matched to the position.[15] An applicant should be hired not because he was a friend, relative, or fellow lodge member, Blackford argued, but because he was especially "fitted" for the work at hand.

The rhetoric of the "fit," the "unfit," and the "misfit" permeates the literature of vocational placement and selection during these years. For this school of employment managers, vocational placement was predicated on the notion that every person was "naturally" fitted to a particular occupation, given the requirements of the position and the employee's innate talents, talents of which the employee himself might be ignorant but which the skilled employment manager could identify. The tragedy of vocational waste, for both the worker and the employer, stemmed from the unintentional "misfit" between a worker and his or her job.[16] Occupational mobility was limited to positions that called for the applicant's particular qualities, qualities whose basic contours, rooted in the biological determinism of late-nineteenth-century scientific thought, were seen as both typical and immutable.

The trope of the misfit reveals a soldering of two early-century ideologies: Taylorism, which saw workers as machined parts that needed to be appropriately slotted to the task, and Social Darwinism, which categorized human beings according to the perceived fitness of their racial stock. Unlike the eugenicists, whose version of Social Darwinism focused on "better breeding" as a means of race betterment, most employment managers were reluctant to categorize any potential worker as ontologically "unfit," choosing instead to understand failings as a result of a "misfit" between the worker's aptitudes and the position.[17] But like the eugenicists, Blackford saw these characteristics as both immutable and biologically determined.

An important new step in the standardization of hiring practices was Blackford's employment application, which asked for much of the usual information: name, address, nationality, emergency contact, previous employers, and so on.[18] This application form took its place alongside a proliferation of other forms, such as performance reports and internal references, all of which were placed in the newly emerging archive of employees' files. But the application form, through which the employment manager ostensibly learned of the applicant's qualifications, was in fact the *least* important source of information in assessing the candidate's fitness for the job in question. Rather than relying upon prior experience or references (which she regarded as worthless), Blackford and

those she trained as "scientific character analysts" instead relied upon an elaborate system of visual analysis. Indeed, all the while an applicant was filling out the application form, the interviewer was "quietly and unobtrusively observing [the applicant] and making mental notes of what he sees," filling out a secret "analysis" form in a code that only the staff could decipher. From visual detection alone, and without recourse to the application form (which became merely a mechanism to allow the interview opportunity for extended observation), the interviewer was learning something about the applicant's "natural aptitudes," "character," and "the use" the applicant had made of "the talents with which nature has endowed [him or her]."[19]

Analyzing the Man

The success of the Blackford Employment Plan hinged upon a convincing methodology for assessing individual character traits. Blackford's system, steeped in scientific language drawn from evolutionary biology, saw the face, head, and body as an index to employee fitness. "There is," Blackford argued, "a constant correspondence between the mental and psychical characteristics of any individual and his physical characteristics." Physical characteristics, such as pigmentation or a prominent jaw, had developed over time "according to the law of the survival of the fittest" in order to enable individuals to adapt to their environment to the greatest possible degree.[20] Through a skilled reading of various somatic signs, Blackford argued, she could accurately assess not only a worker's character but also his or her (biologically determined) aptitude for a particular line of work.[21]

Blackford's discussion of color drew heavily from turn-of-the-century race science, in which biologists, anthropologists, and eugenicists tied perceived physiological racial difference to mental traits and traced these morphological developments to a prehistoric evolutionary struggle from which the white races had emerged as victor. As Blackford explained, the light coloring of blondes (or Aryans, as she also called those of the "white race with comparatively little pigmentation") had developed as a result of a prehistoric migration from the tropics to "cold, cloudy, Northwest Europe." In this inhospitable environment, where food and shelter were more difficult to procure, the darkened pigmentation of the tropics drained away (as it was no longer necessary for protection against the light), and new survival skills were developed. These superior white races soon became the "conquerors and

rulers of dark-skinned races," who were "less aggressive, less bold, less domineering, less vigorous, because their kindly environment had not necessitated the evolution of these rugged traits." Over time, Blackford argued, the various races had developed specific evolutionary traits that in the modern era could be interpreted according to the degree of color (in hair, skin, and eyes) present in any given individual. The result was Blackford's "law of color": "In brief, always and everywhere, the normal blonde has positive, dynamic, driving, aggressive, domineering, impatient, active, quick, hopeful, speculative, changeable, and variety-loving characteristics; while the normal brunet has negative, static, conservative, imitative, submissive, cautious, painstaking, patient, plodding, slow, deliberate, serious, thoughtful, specializing characteristics."[22]

Similarly, climate had influenced the development of cephalic and facial characteristics, which in the modern era could be read as indexes of character. Primitive man, "according to anthropologists," had not only been a brunet but had had a "short, wide, low-bridged nose with large, round nostrils"; the white European, in contrast, had survived the harsh northern climate thanks to a large, high nose, which warmed the cold oxygen before it reached the lungs. "This process of selection," Blackford argued, "developed a race with noses high in the bridge, well set out from the face, with narrow, elongated nostrils."[23] Blackford described the evolution of other types of noses and concluded that "next to color, therefore, the nose as seen in profile is perhaps one of the most easily observed and popularly regarded indications of character."[24]

Blackford republished an Underwood and Underwood image, perhaps drawn from this stereograph publisher's travel series, as documentary evidence for her racist physiognomy (fig. 1.1). Seven African children sit or crouch before a white colonist, who relaxes comfortably, well fed and fully clothed, on a canvas chair. While most of the children look directly into the camera, the colonist leisurely gazes on his assembled charges (the expressions of two of the boys, however, reveal a promising skepticism). Everything about the image, let alone its context, constructs a racial hierarchy that positions whiteness at its apex: the children are subjected to a double, downward gaze from both the colonist and the implied white viewer; they sit or squat on the ground, nearly naked, while the fully clothed colonist (in white, no less) occupies the only furniture. The triumph of Western technology over the "primitive" is thematized by the hand-held stereoscope, which, in contrast to the dormant spear, clearly dominates two of the boys' interest.

FIG. 1.1. Katherine Blackford drew on commercial published images to support theories of racial physiognomy. Her caption for this image reads, "A Group of Negro Boys. Note primitive forehead of boy in middle of rear line. Also flat noses and convex mouths and chins." (Katherine M. H. Blackford, *The Job, the Man, the Boss* [Garden City, NY: Doubleday, Page, 1915], 141.)

The central activity of the image, viewing a photographic representation, emphasizes the power of looking, further legitimizing Blackford's visual methodology.

The acceptance by 1870 of Darwin's theory concerning the evolution of species would seem to entail a fluid and adaptive conception of racial characteristics over time rather than the solidification of prehistoric racial traits. Yet as Nancy Stepan and George Stocking have argued, evolutionary biologists in the last third of the nineteenth century worked hard to adapt pre-Darwinian ideas concerning the fixed and unchanging essences of racial types to post-Darwinian ideas of continual change and adaptation. By 1900 evolutionary biologists and physical anthropologists had developed numerous theories concerning the development of prehistoric racial types, defined by specific physiological traits that at some point in man's development had become fixed and therefore unresponsive to evolutionary selection. By the early twentieth century most anthropologists and biologists subscribed to an "evolutionism with traditional views," predicated upon the "closed nature of racial formation and the fixity and persistence of racial differences."[25]

Blackford's conclusions concerning the evolution of facial features should not surprise any reader familiar with either phrenology or scientific racism. Blackford associated the "strong chin" of Europeans, for example, with courage, will power, and persistence, while the narrow or wide receding chins of the "dark races" signaled the absence of such valued characteristics. "Primitive" foreheads were "low, short, narrow, and receding," while those among the "civilized" were predictably "much higher, much wider, and inclined to be more prominent at or just below the hair-line." The "pure convex type" of facial profile indicated energy, both mental and physical; this type of man "goes directly for his goal and does not hesitate to push aside other people in attaining it" (fig. 1.2).[26] The individual marked by the concave face was, in contrast, "slow, deliberate, meditative, and dreamy in thought . . . capable of a great deal of patience and plodding effort."[27] The combination of these two facial tendencies produced the planar facial type and indicated a balance of qualities, such as practicality and sound judgment. Most individuals, of course, demonstrated a combination of these facial forms; scientifically trained character analysts, Blackford argued, were best positioned to effectively read and interpret these physiognomic signs.[28] After reading the applicant's character from his face and body, Blackford applied her conclusions to vocational placement. If a man was "concave in form," for example, then "all those positions requiring aggressiveness, keenness, alertness, energy, and a sense of the practical are dropped from consideration."[29]

Although Blackford drew on the modern natural sciences to legitimate her racial physiology, the language she used in assigning character traits to somatic signs was equally indebted to the older practices of physiognomy and its offspring, phrenology.[30] Despite occasional references to emotional expression, the vast majority of Blackford's work is based upon fixed, rather than fleeting, physiognomic characteristics. This distinction between physiognomy (the study of fixed, or static, features) and pathognomy (the study of transitory expression of emotions) is an ancient one, maintained by modern students. For example, Darwin, in his pioneering work on emotions limited his study to physiognomy per se, defined as "the recognition of character through the study of the *permanent* form of the features."[31] Physiognomy offered Blackford, as it had for her predecessors, an index to the soul, a somatic map of an individual's innate passions.

Physiognomy, the art of discerning internal ontology from external

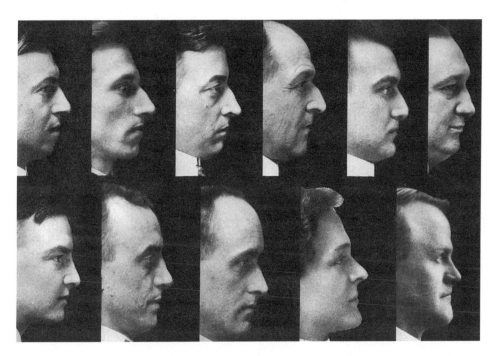

FIG. 1.2. Character analysts relied on physiognomic profiles to assign racial meanings to facial features. Blackford's caption for this image reads, "A Study in Profiles. Beginning at the upper left, which is pure convex, the faces grade into plane at the lower left. Then into pure concave at lower right." (Katherine M. H. Blackford, *The Job, the Man, the Boss* [Garden City, NY: Doubleday, Page, 1915], 159.)

corporeal features, has an ancient history dating from the Hellenistic and Greco-Roman eras. Technical handbooks on physiognomy enjoyed a great popularity among Greek and Roman writers. As Elizabeth C. Evans has argued, these theorists "set down in an orderly fashion what had long been informally observed and practiced," especially by classical writers. The first extant systematic treatment of the topic is a short treatise from the third century B.C. entitled *Physiognomonica*, attributed to Aristotle. Positing that "dispositions follow bodily characteristics" and that in turn the "body suffers with the affections of the soul," the author of the treatise describes methods for treating illnesses, which body parts influence which aspects of character, and the comparisons that may be made between man and specific animals.[32]

The work that had the most far-reaching effect in the modern period,

however, was Johann Caspar Lavater's *Physignomische Fragmente* (1775–78). The appearance of Lavater's richly illustrated, multivolume work caused a "physiognomic craze" among many Enlightenment writers in the 1770s. By 1810 Lavater's work had been published in sixteen German, fifteen French, two American, two Russian, one Dutch, one Italian, and twenty English versions. According to John Graham, "The book was reprinted, abridged, summarized, pirated, parodied, imitated, and reviewed so often that it is difficult to imagine how a literate person of the time could have failed to have some general knowledge of the man and his theories." The influence of Lavater's physiognomy on every branch of European culture, especially eighteenth- and nineteenth-century literature, has been exhaustively documented.[33] Historians have explained the eighteenth century's renewed interest in the old science of physiognomy as a response to the displacements and disruptions that accompanied the transition to modernity. Physiognomy offered a "scientific" methodology to distinguish the sincere from the sycophantic, the authentic from the arriviste. In the age of sensibility (and, later, romanticism), physiognomy became "the science of the truly authentic self."[34]

Phrenology originated in 1795 with the Austrian anatomist Johann Franz Gall, who examined a range of individuals representing various occupations and posited a correlation between each person's mental qualities and the shape of his or her head. For Gall, just as the eye was the organ of sight, the brain was the organ of the mind. The mind, because of its complexity, required a set of related organs, each of which governed a specific mental faculty; each mental capacity could therefore be traced to its corresponding mental "organ," where "size is the measure of power."[35] Gall's work was initially popularized in the United States by Johann Gaspar Spurzheim, whose 1832 lecture tour electrified American reformers and scientists, but later American phrenology is nearly synonymous with the Fowler family, whose head readings, museums, publishing house, and lecture tours popularized the idea that there was an established link between physiology and mental qualities, or character.[36] Several phrenological distinctions, such as the differences between motive, vital, and mental temperaments, found their way into Blackford's work.

Both the ease with which Blackford linked physiology to character and the practical application of character reading to vocational guidance can be attributed, in part, from phrenology's rich legacy.[37]

As Madeleine Stern has discussed in her work on the Fowlers, as the popularity of phrenology waned and its scientific basis was increasingly undercut by advances in medical science, Jessie Fowler, the last of the Fowler phrenologists, turned to vocational guidance in a last-ditch attempt to save the family enterprise. In 1916 the American Institute of Phrenology specialized in what Jessie Fowler described as the "Study of Human Nature and Vocational Guidance"; in 1922 the offices were located at 125 W. Forty-second Street in New York City, several blocks from Dr. Katherine Blackford's office at 50 E. Forty-second Street. Blackford's work was recognized as providing a valuable contribution to scientific management, not only before the war but also through the 1920s. While Fowler's work was explicitly related to the increasingly disparaged practice of phrenology, Blackford's approach, though partially based on phrenological assumptions regarding the relationship between surface and interior, was legitimated through the appropriation of modern scientific language.

Centuries of physiognomic assumptions combined with the taxonomic methodologies of the natural sciences, particularly physical anthropology, to produce a generalized "common sense" concerning the relationship between exterior manifestations and interior states. While some scientists had called these assumptions into question, the general public, especially the business class, to whom Blackford's work was directed, found little to argue with in her racist assumptions concerning the body, ability, and mind. Blackford established her legitimacy not only through her professional credentials as a medical doctor and her learned use of scientific works in her writings but also through her reliance upon photography.

Although much of Blackford's character analysis was performed in person, during an interview, she relied on photographs to demonstrate her methodology and to read an applicant's character *in absentia*. Photographs were superior instruments of vocational standardization because they froze the subject's physiognomy in a static position that, Blackford argued, better assisted the analyst in seeing through the surface distractions of expression to the more telling structure beneath. In Blackford's arsenal, the photograph became a prosthesis of managerial vision, allowing her to see through the subject's chimeras of expression to the passions of the soul.

To demonstrate her character-reading skills, Blackford, like her counterparts in phrenology, recontextualized studio portrait photo-

FIG. 1.3. Portraits of well-known figures, such as this portrait of the reformer Jacob Riis by Frederick Gutekunst, provided evidence for Blackford's claims concerning the relationship between facial features and character. (Katherine M. H. Blackford and Arthur Newcomb, *Analyzing Character: The New Science of Judging Men; Misfits in Business, the Home, and Social Life* [New York: Review of Reviews, 1916], 53.)

graphs of leading American citizens. A studio portrait of the turn-of-the-century urban journalist reformer Jacob Riis by the well-known Philadelphia photographer Frederick Gutekunst typifies the genre (fig. 1.3). Sitting for what is essentially an occupational portrait of a member of the professional class, Riis is dressed in a dark suit and tie, his solid body held in quiet reserve in a three-quarter profile, politely yet insistently offering the viewer, whose gaze he holds confidently, only a partial audience. His arms are crossed across his chest, a masculine working-class stance unusual in a portrait of a middle-class profession-

al but fitting one of a cross-class interloper known for his nocturnal ambushes in pursuit of the urban exposé. The studio lighting casts his form partly in light, partly in shadow, providing a dramatic focus on facial features while functioning here, surely unintentionally, as a metaphor for the subject's work in bringing to public "sunlight" New York's "shadowy" underclass.

Blackford presented Riis's portrait as documentary evidence of her physiognomic practice. Accompanying a textual discussion of the "elements of fitness," the Riis portrait draws its evidentiary value from a rather vague association between his well-publicized character traits and generalized physiognomic observations. In the caption to the image, the only place where this particular photograph is discussed, Blackford first revisits a characterization of Riis that would have been long familiar to her middle-class readers, describing him as "a man of unusual intellectual power, observation, reason, memory, logic, and analysis, with high ideals, great love for humanity, especially for the weak and helpless; good powers of expression, sense of humor, courage and determination." The familiarity of this description works, implicitly, to legitimize Blackford's interpretive abilities; quietly Blackford wins the reader's faith while carrying him or her into more unfamiliar terrain. The caption's second and final sentence situates Blackford as the expert and the reader as an attentive student, a position from which the reader is unlikely to rebel, given the first sentence's common-sense description: "Note large development of upper part of head; fairly well developed brows; high dome over temples; height and width of forehead, especially across center; full lips; well developed nose; strong chin; and alert, poised kindly expression." While Riis tours the urban underclass, Blackford takes the reader on a tour of Riis's face, defining through the caption what is both seen and interpreted.[38]

The caption and the image work to suggest physiognomic "proof" of Riis's character. The text and the photograph's "reality effect" conspire to elicit the reader's faith in the interpretive project.[39] Yet upon closer reading, it is clear that the evidence provided is merely a set of simple, rather nonspecific, associations. Does Riis's "large development of upper head," for example, signify his "unusual intellectual power" or his "sense of humor"? How are we to understand, without measurement or comparison, that Riis's upper head is "large" to begin with? Once we have obediently "noted" the full lips, what somatic interpretation are we meant to draw? Like Lavater, Blackford barely identified, let alone pre-

cisely analyzed, the physiognomic features and their characteristic equivalents.[40] The "science of character analysis" remained fundamentally unexplained, leaving the field open for "experts" rather than amateurs.

Although Blackford sometimes used photographic portraits of everyday men and women, especially in her later work, most of the images she relied upon were recontextualized portraits drawn from illustrated journals or commercially published cabinet cards. Within the context of nineteenth-century portrait aesthetics, the successful photographic studio portrait was one that moved beyond the stiff recording of external features to illustrate aspects of the sitter's inner character. As Albert Sands Southworth, the famous daguerreotype portraitist, argued, "The whole character of the sitter is to be read at first sight; the whole likeness, as it shall appear when finished, is to be seen at first, in each and all of its details, and in their unity and combination." At a glance, the sitter's individuality and character should be readily available, expressed through a synchronic combination of individual features.[41]

The studio portraits that served as Blackford's evidentiary base were originally made with such an aesthetic achievement in view. These highly stylized portraits of acclaimed American leaders offer what Benjamin H. D. Buchloh has called the "traditional promises of likeness and identity, of the centrality of an integrated subjectivity."[42] The three-quarter profile, the sitter's solemn formality, and the use of evocative lighting draw upon an older understanding of the successful portrait as capturing the sitter's individual character. Yet these formal conventions were drained of their original meaning under Blackford's analytical gaze, the continuity of the modern subject being fragmented into a collection of facial features. In these recontextualized studio portraits the sitter's "character" (the nineteenth-century formulation) dissolves into a taxonomy of "characteristics." As suggested in figure 1.4, Blackford ruthlessly banished the portrait's aura of individuality, so avidly pursued in the face of the photograph's mechanical technology, in order to organize her American merchants into a grid of "vital" evidence. For Blackford, the portrait signified not the individuality of the sitter but the organized collection of meaningful physiognomic signs; the parts signified more than the whole. The portrait became an object lesson in character traits, a collection of otherwise individuated, component parts, isolated and tagged according to a physiognomic logic and reissued under the standardizing categories of scientific management and evolutionary race science. Figure 1.5, a portrait of a young professional

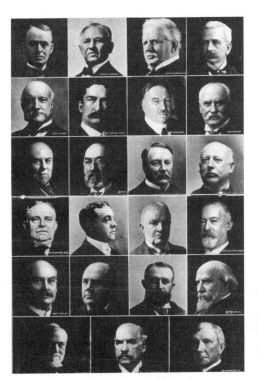

FIG. 1.4. (*left*) A grid of standardized physiognomic features replaces an earlier focus on the individual portrait as expressive of personal character. This set of images represents American merchants, bankers, and financiers, whose features represent the development of the "vital element," according to Blackford. (Katherine M. H. Blackford, *Character Analysis by the Observational Method*, ed. Arthur Newcomb, 3d ed. [New York: Henry Alden, 1918], 22–23.) FIG. 1.5. (*right*) Individual features are erased in this portrait, which Blackford claimed represented "a narrow head, indicating mildness of disposition—an inclination to win way and secure ends by intellect, tact, and diplomacy, rather than by direct conflict." (Katherine M. H. Blackford and Arthur Newcomb, *Analyzing Character: The New Science of Judging Men; Misfits in Business, the Home, and Social Life* [New York: Review of Reviews, 1916], 319.)

man in which the entire face has been blocked out, marks the erasure of individual subjectivity within Blackford's labor physiognomy.

Photography, Measurement, and Racial Typology

Blackford's practice of reading the character of famous American leaders such as Taft, Roosevelt, and Riis continued a long-established tradi-

tion, echoing, for example, Lavater's physiognomic readings of Shake-
speare and Sterne, Caesar and Cicero.[43] To acknowledge Blackford's
debt to physiognomy and phrenology, however, is not to discredit her
work nor simply to assign it to the murky realms of pseudoscience.
As I will make evident, Blackford was one of many professional voca-
tional experts who used photography, phrenology, and physiognomy as
guides in vocational selection before and well after the war. How can
we account for the credibility of their work among the otherwise "hard-
headed" businessmen who hired Blackford and her peers as consultants?
To answer this question, one needs to explore how nineteenth- and
early-twentieth-century scientific and photographic practice worked
together to naturalize—and popularize—physiognomic assumptions
concerning the relationship between mind and body. Even as late as
the 1920s the presumed correlation between physiology and mental
characteristics was being pursued in a number of the social and biologi-
cal sciences, including physical anthropology, criminology, and eugen-
ics. And as Sabine Hake has argued in the context of Weimar German
photographic practice, physiognomic assumptions enjoyed an "unex-
pected return to public discourse" after World War I.[44] Photography's
realist promise as an unmediated record of scientific objectivity made
the medium a preferred methodology for scientists seeking to anchor
truth claims concerning the relationship between mental states and ex-
ternal, corporeal features.[45]

Phrenological logic was far from dead in the war years; rather, mod-
ern biological understandings of the localization of functions in the
brain caused some scientists to reassess older claims in light of the "new
phrenology."[46] As Nancy Stepan has argued, phrenology has been re-
assessed by historians as a "genuine science of mind which happened to
be wrong" but which "nevertheless shaped the views of a generation of
scientists." According to Stepan, "The fundamental place of phrenol-
ogy in the scientific, social and intellectual history . . . in the nineteenth
century is now established beyond doubt."[47] The imperative to natu-
ralize racial hierarchy through the biological sciences had resurrected
phrenology's older claims concerning the links between physiology and
psychology, between the body and the mind.

Within physical anthropology, for example, the key methodol-
ogy for identifying (and constructing) racial traits was measurement
and, later, photography. Although racial prejudice has a long history,
it was not until the early nineteenth century that racial difference be-

gan to be quantified through technologies of corporeal measurement, giving race a "scientific," biological meaning and thereby limiting the degree to which racially marginalized groups could be assimilated. Anglo-European interest in racial measurement focused first on the brain's physical characteristics as an index to racial type.[48] Working on the assumption that cranial capacity was tied to both brain size and race—like the phrenologists, who believed that bigger was better—the distinguished Philadelphia scientist Samuel Morton set out to establish racial rankings by measuring the volume of the cranial cavity. As Steven Jay Gould has argued, long after evolutionary theory had vanquished polygeny's concept of separate creations, Morton's theories of racial ranking were reprinted throughout the nineteenth century as "irrefutable 'hard' date on the mental worth of the human races."[49]

The facial angle, first developed in the modern era by Petrus Camper (1722–89) but linked to intelligence as early as Aristotle, was another key criterion for racial somatology. A vertical line connecting the lower portion of the nose and the brow, bifurcated by a second line connecting the ear's opening to the lower portion of the nose, created a measurable angle: a right angle of 90° marked the advanced races, while the more oblique angles of 70° marked the "Negro." By 1860 the facial angle had become the most common means of explaining the gradation of species among scientists and their popularizers. Samuel Wells, the famous American phrenologist, argued, for example, that the "negro cranium is long and narrow," with a facial angle of 70°, indicating a "prognathous type," in which the "animal feelings predominate over both the intellect and the moral sentiments." Blackford drew upon these racialized methodologies to identify, by means of head shape and facial profiles (a modern interpretation of Camper's facial angle), racial inheritance and therefore, she argued, character.[50]

Post-Darwinian scientists took up the measurement of skulls, head shapes, cranial capacity, brain weight, and size where an earlier generation had left off; in 1899 one American sociologist estimated that more than 11.5 million persons had been measured in Europe and the United States to determine their racial identity.[51] By the second half of the nineteenth century, technologies for measurement, especially of the body's external features, became increasingly standardized in an anthropological subdiscipline known as anthropometry, "the technique of expressing quantitatively the form of the human body."[52] In the United States, the Civil War marked what one historian has called a "watershed" in

anthropometric developments, not only because of the widespread anthropometric examination of Union soldiers but also because nearly all
postbellum theories of racial inferiority looked to war anthropometry
for scientific validity.[53] Anthropologists continued to pursue anthropometric methodologies throughout the nineteenth century and into
the twentieth, avidly measuring bodily and facial characteristics such
as stature, arm length, head length and width, and nose length.[54] The
thinking was that such measurements could help define racial types and
that the isolation of these racial types could help (for some investigators) illuminate not only physical differences but cultural, mental, and
moral differences as well. Through measurement, racial typologies and
hierarchies of both body and mind were constructed and naturalized.[55]

Photography became central to this enterprise of constructing and
mapping somatic difference. In supplementing and providing evidence
for corporeal measurements, the photograph offered seemingly incontrovertible visual evidence for the scientists' racist conclusions. A mechanically produced image, made under standardized conditions often
against a gridded surface, the anthropometric photograph quietly assumed the rhetoric of neutrality and scientific objectivity. In physical anthropology, for example, photography's principal contribution through
at least the 1920s was the documentation of distinct racial types. Photography was also a preferred methodology for eugenicists seeking to
understand rules of genetic inheritance and the social engineering that
they argued logically followed from their scientific discoveries. Francis
Galton, the British scientist who founded eugenics and coined the term
in 1883, worked throughout much of his life, using photography and
other visual methodologies, to isolate, measure, and categorize "inheritable" traits of mental, moral, and physical difference. As Karl Pearson, Galton's colleague in eugenics and the use of statistics in relation
to biology, argued in 1924, "Galton developed composite photography
in his search for a method of ascertaining whether physiognomy is an
index to mind, i.e., whether facial characteristics are correlated with
mental traits."[56]

In criminal anthropology, as Allan Sekula has discussed, photography was used as a means of identifying not only particular criminals
through the recoding and archiving of idiosyncratic corporeal features
but also potential criminals based upon standardized physiognomic
signs.[57] By 1912 Alphonse Bertillion's work in criminal identification
at the Paris Prefecture of Police was well known. Katherine Blackford

made the pilgrimage to visit with him and was thrilled by the rooms of wax and photographic facial features, organized by type. Bertillion, however, refused to admit any correlation between stigmata and criminality; by 1912 the Italian school of criminal anthropology, for which Cesare Lombroso was the main figure, had fallen out of favor in the scientific community.[58] "If only he [Bertillion] could realize the matchless collection of materials for analysis and study of character!" Blackford exclaimed. Frustrated with Bertillion's move to track individual marks in contrast to taxonomizing criminal "types," she ruefully concluded that "he is wrapped up in the one subject of identification, and cares little about the revelations of character which his measurements and photographs reveal."[59]

Commercial Goldbrickers

The relationship between photography and physiognomic taxonomy, then, was an established one by the time of Blackford's work. Her adroit appropriation of photographic evidence of physiological difference and physiognomic meaning powerfully influenced her contemporaries, sparking a new movement in employment management. Although Blackford's system was the best-known system of "scientific character analysis," she had her competitors in the race for corporate clients, some of whom also relied upon photographic methodologies. James G. Matthews, for example, argued that "every living face is a bulletin board of thought, molded . . . by inherited character." He advocated an examination of eye color and facial angle, assigning character traits to lines that Camper had pioneered to identify racial groups (figs. 1.6 and 1.7).[60] Holmes W. Merton, a physiognomist who founded the Merton Institute for Vocational Guidance in 1918 and author of the Merton System, was reported to have trained personnel managers for AT&T, among other companies; like Blackford, he used photographs to decipher the connections between physiognomy and occupation. Commenting on photographs of streetcar operators, for example, Merton discerned that all the portraits revealed "fairly high or wide cheekbones," a physiognomic sign of the caution considered necessary for the job.[61] William Judson Kibby, the head of a New York concern called The Personnel Company, also received positive publicity for his work as a character analyst selecting employees for large corporations. Kibby's racialized system seems to be a direct plagiarism of Blackford's well-known work, emphasizing coloring, head formation, and facial features.[62]

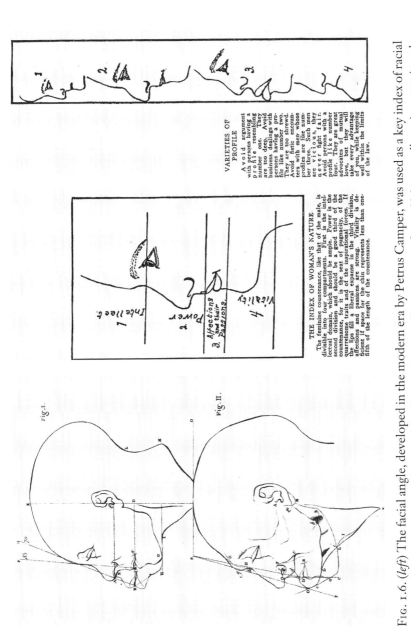

Fig. 1.6. (*left*) The facial angle, developed in the modern era by Petrus Camper, was used as a key index of racial difference, classification, and hierarchy. (Petrus Camper, *Dissertation sur les variétés naturelles qui caractérisent la physiognomie des hommes des divers climates et des différens ages,* trans. H. J. Jansen [Paris: Francart, 1792]. Courtesy Research Library, The Getty Research Institute, Los Angeles, CA.) Fig. 1.7. (*right*) Character analysts appropriated scientific racist methodologies to promote their ability to decipher the characteristics of potential employees. ("Reading the Human Countenance," *Current Literature* 42 [Mar. 1907], 331.)

Blackford claimed to have applied her system to more than twelve thousand job applicants in large contracts throughout the country, successfully increasing efficiency and reducing labor turnover. Despite her seemingly grandiose claims, the contemporary press commented favorably on her work through the early 1920s. As one observer noted, the labor crisis facing American industry in the World War I era had been so great that "it has brought about a revival of the old abandoned so-called science of phrenology, physiognomy, character reading, and character analysis," especially among "industrial executives."[63]

Although these systems were heavily criticized by psychologists, as I will discuss, no one could argue their appeal to businessmen seeking to rationalize employee hiring.[64] The Johns Hopkins psychologist Knight Dunlap, for example, reluctantly acknowledged that these systems "have at least financial success, for many of the character analysts are making money from their practice on commercial and industrial concerns."[65] The psychologist Glen U. Cleeton, of the Carnegie Institute of Technology, in a compact historical summary published in 1926 bemoaned the persuasiveness of modern commercialized systems of character analysis. "In spite of the historical death of the movement," Cleeton wrote, "it would not stay dead. The seemingly dead thing convalesced and gave evidence of a strong recovery shortly after the beginning of the present century. . . . Commercialized character analysis continues to be widely exploited." Once a well-respected "science" positing a correspondence between outward appearance and inward mental states, character analysis is here recast as a type of monster, exploiting the business community in a period of economic vulnerability.[66]

The tenaciousness of commercial systems of character analysis may have frustrated social scientists, but their appeal to businessmen is understandable in an industrial context beset by tremendous growth and heterogeneity. Corporate mergers and the growth of big business, especially in mass-production industries, dramatically increased the number of employees engaged in many businesses, transforming the work experience from that of the closed community of the small town to one characterized by the anonymity of the metropolis.[67] Fifteen million immigrants arrived in the United States in the years between 1890 and 1940; many of those who passed through the visual-inspection line at Ellis Island found their way to industrial employment offices.[68] In their efforts to select the best applicant, employment managers turned

to a long-familiar American emphasis on individual "character," whose lineaments they anxiously deciphered.

Prior generations had come to define character as a highly valued constellation of moral virtues, susceptible to both cultivation and corruption by the influence of others. Within the context of an emerging self-consciousness brought about by the cataclysmic shifts of Enlightenment thought, the development of character suggested both the stability of a shared social order and the promise of mobility within that order. Character signaled the assiduous cultivation of inner virtues such as duty, work, honor, and self-control and emphasized the Protestant ethic of work as salvation in moral, economic, and social terms.[69] Such carefully cultivated virtues shared a physiognomic language in which "the habits of the soul become written on the countenance," legible to all.[70]

Within the context of nineteenth-century urbanization, however, the surface expressions of inner character could be manipulated by strangers, "confidence men" who severed the connection between inner virtue and outward appearances by consciously manipulating the impression made on others. The rapid urban transformation that marked the nineteenth century resulted in a crisis of legibility, the signs of outward appearance no longer able to be confidently anchored to predictable meanings and positions within the social order. This dramatic transformation of everyday life from one taking place in a known community to one taking place in an anonymous crowd, which historians have discussed in relationship to the modern city, characterized not only urban but also industrial life.[71] With single factories employing more workers than lived in small towns, employment managers faced similar worries concerning the relationship of external appearances to inward states.

The competition in the early twentieth century between notions of "character" and the emerging appeal of "personality" reflects an encoded, class-inflected battle. Working-class access to advice books on the cultivation of charm and other "winning" personality traits provided an arsenal of weapons to wield on behalf of job security and class mobility, which savvy job applicants could draw upon during the employment interview. The successful use of these personality tools by industrial job applicants represented part of the problem facing employment managers: appearances could not necessarily be trusted; the character flaws of the occupational misfit could be hidden by the sorcery of personal charm. The emergence of the culture of personality, which cultural the historian Warren Susman has so brilliantly mapped, furthered the

"semiotic breakdown" that John Kasson has argued characterized the nineteenth-century urban experience.[72]

Industrialists needed a reliable methodology to classify the anonymous members of the applicant pool. A methodology based upon character promised not only legibility and a managerial weapon against the dissembling chimeras of "personality" but also a seeming guarantee of "nineteenth-century" virtues such as honesty and industriousness, still very much desired by twentieth-century industrial managers. The rise of Social Darwinism, however, had drained *character* of its malleable, perfectible connotations; early-twentieth-century understandings of character rooted virtues and defects not in the "habits of the soul" but in the body's biological imperatives. In the absence of other methodologies for selecting job applicants, character analysis offered to detect a familiar set of nineteenth-century virtues (character) through modern, scientific (and visual) means (analysis).

Applied Psychology and the Rise of Mental Testing

In the years following World War I a tide of criticism against systems of character analysis began to flood both the popular and scientific press. Phrenology, physiognomy, and character analysis, long known as constituting the "science of the mind," had been resurrected during the second decade of the century to rationalize employee selection. But the years before and especially after the war were also marked by the establishment of a new field that also claimed the mind as its especial province and sought to rationalize the "human element" of industrial production.

Applied psychology, whose triumph as an American discipline can be traced to the English translation of Hugo Munsterberg's *Psychology and Industrial Efficiency* (1913), sought to establish an investigative terrain in an area that until then had been the sole province of the character analysts: the industrial and business world.[73] Unlike the character analysts, the industrial psychologists questioned whether somatic signs provided a reliable index to internal states, including intelligence. Recognizing the limitations of seeing the worker as simply a "human machine," industrial psychologists began looking underneath the skin, to subjective processes that belied the physiognomic "evidence" of prior research. In their desire to script a more complex understanding of human capacity and motivation, psychologists recognized the limitations of focusing on the body's external, structural features, classified under the classical science of physiognomy and its modern descendant, an-

thropometry. Armed with new methodologies for mental testing, this generation of applied psychologists interrogated the subjective, both mental and emotional, eventually severing the classical link between character and external appearance. While photography remained an important methodological tool, its role shifted from providing evidence of the subject's somatic semiology to that of a vaguely theorized catalyst for the viewer's subjective response. Industrial psychologists remained committed to photographic meaning; they knew that physiognomic portraits provided evidence of something, but they were no longer sure just what that something was.

Industrial psychology emerged as a result of psychology's move into experimental science, a development generally dated to 1879, when the German psychologist Wilhelm Wundt founded the first laboratory devoted to the scientific study of the mind, at the University of Leipzig. Wundt's structuralist psychology constructed a common "psychological man," whose response to external stimuli could be predicted, charted, and quantified. It assumed an underlying physiological commonality rather than recognizing individual difference as playing a psychologically significant role in human behavior.[74] Wundt's American students, however, showed more interest in the differences between individual subjects than in what they shared. This second generation of modern psychologists, therefore, moved slowly away from the model of man as standardized machine, with all subjects' parts working identically, to a model that allowed individual differences to be analyzed and accounted for. The rationalization of the human subject, while still a goal in terms of the drive for industrial efficiency, was sought less through standardization of human parts and more through the identification and classification of difference, especially mental difference.

James McKeen Cattell, Wundt's first American student, spearheaded this influential movement in American psychology. In 1890 Cattell coined the term *mental tests* to describe a series of laboratory experiments designed to study individual differences in color vision, rote memory, reaction time, sensitivity to pain, and other phenomena and linked to the anthropometrical measurements so carefully tabulated by Galton.[75] Cattell's emphasis on testing ushered in a defining methodology for American experimental psychology.[76] After 1908, when Alfred Binet's intelligence scale became popular in the United States, mental testing expanded to include intelligence testing as well, but except among the numerous eugenicists, including H. H. Goddard and

Charles Davenport, these mental tests moved away from the classical efforts to link mental capacity to physical features.

By the turn of the century, testing was firmly entrenched as industrial psychology's defining methodology, distinguishing the new discipline from the increasingly disparaged character analysis, which continued to rely upon visual methodologies. The first psychologists to offer their expertise to business and industry constructed customized mental tests as a guarantee of their professional expertise. Hugo Munsterberg, one of America's first film theorists and the head of Harvard's psychological laboratory, began developing tests to explore the relationship between visual acuity, psychology, and efficiency in 1909.[77] Although he was in considerable sympathy with Taylorism's goal of standardizing industrial production, like most members of scientific management's second generation, Munsterberg felt that psychological expertise was necessary to move past Taylor's "excessive driving" techniques in order to foster "the heightening of the individual's joy in the work."[78] Placing workers in jobs appropriate to identifiable "mental types" was an important step in this process, and testing, Munsterberg argued, was the methodology that would enable psychologists to determine the best match.

In his celebrated 1912 test for streetcar conductors, Munsterberg sought to measure the conductor's ability to "keep attention constant" despite distractions, as well as to foresee the erratic movement of pedestrians and vehicles unexpectedly lurching across the tracks.[79] Rather than reading the physiognomies of the motormen, as Blackford would have done, Munsterberg sought to reconstruct, through a carefully designed vocational test, the "inner similarity of mental attitude" necessary for successful conductors. He presented the test-taker with a stack of gridded 4½ × 12 inch cards bifurcated by two heavy lines indicating the streetcar tracks. Red and black numbers within the grid's half-inch squares indicated pedestrians, cars, and horses. Anticipating his later fascination with cinematic seeing, Munsterberg created a glass-topped device to cradle the stacked cards, which he covered with a black velvet belt with a window of 4½ × 2½ inches. When cranked, the velvet viewfinder moved over the gridded cards at a predetermined speed, while the test-taker identified potential accidents based on the obstacles' proximity to the tracks. Munsterberg tested a large number of motormen with varying safety records and discovered a significant correlation between the test results and their work performance. The test-takers agreed that the experiments successfully simulated the "feeling which they have on the car."[80]

In this test vision and attention are linked in processes of rational-
ization whereby the visual field is gridded into standardized units, mo-
tion is controlled, and speed is timed by the managerial expert. The
chaotic near anarchy of an urban street is platted into manageable
parts, while pedestrians, animals, and vehicles become interchangeable,
standardized units representing varying degrees of potential financial
loss. Munsterberg had no expectation that this ability for rationalized
seeing could be read externally by means of a somatic sign system of
physiological features. Instead, the rationalization of vision has gone
under the skin, to internal physiological and psychological processes
that reveal the logic of rationalization without the physiognomic trace.
A shift takes place from the manager's ability to read character in the
test-taker's physiognomy to the test-taker's ability to see, in a rational-
ized fashion, the outside world. Munsterberg's shift from the body's
external signs to its internal processes is part of a longer scientific his-
tory, but its emergence in the context of vocational selection in 1913
implicitly challenged the methodologies of Munsterberg's competitors
in the field, the character analysts.[81]

Munsterberg's work is important for another reason as well. Although
in creating and administering the tests he sought to rationalize both
ways of seeing and conductor efficiency, unlike his industrial-efficiency
colleague Frederick Winslow Taylor, Munsterberg explicitly acknowl-
edged and incorporated the role of subjective experience, especially
emotion. He sought to replicate the "feeling" men had on their cars,
since he understood that the conductors' decision making was the re-
sult of complex subjective states, including not only attention, distrac-
tion, and fatigue but emotional states as well.[82] Although Munsterberg
did not dwell on the complex relationship between attention, vision,
and the emotions in this work, his 1916 book on film theory, *The Pho-
toplay: A Psychological Study*, treats these topics at some length.[83] The
filmic imagination of Munsterberg's velvet-covered viewfinder is more
fully in evidence in this work, as well as in his 1916 screen projects with
Paramount Pictures, in which he introduced vocational selection to a
mass audience through short films that asked, "Can you make quick es-
timates?" and "Can you judge well what is beautiful and what is ugly?"[84]
In Munsterberg's work, as well as in that of his professional colleagues,
visuality is understood in relationship to the observer's subjectivity. The
psychologists' shift from understanding the subject as a repository of
physiognomic meaning to understanding him or her as a constellation

of invisible mental processes marks a shift in the understanding of the visual. Whereas applied psychologists became increasingly concerned with the mechanics of embodied vision, especially in relationship to industrial capitalism's demands upon workers' attention and distraction, character analysts remained committed to an older paradigm that saw the body as visual evidence of otherwise invisible human traits.

Photography and Epistemology: Applied Psychology versus Character Analysis

Despite psychology's increased prestige, the distinctions among the various approaches represented by the applied psychologists, the character analysts, and, increasingly, the Freudians remained unclear to many businessmen. In 1913 Carroll D. Murphy, writing in *System*, the leading magazine for progressive business managers, had offered both character analysis and the new mental testing as equally legitimate approaches to the "standardization" of employees.[85] This catholic appreciation for methodological diversity continued after the war and represented one of the greatest challenges facing the new applied psychologists. As the psychologist Harold Burtt complained in 1926, in the midst of a diatribe against "pseudo-psychology," "when the blonde employees fail to come up to expectations, when the position of the vest button proves to be non-differential of the salesman's success, and when the inspirational phonograph records and the psychology hymns fail to raise the salary, then real psychology gets the blame."[86] During the postwar period, however, "real psychology" was getting the blame on its own: managerial enthusiasm for mental testing as a means of vocational selection had intensified to the point where the applied psychologist Walter Dill Scott in 1919 warned a convention of employment managers against turning the methodology into a "fad" that would inevitably fail to meet overblown expectations. But he was too late: in the years 1922–25 large numbers of firms discovered that psychological tests marketed by, for example, the Psychological Corporation were not producing the promised results. By 1925 only 4.5 percent of even the more progressive companies used psychological tests.[87]

In the wake of this professional disaster, the character analysts found renewed enthusiasm for their approach to "scientific selection." By the mid-1920s it was not uncommon for companies to require the submission of photographs with job applications so that they could read the applicant's physiognomy, in addition to race and gender. In 1924, for

example, school superintendents demanded pictures of candidates for positions in public schools, as did the consular service.[88] As late as 1965 Cyril Curtis Ling noted that "while this erroneous method [physiognomic character reading] has been demonstrated to be invalid, it still creeps into employment decisions via photographs and interviews."[89] As the psychologists Donald A. Laird and Herman Remmers concluded in 1924, during the period of vocational physiognomy's greatest persuasiveness, "That some insight may be gained into mental characteristics by the facial contour and expression is almost universal belief at the present day."[90] The postwar psychological consulting firms were organized, in part, as a guild designed to limit the practice of applied psychologists to those academically trained in psychology; through such professional organizations, the applied psychologists hoped to successfully discredit the character analysts as "charlatans and fakirs."[91] But the temporary failure of their own methodology put the psychologists once more on the defensive.

The period following World War I saw a rash of studies designed to test further the accuracy of character evaluation based on physiognomic readings. Although most of the studies were explicitly concerned with photographs, a few were designed to test Blackford's assertions more generally. A 1922 study, for example, tested the relationship between blondes and brunettes and the traits accorded to them in Blackford's employment plan; the authors concluded that "it seems very probable that Dr. Blackford's law of color with her definite and dogmatic assertion concerning blond and brunette traits is not only misleading but false." Another study investigated the relationship between successful executives and the shapes of their heads and hands; no relationship was discovered. "We were forced to the conclusion," the author stated, "that this system was not reliable."[92]

But while these studies discredited Blackford's assertion that there was a definite correlation between physical features and character, the psychologists were initially unwilling to jettison Blackford's photographic methodology. The Columbia University professor Harry Hollingworth's 1929 revised edition of *Vocational Psychology* included his 1922 discussion of character analysis and was renamed, significantly, *Vocational Psychology and Character Analysis*.[93] In a new chapter entitled "Traditional Methods: II, The Photograph," Hollingworth argued that even though studies had shown no significant correspondence between physical features and actual character traits, there nonetheless existed

a significant agreement among observers of photographic portraits on the perceived presence or absence of certain traits: "Different judges show quite striking agreement in their estimates of the characteristics suggested by a given photograph," especially concerning intelligence, he concluded. "Is there 'an art to read the mind's construction' in the photograph?" Hollingworth asked, and he responded with a tentative yes, saying that in the case of certain traits, such as intelligence, refinement, beauty, snobbishness, and vulgarity, "photographs may be used to suggest useful information concerning the character of the individuals they represent, if the proper technique is employed."[94]

Hollingworth's markedly tenuous endorsement reveals the confusion surrounding the use of photographs in vocational selection during the 1920s. Psychologists wanted to claim the methodology, persuaded perhaps that photography's mimetic qualities necessarily indexed something. Did the value of photographs lay in their ability to fix, and therefore reveal to the trained observer, the innate personal traits of the photograph's subject, or did it lie, as Hollingworth seemed to suggest, in their function as a mirror for the socially inflected responses of their viewers? As psychologists revealed themselves to be unwilling to jettison their assumptions concerning the existence of photographic truth, the question became whether the photograph registered the subjective truth of the photographic subject or of the viewer.

In order to gauge the accuracy of the viewer's reading of a physiognomic portrait, psychologists began to test viewers' responses against a newly quantified trait, recently severed from its ties to the physiological. Intelligence testing provided psychologists with what they understood to be an objective, quantitative rating against which physiognomic readings could be gauged. Early-twentieth-century scientists, especially eugenicists, had become increasingly interested in exploring the long-assumed relationship between physical traits and "intelligence," newly quantified with the publication of Alfred Binet's influential point scale for mental ability.[95] Although some scientists, such as Binet, had abandoned the search for a correlation between external appearance and intelligence, the belief that the body was an index to the mind lingered in both lay and scientific circles through the 1920s. It was this association that the applied psychologists sought to test in a series of experiments designed to explore the relationship between intelligence and physiognomy, as indicated in photographic portraits.

The first study to focus explicitly on judging intelligence from pho-

tographs was conducted by the psychologist Rudolph Pintner at Ohio State University and published in 1918.[96] Using portraits of school-children, Pintner compared the observers' perceptions of mental ability, based upon their readings of the photographic portraits, with the students' IQ (then known as CMA, or coefficient of mental ability). In figure 1.8, six of the twelve schoolchildren smile weakly in the general direction of the school photographer. The wide features and vacuous expression of subject number 8 suggested to her observers a mind slightly less agile than those of her schoolmates. Subject number 12, in contrast, seems alert and self-possessed, her almond-shaped eyes turned frankly toward the camera's lens. But as Pintner discovered, such perceptions bore no relation to the subjects' IQ test scores: subject number 8 scored a reasonably high .88, while subject number 12 scored a woeful .47, representing a mental age of just half her chronological age.[97] Despite occasional high correlations, which Pintner suggested were due to chance, he concluded "that it is impossible by means of photographs to rank children according to their intelligence."[98] Pinter's image organization, a standard grid that echoes the institutional aesthetic of the school portrait, provides a visual argument for the rigorousness of his scientific method.

A series of psychological studies followed Pintner's lead, investigating the links between physiognomic readings and intelligence but also character and vocational ability—Blackford's established terrain.[99] In 1928, after a decade of psychological studies that severed the popular link between external features and character attributes, especially as revealed in photographs, two researchers at Wesleyan University challenged Blackford and her work directly. "[Blackford's] belief that we are able to 'size a man up,' to judge his character, to tell something of his personal qualities, is widely prevalent. Witness the usual request for a photograph with an application for a position, the adding of photographs to the personnel folder, and so on," the psychologists Carney Landis and L. W. Phelps began. The study sought to answer five questions concerning photography and vocational selection, including Blackford's central claim, that it was "possible to predict vocational aptitude from photographs." The researchers consulted the alumni publication of a large university issued twenty-five years after the graduation of 850 men, as well as their class yearbook. Twenty Wesleyan psychology students were asked to judge both sets of photographs for evidence of vocational success. The students' perceptions, drawn from photographs,

No. 7.	Chron. Age 10.	M. A. 9.	C. M. A. .88
No. 8.	Chron. Age 12.	M. A. 9.7.	C. M. A. .81
No. 9.	Chron. Age 12.	M. A. 10.	C. M. A. .80
No. 10.	Chron. Age 15.	M. A. 9.8.	C. M. A. .72
No. 11.	Chron. Age 12.	M. A. 8.6.	C. M. A. .72
No. 12.	Chron. Age 14.	M. A. 7.6.	C. M. A. .47

FIG. 1.8. Academic psychologists begin to test observers' ability to assess intelligence on the basis of facial features. (Rudolph Pintner, "Intelligence as Estimated from Photographs," *Psychological Review* 25 [1918]: 293.)

were correlated with the alumni's own account of their "worldly success" in the twenty-five years since graduation. Landis and Phelps found little correlation between actual vocation and that assigned by the observers and no prediction of success or failure. "In general," they concluded, "we may say that the present study lends absolutely no evidence toward the confirmation of the claims of the physiognomists. It offers no evidence which would indicate that the inclusion of a photograph in a letter of application or on a personnel sheet is of any positive value."[100]

In almost all of these studies the panel of judges was composed of psychologists or students of psychology, a logical enough development given the location of the studies. Yet the choice of observer implicitly established a parallel between the training of the physiognomist and the training of the psychology student. Blackford, Merton, and other "scientific character analysts" had never argued that the casual, untrained observer could accurately and scientifically select workers for appropriate jobs; on the contrary, the training and methodology they offered in their books, home-study courses, and consulting practices provided the expertise necessary for accurate analysis. Their criticism of these studies would surely have been that a few college-level courses in psychology did not a scientific character analyst make; that because twenty Wesleyan college students could not accurately judge future success or failure from photographs did not mean that twenty trained character analysts could not.

By the 1920s, however, the biological determinism that had structured Blackford's nineteenth-century assumptions had given way, in both popular and scientific circles, to new models of human behavior that emphasized individual adaptability and environmental influence during one's own lifetime. Within psychology, John Watson's behaviorism proved a more persuasive model of human nature in the 1920s than the static fatalism of genetic heredity.[101] Psychologists sought anxiously for a model of human nature that explained individual difference while offering the possibility of personal improvement, an ideological cornerstone of the self-made man. During these years of unparalleled economic prosperity, popular thinking proved equally impatient with Blackford's dour determinism: her intractable proclamations seemed out of step with an era in which everything from cosmetics to automobility celebrated incessant personal transformation.

From Physiognomy to Pathognomy:
Performing Emotion

As early-twentieth-century social scientists abandoned the physiognomic assumptions of Blackford, Merton, and Kibby, psychologists and personnel managers developed a renewed interest in what classical writers termed *pathognomy*, or the expression of emotion. This renewed interest in emotional experience had been anticipated by Hugo Munsterberg's streetcar-conductor tests, and the expression of emotion became a mass interest with the rise of Munsterberg's late-career love,

cinema. Signaling a broader cultural shift from the static to the kinetic, Glen Cleeton, a professor of education and psychology at Carnegie Institute of Technology, argued that "it is the *expression*, the mobile features of a face, and not the *fixed* features that give a clue to character."[102] The meaning of emotional expression became increasingly important to businessmen as skepticism mounted about the ability to read character accurately based on the structural features of the head, face, and body. The lines of the face represented a personal record of the applicant's character (increasingly discussed as "personality"), a record accumulated during a person's own lifetime, and was not the necessary result of genetic inheritance.

The French neurologist Guillaume Benjamin Amand Duchenne had pioneered the use of photography in capturing the expression of emotions generated from electromuscular stimuli, a project that had a profound effect on Charles Darwin's influential 1873 study on emotional expression (fig. 1.9).[103] The use of photographs in researching emotional expression won a broader scientific audience in 1914, when Antoinette Feleky reintroduced the method in a short article in the *Psychological Review*. Feleky's work, expanded in her 1922 monograph *Feelings and Emotions*, was directly responsible for psychologists' renewed interest in using photographs to standardize and classify emotional expression.[104]

Feleky's work helped shift psychologists' focus from neurophysiological inquiries to cultural questions, such as, how observers read the semiotics of facial expression? In the experiment most often cited by psychologists in the 1920s, Feleky took several hundred self-portraits over the course of a year. Except for Feleky's facial expression, each image appears nearly indistinguishable from the next: background, pose, clothing, and distance from the lens are all standardized, resulting in a series of images that, when placed adjacent to one another as Feleky had them printed, echo the sequential aesthetic of Eadweard Muybridge's motion photography, as well as film (fig. 1.10). One hundred "reliable individuals" were then given a subset of eighty-six photographs and a list of words naming emotions and asked to write down "the name of the expression which the photograph suggests to you."[105] This study formed the basis for the "Feleky photographs," a set of twenty-four expression-of-emotion photographs marketed by the psychological test company C. H. Stoelting through at least the 1930s.[106]

Feleky's method was widely copied during the 1920s, as other inves-

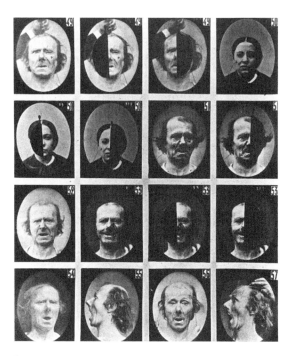

FIG. 1.9. Guillaume Duchenne pioneered the use of photography to document facial expressions. (Guillaume Benjamin Amand Duchenne, *Mecanism de la physiognomie humaine* [Paris: Jules Renouard, 1862], plate 6. Courtesy Research Library, The Getty Research Institute, Los Angeles, CA.)

tigators pursued the relationship between emotional expression, representation, and recognition.[107] Carney Landis, for example, in his study of nineteen Dartmouth students, made his own photographic studies of emotions resulting from a variety of stimuli, including classical music, religious paintings, pornography, and electric shock (fig. 1.11).[108] The fruitful psychological research in this area led Landis to argue that the character analysts' emphasis on static features, rather than on kinetic expressions of emotions, was the reason why "the physiognomists failed to achieve their hope of a permanent science. . . . we really judge character and emotion chiefly by the features in motion . . . and not, ordinarily, by any static pose."[109]

In the years after Binet's work severed the link between the corporeal and the characterological, at least in the scientific community, kinetic pathognomy replaced physiognomy as a more reliable index of the psychological. Emotion had emerged as an unpredictable element

FIG. 1.10. Antoinette Feleky's use of photography in documenting emotional expression was foundational to American psychologists' renewed interest in photographic methodologies. (Antoinette M. Feleky, *Feelings and Emotions* [New York: Pioneer, 1922], 79.)

that threatened to disrupt the smooth functioning of the human machine. In the wake of physiognomy's fall from scientific legitimacy, the ability to accurately identify the only remaining semiotics of the psychological—emotional expression—became increasingly researched and valued. Physiognomic portraits had been replaced by pathognomic portraits; expression-of-emotion photographs were no longer used to analyze the character of the person represented, but instead to gauge the acuity of the viewer. "Intelligence" had moved from the static features of the school portrait to the test-taker, whose skills were assessed by viewing and recognizing a standardized emotional expression. This ability to accurately identify emotional expression was newly labeled "social intelligence" by the psychologist Thelma Hunt in the late 1920s. Using a six-part test, one part of which involved accurate identification of expression of emotion from photographs, Hunt devised a Social Intelligence Test, which measured the "ability to deal with people." The

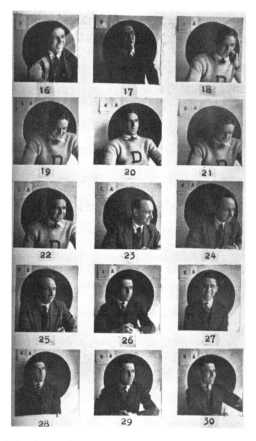

FIG. 1.11. Psychologists such as Dartmouth's Carney Landis helped move research questions away from physiognomy and toward pathognomy, from fixed features to emotional expression. (Carney Landis, "Studies of Emotional Reactions. I. A Preliminary Study of Facial Expression," *Journal of Experimental Psychology* 7 [Oct. 1924]: 342.)

scale, she argued, had a practical use in industry as a means of weeding out social misfits, a growing concern during a decade marked by a new managerial imperative for "industrial togetherness."[110]

The Smile That Pays

Within business circles, personnel managers adopted the new emphasis on emotional expression alongside the older physiognomic methodologies. By the 1920s, however, as the distribution of mass-produced goods emerged as the central problem of the postwar boom economy,

emotional expression in relationship to retail sales dominated business trade literature.[111] Salesmanship, which the business writer James Samuel Knox defined as the "ability to so manipulate the other man's mind so as to make him think as you think, feel as you feel, act as you would like him to act," stood to benefit greatly from advances in the new psychology.[112] Even while salesmen were being personally subjected to new methodologies of "scientific selection" through the work of Munsterberg and other applied psychologists, once in the field, they incorporated the new emphasis on emotional expression into their arsenal of sales methods.

The salesman's interaction with the buyer, whether wholesale or retail, was a dialectical process of "sizing up" of the prospect and an effective presentation of self, all in service of making the sale. As Knox, a former salesman at National Cash Register and an influential writer on sales efficiency from 1911 through 1958, remarked in his first work on the subject, published in 1911, "Human nature is the same everywhere. But we must know how to interpret and manipulate it. No man will understand all about Salesmanship until he is able to categorize every passion and emotion and knows how to control them."[113] Well before Blackford's ideas became popular in 1913, salesmen were discussing the importance of identifying and assessing what one writer called the buyer's "readable signs." While some of these signs were "shown by the expressions of the face," still others were structural features. "Every man is an illustrated advertisement of his character," wrote Wanamaker salesman J. Fred Larson in 1905, "and the person who can understand pictures has little difficulty in understanding the people that he meets." Like other writers in this vein, Larson argued the importance of studying the shape of the head, the profile of the face, and the formation of eyebrows, eyes, noses, chins, lips, and foreheads in "reading customers" (fig. 1.12).[114]

But as salesmanship increasingly incorporated the contributions of psychology through the 1920s, the older emphasis on character reading steadily gave way to a newer emphasis on personality and its somatic analogue, the facial expression of emotion. Gradually, the neologism *personality* came to denote a set of qualities having to do with the outward expression and *perception* of personal attributes, rather than the attributes themselves (otherwise referred to as aspects of character). Thus, Knox, writing in 1922, offered in the absence of an adequate definition of *personality* to coin one for his readers. "Personality," he

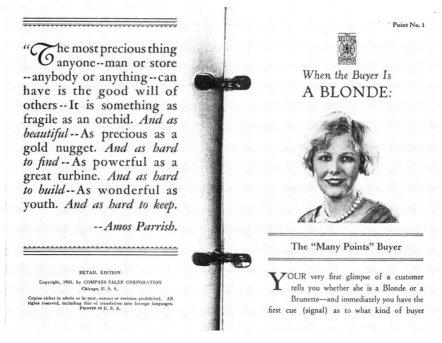

"The most precious thing anyone--man or store --anybody or anything--can have is the good will of others--It is something as fragile as an orchid. *And as beautiful*--As precious as a gold nugget. *And as hard to find*--As powerful as a great turbine. *And as hard to build*--As wonderful as youth. *And as hard to keep.*

--*Amos Parrish.*

RETAIL EDITION
Copyright, 1933, by COMPASS SALES CORPORATION
Chicago, U. S. A.
Copies either in whole or in part, extract or revision prohibited. All rights reserved, including that of translation into foreign languages.
PRINTED IN U. S. A.

Point No. 1

When the Buyer Is
A BLONDE:

The "Many Points" Buyer

YOUR very first glimpse of a customer tells you whether she is a Blonde or a Brunette—and immediately you have the first cue (signal) as to what kind of buyer

Fig. 1.12. Business writers continued to advocate older methodologies in "reading customers" through at least the 1920s. (Compass Sales Corporation, *The Selling Compass* [Chicago, 1933], point no. 1.)

wrote "is that magnetic outward expression of the inner life, which radiates courage, courtesy, and kindness. It attracts people by producing a pleasing effect, and is the product of the development of positive qualities."[115] Personality here differs from physiognomical "character" in key respects. First, personality's currency is valued only in relationship to the perception of other people; and second, personality, unlike the static "character traits" indexed by physiognomy, can be cultivated. As Knox emphasized, "You were not born with your personality. You create it out of ideas, ideals, and the kind of work you do."[116]

The distance from the "outward expression of the inner life" to an emphasis simply on outward expression was not great. Increasingly, throughout the second and third decades of the century the positive outward expression of the salesman's emotion came to define the "winning" sales personality. This shift in focus to the salesman's emotional expression matched the shift in advertising and sales literature away

from a model of the consumer as rational decision maker to a model of an irrational, emotional buyer buffeted by inchoate desires, instincts, and impulses.[117] Increasingly, sales and consumption depended not only on the salesman's successful manipulation of these newly identified nonrational, psychological processes but also on the emotional expression of the salesperson himself.

William James's theory of emotional expression during the first decades of the twentieth century was perfectly suited to this strategic, if temporary, severing of outward expression and inner subjectivity. James suggested a new order of events in the expression of emotion; rather than bodily changes following emotional experiences, he offered an alternative model that posited perception, physiological or muscular reaction, and then, at the end of the chain, emotional response. The physical, in other words, produced the emotional, rather than vice versa. This reversal perfectly suited the new demands of modern commercial culture: all the salesman needed to do was make the emotional expression corresponding to, for example, "happiness," and as night follows day, his smile would produce a genuine shift in the subjective, which in turn would make his sales pitch all the more persuasive. The lingering, increasingly antiquated problem of "insincerity"—the incongruence between inner feeling and outward expression—would disappear with a model according to which acting produced subjectivity.

The importance of personal appearance and especially the smile permeated the trade literature during the years 1905–20. A club was even formed, it seems, whose "great object is to impress upon persons who want to succeed in business that they should 'keep smiling.'"[118] James's work on emotion was often cited as a rationale for smiling even when the salesman might feel otherwise. Perhaps the most famous spokesperson for this approach to personality was a young graduate of the American Academy of Dramatic Arts. In 1912, two years after his graduation and barely making a living as a Packard salesman, Dale Carnegie began his course on public speaking and human relations in a New York City YMCA night school. In *How to Win Friends and Influence People*, Carnegie's 1936 bestselling summary of the YMCA Dale Carnegie Course, Carnegie encouraged his readers to cultivate the kind of smile that would "bring a good price in the marketplace." "First," Carnegie advised, "force yourself to smile. . . . Act as if you were already happy, and that will tend to make you happy. Here is the way the late professor William James of Harvard put it: 'action seems to follow feeling, but

really action and feeling go together; and by regulating action, which is under the more direct control of the will, we can indirectly regulate the feeling, which is not.'"[119] This "working handbook in human relations" packaged Carnegie's popular night course for a still broader audience, offering a potent recipe for emotional performativity in the service of social adjustment and sales.[120]

In her texts on character analysis, Blackford had argued for the superiority of photographs over the personal interview. "A photograph is," she wrote, "a purely mechanical product," providing a graphic record of the "subject's physical characteristics, stripped of all of the atmosphere, so to speak, of his personality." Because the analyst was not influenced by the subject's interpersonal skills or expressions, he or she was able to "apply the principles and laws of the science relentlessly and almost mathematically."[121] As a result, the photograph provided a more objective and accurate record of the subject's character as evidenced by his physiognomy. Yet Blackford's almost exclusive focus on physiognomy, as well as her naive dismissal of an applicant's "personality," suggests the extent to which the character analysts were no longer in step with emerging methodologies. Their work had become increasingly marginalized during the 1920s as psychology gained academic and business legitimacy and as the focus of American culture shifted from character to personality, from physiognomy to pathognomy, from nature (Social Darwinism) to nurture (behaviorism). An anecdotal example of this shift can be seen in Blackford's *The Right Job: How to Choose, Prepare For, and Succeed in It* (1924). The work revisits many of Blackford's earlier themes, but here her subjects are schoolchildren, and her audience parents and teachers. Whereas earlier Blackford publications show signs of heavy use by readers, for example, tracing shapes in pencil over the heads of the photographic subjects, one reader of the *Right Job* was clearly oppositional. In bold capital letters on the title page, he or she inscribed, "This book i[s] out dated. Strictly from the Middle Ages. Go read a good psychology book."[122]

INDUSTRIAL
CHOREOGRAPHY

*Photography and the
Standardization of Motion*

Adam Smith coined the metaphor *invisible hand* to describe a capitalist market driven by individual gain but resulting, nonetheless, in the common good.[1] Although Smith's eighteenth-century mercantile audience may have found this metaphor persuasive, by the early twentieth century social engineers and technocratic utopians had began to question the advisability of an invisible hand.[2] Rexford Tugwell, the Taylorite who played a role in fostering the Farm Security Administration's photography project, argued that Smith's invisible hand was a myth and that instead "a Taylor was needed for the economy as a whole." "The jig is up," he wrote. "The cat is out of the bag. There is no invisible hand. There never was . . . instead, we must now supply a real and visible guiding hand to do the task."[3] To borrow the business historian Alfred Chandler Jr.'s formulation, the *visible hand* of management would replace Smith's *invisible hand* of market forces.[4]

The visible hand of managerial reform, however, made the hand, itself a synecdoche for the industrialized worker, increasingly invisible under scientific management, as the worker became abstracted as "the labor process" in the late nineteenth and early twentieth centuries.[5] As managers sought to erase the worker and her hands from representation—visual, discursive, or political—they sought to insert themselves, as engineers, efficiency experts, and industrial consultants, into the performance of work as the planners and publicizers of industry's managerial revolution.[6]

In 1907, the year after Taylor published *On the Art of Cutting Metals*,

he met an exuberant building contractor and efficiency advocate. Frank Bunker Gilbreth's December 1907 introduction to Taylor in December 1907 had a decisive impact on Gilbreth's career; over the next several years Gilbreth introduced elements of Taylor's system into his construction jobs, while developing a very close relationship with Taylor and his management ideas.[7] At the same time, Gilbreth continued to refine his own studies in bricklaying efficiency, studies that were increasingly dependent upon photographic technologies. By 1912, riding the wave of the era's popular efficiency craze, Gilbreth was ready to exploit the potentially universal applicability of what he now called "motion study" by starting his own consultancy business.[8]

During the same prewar period in which the character analysts were refining their visual-based methodology for rationalizing the employment-selection process, successful job applicants in custom-, bulk-, and mass-production industries found their work to be the site of increased scrutiny by a second generation of scientific managers. One of the most promising new technologies for rationalizing industrial production was that of motion study, pioneered by Frank and Lillian Gilbreth in the prewar years. The Gilbreths used visual technologies to rationalize the working body by breaking down the body's organic movement into discrete, interchangeable motions, which they then reconfigured in more efficient combinations.[9] It is not at all clear that workers' reduced motions remained at a modernist premium once the Gilbreths moved on to another consultancy job. In fact, as in the case of the Taylor installations, there is considerable evidence that the Gilbreths' installations unraveled once they had left the factory or that any long-term efficiency gains were the result of reorganizing work stations, rerouting the flow of work, and other Taylorite innovations that were not, in fact, reliant on photographic technologies or the reduction of discrete hand motions in, for example, folding a handkerchief. Nonetheless, motion study contributed significantly to the success of post-Taylor industrial-efficiency efforts. Embedded in the seemingly objective discourses of both science and photographic representation, motion study allowed the Gilbreths to present their work in scientific management as a progressive technology designed to improve working conditions and the standard of living for all Americans. These were utopian claims that Taylor had also made, but after more than twenty years of labor activism against Taylor's hard-driving methods, scientific management needed a kinder, gentler public persona. Motion study enabled the Gilbreths to rehabilitate scientific

management's shattered reputation while deftly positioning the Gilbreth firm as its leading practitioner.

Like his one-time mentor Taylor, the "father" of scientific management, Gilbreth shocked his middle-class family by donning overalls and pursuing an apprenticeship in the trades.[10] He began as a bricklayer, one of only fifty-seven apprentices who joined that year, but by 1895 he had started his own contracting company, eventually specializing in speed work and running large-scale jobs across the country.[11] In 1904 Gilbreth made perhaps his most brilliant career decision: he married Lillian Bunker. While pursuing her master's degree at Columbia University, Lillian Gilbreth had worked with the noted applied psychologist Edward Thorndike (whom Lewis Hine later approached as a potential partner in making physiognomic portraits of workers, in order to provide visual evidence of workers' intelligence). After marrying Frank and relocating from California to the East Coast, Lillian entered Brown University's new program in applied management, receiving the doctorate in 1915. Her dissertation, "The Psychology of Management," was serialized in *Industrial Engineering* (from May 1912 to 1913) and then published as *The Psychology of Management* by Sturgis and Walton in 1914.[12] One of the first books on the topic, it was very influential in the emerging discipline of applied psychology. While Frank brought an interest in visual methodologies to the partnership, Lillian helped steer their work as partners away from an older mechanistic conceptualization of labor efficiency and toward a more nuanced appreciation of the subjective, psychological aspects of employee productivity. Her work, as well as that of other female psychologists, such as Leta Hollingworth, anticipated the conclusions of Elton Mayo and his colleagues in the 1920s (Mayo's work in the Western Electric's Hawthorne plant in the 1920s is discussed in chapter 3).[13]

Frank Gilbreth's early work as a contractor was marked by an increasing concern with system and efficiency in human motion and a growing interest in the use of photographic technologies. Like many fellow Progressives, Gilbreth was infatuated with the promise that system and standardization offered for imposing order on an apparently inefficient and disorderly world.[14] The replacement of oral instructions with written rules, designed to be applied uniformly despite local conditions, was part of a larger transformation toward "systematic management," which sought to replace the foremen's rule of thumb with uniform standards.[15] This move toward system was in turn a response

to what late-nineteenth-century industrialists saw as the high cost of American labor; if wages could not be effectively reduced, especially given the militancy of organized labor during these years, then perhaps costs could be reduced through what managers saw as more efficient production.[16] As the size of firms grew, managerial innovators in a number of industries turned their attentions to appropriating craft knowledge, standardizing interchangeable parts, making the division of labor more pronounced, and coordinating the increasingly complex flow of goods and labor with newly developed instruction, routing, and accounting systems.[17] Systematic management emerged gradually over the late nineteenth and early twentieth centuries, reconfiguring the way both goods and workers were organized in any number of industries and workplaces.[18]

Instrumental Images: Photography and Efficiency

Gilbreth's growing enthusiasm over construction efficiency dovetailed with his sustained exploration of Taylor's ideas concerning systematic management.[19] Gilbreth had heard of Taylor many years before their first meeting, having joined the American Society of Mechanical Engineers (ASME) in December 1903. And Sanford Thompson, Taylor's time-study expert, had visited a Gilbreth worksite in order to make bricklaying time studies in 1898, although Gilbreth later claimed that he had thought Thompson was a journalist and had had no idea that he was surreptitiously timing Gilbreth's employees. But it was only after their personal introduction in 1907 that Gilbreth moved from being an outside admirer to being an effusive Taylor booster and eventually disciple.[20]

Taylor and Gilbreth discussed the relationship between systematic management and the construction industry, as each was interested in the other's innovations in this field. Taylor was especially interested in Gilbreth's studies in bricklaying efficiency and suggested that the two collaborate on a treatise modeled after Taylor and Thompson's recent work on concrete.[21] Thompson, however, was not happy with Taylor's enthusiasm for Gilbreth's work, writing Taylor that in his view Gilbreth "is a great bluffer, and has the reputation of not always being on the square"; Thompson also accused Gilbreth of winning contracts by submitting artificially low bids and then subsequently raising the price through his cost-plus-a-fixed-rate contract system. Taylor was not put off, however, and continued his discussions with Gilbreth throughout

January 1908. Although Gilbreth was tempted to undertake the collaboration with Thompson and Taylor, he decided that his long-term goals would be better served by publishing his own work on bricklaying, which was already substantially under way.[22]

Gilbreth's January 1908 decision to refuse the written collaboration with Taylor did not mean that Gilbreth was distancing himself from Taylor's management ideas, however. To the contrary: Gilbreth was freely distributing copies of Taylor's "Shop Management," and he wrote Taylor that "I am absorbing the ideas that you have given me as fast as I am mentally capable, but I am afraid that the whole thing will result in my having 'Tayloritis.'" Management ideas made their way into practice as well, as Thompson worked with Gilbreth on an ill-fated partial installation of the Taylor System on a Gilbreth construction site in Gardner, Massachusetts, in April, 1908.[23]

Gilbreth's interest in visual technologies dovetailed with Taylor's often expressed desire for a time-study device more precise than the stopwatch. Time study, the basis of Taylor's scientific-management system, necessitated the presence of a time-study clerk, who observed the work in progress, subjectively decided when a particular task began and ended, and then physically stopped and started the stopwatch. Even if the time-study clerk was familiar enough with the tasks being timed to discern, through observation, the beginning and ending of a discrete cycle of motions, the two subjective decisions and two motions necessary to press the stopwatch belied the time-study experts' claim to scientific accuracy.[24]

The camera, on the other hand, suggested a mechanical solution to the problems of subjective observation.[25] According to H. K. Hathaway, who was one of the few authorized by Taylor to install his system and who worked with Gilbreth on several jobs between 1907 and 1909, it had been "Mr. Taylor's often expressed hope or wish that someone might develop a time study machine which would be better than the stop-watch."[26] In Hathaway's view, Gilbreth's enthusiasm for time and motion study, as well as his interest in developing a more sophisticated recording device, stemmed from his close association with Taylor during these years.[27]

Gilbreth's early contracting work combined his interests in efficiency in human motion and photographic technologies. Whereas other systematic managers, such as Taylor, had been primarily concerned with *time*, Gilbreth sought to standardize *motion*.[28] Waste, the night-

mare haunting Progressive Era efficiency experts, applied not only to production systems but also to the "needless, ill-directed and ineffective motions" of industrial workers themselves. As Gilbreth argued, "The greatest saving in time, in money and in energy will result when the motions of every individual, no matter what his work may be, have been studied and standardized."[29] Through the observation, analysis, and reconfiguration of the body's movement, Gilbreth sought to standardize labor, both the performance of work and the subjectivity of those performing it.

Although Gilbreth, who had been interested in system since his days as an apprentice, had institutionalized many aspects of systematic management in his contracting work, he did not turn his full attention to systematizing motion until he began construction on six brick buildings for the Atwood McManus Company, a massive wooden box factory, in 1909. Since Gilbreth's business reputation was based on speed work, the efficiency of the worker's motions in laying each brick became paramount.[30] He analyzed the bricklayers' work, then codified these motions in a chart, delineating which motions were "right" and which were "wrong" and noting which motions the bricklayer could omit; apprentices were to consult the chart and accompanying photographs to learn the correct method, and wages were tied to compliance.[31] Through this system, Gilbreth claimed to reduce the number of motions necessary to lay a brick from 18 to 4.5 while introducing an intensified division of labor; apprentices were expected to internalize these efficiencies by making "charts representing their own motions."[32]

Gilbreth's McManus job represented a shift not only in methods for laying bricks but also in the possible role photography might play in generating efficiency in movement. In December 1908 Gilbreth began using the still camera to document each of a bricklayer's "right" motions and organized these images into a sequence that he hoped told the story of the body's efficiency.[33] Many of these images were later published in his 1909 book *Bricklaying System*, where they served to "teach apprentices that a brick can be laid with very few motions."[34] Gilbreth saw the bricklaying photographs as a first step in applying photography to work, writing in his 1908 diary, "Photographs of motions in all trades. Photographs of the right way and wrong way of doing it."[35] *Bricklaying System* represents Gilbreth's early foray into what would later expand into motion-picture and chronophotographic technologies for standardizing the motions of the working body.

The halftone illustrations in *Bricklaying System* represent what Gilbreth calls, for the first time, "actual motion studies," the visible hands—and usually only the hands—of bricklayers spreading mortar and laying bricks. The first three images in figure 2.1, for example, show a bricklayer spreading mortar, cutting it off, and tapping down the brick. It is clear that Gilbreth is seeking to use the sequential arrangement of these still images to suggest a succession, in time, of the "right way" to lay bricks.[36] There are two ironies here, however, that suggest the tentative nature of Gilbreth's investigations at this point. First, these photographs, meant to teach apprentices the correct Gilbreth system, actually show steps that Gilbreth sought to *omit*; in his chart Gilbreth lists this step as operation 10 under the heading "The Wrong Way," since "if the mortar is thrown from the trowel properly no spreading or cutting is necessary."[37] Since it is difficult to photograph absence, lack, or omission, Gilbreth photographed excess—without, however, naming it as such in his caption. Second, the first three images here, representing the same worker at the same job with hands in similar but not identical poses, suggest a series rather than a group; that is, the viewer is led to believe that the images depict one motion photographed over time.[38] Yet these halftone illustrations can only imperfectly convey the new series of motions required of apprentice bricklayers: not only are steps in the process missing but who can say how much time has elapsed, or what has taken place, between the frames? The cinematic imperative implied by a set of sequentially arranged images works against alternative interpretations for these images; we are not invited to speculate whether the worker had an extended lunch break or a work stoppage between the frames shown.[39] The still images and the static charts, while laying out a partial sequence of motions, are incapable of describing or prescribing the speed at which these discrete motions should be performed (fig. 2.2). The photographs can only suggest a temporal continuity; they fail, ultimately, to document time or motion, the cornerstones of efficiency.

Nonetheless, these images represent a shift in Gilbreth's approach to photography from a functional realism, according to which the image serves as an empirical substitute for the object, a type of evidence, to an instrumental realism, in this case, using the realist promise of the photograph as truth to restructure the ways in which work is performed.[40] Gilbreth shifted the role of his images from the generalized illustration of sites and buildings that pervade his earlier publications

Fig. 123.—Exterior Face Tier, Working Right to Left, Spreading Mortar.

Fig. 124.—Exterior Face Tier, Working Left to Right, Cutting Off Mortar After the Brick Is Laid.

Fig. 125.—Exterior Face Tier, Working Left to Right, Cutting Off Mortar After the Brick Is Laid.

Fig. 126.—Exterior Face Tier, Working Left to Right, Buttering the End of the Laid Brick.

Fig. 131.—Spreading Mortar with One Motion.

FIG. 2.1. (*top*) Frank Gilbreth's early use of photography to document efficiency suggest the limitations of his initial approach. (Frank Gilbreth, *Bricklaying System* [1909; reprint, Easton, PA: Hive, 1974], 145.) FIG. 2.2. (*bottom*) The bricklaying photographs fail to capture time, which managers considered a key indicator of worker efficiency. (Frank Gilbreth, *Bricklaying System* [1909; reprint, Easton, PA: Hive, 1974], 157.)

to a more specific focus on the human body in motion, with the goal of using these new images to affect the way in which work is performed. Although his efforts here are tentative at best, his steps nonetheless suggest a new way for scientific managers to understand the relationship between visuality and the working body. The images also represent a new direction in his work toward motion study and away from time study, a distinction that eventually led to an irreparable break with Taylor.[41]

Early Motion-Study Efforts, 1908–1911

For Gilbreth, motion study represented both a cost-controlling device and a means of distinguishing his management system in an ever more crowded field of competitors. In one of his early articles on the subject, Gilbreth joined a host of Progressive Era voices concerned about the waste of American resources by arguing that workers' "needless, ill-directed and ineffective motions" represented one of the nation's great calamities.[42] Gilbreth compared the wasted labor represented by useless motions to the abuse of natural resources then consuming the attention of Progressive Era conservationists: "While the waste from the soil washing to the sea is a slow but sure national calamity, it is of much less importance than the loss each year due to wasteful motions made by the workers of this country."[43] With this analogy, Gilbreth both allied himself with Progressive technocrats and rhetorically abstracted labor power from the human beings who produced it. Work was no longer subject to an individual worker's control and definition; instead it was an abstracted national resource threatened by waste and inefficiency. Workers became motors whose fuel was an abstracted form of labor power: "After all, a human being or a work animal is a power plant, and is subject to nearly all the laws that govern and limit the power plant."[44] Once Gilbreth had divorced labor from those who performed it, the motions made by workers could be objectified, analyzed, and standardized as simply another variable in the labor process.[45]

Gilbreth set about analyzing motion by identifying a variety of variables that affected work. Variables affecting the worker included individual "anatomy," "brawn," "creed," and eight other factors, while environmental variables included tools, surroundings, entertainment, and other aspects of the workplace that might affect productivity.[46] After analyzing these aspects of the individual and the environment, the Gilbreths turned their attention to the thirteen separate "variables of the motion." The "automaticity" of often repeated motions was a vari-

able that Gilbreth frequently emphasized. Since both good and bad habits were equally susceptible to automaticity, correct training was necessary to ensure that the worker's "methods conform to standardized motions." Gilbreth also focused on the combination of motions, as well as their sequence, arguing that dissimilar consecutive motions impeded automaticity. Combinations of motions (or movement) could not be standardized, he argued, until the component parts, or motions, had been standardized individually; only then could they be strung together to create efficient, standardized combinations.[47] Gravity, the direction and path of motion, the relationship of the worker's body to necessary tools and materials, the role of inertia and momentum, and the relation between the ending of one motion and the beginning of the next (what Gilbreth, borrowing from billiards, called "play for position") all influenced the efficiency of discrete motions.

The end goal of these motion investigations was cost reduction: "The elimination of wastes in the trades offers the largest field for savings," wrote Gilbreth. To accomplish this savings, he argued, "skill" motions needed to be separated out from "brawn" motions; motion study necessitated an increasingly specified division of labor in which "high priced men" would be relieved of nonskilled activities, such as flipping over a brick, yielding these prosaic tasks to unskilled, lower-paid workers. The result would be increased production at reduced costs, which Gilbreth argued would in turn produce higher wages and shorter workdays.[48]

The systematic managers' concern with the standardization of parts and processes found its analogue in Gilbreth's motion-study work, where the automaticity and efficiency of motion was predicated upon the standardization of both environmental elements and discrete motions. As he argued,

> The great point to be observed is this: once the variables of motions are determined, and the laws of underlying motions and their efficiency deduced, conformity to these laws will result in standard motions, standard tools, standard conditions, and standard methods of performing the operations of the trades. Conformity to these laws allows standard practice to be attained and used. If the standard methods are deduced before the equipment, tools, surroundings, etc., are standardized, the invention of these standard means is as sure as the appearance of a celestial body at the time and place where mathematics predicts that it will appear.[49]

Although Gilbreth shared an enthusiasm for industrial standardization that was widespread among engineers and managers, his focus on the standardization of the "human element" through motion study (as opposed to the standardization of machine parts and products) was unique during these years. Through the analysis of individual motion, Gilbreth hoped to deduce a standard vocabulary of unchanging elements that industrialists could craft into coherent and productive motive sentences. Standardization of work both exhibited and constructed managerial superiority in an era defined by workplace battles over scientific management's new panoply of functional foremen.

Throughout this period, however, Gilbreth's visual methodologies were rudimentary. As late as 1908 his initial explorations into what he was just beginning to call motion study made no reference to photographic technologies, relying instead upon what the supervisor's eye could observe.[50] In an April 1910 article Gilbreth argued that the "present stage of motion study" required the following steps: reducing the present practice to writing; enumerating the motions used; enumerating the variables that affected each motion; reducing the best practice to writing; enumerating these motions to writing; and then enumerating the variables that affected each motion.[51] His methodology was still dependent upon a written or language-based translation, and although he used photographs, it was chiefly as illustrations of, or supplements to, his chart-based analysis. Although Gilbreth argues in his 1911 book *Motion Study* that "the stereoscopic camera and stereoscope, the motion picture machines, and the stereopticons enable us to observe, record, and teach as one never could in the past," there is no evidence that he used the motion-picture camera prior to 1912.[52]

Industrial Chronophotography: Filming Micromotions

Gilbreth's opportunity to introduce visual technologies as part of an installation of scientific management came on 13 May 1912, when he signed a contract with the New England Butt Company, of Providence, Rhode Island. The company, which employed about three hundred workers, produced and assembled braiding machines for the manufacture of shoelaces, dress trimmings, and insulated wires. The contract represented Gilbreth's first as an independent management consultant and marked his departure from his increasingly precarious construction business. Gilbreth's work with the company lasted about a year, and was marked by several overlapping stages: initial assessment and plan-

FIG. 2.3. Filming and photographing in the New England Butt Company "Betterment Room." (Photo 610-109, "P" album, p. 26, "N" file 10/0031-4. Courtesy Frank and Lillian Gilbreth Collection, Purdue University Libraries Special Collections, Purdue University, Lafayette, IN.)

ning; the installation of industrial-betterment elements (today known as welfare capitalism) as a means of securing employee cooperation; the preliminary introduction of an office system, again in the effort to defuse shop-floor suspicion of "Taylorist" managerial efforts; and the installation of a motion-study laboratory, which the Gilbreths named the Betterment Room (fig. 2.3).[53]

The Betterment Room was the central element of Gilbreth's work at the New England Butt Company, and the innovations he devel-

oped there generated the publicity and reputation necessary for his future contracts.[54] The room was located in the factory, painted white, and fitted with the various lights, cameras, compressed-air lines, and machinery necessary to record workers at their tasks. The floor and background were cross-sectioned with lines four inches apart, and the dimensions of all the furniture were evenly divisible by four so that the motion study expert could easily calculate any distance traveled.[55] Gilbreth was anxious to begin his work in the Betterment Room, because even before signing the contract with the company, he had announced the development of a new motion-study technology to friends and colleagues.[56]

The Gilbreths succeeded in their efforts to introduce chronophotographic, or time-based, technologies to what the engineering community dubbed micromotion study. Their work involved two main visual methodologies: motion pictures (which were introduced in July 1912) and chronocyclegraphs (introduced in April 1913). The motion-picture process for which Gilbreth was seeking patents in April 1913 consisted in taking a moving picture of a worker performing a given operation while a clock within the frame recorded time and a gridded background allowed the distance traveled to be subsequently determined. Gilbreth also sought to patent the taking of stereoscopic moving pictures; the process of editing out "waste" motions recorded on film and then splicing the new, more efficient sequence together; and several apparatuses for viewing the various films.[57]

Gilbreth hired S. Edgar Whitaker, a consulting engineer who had worked with Taylor and Morris L. Cooke in reorganizing the ASME offices in 1906, as the specialist in charge of the micromotion work in the Betterment Room.[58] They had planned to replace the stopwatch with the camera as a time-study device, but the paucity of natural light, combined with the inadequacy of artificial light, meant that filming in any place but the Betterment Room was impractical. As a result, any jobs that could not be easily replicated in the Betterment Room needed to be time-studied on the factory floor using the stopwatch. Gilbreth hired H. R. Brown, an orthodox time-study expert from the Link Belt Company (a model Taylor installation), to undertake stopwatch studies. When Brown arrived in December 1912, however, filming efforts had been under way for some months.

When Whitaker began work in the Betterment Room, in June 1912, he concentrated on cleaning the windows and on moving a twelve-

strand braiding machine into the room for motion study.[59] By mid-July Whitaker, working with an assembler and a technician, reported, "I have been doing some experimental work with Mr. Winter; we have a fair positive to show you, that was obtained today."[60] The experimental work mentioned was likely a still photograph of the packet assembly, as during the following week the team began making still photographic records, along with motion studies, of the packet assembly of the braiding machine.[61]

Finally, on Thursday, 25 July 1912, Whitaker reported his success in making their first filmic motion study: "This afternoon we took the first record with our standard Vadigmeta. The records were very clear and satisfactory." Gilbreth and Whitaker made positive prints of the filmstrips and mailed a sample off to Frederick Taylor. Two days later, on 27 July, Whitaker reported that "we have taken a record film showing all the principal claims in Mr. Gilbreth's invention of the Vadigmeta and containing the date . . . for evidence in case it should be necessary to establish the priority of the idea." By 19 August Winter was studying a roll of film depicting a complete assembly for one of the braiding machines; by observing the position of the clock hands captured on film, he reported, he could tabulate the times of each motion to one-thousandth of a minute (fig. 2.4).[62]

Ever sensitive to the charge of self-promotion, Gilbreth arranged to have his "discovery" publicly presented by third parties. The New England Butt Company's John G. Aldrich and Robert Thurston Kent, an engineering writer, introduced the technology of micromotion study at the December 1912 meeting of the ASME to a rapt audience. (Kent was responsible for many of the subsequent articles appearing in the scientific press.) Included in the frames of the films was a special clock, or *chronometer*, designed by Gilbreth that made ten revolutions per minute; the dial, divided into one hundred divisions, could reveal time divisions of one-thousandth of a minute.[63] Alongside the chronometer the Gilbreths placed a regular twelve-hour clock, which they eventually argued both recorded real time and worked as a check against the chronometer, making sure that its revolutions were accurate. The resulting film was a *cinematograph*, which, when viewed with a magnifying glass or projected, allowed the motion-study expert to develop a standard time for each discrete motion (fig. 2.5).[64] The film enabled the motion-study analyst to isolate and deduce the efficiency of individual motions through an analysis of the time (provided by the clock[s] as well as by the speed of the

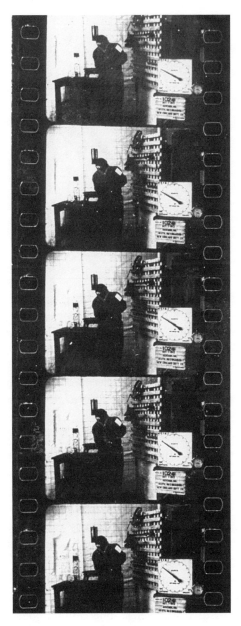

FIG. 2.4. An early example of Frank Gilbreth's use of film to document and analyze efficiency. (Filmstrip 1024, c. July–Aug. 1912, New England Butt Company, "N" file 10/0031-3. Courtesy Frank and Lillian Gilbreth Collection, Purdue University Libraries Special Collections, Purdue University, Lafayette, IN.)

FIG. 2.5. The film viewer magnified frames, enabling motion-study experts to analyze the time and motion of workers' movements once recorded on film. (Photo 610-G16, c. 1912–13, New England Butt Company, "N" file 10/0031-3. Courtesy Frank and Lillian Gilbreth Collection, Purdue University Libraries Special Collections, Purdue University, Lafayette, IN.)

camera) and the distance (provided by the gridded background). With the film, or "micro-motion study," the efficiency engineer could examine the "minutiae of motions and the consequent resulting inventions from the synthesis of such selected subdivided motions."[65]

The purpose of these films was initially to replace the stopwatch. With the motion-picture camera, Gilbreth argued, an observer could more "scientifically" analyze the work with the goal of setting times for discrete tasks since the camera, running continuously throughout several cycles of repetitive motion, "objectively" recorded both the beginnings and endings of work cycles. The camera could "automatically" record wasteful movements and "will detect instantly any attempt on the part of workmen to defeat time-study by soldiering, for while a workman may deceive a time-study man, he cannot deceive the camera."[66] Gilbreth relied upon the realist promise of the photographic technology, the belief that the camera offered unmediated access to

an observable reality, to argue that the camera, not the motion-study expert, timed and recorded the work process: the photographic record provided "indisputable evidence" of motion efficiency. In this analysis Gilbreth presented his team as disinterested professionals utilizing a neutral technology to further the goals of both business and labor. They were not, as Industrial Workers of the World organizers no doubt argued when they sought, unsuccessfully, to organize the New England Butt Company workers in August 1912, working against the interests of labor on behalf of management.[67]

Early on, however, Gilbreth discovered new purposes for these films. After filming an expert assembler working at normal speed, Gilbreth could then project the resulting record at slow motion to those learning the job, thereby using the camera to appropriate the experienced worker's transfer of skill from expert to learner.[68] As Kent reported, "A film shows a workman not only what to do, but how to do it to the last detail, and, therefore, teaches him what printed instructions and books can never impart adequately."[69] Gilbreth also used the films to show plant foremen how the jobs could be most efficiently performed: he ran the films at normal speed and at slower and faster than normal speed and also ran loops of discrete motion cycles to emphasize a particular set of motions.[70] Through these industrial movies, he argued, foremen would learn the new motion sequences. Finally, Gilbreth used the films as a form of self-promotion, mailing photographs, filmstrip positives, and captions to prominent figures on both sides of the Atlantic, anyone whom Gilbreth sought to impress with his motion-study work.[71] The images worked as a type of visual calling card, gaining Gilbreth access to an international community of scientists, managers, and progressive industrialists that otherwise might have been closed to him given his lack of advanced training.[72]

Indeed, it can be argued that publicity was the most important work that these early filmic images performed.[73] As Brian Price has pointed out, major elements of the company's reorganization, such as the development of the new assembly methods, had preceded the introduction of motion study. What motion study offered Gilbreth was a novel and extraordinarily successful publicity tool; he estimated that by February 1913 word of the motion-picture camera's application to industry had been published in 2 million individual copies of periodicals.[74] In several of the articles describing the discovery of micromotion study, Kent claimed that the motion-picture camera enabled the firm to reorganize

the ways in which machine assembly took place in the factory. Kent argued that it had revealed "an irregularity and lack of rhythm in the movements of assembling" the braiding machines, leading to Gilbreth's introduction of the packet system. But as Whitaker's daily job reports demonstrate, Gilbreth's packet-assembly innovations predated the use of the motion-picture camera. Using his own experience with scientific management and Taylorist principles, he had made machine assembly more efficient without recourse to film or photography. Yet Gilbreth nonetheless claimed an instrumentalist role for the images, for he realized that the use of film was the innovation that would give his fledgling business the greatest public-relations boost.

Gilbreth hoped that the publicity value of the filming operations would help to win over the support of the workers. As the Gilbreths' contracts came to involve the standardization of hand-assembly work, the operatives were increasingly likely to be women; the contracts with the New Jersey handkerchief manufacturer Hermann, Aukam and Company mark the beginning of this pattern in the Gilbreths' work.[75] The attention of the lights, the movie camera, and the double wages combined to create an internal, factory-operative "star system," a pale shadow of Hollywood's emerging cinema celebrity culture. In securing cooperation and increased productivity through the focused attention of the Betterment Room, especially through film, the Gilbreths anticipated what later industrial sociologists dubbed the "Hawthorne Effect": the productivity of test workers increased as a result not of the improved wages or improved workplace conditions but of the managerial attention bestowed on otherwise anonymous operatives. (This important experiment is discussed at length in chapter 3.)[76]

By 1910, as Kathy Peiss has shown, movies were among the most popular of urban entertainments for working-class women, who constituted 40 percent of movie audiences.[77] Cheap tickets, continuous shows, and increasingly ubiquitous storefront nickelodeons combined to make moving pictures what a contemporary observer called "the favorite entertainment today of the wage earning classes of the world."[78] The resultant groundswell of public interest in movie actors was made clear to distributors and producers through fan mail, periodical correspondence, and other venues; by 1910 both independent and licensed companies had begun to adopt the theater, opera, and vaudeville star system as a means of building audiences for their productions by, for example, providing photographs of movie "stars" in theater lobbies and as

FIG. 2.6. Workers' on-camera enthusiasm suggests linkages to contemporary film fan culture. (Full page of film positives, [2 Oct. 1917?], "N" file 11/0031-10. Courtesy Frank and Lillian Gilbreth Collection, Purdue University Libraries Special Collections, Purdue University, Lafayette, IN.)

patron "giveaway" images, which were avidly collected by fans.[79] During this same year the independent movie distributor Carl Laemmle hired Mary Pickford away from Biograph, doubled her salary, and gave her star billing. As Robert Sklar has concluded, in this period "building up audience recognition of star names was almost the only effective form of advance publicity."[80]

　　This dramatic transformation in working-class leisure patterns was not lost on Gilbreth, himself an avid—sometimes daily—moviegoer. He adjusted his vocabulary, referring to the filmed worker as the "star"; film positives suggest that at least some of the operatives enjoyed the momentary attentions of the lights and cameras, as well as the increased wages (fig. 2.6).[81] In filming the operative "stars," Gilbreth directed the company's attention to the workers' indispensable role in the factory, thereby perhaps helping to win the operatives' cooperation, at least temporarily.[82] Ironically, during a period when the movies subverted the clock-scheduled time of work life by offering continuous showings

of often plotless film, thereby offering factory operatives an alternative to the driving efficiency of the workplace, Gilbreth used film's spectatorial pleasures to reintroduce a still more disciplined adherence to industrial timekeeping.[83]

Gilbreth continued to film workers throughout his career, and micromotion study was used by generations of industrial managers after Frank Gilbreth's death in 1924.[84] The filming of repetitive industrial labor encapsulates the logic of the industrializing process. To produce a film is to decompose and reconfigure, through the aid of machinery, what had been a continuous visual field: the film's numerous discrete photographs are nearly, yet not quite, identical in content, and when they are projected, they constitute a narrative of motion—a reconfigured visual field that obscures its discrete and nearly standardized component parts. The motion-picture film echoes and reinscribes the foundational structures of industrialization through its kinetic sequencing of individual components. Similarly, through this filmic methodology, Gilbreth observed the working body, isolating organic movement into discrete component parts, which he literally edited into more efficient motion cycles. Although the films may have suggested new ways of seeing the working body, they were less the generator of a new visual consciousness in the industrializing workplace than the logical end point for an industrialized spectatorship.[85] The ways in which Gilbreth saw the working body had already been structured by an industrialized consciousness predicated on decomposition, interchangeability, standardization, and kineticism. Film presented itself in 1912 as a logical methodological culmination of Gilbreth's already fully industrialized visuality.[86]

The Gilbreths' Cyclegraphs, Marey, and the European Science of Work

Filming provided the efficiency expert and the apprentice worker with most of the required visual data necessary to learn the Gilbreths' new sequence of industrialized motions, but film could not readily provide this data in three dimensions, nor could it represent a continuous path of motion through space on a single sheet of film. Despite slowing down the film, editing it into repeated motion-cycle loops, speeding up the film, examining it under a microscope, or projecting and therefore enlarging the image (all of which Gilbreth did with his motion films),

Fig. 2.7. The cyclegraph light, mounted on the hand, produced the trace of motion through space when the worker was photographed using a long exposure. (Photo 610-G24, 1913, New England Butt Company, "N" file 10/0031-3. Courtesy Frank and Lillian Gilbreth Collection, Purdue University Libraries Special Collections, Purdue University, Lafayette, IN.)

Gilbreth had not achieved an image that could capture the passage of time and the movement through space on a single, lengthy exposure.

The Gilbreths succeeded in their efforts to map motion in three dimensions in April 1913, when Whitaker successfully reported what was originally called the "orbit method" of motion study and later the *cyclegraph*.[87] The cyclegraph involved attaching a mini electric light to the worker's moving body part (usually the hand and sometimes the head) and then photographing the worker while he or she performed the assigned task, using a long exposure (fig. 2.7). An exposure of several seconds' duration resulted in the worker's moving body parts either being recorded as blurs or escaping representation altogether; all that the camera would record was the illuminated pathway of the electric light's movement through space, as the worker went through the repeated cycles of motion necessary for the task at hand.[88] The following week, Whitaker reported that he had successfully interrupted the light's electric current, creating intermittent pulsations that could vary in number from one hundred to one thousand per minute.[89] The flash-

es were recorded as parsnip-shaped dashes that, when photographed against a gridded background, promised to map the direction of movement as well as record the time.[90] The direction of movement could be detected from the shape of the dashes, as the narrow end represented the slowly lingering light pulsation and therefore the direction from which the body part had traveled. Gilbreth called the new dotted-line images *chronocyclegraphs* since they represented time as well as motion; when motion cycles were photographed with a stereographic camera, as was usually the case, the resulting document was called a *stereochronocyclegraph*. Most of the time, however, the Gilbreths used the term *chronocyclegraph*.

Gilbreth's introduction of moving pictures and photography to industrial efficiency was a public-relations coup. His fledgling business, as yet dependent upon Taylor without, however, Taylor's imprimatur showing him to be an approved installer of the Taylor System, was a fragile enterprise; the use of the still and motion-picture cameras provided a way for Gilbreth to distinguish his work in the mushrooming field of efficiency engineers, a field increasingly marked by "charlatans, quacks and fakers."[91] Yet although Gilbreth was an avid filmgoer and snapshooter, there is no evidence that he had any technical knowledge of motion-picture photography until well after 1917, nor did he have the technical background to invent chronophotography on his own.[92] Rather, Gilbreth's exposure to European successes in photographing and filming the physiology of movement gave him the raw material to duplicate these efforts in the United States, while only rarely crediting his European antecedents.

Gilbreth's claim to both professional success and the historical record was motion study, which after 1911 increasingly became associated with and eventually defined by the use of visual technologies. And although the use of film as a means of rationalizing the work process appears, in hindsight, to be a logical culmination of Gilbreth's work, the rather sudden appearance of film in his promotional portfolio, combined with the complex early history of the industry, suggests his liberal appropriation of technological innovations developed elsewhere. Gilbreth's use of film is one of several examples of his appropriating technological innovations from a variety of fields and reapplying them to the science of work, while claiming to be their originator. The cultural history of visuality, motion, and work during these years had made the technologies and their uses available in discrete units; Gilbreth, as

industrial *bricoleur*, assembled these innovations and applications into a visually based consultancy business, claiming the whole and often the parts as his original contribution to scientific management.

Because the Gilbreths saw their contribution to management practice as an original one, and because they were anxious to patent aspects of their work both in the United States and in Europe, their otherwise voluminous archive offers few clues to the technological and scientific origins of their motion-study work.[93] Although it is clear that Frank Gilbreth came across the idea of motion study in the year or so before March 1912 (when he announced his successful efforts to friends), the archive lacks key correspondence and diary entries between January 1911 and 30 November 1912, the precise period in which Gilbreth was developing his micromotion-study work. Despite a rather thorough record of their business and personal years together, both Frank Gilbreth's personal diaries and Lillian's later transcription jump inexplicably from the end of 1910 to late 1912, after they had introduced micromotion work to the engineering community. Absent there is any record of meetings or trips that would reveal how Gilbreth's thinking shifted from progress photographs to film and chronophotography or what had been the innovative and technological impetus to put such a plan into action.

There are numerous ways, however, in which Gilbreth may have first learned of the idea of using photography and film in relationship to motion study. By 1912, of course, moving images had been commercially displayed as an aspect of mass entertainment for nearly twenty years; and, as film's technological origins lay in its industrial applications, Gilbreth's project returning film to its industrial birthplace is not as much of a leap as it may seem today.[94] A more direct source for Gilbreth's ideas, however, was his European contacts, especially his devoted English patent agent, James F. Butterworth. Butterworth, a close friend of the Gilbreths and a prolific reader in European scientific, managerial, and photographic literature, obtained and mailed the Gilbreths numerous books and articles about film, photography, motion study, scientific management, and the "science of work" during this period. Among these was an article on micromotion study published prior to July 1910, when Frank and Lillian took their first trip abroad together to attend a joint meeting of the ASME and the British Institute of Mechanical Engineers at the Japanese-British Exposition in London. The "micro-motion" paper Gilbreth referred to in his correspondence

with Lillian was not one that he himself had written, since Gilbreth did not publicly present his work before his December 1912 presentation to the ASME.[95] According to Lillian Gilbreth, it was James Butterworth who first acquainted Frank with the work of two important photographic predecessors, Eadweard Muybridge and Etienne-Jules Marey, although she argued that her husband's work on cyclegraphs was substantially complete by the time he learned of their work.[96] We know that Gilbreth knew of Muybridge's photographic studies of locomotion at least by 7 December 1911, when the engineer Charles Day, commenting on Gilbreth's interest in the subject, sent him a copy of Muybridge's work on animal locomotion.[97] Gilbreth's main source of inspiration, however, was the work of Etienne-Jules Marey, the French research scientist who spent his life recording motion, first through various graphic-inscription machines of his own invention (such as his 1860 sphygmograph), then through photography (especially after seeing Muybridge's photographs of the horse in motion in 1878), and finally through film (after 1890). As Marta Braun has convincingly argued, Gilbreth's chronophotographic method of "attaching light bulbs to the subject and using a still camera to track their movement was an exact emulation of the system Marey had devised" more than twenty years earlier.[98]

The Gilbreths took great pains to distance themselves from Marey's accomplishments. Frank Gilbreth argued—despite a dearth of evidence—that "we made our first cyclegraph in 1899, but were not able to record exact times, speeds and directions until after years of effort on the problem."[99] And although the Gilbreths owned an 1895 English translation of Marey's seminal work, *Le mouvement*, Frank Gilbreth was careful to inscribe the following note in the flyleaf:

> This book was bought by me in London July 12, 1913. I had my attention called to this book by Jas. E. Butterworth, 24 Linden Gardens, London, W, and together we went to the publishers of this book and bought it on this day. I was astounded to find that the author had described many inventions of which I had thought I had priority and although I have still apparently priority on many methods of what we both have named "chronophotography." I agree with all his conclusions. July 21, 1913.[100]

By 1914 Frank Gilbreth had reluctantly acknowledged Marey's work in the field, grudgingly commenting in his 1914 scientific-management seminar that "Marey's scheme was impracticable, but he did the job

and he did it first." He nonetheless retained his claim to having originated the photographing of direction by interrupting the light's electric current.[101] Despite informing his audience that he had since visited the Institut Marey and become "fast friends" with Marey's successor, Lucien Bull, Gilbreth ended the session by downplaying the historical importance of one of the nineteenth century's most innovative scientific minds. When a student asked who Marey was, Gilbreth responded: "He was just an every day, wise man. He liked to do things that other people could not do, whether they were practical or not. He had so many babies to take care of that he did not have enough time to do anything but get them started. He did not finish anything that he did." This description seems to apply not so much to Marey but to Gilbreth himself.

In the Gilbreths' view, wasted work motions were the primary cause of worker fatigue, which in turn threatened industrial efficiency, production, wages, and ultimately workplace harmony. The Gilbreths' growing interest in the psychology of work and management, influenced by Lillian Gilbreth's background in applied psychology at Columbia and Brown universities, included a considerable focus on worker fatigue, which turned the Gilbreths' attention to the worker's physical relationship to his or her work station.[102] Standardization of the work environment as well as of the body's working motions, the Gilbreths argued, reduced fatigue, positively affecting workers' mood and therefore productivity. The Gilbreths redesigned stools, chairs, and footrests in order to reduce worker fatigue; for example, they added springs to chair legs as a means of absorbing the vibrations caused by working machinery or introduced adjustable stools to workers who had formerly been expected to stand at their work stations. One of the Gilbreths' many projects while working in Providence, Rhode Island, was to establish a Museum of Devices for the Elimination of Unnecessary Fatigue, where they collected objects, mostly of their own design, aimed at reducing worker fatigue (fig. 2.8).[103] The museum never really got off the ground—in late 1914 it had only six devices, mostly chairs, four of which the Gilbreths had designed—but it enabled the Gilbreths to publicize their interest in what progressive post-Taylor managers were increasingly calling the human element in production. According to one newspaper report, "tens of thousands of letters have been mailed" soliciting objects for the museum, resulting, "strange to say," in only six objects.[104] In addition to the letters, the Gilbreths used the photographs

FIG. 2.8. Chairs from Hermann, Aukam and Company, 1913. The Gilbreths' early interest in fatigue and what later became known as ergonomics is demonstrated by their redesign of factory furniture. (Photo 618-L3, "N" file 11/0031-7. Courtesy Frank and Lillian Gilbreth Collection, Purdue University Libraries Special Collections, Purdue University, Lafayette, IN.)

of the chairs as evidence of their interest in the workers' welfare, distributing them to newspapers as well as to professional colleagues and potential clients.[105]

These ergonomic efforts, despite their seemingly innovative status in the United States in 1913, had been an important focus of investigation in Europe for some decades before the Gilbreths' work in Providence. As Anson Rabinbach has shown, an international scientific community of physiologists, physicians, and reformers had been engaged in the study of the physiology of labor power as a means of increasing industrial productivity while eliminating class conflict. Worker fatigue marked the limits of this utopian promise, and after 1890 a new generation of European scientists sought to understand fatigue's physiological, ergonomic, and psychological causes. The foundational text in the new field was the Italian physiologist Angelo Mosso's 1891

La Fatica (translated as *Fatigue* in 1904), the result of a decade of laboratory investigation and a synthesis of German and French research; by 1900 fatigue laboratories had been established in almost all European countries. Rabinbach reports that "after 1900 the journals of the German, French, and Belgian scientific academies overflowed with literature on every aspect of fatigue."[106]

Whereas the European interest in the efficiency of the working body was dominated by scientists working for the most part in a laboratory environment, the focus in the United States was on the pragmatic, workplace experiments of Frederick Winslow Taylor and his followers. From the perspective of the European scientists seeking to understand immutable laws of human physiology, Taylor's crude methodologies were distinctly rule of thumb. The United States lacked the scientific tradition of the laboratory investigation in the field of industrial physiology before the 1920s; most of the information concerning the limits of the working body came to the attention of industrial managers, not through the European scientific community, but through either American reformers or industrial managers, that is, through Taylor, Gilbreth, and other efficiency engineers. The Gilbreths' trip to Europe and England in the summer of 1910, as well as Frank Gilbreth's several extended work stays in Germany before and during World War I, put them in contact with both the scientific literature concerning the physiology of labor and many of the key figures as well. Although they rarely acknowledged the European sources for their ideas, the Gilbreths were nonetheless lay popularizers of the European science of work, especially the concern for worker fatigue.[107]

Although American engineers and efficiency consultants may not have been fully aware of European laboratory investigations in industrial physiology, a concern for the worker's relationship to his or her work station was nonetheless shared by other systematic managers seeking to rationalize the modern factory, especially as the younger generation of managers turned their energies toward improving workplace conditions as a means of defusing labor antipathy to scientific management.[108] Gilbreth's use of photography, however, distinguished his work from competitors', and so despite the likelihood that major efficiency gains had been made without recourse to visual technologies, Gilbreth avidly photographed and filmed drill-press work, claiming an instrumental role for the images he produced.

Expanding Applications

Gilbreth introduced his work to the scientific and managerial commu-
nity mainly through two different motion-study projects: his drill-press
series at the New England Butt Company (1912–14) and his studies of
handkerchief folding at the New Jersey plants of the Hermann, Aukam
handkerchief-manufacturing company (1912–14).[109] The drill-press se-
ries addressed the question how to reduce the time necessary to coun-
tersink a hole in the latch handle of a braider machine. As with most of
his efforts, Gilbreth approached the problem in two ways: by reorgan-
izing the worker's relationship to his materials and tools and by using
visual technologies to analyze motion. And, as with most of his efforts,
the greatest efficiency gains seem to have stemmed from his rearrang-
ing of the materials and equipment, usually done prior to beginning
the micromotion study. Nonetheless, Gilbreth attributed his success
in reducing motions and increasing corporeal efficiency to visual tech-
nologies rather than to more prosaic Taylorist methodologies.

Gilbreth's motion study of machine-part drilling work at the New
England Butt Company showcased photographic technologies' uto-
pian promises. The cyclegraph recording of the drill-press work began
in 1913, with John G. Aldrich, vice president and general manager of
the company as well as Gilbreth's key supporter, operating the press.[110]
Soon, however, a skilled mechanic named Tommy Perroti, a "quick mo-
tioned . . . Italian American with all the defects and good qualities of the
race," became the operator whose work was most consistently recorded
(fig. 2.9).[111] Figure 2.10 shows Perroti with three onlookers, including
Whitaker, at the beginning of the cyclegraphic work in 1913. Two tote
boxes are located to the left of the press, and on Perroti's left arm can
be detected the cyclegraphic wire, with the electric light glowing on
his stationary left hand; the foursome look expectantly at the camera,
placing themselves in readiness for the work and, more importantly, for
its recording. Gilbreth documented the drill-press work at least twice,
once in 1913 and then again the following year. In his lectures, pub-
lications, and summer-school classes Gilbreth used the cyclegraphs to
demonstrate the "one best way" of performing the work, often reusing
older images as visual proof of management theories he only later de-
veloped. Thus, several of the images were called into service in a num-
ber of different contexts over the years and given new lecture captions
to illustrate new motion "laws."

FIG. 2.9. (*top*) Tommy Perroti, a drill-press operator at the New England Butt Company, at the beginning of the cyclegraph work in 1913. (Image 610-37, stereocard 80.0785.017. Courtesy Gilbreth Collection, Division of the History of Technology, National Museum of American History, Behring Center, Smithsonian Institution.) FIG. 2.10. (*bottom*) Drill-press cyclegraph representing operator Tommy Perroti's motions after a year's absence from the machine. Frank Gilbreth argued that the wavy lines represented the mental, and therefore physical, hesitation that stemmed from inexperience or lack of habit. (Half of image 610-219, "N" file 10/0031-3. Courtesy Frank and Lillian Gilbreth Collection, Purdue University Libraries Special Collections, Purdue University, Lafayette, IN.)

Figure 2.10 represents Perroti at the drill press in 1914, after being away from the machine for a year. Four cycles are represented here; eight lines, difficult to decipher, mark Perroti's pathway from latch-handle tote box to drill press and back again. Gilbreth used this image to demonstrate the mental and therefore physical hesitation that results when a worker is either not in the habit or not accustomed to a new task: "The cyclegraph shows very wavy lines due to positioning during transportation while going to the machine, and a little hesitation due to the lack of recent practice in going back to the totebox."[112] Wavy or jerky lines represent hesitation and offer evidence of lost time (inefficiency).

This image, as well as the others in the series, is odd for a few reasons. First, two clocks are prominently displayed in the photograph, suggesting that the photograph records time as well as motion, which was impossible given that the path of light through space could not document how much time had elapsed since the camera's lens had been opened. Surely the clocks were present for the purposes of the movie camera, which was also being used to record the experiments. Yet the clocks' presence within the photograph's frame serves the further purpose of legitimizing the cyclegraphic work as an objective report of a specific time and place, implicitly suggesting the photograph's role (via Gilbreth) in providing time study as well as motion study.[113] Second, given that Gilbreth had made the effort to rearrange the two tote boxes, it seems peculiar that the pathway traced here does not mark a visit to the tote box on the left, which appears to have no function whatsoever in the image. Is Perroti simply picking up and transporting the same latch handles, over and over again, to the same box? One would expect a triangular path to be marked in space—from the tote box holding unfinished latch handles (the lefthand box presumably) to the drill press to the tote box of finished handles (the righthand box), back to the box of unfinished handles, and so on. Instead, we see a repeated arc of motion from only one box to the machine and back again. Perroti appears, against all efficiency guidelines, to be commingling finished and unfinished pieces in a promiscuous assembly. Despite Gilbreth's claims that the purpose of the cyclegraphic work was to redesign motion, it seems clear that at least in this series of experiments the main goal was to use the novelty of the cyclegraphic technology for self-promotion.

While working at the New England Butt Company Gilbreth secured a contract with Hermann, Aukam (fig. 2.11). As with bricklaying,

FIG. 2.11. Handkerchief folder, Hermann, Aukam and Company, 16 February 1913. Frank Gilbreth considered handkerchief folding an ideal subject for his motion-study work owing to the centrality of hand labor in the creation of complex folding patterns. (Stereograph 618-81. Courtesy Frank and Lillian Gilbreth Collection, Purdue University Libraries Special Collections, Purdue University, Lafayette, IN.)

Gilbreth's goal was to make the handwork of handkerchief folding more efficient by reducing the number of motions required to fold. And as he had argued in the case of the drill-press work, conducted at roughly the same time without the pulsating light, the chronocyclegraph mapped inefficiency by means of a jerky, frenetic line (fig. 2.12),[114] whereas the path of motion of an expert folder using Gilbreth's standard motions would be smooth. Figure 2.13 shows, for example, ten cycles on one exposure of an expert folder.[115] Gilbreth liked to use the example of handkerchief folding as a showcase for his motion-study work since, he argued, "it is purely a case of reformed and selected motions. It has no belting to adjust; there is no case of standardizing machinery so that it will not break down." Instead, the workers themselves became standardized. As Gilbreth claimed, "Another fine feature of this motion study is the benefits we obtain by having all operators habitually think in elementary motions."[116]

We know that figure 2.13 shows ten cycles of an expert folder only because Gilbreth, in his presentations and correspondence, deciphered the image for us. It seems unlikely that a close observer would have

FIG. 2.12. (*top*) The pulsing light of the chronocyclegraph promised to map time as well as motion. Here the jerky lines suggest, in Frank Gilbreth's analysis, the work of an inexperienced handkerchief folder. (Photo 618-G68-1, "N" file 11/0031-7. Courtesy Frank and Lillian Gilbreth Collection, Purdue University Libraries Special Collections, Purdue University, Lafayette, IN.) FIG. 2.13. (*bottom*) Ten cycles of an experienced handkerchief folder. (Photo 618-G70-1, "N" file 11/0031-7. Courtesy Frank and Lillian Gilbreth Collection, Purdue University Libraries Special Collections, Purdue University, Lafayette, IN.)

been able to detect ten distinct cycles of motion from the image alone or to detect time. Counting individual dots and dashes with any accuracy is impossible since the motions of an "expert" folder are meant to follow each other closely in space, so that each individual motion path is less than distinct. Photographing ten cycles of motion on a single photographic plate resulted in an image that Gilbreth jokingly referred as to a "plate of macaroni." Gilbreth's genius was his showmanlike abil-

ity to present these cyclegraphs as both photographic pasta and scientific documents, inviting the skepticism of a "humbug" only to win over his audiences with his mastery of the photographic sublime.[117]

Gilbreth's first of several contracts with Hermann, Aukam and Company, signed in late summer 1912, was a lucrative one: for fifty-two days of work he was to receive twelve thousand dollars. (He eventually earned thirty-five thousand dollars from the job.) His approach, characteristic of his management work, was double-edged. He began with motion study as a publicity endeavor (for audiences both internal and external to the plant), while analyzing the factory according to scientific-management principles. He proposed changes in work routine, such as keeping each sewing station stocked with adequate material; developed target production charts for each operative; reorganized the storage rooms for tools and materials; developed a planning department; reorganized work stations and materials; and instituted regimented work and rest schedules. These changes were completely consistent with Taylorist principles, and in fact Gilbreth wrote Taylor that "as usual we are standing for the *'Taylor System' without the slightest deviation* so far as we are able to interpret it."[118] Gilbreth began the cyclegraphic motion-study work in October 1913.

As Gilbreth's note to Taylor suggests, he was at pains to remain on good terms with Taylor, aware that his move to industrial management had shifted the nature of their relationship by positioning Gilbreth as a potential competitor of Taylor's. Even though Gilbreth had never become an approved Taylor expert, with permission to accept installations of the Taylor System, Taylor had nonetheless recognized Gilbreth's valuable role as a publicizer for scientific management. He had selected Gilbreth to represent the Taylor System at the New York Civic Forum in 1911 and at a meeting of the Western Economic Society in 1913, and Gilbreth was instrumental in founding the Society for the Promotion of the Science of Management (later named the Taylor Society) in 1910. But as Milton J. Nadworny has suggested, when Gilbreth turned from contracting to consulting in 1912, "toleration on the part of the Taylor group turned increasingly to hostility."[119] Gilbreth and Taylor's delicate relationship was about to receive its final blow.

By January 1914 Gilbreth had left day-to-day work at both the New England Butt Company and Hermann, Aukam and Company to pursue another, more lucrative contract in Berlin. The shift of his energies and personnel away from Hermann, Aukam caused considerable acrimony

among the company directors. Feeling that they were being "left in the lurch," Milton Hermann, a partner in the company,) toured a showcase Taylor management installation (for the Tabor Company) and shared his grievances with Taylor himself. Taylor wrote Gilbreth to tell him what he had been told by Hermann; he also wrote to H. K. Hathaway to tell him that Hermann was interested in having Hathaway, an orthodox Taylor disciple who had assisted Gilbreth in the early stages of work at the New England Butt Company, clean up the fraying installation at Hermann, Aukam. Hathaway reluctantly agreed and, unknown to Gilbreth, began work at the company before Gilbreth's contract had expired (Gilbreth's fifth contract with the company was due to expire in May 1914). Furious at what he considered Taylor's "act of war" in sending in his disciple before Gilbreth had settled his own contract, Gilbreth severed relations with the Taylor camp, declaring to Lillian that "we must have our own organization and we must have our writings so made that the worker thinks we are the good exception."[120]

Although Gilbreth had enthusiastically informed Taylor of his various camera-based innovations before this break, Taylor's response had been lukewarm. Work measurement was predicated on stopwatch time study, which Taylor considered the "foundation of scientific management."[121] Gilbreth's use of the motion-picture camera, which recorded both time and motion, implicitly threatened the supremacy of the stopwatch in scientific management and, by extension, Taylor's control over the methods and practices of the growing field. Clearly aware of the risk he was running in alienating Taylor through his use of the camera, Gilbreth had been quick to reassure him, writing Taylor that "I do not believe that this method will ever wholly do away with the present stop watch method, but it will have a tremendous use in teaching certain elements of processes by the exhibition of these educational films."[122]

After his break with Taylor, however, Gilbreth no longer had any reason not to fully exploit the publicity value of his photographic methodologies, and he increasingly disparaged the stopwatch as a strategy in publicizing the camera's superior "accuracy" in recording time and motion. In 1915, for example, the Gilbreths argued, "Early workers in time study [i.e., Taylor] made use of such well-known devices as the . . . stop-watch. . . . The objection to the use of these methods and devices is their variation from accuracy, due to the human element. This is especially true of the use of the stop-watch, where the reaction time of the observer is an element constantly affecting the accuracy of

the records." In discussing the use of the camera later in this paper, however, the Gilbreths did not call their readers' attention to the human element involved in photographing work. Problems with uncovering and closing the lens at the precise point in the motion cycle or with deciphering the cyclegraph's hieroglyphics were not discussed.[123] The Gilbreths' break with Taylor, as professionally disruptive as it may have initially appeared in the context of a small management field, eventually enabled them to build their own management business on the publicity afforded by photographic methodologies.

Meanwhile, at the Auergellschaft Company in Berlin Gilbreth had two weeks to demonstrate his expertise and win a larger, more lucrative contract. The Auergellschaft Company, a manufacturer of gas mantles and incandescent lights, employed more than ten thousand workers, many of whom performed hand assembly work, which was emerging as Gilbreth's area of specialization. Gilbreth's goal was to impress the company directors enough to land the larger, long-term contract without alienating the Social Democrats or providing the directors with precise photographic methodologies, which would render his own further involvement unnecessary. Gilbreth was warned on his first day on the job not "on any account" to "mention the word Taylor—it is in very bad with the workmen here." Less than a week later, however, Gilbreth reported that the "Social Democrats have found out who I am, Remane says, and are asking him just what I propose to do . . . they are all very friendly, but they all watch me from morning till night." Remane, one of the six company directors, had a vested interest in Gilbreth's reception within the company, for a strike at Auergellschaft would affect all of Germany.[124] Remane offered to "explain" Gilbreth's work to the employees "so that they will accept it O.K." At the same time, Gilbreth needed Remane's support both to persuade the remaining directors of the importance of Gilbreth's work and to manage the workers' response to Gilbreth's production changes. Recognizing the critical role Remane would play for his own success, Gilbreth wrote to Lillian, "*He needs me and I need him.* . . . Tomorrow I have a date with him at 9:15 AM and I will chloroform him. I'll use the book of lectures before I finish with him and that will do it."[125]

As with his other contracts, Gilbreth's approach was twofold: job and work-station reorganization and photographic technologies. Working within a two-week window, he had little time to institute any major changes. The company directors, perhaps afraid of alienating

the factory production workers, wanted Gilbreth to demonstrate his potential in the packing room. Even though Gilbreth felt this was the wrong place to start, he agreed, realizing that the packing room was "the easiest place to make motion savings." Within his two weeks, he claimed, he invented a booster truck to carry sixteen bulb boxes at once; a nailing device using a magnetized hammer; and individual portable workbenches. He also introduced in and out baskets, route models, new charts, a tickler file, self-inking stamps, and other hallmarks of office and planning-department efficiency. Gilbreth ended the women packers' practice of working in groups and assigned each to her own work stations. He began the process of "functionalizing" their tasks (breaking them down into component parts and reassigning pieces) by having men bring boxes of bulbs to and from the work stations, thereby ending the women's practice of breaking their packing routine by retrieving additional material. The women's productivity rose as their work patterns and motions became standardized and streamlined.[126]

Historians of technology, business, and labor have overlooked the extent to which unorganized women workers were prime targets for systematic managers seeking to reengineer both the industrial workplace and the industrial worker. At the bottom of the pay scale, clustered in historically nonunionized jobs, and usually excluded from any of the unions to which they otherwise might have belonged, unskilled women workers were among the groups least likely to resist scientific management in an organized fashion. Excluded from most trades and from the apprentice-to-journeyman system, this working population had not enjoyed substantial worker's control since the advent of even the first industrial revolution; consequently, they were less likely than male trade unionists to openly resist scientific management.[127] The Gilbreths' focus on hand assembly led them back to this industrial population; as a result, the working bodies the Gilbreths sought to standardize were female. Female workers' hand assembly provided the perfect arena for the Gilbreths' motion study; as Frank asserted in the context of his Auergellschaft contract, the work performed by the women entailed "no metal cutting, no slide rules, motion study, etc. are the things."[128]

As Alice Kessler-Harris has suggested, scientific management had both positive and negative effects on women workers. Women retained by "progressive" U.S. companies were subject to increasingly Draconian technologies designed to reduce "waste" motion, including further routinization of what had already been repetitive tasks. On the

other hand, some women received higher wages and more comfort-
able working conditions. For those at the lowest end of the job scale,
for whom repetitive labor had long been the industrial norm, scien-
tific management meant a less arbitrary wage and supervisory system.
Kessler-Harris argues that "the idea, if not the practice, of scientific
management offered women for the first time the systematic pros-
pect of limited upward mobility within their own factories."[129] The
Gilbreths, in their contracts at Hermann, Aukam, Auergellschaft, and
other firms, coupled their motion standardization with the promise of
higher wages, internal promotion, and attention to work fatigue. Their
focus on these issues helped them to increase productivity and to defuse
suspicion or opposition to new work systems.

In addition to his initial work functionalization at Auergellschaft,
Gilbreth's chronophotography played a critical role in winning him
a contract that would pay fifty-four thousand dollars a year for two
years.[130] As Gilbreth wrote to Lillian in a flush of excitement over the
directors' response to his work, "I have made a decided hit. . . . The
cyclegraphs will make anybody sit up and take notice."[131] For this con-
tract, however, Gilbreth completely severed the fictive relationship
between photography and efficiency, at least with respect to the pho-
tographs he produced during his two-week stay, though surely not in
interpreting his images to the company directors. Very few of the actual
chronophotographs he made in Berlin had anything whatsoever to do
with the assembly of gas mantles or incandescent bulbs.[132] Instead, they
functioned as publicity stills for what Gilbreth could, or would, do if he
got the longer contract.

Within several days of Gilbreth's arrival at the plant, the company
had bought him a motion-picture camera and a stereoscopic camera
and turned three rooms into an experiment station for the photography
work. In addition, Gilbreth had hired Roger Freeman, a photographer,
to develop both motion pictures and cyclegraphs. None of the resulting
images, however, documented factory work performed by Auergellschaft
employees. The first set of cyclegraphs were typewriting studies: Gil-
breth had engaged a Miss Felsh, a "good looker," to type for the purposes
of demonstrating "typewriter motions and fatigue saving."[133]

A second set of images demonstrated efficiency in surgical tech-
niques. Gilbreth had long been interested in applying his photographic
work to nonindustrial fields, in particular to "high-brow" occupations;
in this way he hoped to broaden the interest in and applications for his

work, while countering organized labor's claim that motion study's real purpose was to mechanize the worker. If he could win support among surgeons for his scientific management, then he would guarantee himself excellent publicity, generated by the "right kind of people."[134] Gilbreth's interest in hospital work served as a kind of cover for his Berlin trip. Perhaps worried about jeopardizing his Hermann, Aukam contract, as well as leaking to the Social Democrats his interest in industrial motion study, he wrote to Lillian: "I hope Abby Cooke will not print that I have gone abroad, and if she does, I hope it will be that I am visiting hospitals. . . . Do not hesitate to tell anyone that I am here for hospitals. It is Psychologically right from every standpoint to have me on hospitals."[135] And, indeed, he did visit hospitals: on 12 January he took cyclegraphs and film footage of a Dr. Kuckenstein tying surgical knots. These images were, Gilbreth reported, "exceptionally fine, perhaps the best we have ever taken. Everyone thinks cyclegraphs are wonderful."[136] The other images that he displayed to the company directors at the end of his two-week stay included a light-written holiday greeting to the company manager, Director Schlupman, as well as a series of fencing cyclegraphs (fig. 2.14). The fencing images featured a German and a Russian fencer demonstrating standard motions; Gilbreth hoped to use them as a means of winning an introduction to Kaiser Wilhelm III, which he did.[137] In the holiday-greeting cyclegraphs (there were others as well) Gilbreth's publicity logic is manifest: these images are indeed "visual calling cards" (fig. 2.15).[138]

The fencing photographs represent the continuation of a long-term interest in applying motion study to sport, a primarily publicity-based project that Gilbreth hoped would gain him a larger audience for his motion-study work among both scientists and the general public. In the spring of 1913, while working at the New England Butt Company, Gilbreth had photographed and filmed Brown University's baseball and track teams in Providence. On 31 May 1913, at the invitation of the *New York Tribune* and before an audience of 20,000 fans, he and Whitaker had conducted a motion study of the New York Giants baseball team in New York.[139] "There is no reason," Gilbreth reportedly asserted, "why such methods of analysis should not do for baseball or any other form of athletics what they are doing in the manufacturing industry."[140] The *Tribune* sportswriter agreed: using language eerily similar to that of the scientific managers, the author argued that the baseball player's "mental reaction time" would determine his value to the new "science" of base-

FIG. 2.14. (*top*) A German and a Russian fencer demonstrate standard moves at the Auergellschaft Company in Berlin, 15 January 1914. ("N" file 12/0031-18. Courtesy Frank and Lillian Gilbreth Collection, Purdue University Libraries Special Collections, Purdue University, Lafayette, IN.) FIG. 2.15. (*bottom*) Holiday greetings in light, Berlin, 1914. The Gilbreths used chronophotographic technologies as their company "calling card." (Image 199, "N" file 1/0006. Courtesy Frank and Lillian Gilbreth Collection, Purdue University Libraries Special Collections, Purdue University, Lafayette, IN.)

ball. Implicitly, though not unfavorably, comparing the baseball player to the industrialized factory worker, the author asked: "Will the time soon come when a heavy hitter of the ball from right field to third will be asked to pose for the moving picture speed testing machine and obtain a card certifying that he is a whirlwind before a manager will consider his application for a job?"[141] The answer, of course, was yes, as baseball was being transformed during these years into a profitable, mass spectator sport, increasingly subjected to the discipline of the clock.

Gilbreth's attention to sports and efficiency led to a brief collaboration with Walter Camp, the Yale football coach whom historians have credited with transforming college athletics into a mass spectator sport. Taylor had told Gilbreth that Camp was interested in applying motion study to athletics, and Lillian Gilbreth, writing on her husband's behalf, followed up with a letter of inquiry to Camp in October 1913.[142] By December 1915 Camp had presented Gilbreth with a business proposition: a series of illustrated articles on the application of efficiency to athletics featuring champion athletes of the world, with text by Camp and photographs by Gilbreth.[143] Further discussions produced a proposal for a motion-picture collaboration in which Camp and Gilbreth would produce movies of famous athletes to be distributed nationally through commercial movie theaters. The series was to be called the "Walter Camp Sports Series/Camp Gilbreth," and the logo Gilbreth designed bears a striking resemblance to that of the IMP motion picture syndicate.[144] The proceeds from newspaper pieces would be split three ways, between Camp, Gilbreth, and Otis Wood, the news agent who would place the articles. Their first effort was a series on golf efficiency. By early February 1916 Gilbreth had sent Camp a series of cyclegraphs of Roger Hovey, a champion golfer of Rhode Island and Connecticut. Some of the images featured four lights—one on the right hand, one on each shoulder, and one on the head—while others included an additional light on each knee, as well as one on the golf club. Soon Gilbreth had completed studies of a number of other champion golfers, including Francis Ouimet, James Barnes, and Gilbert Nichols (fig. 2.16). The cyclegraphs demonstrated the path and speed of the golfers' limbs and clubs in full swing, demonstrating, for example, whether the head moved during the swing or that the up and down swings occupied different paths.[145] Many of these images were included in articles in *Golf Illustrated* and *Vanity Fair* in 1916, generating considerable publicity for Gilbreth's motion-study work.[146]

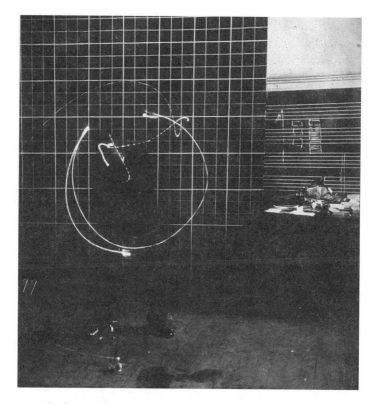

FIG. 2.16. Cyclegraph of champion golfer Gilbert Nichols. Frank Gilbreth's work in photographing champion sports figures echoes the broader applications of motion study developed by Etienne-Jules Marey in France. (EF 731, "N" file 13/0031-23. Courtesy Frank and Lillian Gilbreth Collection, Purdue University Libraries Special Collections, Purdue University, Lafayette, IN.)

The popularity of the sports-efficiency project was a source of some concern for Gilbreth, however. Though he very much wanted to develop a larger audience for his work, he was worried that by linking motion study with sport he would jeopardize his reputation as an industrial-efficiency expert. Writing to Camp, he urged, "I hope therefore, that you will lose no opportunity to make it very plain that my real work is that of Consulting Engineer and nothing else, and that this work on the Golf, etc., is my play."[147] Despite these efforts to manage his public reputation, however, Gilbreth realized that the tremendous public interest in both efficiency and mass sport would benefit his growing business as a management consultant specializing in motion study.

The public interest in sport complemented the rich European and American scientific tradition concerning the physiology of movement, a tradition with a significant photographic component as well. Eadweard Muybridge, for example, had photographed fencers and other athletes first with Leland Stanford in California (1874) and then at the University of Pennsylvania (1884–86). In France, Etienne-Jules Marey had studied the relationship between physiology and sport beginning in 1891, using chronophotography as a methodology; his work had led to design revisions in contemporary bicycles in the 1890s. He had also studied athletes at the 1900 Olympic games, taking anthropometric measurements, as well as making photographic and film studies, of numerous track-and-field athletes. Gilbreth had known of Muybridge's work since 1911, if not earlier. His decision to photograph athletes followed Marey's interest in photographing the "champions of the world" in order to understand the physiology of skill, while his use of chronophotography and the resulting images successfully placed him in a venerable scientific tradition, at least as far as his industrial clients were concerned.

Gilbreth's interest in sports and in hospital work represented successful forays out of the factory and into both popular and scientific cultures. These projects provided opportunities to demonstrate the efficacy of photographic technologies in mapping efficiency in movement regardless of the setting or application. By 1914 Gilbreth was less interested in making particular tasks—such as bricklaying or baseball—more efficient than he was in making the motions that made up these tasks efficient, standardized, and interchangeable. In this effort Gilbreth's interest paralleled that of his contemporary, the French physiologist Jules Amar, who was also during these years searching for a universal law of motion governing all activity. Amar used his theories concerning the dynamic regularities of labor to explore not only shop work but also writing, playing musical instruments, and participating in athletics, sports, and the military.[148] Like Amar, Marey, and other European scientists, Gilbreth sought an underlying motion language, a corporeal alphabet that he could use to formulate a new somatic vocabulary marked by efficiency and standardized uniformity. But unlike the Europeans, Gilbreth wanted first and foremost to build his own business reputation and win additional, lucrative contracts. Motion study, regardless of the subject matter, had become his business card.

Therbligs, Motion Study, and the Disabled

Gilbreth's drive to industrialize the movements of the working body converged with his public-relations savvy when he introduced a new set of techniques under the guise of rehabilitating the crippled World War I soldier in October 1915. The "simultaneous cycle motion chart," which Gilbreth presented to the New York section of the American Society of Mechanical Engineers in October 1915, graphically displayed "the interrelation of the individual motions used in any method of performing any piece of work."[149] The chart required the isolation of individual motions, which could be identified and charted, in their varying sequences, in relationship to time. With the "SIMO" chart Gilbreth introduced these foundational motions, which he argued provided the basis of all work-related movement. The October 1915 list contained sixteen components: search; find; select; grasp; position; assemble; use; dissemble, or take apart; inspect; transport, loaded; pre-position for next operation; release load; transport, empty; wait (unavoidable delay); wait (avoidable delay); and rest (for overcoming fatigue).[150] These foundational elements, later called *therbligs*—in the singular a near reversal of *Gilbreth*—could be reconfigured into increasingly efficient combinations. Each component was assigned a standard color (matching those used in the SIMO chart) and a symbol (which Gilbreth called a "hieroglyph") (fig. 2.17).[151]

Once Gilbreth had filmed a particular work cycle, he could then run the film slowly enough to isolate the individual therbligs, which were then transferred to the SIMO chart (fig. 2.18).[152] The chart was a means of visualizing the motions used for any type of work: the horizontal lines, reading from the top down, represent time, while the vertical spaces represent anatomical groups, such as right arm, with subgroups, such as wrists, thumb, and so on. This anatomical map showed, according to Gilbreth, "which members of the human body are doing the work [and which] are inefficiently occupied" during the performance of any task.[153] Just as Taylor introduced work functionalization to the industrial workplace by breaking skilled work down into component tasks, which he then reassigned to lower-paid workers, Gilbreth introduced work functionalization to the body itself. With the SIMO chart, Gilbreth could see at a glance evidence of "soldiering" limbs, to use Taylor's term, and he reassigned tasks accordingly in order to make full use of the working body. With all limbs working to full capacity, he ar-

SYMBOL	NAME OF SYMBOL	SYMBOL COLOR	NAME OF COLOR	NAME & NUMBER OF PENCIL OR CRAYON
⟳	SEARCH	▬	BLACK	DIXON'S BEST BLACK #331
⟳	FIND	▬	GRAY	DIXON'S BEST GRAY #352½
→	SELECT		LIGHT GRAY	DIXON'S BEST GRAY #352½ APPLIED LIGHTLY
∩	GRASP	▬	LAKE RED	DIXON'S BEST LAKE RED #321½
⌣	TRANSPORT LOADED	▬	GREEN	DIXON'S BEST GREEN #354
𝟫	POSITION	▬	BLUE	DIXON'S BEST BLUE #350
#	ASSEMBLE	▬	VIOLET	DIXON'S BEST VIOLET #323
U	USE	▬	PURPLE	DIXON'S BEST PURPLE #323½
⧺	DIS-ASSEMBLE		LIGHT VIOLET	DIXON'S BEST VIOLET #323 APPLIED LIGHTLY
0	INSPECT	▬	BURNT OCHRE	DIXON'S BEST BURNT OCHRE #335½
8	PRE-POSITION FOR NEXT OPERATION		SKY BLUE	DIXON'S BEST SKY-BLUE #320
⌒	RELEASE LOAD	▬	CARMINE RED	DIXON'S BEST CARMINE RED #321
⌣	TRANSPORT EMPTY	▬	OLIVE GREEN	DIXON'S BEST OLIVE GREEN #325
⎰	REST FOR OVER-COMING FATIGUE	▬	ORANGE	RUBENS "CRAYOLA" ORANGE
⌢o	UNAVOIDABLE DELAY		YELLOW OCHRE	DIXON'S BEST YELLOW OCHRE #324½
╌o	AVOIDABLE DELAY		LEMON YELLOW	DIXON'S BEST LEMON YELLOW #353½
⌶	PLAN	▬	BROWN	DIXON'S BEST BROWN #343

FIG. 2.17. Standard colors for Therbligs. *Therblig*, a near reversal of *Gilbreth*, was the Gilbreths' term for the standard motions they argued were foundational to all work-related movement. ("N" file 53/0298. Courtesy Frank and Lillian Gilbreth Collection, Purdue University Libraries Special Collections, Purdue University, Lafayette, IN.)

gued, the method of least waste would result, one best fitted to become the standard method. The standard method, in turn, would result in the least fatigue for the worker, as well as the greatest prosperity for both worker and employer.[154]

Of course, for the crippled World War I veterans, "soldiering" limbs were often a result of missing limbs: more than 247,000 Americans were eventually disabled during the war, a large percentage because of loss of limb.[155] In a brilliant public-relations move, Gilbreth

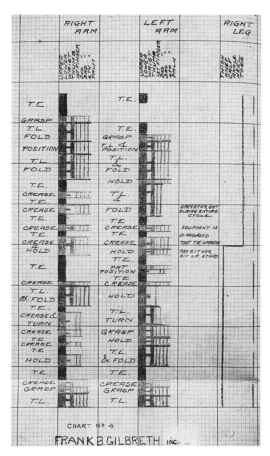

Fig. 2.18. A SIMO chart representing handkerchief folding. The simultane-ous cycle motion (or SIMO) chart promised to document the performance of therbligs in time and space. ("N" file 52/0297-5. Courtesy Frank and Lillian Gilbreth Collection, Purdue University Libraries Special Collections, Purdue University, Lafayette, IN.)

introduced and popularized his SIMO charts, arguably the apotheosis of his efforts to industrialize the working body, initially only in the context of his work on behalf of disabled war veterans. By tying discus-sions of corporeal efficiency to an international concern for what was widely known as the "crippled soldier problem," Gilbreth invited—and received—unprecedented positive publicity for his motion-study work. At a time when scientific management's reputation had been seriously undermined by years of sustained criticism on the part of organized

labor, Gilbreth effectively outflanked his critics by wrapping motion study in the patriotic flag of war-hero rehabilitation.[156]

Working in Berlin at the beginning of the war, well before the U.S. entry in April 1917, Gilbreth had ample opportunity to observe the physical devastation wrought by the conflict. His surgery motion-study work was taking him into German hospitals, where he saw "such terrible things you never heard of or could imagine," including amputations, infected wounds, and other evidence of the war's carnage.[157] His reaction was an odd mixture of sincere horror and gleeful recognition of a unique business angle for his motion-study work. He reported being "positively sickened" by the war and thought that a film showing a Bridgeport ammunition manufacturer, followed by images of operations and wound dressing, would be a "great hit."[158] Yet his outrage complemented his opinion that the work on crippled soldiers represented the "greatest subject" he had ever had; it was, in his words, "sob-stuff" that held his audience "spellbound."[159]

Gilbreth's goal was to use motion-study technologies, including film, photography, motion models, and SIMO charts, to reintroduce crippled veterans to productive employment after their release from convalescent hospitals. His plan was international in scope, both because he found a more sympathetic audience in Canada and Europe in the years before U.S. involvement in the war and because he sought to sell complete motion-study packages to hospitals and vocational and occupational therapists for a thousand dollars each.[160] His public discussions of the need to "solve the crippled soldier problem" quickly developed into a standard set of formulaic elements, among which definitions of gender were key.

Gender, especially the perceived problematic masculinity of the disabled veteran, emerged as a key concern for most commentators on the problem of the crippled soldier, including Gilbreth. For many contemporary observers, the veteran's possible economic dependence upon the state or upon his family threatened to undermine his masculinity, as manliness had been defined in large part by a man's role as breadwinner.[161] "The sudden drop from the strenuous life at the front to the inactivity of the hospital" appeared to threaten the soldier's masculinity both because the wounded veteran no longer retained the "fighting spirit of the trench" and because his disability prevented him from returning to "productive life."[162] Furthermore, the war years also saw the height of women's suffrage activism in the United States, espe-

cially after President Woodrow Wilson's reelection in 1916: both the lobbying work of the National American Woman Suffrage Association and the direct-action politics of the National Woman's Party pointedly called into question contemporary definitions of American masculinity, in this case the assumed relationship between manhood and the vote. Battlefront disabilities combined with homefront suffrage activism engendered a "crisis of masculinity" in the wake of the war, a crisis encapsulated by the "crippled soldier problem."

In his writings and lectures on behalf of crippled soldiers, Gilbreth addressed these gendered anxieties to brilliant effect. Unlike many of the professionals whose rhetoric dripped with saccharine condescension for the "poor veteran," Gilbreth positioned himself as the veterans' manly champion, a fellow cripple disdainful of the rehabilitation experts' feminizing concern. He opened one of his numerous lectures on the subject with the charge, "No man with red blood in his veins, no matter how disabled he may be, who has ever taken a man's part in the world's work is satisfied to become a national charge."[163] In other discussions, Gilbreth attacked the occupations that were being taught to disabled veterans during their rehabilitation. Many of those in charge of retraining veterans in the wake of the war were women who, Gilbreth claimed, taught only those occupations that they themselves knew best. "As the result," he argued, "many a strong hardy man became a weaver of baskets, a maker of toys, or a worker at some other feminine occupation."[164] Gilbreth advocated, in principle though not necessarily in practice, retraining for more manly pursuits—muscular work that could be commended as "a 'man's job,' the work of a producer, economically necessary, and therefore satisfying the social sense of the worker."[165] Paradoxically, Gilbreth's limited documentation of the rehabilitation work features the disabled veterans in jobs that had, by this period, become predominantly female, including typing, retail sales, and a new job that Gilbreth ceaselessly advocated in the cause of efficiency, that of dental hygienist.[166]

Gilbreth needed to critique his contemporaries' pedagogical practices for two reasons. First, the way he wanted to make money was not by retraining the veterans himself but by training their teachers. In order to outfit convalescent hospitals with motion-study equipment, he needed to argue that current vocational training was inadequate. Exacerbating contemporary anxieties about the veterans' masculinity and then presenting himself as the instrument of remasculinization by

providing more manly occupations was an effective rhetorical strategy. Second, Gilbreth sought to introduce motion study as a scientific technology, one that would reveal new occupations for the disabled. While claiming a role for motion study in determining appropriate occupations for the disabled, however, the Gilbreths argued that the technology had limitless applications. This flexibility was not so much due to the technology as it was to the continuity in the study subjects. "When we come to consider the subject closely we see that every one of us is in some way a cripple, either through being actually maimed or through having some power or faculty which has not been developed or used to its fullest extent." From an efficiency standpoint, any impediment to what the Gilbreths now called "the one best way to do work" represented a handicap of some sort, whether the disability was a corn on a policeman's foot or a typist's missing arm. "We can, then, think of every member of the community as having been a cripple, as being a cripple, or as a potential cripple."[167] With such a flexible definition of the disabled, the Gilbreths effectively collapsed the rhetorical distance that gave rise to the helping professions' pitying condescension toward the wounded veteran, while at the same time constructing a motion-study audience limited only by the size of the industrialized world's adult population.[168]

Photography played an important role in publicizing the Gilbreths' work with crippled soldiers. The first step in furnishing "real work to the cripple," the Gilbreths argued, was to illustrate, photographically, work currently being done by the disabled or even work that looked as if it were being performed by crippled persons. Albert Jay Nock, the editor of *American Magazine*, who also circulated the Gilbreths' work in this area to *Scribner's* and *Scientific American*, was explicit on this point: "It is not important that the pictures be of actually crippled persons; the thing is to convey as strikingly as possible, a clear idea of what can be accomplished with cripples," wrote Nock. He provided the Gilbreths an explicit shooting script: "What I want is this: Take a well man and make him simulate a cripple. Then take photographs of him showing just what you would do if he had lost a hand, and you are testing him out for certain work under this disability." "If you will just come through with illustrative photographs of the proper sort, for a popular magazine," he urged, "I will be able to get you very good publicity."[169]

The Gilbreths responded with a series of photographs that documented the "disabled" at work. Since the photographs were intended as

FɪɢG. 2.19. A dentist feigns disability in order to demonstrate how dentistry could be performed with the use of a single arm. (Photo 17039. Courtesy Gilbreth Collection, Division of the History of Technology, National Museum of American History, Behring Center, Smithsonian Institution.)

motivational images, designed to suggest the "possibilities and the advantages of working," a photograph that featured an able-bodied person simulating a handicap had important pedagogical value (fig. 2.19). Figure 2.19, for example, shows what appears to be a disabled dentist working on a patient. A closer examination of the dentist's white coat, however, suggests the bulkiness of a stowaway limb. Indeed, Lillian Gilbreth's private correspondence concerning this image makes no attempt to pass it off as photographic evidence in the documentary sense: "One-eyed, one-armed, legless dentist engaged in cleaning the teeth. The subject of this slide is a well-known dentist who allowed himself to be crippled as seen in order to demonstrate that cleaning the teeth can be done with one hand and chiefly through the sense of touch."[170] As it does not appear that the Gilbreths actually worked with very many of the disabled themselves during this period, simulating the disabled through photography became important if Nock's illustrations were to be provided.

Although photography's role was to provide visual inspiration rather than documentary evidence, the interpretive habit of seeing the photographic image as an index to a past "fact" adds evidentiary weight to figure 2.19, which was essentially a publicity still, advertising new work possibilities both for the disabled and for Gilbreth, Inc. These early publicity photographs traffic in the visual rhetoric of documentary realism, which explains their effectiveness, but their staged quality works against a documentary interpretation. Historically and aesthetically, they inhabit the transitional space between the social documentary rhetoric of early-century reform photography and the capitalist realism of *Fortune* magazine photography in the late twenties. At the time, however, because of photographic realism's effectiveness as an evidentiary tool in both magazine journalism and social-reform movements, these Gilbreth images would have most certainly been understood as documentary evidence of the disabled at work. Regardless of the Gilbreths' intentions in producing the images, then, their publicity force stemmed in part from their being *misread* as documentary.[171]

Once motion study had identified appropriate work for the disabled, the next step was to "[adjust] the cripple to the work." The fit between the disabled worker and the job was approached from two directions. One approach was to understand the workplace as a standardized element not amenable to redesign or change and to create prosthetic devices that would help the disabled veteran interact with this environment. One would expect American industrial engineers, reared on the gospel of workplace standardization, to have pursued this approach. Surprisingly, however, despite their own emphasis on the standardization of the work environment, the Gilbreths eventually championed an alternative method, one that emphasized adapting the workplace, especially machinery, to the disabled worker's needs. The Gilbreths preferred to see the disabled worker (rather than the environment) as the "fixed element," around whom mechanical devices or machines would be adjusted in order to accommodate specific disabilities. They argued for the role of motion study in discovering exactly which motions were required to perform a particular activity and then determining which of these motions could be reassigned or eliminating by altering the machine itself. This approach, which was innovative in its emphasis on environment over disability, was also designed to emphasize the Gilbreths' motion-study technologies, whose focus was the relationship between the individual body and its workplace environment.[172]

FIG. 2.20. Mr. Casey, the one-armed secretary to the mayor of Boston, had redesigned his machinery in order to accommodate his disability. (Photo 16269. Courtesy Gilbreth Collection, Division of the History of Technology, National Museum of American History, Behring Center, Smithsonian Institution.)

When considering the plight of the war-disabled, the Gilbreths reintroduced their concern with the worker's environment to analyze the ways it could be adjusted to meet the needs of the disabled. Among the individuals they mentioned most frequently in their discussions of the problem was Mr. Casey, the one-armed secretary to the mayor of Boston. When the Gilbreths were introduced to Casey, he had already altered his typewriter by inventing devices to insert paper and to activate the shift key with a foot pedal. The Gilbreths elaborated on Casey's innovations by inventing an elaborate paper roller (thus doing away with the need to change paper), as well as advocating the use of a carbon ribbon and a double bank of keys (eliminating the need for the shift key) (fig. 2.20). Although it can be argued that Casey seemed perfectly able to accomplish his work thanks his own inventiveness prior to the motion study, the Gilbreths nonetheless argued that motion study was still a necessity: "It is only through [motion and fatigue study] that one is able to classify completely the motions involved, and to discover which ones of these can be handed over to available, securable, or inventable devices."[173] Photographs of Casey being motion-studied took their place alongside a series of related images of the disabled at work and were circulated throughout the periodical press, in lectures and personal correspondence, and at academic conferences. Through this photographic publicity, Gilbreth successfully fueled public concern for

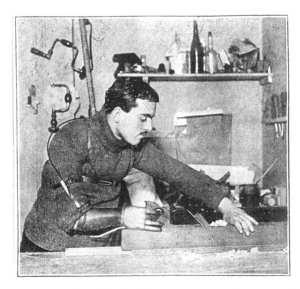

FIG. 2.21. The French physiologist Jules Amar's research on prosthetics for the disabled veteran influenced the Gilbreths' work in the United States. (Scrapbook page from Gilbreths' materials, "N" file 15/0031-24. Courtesy Frank and Lillian Gilbreth Collection, Purdue University Libraries Special Collections, Purdue University, Lafayette, IN.)

the disabled and also generated "personal publicity that will furnish jobs" for Gilbreth, Inc.[174]

The Gilbreths contrasted their approach of "adjusting the work to the cripple" to that of the French physiologist Jules Amar, who preferred the use of prostheses in reintroducing the disabled veteran or industrial worker to salaried employment. Whereas Gilbreth's approach entailed "adapting methods and devices to the cripple," Amar "adapted the cripple to existing methods and devices."[175] In addition to advocating providing artificial limbs to the disabled, Amar invented an artificial "work arm" with a chuck, into which interchangeable hands or tools (for example, a file for work and an aesthetically pleasing hand for leisure) could be inserted.[176] For Amar, as for Gilbreth, the issue was not so much one of missing limbs as of missing functions, and his solution was to provide what the Gilbreths called "supplementary limbs" that could most effectively simulate missing functions such as grasping (fig. 2.21).[177] The utilitarianism of such devices and the urgency of returning the disabled to productive employment outweighed any customary

aesthetic considerations. The authors of an article describing the special work appliances that could be fitted to an arm stump declared that "drawing room considerations must be abandoned" in order to restore "the armless to a place in the industrial world."[178]

Frank Gilbreth was very much taken with Amar's approach, writing to Lillian, "I am glad that you appreciated the possibilities of the *re-design* as well as the re-education of the cripple. By making mechanical additions to his four *missing* or *present* or replaced limbs we can have a soldier with 10 limbs, adjustable, removable, replaceable, for special uses. A new line of possibilities without end for the crippled heroes."[179] This idea is clearly Amar's, and though the Gilbreths toyed with promoting replaceable limbs designed to accomplish specific work-related functions, in the end they advocated the "American" approach of retooling machinery rather than designing prosthetics. Their argument was that since most artificial limbs and machinery were designed and built in the United States, Americans were better positioned to redesign machinery in order to accommodate the disabled veterans' special needs. The prosthetics, or additions, that the Gilbreths advocated were not limited to the material culture of artificial limbs. Instead, they argued for an environmental prosthetics that required adjusting the environment to the needs of the worker, thus anticipating the call for "universal design" by some seventy years.[180]

There is little evidence that the Gilbreths contributed much besides rhetoric to improve the plight of the disabled during Frank's lifetime; the few examples that mark their work before Frank Gilbreth's death in 1924 had to do with disabled workers whom the Gilbreths came across in the course of their general motion-study contracts, and most of these few disabled workers were not war-disabled.[181] The Gilbreths' efforts to industrialize the working body through motion study had both utopian and dystopic implications. If the visual analysis of the war-disabled promised a valorous return to productive life, it was as a human machine within industrial capitalism, a "hand" in an increasingly rationalized labor force. The visual technologies of motion study rendered the worker invisible while rendering Frank Gilbreth the increasingly "visible hand" of planning. As part of this visualizing process, what had been the visual hand of the laborer became the abstract trace of movement through space, a shift that metaphorically marks the transformation of labor during this period, at least from the perspective of scientific managers. If we were to return to the Greek etymology of *prosthesis* as

"addition," then we could understand the Gilbreths' motion study as it-self a prosthesis, a technological addition that replaced workers' control and craft knowledge with the mind of management.

Frank Gilbreth began his photographic investigations into corporeal efficiency with the goal of using photographs to reduce "waste" motion and making production more efficient. Motion study, including the use of photographs, stereographs, film, motion models, and SIMO charts, was intended to provide incontrovertible object lessons concerning the "one best way" to do work. Photography's indexical qualities seemed to promise both an indisputable record of motion efficiency and an unpar-alleled pedagogical tool. Yet as the Gilbreths' methodologies became more complex, the meanings and uses of the images began to shift. As photo studies of bricklaying were replaced by film, cyclegraphs, chronocyclegraphs, and other hieroglyphs, the precise relationship be-tween efficiency and the photographic image seemed to become less, rather than more, clear. The role of photographic technology in the Gilbreths' practice shifted, profitably, between an instrumental realism and the new imagework of corporate public relations, a direction that is investigated more fully in chapter 3. After Frank Gilbreth's death in 1924, motion study proved to have a bright future in mapping corpo-rate efficiency through the work of engineers and consultants working in the decades after Gilbreth, such as Allan Mogensen, Ralph Barnes, Herbert Sampter, and Marvin Mundel.[182] And as chapter 3 shows, the Gilbreths' attention to the subjective and the psychological in industrial production became the focus of the largest social-science investigation in American industry, the Hawthorne experiments.

3

ENGINEERING
THE SUBJECT IVE

*Lewis W. Hine's Work Portraits
and Corporate Paternalism
in the 1920s*

In 1921 the reform photographer Lewis W. Hine sent the educational psychologist and mental testing pioneer Edward L. Thorndike a proposal. Thorndike was a professor at Hine's alma mater, Columbia University, one of the nation's foremost centers of intelligence research. As the movement for immigration restriction gathered force in the early 1920s, some psychologists, especially those psychometricians who had used intelligence testing to classify personnel during the war, began to use the results of their testing as an argument for ending immigration, especially from southern and eastern Europe. Thorndike was a founding member of the Eugenics Committee of the United States of America, founded in 1921, which later became the American Eugenics Society, and a member of the advisory board. One of the advisory board's first decisions was to campaign for immigration restriction based upon the results of intelligence tests. In 1922, in testimony before the House Committee on Immigration and Naturalization, the prominent eugenicist Harry Laughlin presented evidence in favor of restriction drawn from both the army intelligence tests and a "rogue's gallery" of photographs of "defectives" taken at Ellis Island that purported to show "Carriers of the Germ Plasm of the Future American Population."[1]

All the available evidence suggests that Lewis W. Hine would have been deeply distressed by the racist rhetoric that pervaded the anti-immigration arguments of the early 1920s. During the years 1904–9 he had, in fact, taken his second-generation immigrant students to

Ellis Island in order to document sympathetically the greatest wave of immigration the United States had yet witnessed. But it is less clear whether Hine questioned the Eugenics Committee's assumption that photography could map intelligence. As the Hine historian Judith Gutman reports, in 1921 Hine wrote Thorndike suggesting a collaboration: Thorndike would introduce intelligence testing to Hine's industrial photographic subjects in order to "show how these workers compared in general intelligence, etc., with those in the professions and elsewhere." According to Gutman, Thorndike was interested; however, no further information about this potential collaboration has surfaced.[2] Although Hine's work in industrial portraiture was increasingly unlikely to be viewed through the lens of character analysis, it did play a critical role in a newly emerging genre of instrumental image making, corporate publicity.

Hine's 1920s photographic work was central to a new effort to rationalize postwar American labor-management relations. During the years 1918–20, while working for the American Red Cross, Hine's emphasis shifted from a critique of workers' lives under industrial capitalism to an affirmation of their role in the large industrial workplace. Although Hine's celebration of the skilled worker is evident in his Empire State Building series, published in his only book, *Men at Work: Photographic Studies of Men and Machines* (1932), this valorizing of artisanal republicanism under the radically altered conditions of monopoly capitalism had its roots in the early 1920s, when Hine began freelancing for several major corporations, including Western Electric. Hine's "work portraits" were featured in the pages of corporate employee magazines, where their photographic meanings were overdetermined by a postwar managerial rhetoric that privileged industrial "togetherness" and corporate family harmony over independent union organizing. Hine's photographs represent an early articulation of corporate public relations, designed for an audience internal to the corporation, the employees. In this context Hine's work, regardless of his intentions, must be seen as part of larger corporate initiatives designed to rationalize the subjectivities of big-business employees and to naturalize the business-state alliances that came to define postwar corporate liberalism.

Lewis W. Hine and the Photography of Progressive Reform

Lewis Wickes Hine was born in Oshkosh, Wisconsin, in 1874. His mother was a teacher, and his father pursued several occupations, including sign painting and restaurant work. When Hine was eighteen, in 1892, his father died from an accident. Recently graduated from high school, Hine helped support the family with a series of low-wage jobs, including work as a janitor, a water-filter salesman, and a department-store employee. During the same period he took advantage of Wisconsin's progressive educational policies by enrolling in university extension courses. At the urging of Frank Manny, then principal of the State Normal School in Oshkosh, Hine enrolled in that school. In 1900–1901 Hine took additional courses in teacher education at the University of Chicago, where he worked with the progressive educators John Dewey and Ella Flagg Young.[3]

As Alan Trachtenberg has argued, Hine's ongoing interest in the conditions of labor began with his own manual-labor experiences as a young man in Wisconsin. While sweeping the floors of the bank or working to pay off his tuition as an office worker in Chicago, Hine became keenly aware of the often invisible labor that gave shape to the material world of buildings, machines, and commodities.[4] Hine took his interest in labor and his Progressive Era ideals with him to New York City when he moved there in 1901 to become a teacher in the Ethical Culture School, where his mentor Frank Manny had been appointed superintendent. Hine taught geography and nature, and in 1904 he began using the camera at the suggestion of Manny, who wanted Hine to document school activities; soon Manny suggested that Hine use the camera as an educational tool. As Daile Kaplan has argued, Hine's experiences at the Ethical Culture School, where he worked from 1901 to 1908, cannot be overestimated. It was through his relationship with Manny and his students that Hine refined a type of camera work that he soon dubbed "social" or, after World War I, "interpretive" photography.[5]

Hine became increasingly interested in using photography as a progressive social tool, and he found a subject in Ellis Island, which he first visited at Manny's urging in 1904. Hine returned many times to Ellis Island to photograph recent immigrants, often accompanied by his students, to whom Hine was now teaching photography. Hine's pho-

tographs of Ellis Island's eastern and southern European immigrants eloquently convey a quiet respect and interest; though typical details might be represented (the kerchief, the piled luggage), the new arrivals are rarely reduced to picturesque "types." While pursuing photography's pedagogical and progressive promise, Hine attended the Columbia School of Social Work and received a master's degree in pedagogy from New York University.

Hine's documentary aesthetic, first sketched in the Ellis Island photographs, crystallized in his photojournalism and his work for the National Child Labor Committee (NCLC). Hine met the brothers Arthur and Paul Kellogg in 1904, while working at the Ethical Culture School. The Kelloggs edited what was to become a profoundly important institution in the developing Progressive reform movement, a social-welfare magazine entitled *Charities and the Commons.* In 1907 Paul Kellogg, the managing editor, published the first of dozens of Hine photographs to appear in the journal over the next three decades. In 1908 Hine became the staff photographer for the magazine, which was renamed *Survey* in March 1909.[6] During this period Hine began freelancing for the NCLC, a Progressive Era organization founded in 1904 by Dr. Felix Adler, founder of the Ethical Culture School, and devoted to ending child labor in America's canneries, textile factories, agriculture, and other industries.[7] By 1908 Hine had quit his job at the Ethical Culture School to work full time as a staff investigator and photographer for the NCLC. By 1914 he was also the NCLC exhibition designer, and in that year alone eleven exhibits were organized and shown in fifty cities in twenty states.[8]

Hine's reform photography has come to define the documentary aesthetic that flourished in the Progressive reform politics of the early twentieth century and has continued to shape the genre since. Unlike the work of contemporary pictorialist photographers, Hine's work is characterized by the sharp focus and direct address characteristic of what later became known, in part through the work of Hine's student Paul Strand, as "straight" photography.[9] Yet whereas Strand sought to reveal the patterns and repetitions central to the modernist aesthetic, Hine documented social conditions in order to teach middle-class audiences the costs of unregulated industrial capitalism. Hine's reliance on sharp focus, crisp detail, and straightforward lighting placed his work, in the early years of the century, in a realist tradition that, as Miles Orvell has argued, emphasized the "art of the commonplace."[10] Hine not

FIG. 3.1. Lewis W. Hine, *Young cigar makers in Engelhardt & Company, Tampa, Florida*, 1909. Hine's work for the National Child Labor Committee emphasized the worker's direct address of the camera's lens. (Courtesy National Archives, Still Picture Branch, College Park, MD.)

only stressed the importance of composition and careful selection of detail in order to pull symbolic meaning from vernacular subjects but also, like the pictorialists, argued for the importance of studying existing models of Western painting and photography in order to derive aesthetic principles for a new, socially engaged photographic practice.

The emphasis on composition and the straight photographic aesthetic were evident in Hine's early images of immigrants and workers, especially child laborers. Hine's commitment to the politics of Progressive reform called for a rhetoric of quiet exposure, a sympathetic display of working-class dignity in the midst of poverty and overwork. People—workers, immigrants, and children—are the subjects of Hine's images, and his reform photography constitutes a type of motivated portraiture. The surreptitious nature of Hine's child-labor investigations lends an almost snapshot quality to some photographs. The three young cigar makers in figure 3.1 look intently to the right of the cam-

FIG. 3.2. Lewis W. Hine, *Millworker*, 1908. This young worker retains her dignity despite her youth and working conditions. (Courtesy National Archives, Still Picture Branch, College Park, MD.)

era, their focused attention suggesting immediacy in their encounter with the photographer. The blurriness of the boy on the right and the suspended fingers of the other workers testify to the hurriedness of the portrait, as well as the inadequate lighting. In most of his photographs of children for the NCLC, as well as in his work documenting Ellis Island immigrants, Hine directly addresses the individual or the group. His preference for photographing the subject frontally rather than obliquely suggests a connection, an intimacy, between the subject and the photographer (and by extension the viewer) even when, as in the case of the cigar workers, the subjects' eyes might stray elsewhere.

A portrait of a South Carolina millworker typifies Hine's aesthetic during the prewar period (fig. 3.2). In the photograph, a young spinner stands at attention, dwarfed by two spinning machines. Her eyes address the camera directly, and the machines' receding lines abruptly collapse the foreground, bringing the viewer anxiously, protectively

closer to this old woman in a child's clothing, who nonetheless maintains an inviolate subjectivity. The image represents what Hine considered two significant aspects of his work: "the appeal of the common man" and "the value of the realistic photography," which he contrasted with Victorianism's "fuzzy impressionism."[11] The young worker epitomizes the exploitation of children under unregulated capitalism, and the photograph captures the child's quiet strength; unlike in the rhetoric of Hine's later work portraits, this young worker maintains her dignity despite her working conditions.

But as Alan Trachtenberg has argued, Hine's photographic liberalism depended not only on the strength of the individual image but also, and more importantly, on the "reproduced image within an ensemble of images and words."[12] Hine's images reached the public primarily through their reproduction in magazines, brochures, and exhibitions; the semantic meaning of any given image was always anchored by a variety of other texts and contexts, including captions, feature articles, and the agency or organization presenting the material.[13] Often, especially in his work for the NCLC, Hine sought to direct the image's interpretation through the inclusion of elaborate field notations, comments on the circumstances under which he had taken the photograph, and remarks on the conditions of labor and the workers represented. For example, in Hine's notes on the back of a print documenting the practice of sending small children into southern textile mills he directs the viewer's interpretation of the image by reading the group of often smiling children through the lens of child exploitation: "Many of [the dinner-pail-toting children] are paid by the week for doing it, and carry, sometimes, ten or more per day. They go around in the mill, often help to tend the machines" (fig. 3.3). As Maren Stange has noted, Hine's field notations also often made their way into magazine articles detailing the specifics of child labor or conditions in the nation's factories. In the context of an article on Gulf Coast cannery workers, for example, Hine's field notes, incorporated as eyewitness testimony in an article in the *Survey*, urged the implied middle-class reader to interpret his photographs as visual evidence of subhuman working conditions.[14] Viewers encountered Hine's images as they were reproduced and embedded in a web of meaning overdetermined by complementary though sometimes contradictory linguistic messages.

Hine's commitment to the political project of socially engaged photography led him to early experiments in arranging text and image to

FIG. 3.3. Lewis W. Hine, *Dinner Pail Toters*, 1913. Hine's caption for this image directs the viewer to look past the children's smiling faces to focus on the inhumanity of child labor. (Courtesy Milwaukee Art Museum, M1978.161-3458. Gift of Robert Mann.)

create a more forceful reformist message. In his posters for the NCLC, for example, Hine alternated headlines and images to engage the viewer directly with questions referring to child labor, poverty, and other social issues. In this reform-oriented work, Hine juxtaposed images of dire social and economic conditions, such as child labor, with linguistic texts such as a call for "child labor laws" in the hope that the jarring contrast between the "facts" of contemporary industrialization (rendered legible by the photograph) and the "ideals" of democracy and equal opportunity (highlighted linguistically by the headlines) would motivate the middle-class viewer to agitate for Progressive Era reforms.[15] Hine's later text-image innovations were based on the assumption that the viewer was already familiar with the social problems being addressed by Progressive reform efforts. For example, a 1910 NCLC poster that asks, "What are we going to do about it?" assumes that the

FIG. 3.4. Lewis W. Hine, National Child Labor Committee poster, c. 1910. This poster demonstrates both Hine's text-image innovations and his direct address to an implied reform-minded audience. (Courtesy Library of Congress.)

reform-minded viewer already knows that the "it" is the poor condition of child welfare (fig. 3.4). In this instance Hine uses the photograph to depict a utopian future in which reform legislation had indeed passed, guaranteeing Progressive reform goals such as compulsory education and vocational guidance.

Hine's interest in text-image collaborations evolved into an early form of Progressive photojournalism that he dubbed the "photo story" in 1914. By that time Hine had nearly eight years of experience sequencing images and text (captions, articles, headlines) both in exhibitions and in the pages of numerous magazines, including *Charities and the Commons*, the *Survey*, *Everybody's Magazine*, and others. Hine played a key role in not only taking the photographs but also determining how they would be reproduced. Unlike many photographers who worked for magazines or corporate clients, Hine insisted on having his images credited to him when they were reproduced. He provided caption information for many of his photographs; wrote accompanying articles; retained control of the negatives; insisted on his role in sequencing the images and text in magazines, posters, brochures, and exhibitions; and made sure he received a byline.[16] In an early, ten-page NCLC pamphlet entitled *Night Scenes in the City of Brotherly Love*, for example, Hine chronicles the night's work of children working as "newsies," in a box factory, and as messenger boys. The panels move the viewer through time in a filmic sequence that combines Hine's nighttime photographs, the time he took the picture, and a caption, sometimes including a rendition of the boys' dialogue. The last frame features a child worker asleep on a city grate at 4:00 A.M.[17] In these early "photo stories" Hine harnessed the semantic power of text-image combinations to showcase the lives of workers and immigrants and to argue for Progressive reform.

Hine's inventive use of text and image during the pre–World War I era has caused Hine scholars to hail him as a pioneer of Progressive photojournalism. Daile Kaplan, for example, has argued that Hine's work in the Progressive Era may be regarded as the prehistory of the golden age of American photojournalism, epitomized in *Life* magazine, first issued on 23 November 1936.[18] Indeed, most of the scholarship concerning Hine has emphasized his work before the 1920s, that is, his reform photography.[19] Most people who are familiar with Hine at all associate him with the NCLC or Ellis Island photographs discussed thus far, but Hine's work can be seen as a forerunner of another influential form of journalism, also epitomized by a Luce publication. What happens if we read Hine's work in the context of the emerging modern business photojournalism, a genre that found a mass circulation with *Fortune* magazine in 1929 but was fully elaborated in the early decades of the twentieth century by scores of lesser-known corporate magazines

designed for internal audiences?[20] For by 1919, when Hine returned from Europe, where he had been photographing for the American Red Cross, he had jettisoned the critical rhetorical tone of his NCLC work in favor of a more utopian portrayal of 1920s labor-management relations. With this shift to representing the dignity of labor in the modern corporation, Hine's work proved of interest to corporate publicity and personnel managers seeking to build employee loyalty through a new genre of instrumental image making.

Corporate Public Relations and the Instrumental Image

Nineteen nineteen, the year Hine returned from Europe to continue his work in the Red Cross's publicity department, was a watershed in American history and politics. Initially, once they had recovered from the surprise of President Woodrow Wilson's declaration of war in 1917, many Progressives saw the U.S. entry into the war as a chance to demonstrate how new social- and applied-science methodologies could be used to direct social policy toward the common good. Despite some gains, such as the passage of the 1921 Sheppard-Towner Act for child and maternal welfare, however, the utopian optimism of the prewar Progressives lost ground to a postwar conservatism marked by a general suspicion of governmental social planning.[21] One million workers had struck against forty-two hundred different employers in 1917; after the war, race riots erupted in dozens of U.S. cities as white Americans reacted violently to shifting demographics in the wake of the Great Migration. The mood of the nation swung to the right as President Wilson dismantled the government agencies designed to coordinate wartime production, while President Harding declared an end to Progressive experimentation with a call for "normalcy."[22]

In the context of an increasingly conservative postwar America the liberal reform rhetoric of Progressive organizations seemed outdated, if not naive. The American Red Cross, Hine's employer during the war until August 1920, was one of several organizations and journals, including the *Survey*, that shifted their message from a critique of social problems to a positive, upbeat report of their accomplishments. Representations of destroyed towns and ravaged landscapes gave way to stories featuring smiling refugees associated with Red Cross activities. In October 1919 the *Red Cross Magazine* introduced a feature designed as a "continued story of accomplishment."[23] The organization had emerged from the war with a more sophisticated understanding of the impor-

tance of publicity in winning public support for social programs. Lewis Hine, a Red Cross staff photographer, was at the center of this ideological shift as a member of the organization's newly organized publicity department. Hine's shift to "interpretive photography," to what he called the "publicity and moral stuff" of his 1920s work portraits, was part of this move from a critical interpretation of social problems to a "positive documentation" of workers' accomplishments.[24]

But while Progressive reformers may have been disappointed in the war's impact on peacetime social planning, business leaders had used the war as an opportunity to build lasting ties between government and the corporate sector. Corporate executives on loan to the government during the war years had provided the leadership and vision for wartime mobilization; after the war the public's suspicion of big business declined, while the government retreated from Progressive Era antitrust investigations. The war effort had also demonstrated the importance of advertising and image making in galvanizing public opinion. Advertising was a legitimate business expense under wartime tax policies, and many companies dramatically increased their advertising budgets rather than pay increased taxes. Importantly, businesses began to realize that not just goods but also policies and ideas could be sold. As Roland Marchand has argued, "Wartime publicity so impressed the rising generation of advertising professionals that in subsequent years their trade journals would claim that institutional advertising had been 'born in World War I.'"[25]

While the prewar years had seen Progressive social reformers criticize big business through the use of muckraking journalism, exhibitions, pamphlets, and posters, after the war businesses began to incorporate the same methodologies to win public support for business concerns. The field of public relations emerged during the first decades of the twentieth century as businesses, especially manufacturing and communications industries at the forefront of both labor activism and welfare capitalism, responded to negative public opinion by hiring public-relations consultants and eventually founding corporate publicity departments. The American Telephone and Telegraph Company (AT&T), for example, was a pioneer in public relations, hiring an independent public-relations consultant, Pendleton Dudley, in 1906. With the intervention of a new generation of publicity experts, most of whom, like Dudley, were former journalists, corporations began to abandon the "public be damned" attitude exemplified in a notorious

New York Times interview with the railroad magnate William H. Vanderbilt in 1882 in which Vanderbilt refused to concede any public right to information concerning corporate activities. In the face of railway accidents and coal strikes and the damaging press coverage that resulted, corporations began to hire publicity consultants who would meet with the press and answer questions in an effort to shape the public's opinion about events and businesses. Closely related to advertising, journalism, and a growing appreciation for public opinion in an age of mass culture, public relations can be understood, in Richard Tedlow's useful definition, as "the controlling of news about an individual or an organization by planned and organized effort through informing and cultivating the press and through encouraging the corporation itself to alter its policies in accord with perceived public desires."[26]

The person historians credit with being the father of modern public relations is Ivy Lee, a man whom Upton Sinclair nicknamed "Poison Ivy" in his book about the press, *The Brass Check* (1919).[27] A former newspaperman, Lee started his career as a director of publicity for the Democratic Party in its effort to defeat Theodore Roosevelt in 1904. By the time of his death in 1933, working independently as well as through a succession of firms, Lee had organized public-relations campaigns for many of the country's largest corporations, including the Pennsylvania Railroad, AT&T, Western Electric, and International Harvester; the anthracite coal industry; a series of power companies; the Rockefeller businesses; Bethlehem Steel; and the Standard Oil Company, among other companies and trade associations. As part of his probusiness corporate public-relations work Lee was influential in founding a number of industry trade organizations, such as the American Petroleum Institute, as a means of deflecting public attention away from the individual "robber barons" of the late nineteenth century and toward industry spokesmen who could appear more disinterested before the public eye. Lee pioneered many of the corporate public-relations vehicles central to rehabilitating big business's public image—press releases, authorized corporate "statements," employee magazines, staged events, direct (and documented) contact between absentee corporate owners and their distant plants and mines, and the sophisticated use of mass-communications technologies, including radio, moving pictures, loudspeakers, and photography—to replace the public perception of the "soul-less corporation" with that of a caring, family-oriented concern.

In the early years of his career Lee's introduction to corporate own-

ers and managers usually took place in the wake of highly publicized labor disputes. Lee's first important clients were the operators of anthracite coal mines, who hired Lee in 1906 to construct a more palatable public image (the United Mine Workers, led by John Mitchell, had won the publicity war of the 1902 strike). Then in April 1914, while Lee was engaged in directing the Pennsylvania Railroad's successful campaign for a rate increase, the Colorado Fuel and Iron Company militia opened fire on the striking United Mine Workers' tent colony, setting the camp on fire and burning two mothers and eleven children to death. The absentee owners John D. Rockefeller and his son, John D. Rockefeller Jr., were pilloried in the press, and after seeking advice from colleagues, they hired Ivy Lee as public-relations counsel for the Rockefeller interests at a thousand dollars a month. On Lee's advise, the sheltered John D. Rockefeller Jr. made an unprecedented two-week tour of the Colorado mines, where he chatted with the miners, shook hands, danced with the wives, and generally presented himself as a sympathetic employer anxious to address his employees' concerns.[28] He planned and published a series of bulletins entitled *The Struggle in Colorado for Industrial Freedom* (the United Mine Workers put out their own bulletin entitled *The Ludlow Massacre*). Lee recommended that the Rockefellers blanket the mines with posters explaining "the work of the company and its relations with the men."[29] Another result of Lee's involvement was the lushly produced twenty-six-page employee magazine the *CF&I Industrial Bulletin*, whose first issue, dated October 1915, included an open letter from John D. Rockefeller Jr. promising and seeking "loyal support and co-operation in the furtherance of our common interests" (fig. 3.5).[30] Rockefeller's visit to Colorado was part of what became known as the "Rockefeller Plan," a package of publicity maneuvers, employee-representation schemes, and welfare-capitalist benefits. The Rockefeller solution to independent union organizing and negative corporate publicity was enormously influential among managers and owners, many of whom adopted aspects of the plan in their own companies.

Ivy Lee, like his contemporaries in applied psychology and journalism, was an early investigator on the question of the "public," or the relationship between the individual and the crowd in mass culture.[31] While working as a consultant to the Pennsylvania Railroad in the prewar years, a contract he retained for most of his career, Lee struggled with the problem of how to convince the American public that the rail-

Fig. 3.5. *CF&I Industrial Bulletin* 1 (Oct. 1915), front cover. The corporate public-relations consultant Ivy Lee suggested that the Rockefellers found an employee magazine in the wake of the 1914 Ludlow Massacre. (Courtesy Baker Old Class Collection, Baker Library, Harvard Business School.)

roads were the "good guys" in the face of more than 1,395 separate state bills designed to regulate railroads in 1913 alone. In arguing for the role of public relations, Lee observed that "people in the mass act upon impulses . . . crowds are led by symbols and phrases." In a speech before the American Railway Guild in 1914, Lee emphasized that "the problem of influencing the people en masse is that of providing leaders who can fertilize the imagination and organize the will of crowds . . . in working out the railroad problem we must take account of these same principles in crowd psychology." The way to do that, he argued, was to "make the public feel."[32]

Lee's work as a public-relations consultant overlapped with Hine's contracts in a few instances, beginning with their overlapping participation in the American Red Cross's World War I relief work and continuing through later corporate public-relations work. Hine's shift from a critical social documentarian to a booster of the corporation's soul, the worker, unfolded while he was employed as a staff photographer for the Red Cross, working after the war in the organization's publicity department. Hine himself recognized his Red Cross work as a transition from early documentary work to the celebratory rhetoric of his later work portraits: as he reminisced in 1938, "In Paris, after the Armistice, I thought I had done my share of *negative* documentation. I wanted to do something *positive*."[33] Hine's shift in emphasis was shared, if not directed, by the director of the American Red Cross's publicity work, Ivy L. Lee.

When President Wilson declared war in April 1917, he recognized the American Red Cross's importance in organizing not only relief but also publicity about the war effort for both a domestic audience critical of Wilson's abandonment of neutrality and an international audience suspicious of American commercial interests. Wilson was the titular head of the American Red Cross, and he created the office of the assistant to the chairman of the War Council to have "special authority . . . over matters relative to publicity." On 10 May 1917 Ivy Lee was appointed to this office, which he pursued to the exclusion of other public-relations work through the remainder of the war.. In June 1917, while Hine was still working for the NCLC, Lee moved to Washington, DC, to direct the Red Cross's publicity. In order to raise a quick $100 million for relief work, Lee wrote "speeches, drafted magazine and newspaper articles, pamphlets, brochures, and leaflets, laid out advertising and posters, and oversaw the entire promotional operation."[34] His success in this effort led to his being named director of publicity for the entire Red Cross.

Red Cross Chairman Henry P. Davidson gave Lee the latitude to make sweeping changes in the Red Cross's publicity efforts. Between July 1917 and August 1918 Lee transformed the organization's publicity work. He brought in a wide array of specialists and professionals, including not only Lewis Hine, who began his work with the Red Cross in June 1918, but also journalists, other photographers, and advertising personnel. Lee created publicity departments in each of the foreign as well as the American divisions of the Red Cross; he reorganized the Mo-

tion Picture Department and set up the Speaker's Bureau using teams of four "minutemen" to travel around the country to deliver illustrated lectures. He streamlined the organization's relationship with the press, fitting stories to each periodical's specific readership; reorganized the organization's journal, the *Red Cross Magazine*, in which Hine's work appeared; and created posters of Red Cross stories for display in banks, churches, and railway stations. After the armistice, Lee served as a consultant to the International Red Cross's Commission to Europe for the remainder of his life.[35]

Lee's work for the Red Cross helped shift the organization's publicity work from a documentation of social problems as a result of the war to a celebration of America's Wilsonian role in promoting peace, harmony, and international cooperation. World War I was the first war in which the public perception of U.S. involvement was actively managed through a public-relations campaign; and along with George Creel's Committee on Public Information, Ivy Lee was responsible for that effort through his work with the Red Cross. Through his travels in Europe after the armistice, Lee identified a whole new arena for public relations: the promotion of American ideals and values to an international audience. He began to recognize that the Red Cross could be more than a relief organization: it could serve as the venue for a public-relations campaign on behalf of America itself.[36]

Hine's photographic work mirrored this shift from the documentation of social problems to a more sanguine visual style. During his time with the Red Cross Hine's depiction of children, especially working children, differed greatly from that in his prewar NCLC work. Hine's photographs of child laborers in Greece and Serbia, for example, show the children smiling happily while carrying water, shining shoes, or herding cattle. Hine's images contradict Homer Folks's text, which provides a critical interpretation of working conditions. As Daile Kaplan argues, "The children not only appear to enjoy being photographed but seem quite content with their work."[37] Hine's shift to an upbeat visual rhetoric made his photographs available for a number of different purposes. In particular, the images helped generate a positive range of emotional responses in an implied viewer whose readings Lee sought to direct toward a noncritical, positive celebration of American ideals and programs. Hine's new style, pioneered during his time with the Red Cross publicity department, found a responsive home with Lee's other client base, the publicity departments of major corporations.

The Corporate Family Album

In August 1920 Hine quit his job as a staff photographer for the Red Cross to devote his energies to a new form of interpretive photography that he called, following Arthur Kellogg's suggestion, "work portraits." Hine maintained his connection with the *Survey*, renamed *Survey Graphic* in 1921, but pursued this new approach as a freelance photographer.[38] Unlike the NCLC work, Hine's 1920s workplace portraiture was designed to help skilled workers, mostly employed by large corporations, feel a sense of accomplishment in their work. He banished conflict in favor of a labor boosterism that, when viewed in context, is indistinguishable from an early articulation of corporate public relations. "As I see it," he told an interviewer in 1926, "the great problem of industry is to go a step beyond merely having the employer and employee 'get along.' The employee must be induced to feel a pride in his work." Hine's language suggests an instrumental goal for his photographic practice; his portraiture would help workers valorize their own role in the industrial economy. Through a form of motivational photography, Hine argued, a "so-called 'human-machine'" (a worker) could be influenced to take a "genuine interest in the finer things of life," usually in evidence outside of the workplace, redirected to the job.[39] Here, Hine argues again for photography's instrumental value: except after the war, Hine no longer focused on the conflict between labor and capital. In the decade of strikes, depression, "normalcy," and company unions immediately following the war Hine emphasized the dignity of labor without calling attention to the corporation's role in structuring the nature and condition of that labor.

Hine published a number of his new work portraits in the *Survey* and then with its successor publication, the *Survey Graphic*. But from 1923 to 1927 Hine also made work portraits for one of Western Electric's employee magazines, the *Western Electric News*. In addition to the thirty-one issues for which he provided Western Electric work portraits during these years, Hine made a smaller number for the *Vacuum Oil News* in 1926 and 1927. These magazines were lush publications: the *Western Electric News*, for example, ranged between twenty-eight and forty-eight pages on coated stock, heavily illustrated with halftones and a four-color image on the cover. By the 1920s Western Electric had a motion-picture division and a number of employee publications, in-

cluding the *Hawthorne Microphone*, a daily newspaper for the suburban Chicago Hawthorne works.

By 1923, when Hine began working for Western Electric, corporate managers, especially in the communications industries, had a highly sophisticated understanding of the ideological power of photographic representation. As David Nye argued in his important work on General Electric and commercial photography, the electrical industries were at the forefront in using publicity, institutional advertising, and photography as a means of sustaining corporate growth through the acquisition of new markets.[40] Western Electric was the major supplier of telephones and switchboards to the American domestic market, and although the company was not legally owned by AT&T, the Bell System held 97 percent of Western Electric's stock. By 1922, as Charles DuBois, an executive in both companies, argued, Western Electric was "in all but legal status, a department of the Bell system."[41] With the explosion of the telephone industry in the early twentieth century, Western Electric's work force ballooned to more than sixty thousand in 1924, with most workers at Western's Hawthorne works.[42] The *Western Electric News*, first launched in 1912 as a "natural medium for the expression of our common interests," was a monthly magazine with a circulation of 76,380 in 1924.[43] The magazine's editor, Philip L. Thompson, was also Western Electric's advertising manager, and the magazine was part of a much larger program of welfare-capitalist initiatives.[44]

The *employee magazine* is a publication designed for an audience internal to the corporation, in contrast to the *house organ*, which is traditionally directed to an external audience, such as distributors or retailers.[45] The earliest employee magazine was a monthly twelve-page journal issued by the National Cash Register Company (NCR) in 1887.[46] As corporations grew in size during and after World War I, emerging personnel-management departments, especially in the larger companies, turned to employee magazines as a means of communicating information efficiently to an ever-growing work force.[47] The employee magazine artificially constructed the lost community mourned in what Roland Marchand has called "the lament" in the postwar years: managers' nostalgic ruminations about the "good old days" when the more intimate scale of business allowed an easy, first-name conviviality between employers and employees.[48] A 1921 study of 334 employee magazines found that 91 percent of them had been founded in the years

1917–20. Although the business depression of 1920–21 caused some magazines to be discontinued, by the end of 1921 the idea of employee magazines had again gained ground among business leaders and managers.[49] By the early 1920s, employee magazines were increasingly viewed as a central managerial tool for building employee loyalty, furthering labor-management "cooperation," and in some instances disrupting unionization efforts. A 1921 editorial concerning the importance of the employee magazine stated that "more and more manufacturers are becoming interested in this vital subject. To carry over a spirit which will make the men in their plant say *our* plant instead of *their* plant, to say *us* instead of *them*, is one of the most important questions facing the big executive today."[50] By 1925 there were more than 539 employee magazines; larger corporations, such as the Pennsylvania Railroad, had as many as six magazines directed toward different internal audiences.

One of the magazines' main functions was selling the corporation to the workers themselves. As John Mills, the director of publication for the Bell Telephone Laboratories, a research unit within the Western Electric Company, argued in 1926, "The employees' house magazine has to 'sell,' just as surely as does any salesman on the road."[51] Early-twentieth-century business leaders sought to replace a public suspicion of big business as the "soulless" corporation with a perception of a more intimate, caring business.[52] The employee magazine was central to this image renovation for an audience internal to the corporate "family," the workers themselves. As Mills explained, not only the general public but also the employees themselves were likely to see the executives as "heartless." He viewed the employee magazine as the "great connecting unit running throughout all the organization . . . it inspires ambition, records advancements and promotions, and at its best, becomes the great binder which moulds the entire organization into one mass, all going in the same direction and for the same purpose."[53] The magazine would "sell" the corporation to its own employees, building employee loyalty in the process.

Increasingly, managers understood employee loyalty as a major product of the employee magazine. The emphasis on loyalty was a response to increased organizing among American workers, as well as managerial fear of working-class "bolshevism" in the wake of the Russian revolution. Sometimes referred to as "good will," *loyalty* represented a constellation of worker emotions that employment managers

sought to identify, produce, and nourish through the plant magazine and other welfare-capitalist initiatives.[54] These positive emotions were newly isolated and identified by employment managers in the post–World War I period, as Taylorist mechanistic metaphors gave way to the recognition of emotion as a key motivator in human behavior.[55] Following the Gilbreths' celebration of worker "happiness minutes," post-war employment managers identified a new range of employee moods and feelings that managers hoped to map and manage, along with hours, wages, and motion. The employee magazine was designed to create and reflect only a positive range of emotions that signaled, from the managerial perspective, an appropriate identification of the mutual interests between employer and employee. Managers and employee-magazine boosters sought to manufacture an "unseen spirit" of "mutual understanding and cooperation."[56] The successful employee magazine, according to Clifford G. Bigelow, author of a multiyear series on the subject in the paper and advertising trade journal *Printed Salesmanship*, would build up a "spirit of friendship and pride" among workers.[57] Or as the editor for the Michigan Bell employee magazine argued in 1928, the goal of the magazine was "the furtherance of group consciousness and *esprit de corps;* for the promotion of pride in and loyalty to the company, and satisfaction with the job."[58] Loyalty, pride, good will, and satisfaction emerge as the goals of a new managerial ideology focusing on human as well as mechanical engineering, and progressive managers saw the employee magazine as a means for achieving them.

In many ways American corporations succeeded in instilling these more cooperative sentiments in their employees during the 1920s, if the decrease in the number of strikes and the reduced labor turnover during the decade can be taken as evidence. In contrast to the volatile prewar years, the 1920s saw very low labor turnover owing to an influx of unskilled labor from rural America, as well as the developing personnel-management movement, which sought to stabilize labor turnover. Industry made relatively few hires, and fewer workers quit. At Metropolitan Life, for example, the median monthly rate of new hires fluctuated between 3.1 and 4.0 percent in 1924–29, a far cry from prewar figures.[59]

Despite income inequality and a relatively low standard of living for American workers in the midst of prosperity, there was little labor protest among the working class in the 1920s. As James R. Green has argued, the collapse of organized labor in the 1920s needs to be un-

derstood in the larger context of mass consumer culture and Fordism, a combination Green identifies as "new capitalism."[60] Several factors emerge as key to the era's labor-management relations. Despite tremendous income disparities, even within the working class, real income increased for all American workers by an estimated 9.1 percent from 1923 to 1928. At the same time, the growth of installment buying made consumer durables such as telephones, automobiles, and household appliances available to working-class families with limited cash resources.[61] Despite its deficiencies, the standard of living of American workers was among the highest in the world, an economic fact evident to many new immigrants and their children.[62] State and corporate repression in the wake of the strike waves of 1919, part of the larger Red Scare of 1919–20, had resulted in the firing, blacklisting, jailing, deportation, or silencing of many American labor radicals, including nearly the entire leadership of the Industrial Workers of the World (IWW).[63] Finally, union membership fell during the decade, from a peak of 5,047,800 in 1920 to 3,622,000 in 1923, with little change until the 1930s.[64] Critics lambasted the American Federation of Labor (AFL), with which most unions were affiliated, for ignoring industrial unionism, cautioning conservatism, and failing to safeguard wartime labor gains. At the same time, the expansion of the scope of business in the wake of the merger movement and the war produced new corporations vehemently opposed to collective bargaining, especially in the steel, automobile, chemical, and other industries, and supported by federal regulations and antilabor court injunctions. By the 1920s most workers had come to accept big business and the managerial structures of large capitalist enterprises.[65] The AFL's focus on craft unionism had become outdated by the 1920s as increasing numbers of unskilled workers remained unorganized in new sectors, such as the electrical-manufacturing and automobile industries. As James R. Green has argued, "Never before had corporate capitalism dominated the workers' world so thoroughly."[66]

Corporate domination of labor-management relations was not easily won, however, and employers used a number of tactics to fight against unionization, including the open-shop campaign and a renewed focus on welfare capitalism. In the early 1920s the Progressive legacy of labor reform combined with post-Taylor scientific management, the emerging field of applied psychology, and general business prosperity to offer a more harmonious interpretation of labor-management relations. Increasing numbers of American businesses, especially the larger

corporations, began to offer workplace reforms in a successful effort to reduce labor turnover, increase productivity, and build employee loyalty. These programs varied widely in scope but included company efforts to enable employees to acquire property and begin savings accounts; factory and workplace beautification programs ranging from landscaping to interior painting; the establishment of employee athletic and social clubs; workplace-safety programs; employee lunch programs and health care, usually through visiting-nurses programs; pension plans; and employee-representation schemes, known within the labor movement as "company unions."[67]

Recent work on the history of welfare capitalism, while acknowledging the open-shop agendas of some employers, has recovered both the gendered dimensions of early welfare work and the lingering Progressive impulses embedded in 1920s workplace reform.[68] The gendered rhetoric of welfare capitalism was a foundational element of the Bell System's employee strategy, in which, as Venus Green argues, the "meticulous choice of the family metaphor in 1915 became a cornerstone for the company's control over [Bell] workers in the years following World War One."[69] Western Electric, the manufacturing division of the Bell System, was a progressive leader in corporate welfare capitalism. In 1906 Western Electric introduced a pension system, and by 1913 a package of welfare benefits had been introduced throughout the Bell System. By 1915 the company had added insurance and benefit plans, opened a hospital and medical department, convinced the Chicago Public Library to locate a branch at the Hawthorne works, and established a Hawthorne Club to plan concerts, classes, dances, and parties. By the early 1920s the Hawthorne works alone had six adjacent baseball fields, thirteen tennis courts, as well as an athletic track. By the mid-1920s AT&T's employee stock-purchasing plan was the largest in the country. The company positioned itself as munificent father to an unorganized work force, who were encouraged to call the works manager "Dad."[70] Corporate paternalism came at the price of independent unions, which managers fought against with every available tool, including corporate communications.[71]

Employee magazines were a central component of postwar welfare-capitalist initiatives in the larger corporations.[72] By the early 1920s, editors had realized that employees would only read the magazine if it seemed to be written from the workers' point of view rather than a mouthpiece for management. As a result, management recruited assis-

tant editors and reporters from among the employees in order to make the magazine appeal to employees. Employee contributions might be anecdotes about working life in the contributor's department or a journal of a vacation trip to the Rocky Mountains.[73] As one critic observed, "The more contributors there are, the better. Every contributor is an earnest reader; his friends and acquaintances and even his enemies are also attentive readers." Some of the companies charged a nominal fee for the magazine in order to keep track of circulation. The Hood Rubber Company, for example, charged one cent per issue for their magazine in the early 1920s and discovered that 85–90 percent of the eight thousand employees bought the paper.[74]

Photography's indexical qualities made it a potent ideological tool, providing a human face to the otherwise soul-less corporation. Editors of employee magazines, who were usually also responsible for institutional advertising, focused on the power of photography in building worker loyalty. In addition to group photographs of corporate welfare activities, such as baseball games and company picnics, most employee magazine photography fell into the two main genres of domestic snapshot and the work portrait.[75] The two genres complemented each other: while the work portrait individualized and idealized a single worker, the domestic snapshot articulated an ideology of corporate paternalism that safely knit the heroic worker into a hierarchical family system managed by corporate "dads."

The editors of employee magazines actively solicited photographs of workers and their families at home or on vacation. These were usually snapshots of the "modern family at play," a standardized form of visual representation that Eastman Kodak had heavily—and successfully—marketed since the late 1880s.[76] Images could be read by non-English readers, who might follow the text through the images, asking a neighbor or family member to translate. Editors recognized that most readers were self-interested and would be more likely to read a publication in which they might find themselves or their coworkers featured photographically. The editors of *The Next Step*, the employee magazine for N. W. Ayer and Son, for example, solicited "informal, vacation snapshots" from its employees and were rewarded with snapshots of "Hig's" thirty-four-pound channel bass, landed at Corset's Inlet, New Jersey; Mrs. Hardy and her husband at the beach; Ricker at Atlantic City; and Mr. and Mrs. Harold Taylor sitting in their bathing suits in front of a rural cottage.[77]

The vacation snapshot embedded within the company magazine challenged the distinctions between private life and work life, implicitly opening the employees' nonwork time to managerial scrutiny. Workers' personal lives had long been the subject of company observation, from the days of craft apprenticeships to the those of the early-twentieth-century "welfare manager." Although such corporate interference was on the wane in the 1920s, the vacation photograph helped build an ideology of labor-management harmony by drawing on the relaxed "togetherness" that marked the ideal vacation. Clifford G. Bigelow, a trade reporter, singled out the *Northwestern Bell* as a top magazine in part because of its use of employee photographs. "One of the most interesting features," he wrote, "lies in the informal, personal Kodak pictures, shown with the heading 'Snapped Along the Trail.' These are the pictures sent in by the correspondents. Undoubtedly these pictures furnish the real lure to the readers, for all of us enjoy seeing our pictures in print."[78] By publishing the vacation snapshot in the employee magazine, the company sought to erode the distinction between family time and company time while positioning itself as the proud parent and benefactor of employee-children. *Northwestern Bell's* images of vacationing employees are published alongside images documenting company welfare initiatives, such as a Bell health course. Personal and company time are yoked together under the headline "Snapped Along the Trail," a title that draws on Western frontier narratives to link public and private into a metaphor for industrial progress. The representation of workers' private lives in the pages of the company-run magazine sought to construct an easygoing conviviality that rendered any workplace conflict over hours, wages, or benefits unseemly, a violation of the assumed trust between employees and managers, as well as of the middle-class norms implicit in the family metaphor.

In addition to vacation photographs, the editors of employee magazines published photographs of employees' families to illustrate the managerial rhetoric about the corporate "family." As Nikki Mandell has argued, even though male personnel managers had banished an earlier generation of corporate welfare "mothers" from welfare-capitalist initiatives by the 1920s, an earlier rhetoric of the corporation as family continued to structure managerial narratives about labor-management relations.[79] With a rhetoric of idealized family harmony editors could banish the possibility of actual conflict—over wages or hours, for example—from the magazines' pages. Instead, the magazines focused on

the employees' personal life at home and on the job. The snapshots address a managerial lament for a lost village community by constructing intimacy and familiarity by including the family snapshot in the employee magazine.

The family snapshots in employee magazines express both family kinship and labor-management harmony. The family photograph, usually placed within the narrative frame of the family album, is overdetermined by the heterosexual, reproductive normativity that marks the modern bourgeois family. As the sociologist Pierre Bourdieu has argued, "More than two-thirds of photographers are seasonal conformists who take photographs either at family festivals or social gatherings, or during the summer holidays."[80] In such images conflict is banished; the snapshot returns from the processing lab a triumphant testimonial, declaring cohesion, unity, and harmony. The snapshot of the family get-together functions as the handmaiden to the family as entity; the image simultaneously represents and reproduces the family as social fact. The photographs attest to the flesh and blood of discrete individuals, but the conventions of domestic photography and the ideologies of sexuality and kinship overdetermine the image and insist that the reader organize the represented individuals into a social grouping of cultural significance: the modern nuclear family. As Simon Watney has argued, the "conventions of domestic 'family' photography are experienced as second nature, which precisely marks them as densely ideological."[81]

Part of the family snapshot's ideological power stems from its placement in the family album, often centered on the child. Such albums often begin with the first baby picture and move chronologically through the child's life, with new siblings included as the album unfolds. The child is central to the definition of family in this hegemonic visual narrative, for without the child the hierarchical organization of parent and child that is key to the ideology of family dissolves into the less stable configuration of romantic couple. Editors of employee magazines hijacked these ideologies of kinship, hierarchy, and togetherness by featuring employee family snapshots in the pages of the magazine, which was thus restructured as a type of corporate family album (fig. 3.6). As a *Printers' Ink* author noted, "It means absolutely nothing to an art critic to see a picture of the Jones' baby boy, but to the members of Tom's department it does mean something, for haven't these people heard for months all about Junior's wonderful ability to do that which no baby has ever done before?"[82] Though the captions identify each baby's

FIG. 3.6. Baby pictures from the employee magazine of the Whitin Machinery Works in Whitinsville, Massachusetts. The employee magazine's reliance on employee baby pictures reinforced the company's paternalist rhetoric. (*Whitin Spindle* 3 [May 1922]: 3. Courtesy Baker Old Class Collection, Baker Library, Harvard Business School.)

parent as a company employee, the narrative conventions of both the baby portrait and the family album overdetermine the image, shaping its meaning in the context of the employee magazine. The magazine tilts ideologically toward the family album, where the baby pictures metonymically function as stand-ins for their employee parents, who are thus infantilized in a corporate family structure. Private images are powerfully reorganized to convey new public, instrumental meanings.[83]

Some workers recognized the managerial agenda behind the inclu-

sion of employee snapshots in the company magazine. Robert Dunn reported that a striker on the Interborough Rapid Transit lines in New York City had told him that in 1926 the editor of the *Interborough Bulletin* had been "pestering him for months to get his children's pictures." The striker was one of the few that refused "to help the company in his plans to use family photograph albums as a veil to hide the tyrannies of the company union 'Brotherhood' and the 'yellow dog' contract." All the company periodicals agreed, concluded Dunn's informer, that it was a "good plan to use photographs and plenty of names."[84]

The other major photographic genre within the employee magazine was the work portrait. Managers actively worked to create a visual culture of dignified labor as a means of increasing job satisfaction and discouraging unionization, and Hine's work was useful toward these ends. Hine's heroic portraits of American workers dovetailed seamlessly with a managerial discourse that valorized individual labor at the expense of union organizing. Five hundred corporations founded company unions in the period from 1919 to 1924, and the employee magazine played an important role in promoting "industrial democracy" at the expense of a closed shop. Individual unions may have protested—for example, System Federation No. 90, affiliated with the Railway Employees' Department of the AFL, protested against the 1922 founding of the *Pennsylvania News*, an employee magazine directed at railroad workers[85]—but in the context of a plummeting union membership, which dropped from 5 million to 3 million during the decade, employee magazines continued to proliferate, with photography playing a primary role in naturalizing the decade's conservative labor policies.

Hine's work portraits are formulaic in their style, approach, and lighting. Made with Hine's 5 × 7 inch Graflex camera, the photographs have the crisp detail reminiscent of his earlier work. Also in continuity with Hine's portraits of children and immigrants, the subjects are often posed in the middle distance, with aspects of their environment included in the frame. Yet the tone of these 1920s work portraits differs dramatically from that of Hine's prewar photographs. The workers are presented as engaged pensively in their tasks, their hands engaged with their machines or tools, the bodies gracefully attuned to both the task and the machine. Unlike in Hine's earlier work, the subjects do not usually engage the camera lens; instead, their eyes are fixed on the task at hand, though their bodies signal an awareness of the lens. Hine again keeps a respectful distance, yet his practice of photographing the

Fig. 3.7. Lewis W. Hine, work portrait of H. Prosser. (*Western Electric News* 13, no. 1 [Mar. 1924]: 28. Courtesy Baker Old Class Collection, Baker Library, Harvard Business School.)

subjects obliquely or in profile while they are occupied with their work gives the images a static, if not sculpted, quality. The subjects' focus on their work signals a corporeal rebuttal to the reformist's critique of the relationship between labor and capital (fig. 3.7). No element of the image is blurred; the floodlighting washes over the individuated subjects, frozen epitomes of unalienated labor. Even though the workers are again represented with the machine, unlike in the photograph of the Carolina mill girl (see fig. 3.2), the brutish machine submits to the superior skill of the worker (fig. 3.8).[86]

FIG. 3.8. Lewis W. Hine, work portrait, 1921. In his later work portraits Hine's subjects demonstrate skill and control in relationship to the machine. ("Power-makers; Work Portraits by Lewis W. Hine: Photographs Taken in the Power Plants of the Pennsylvania System," *Survey* 47 [31 Dec. 1921]: 511.)

Hine's heroicized workers were the most sophisticated photograph-ic examples of a broader visual culture of capitalist realism in 1920s business journalism.[87] In drawings, paintings, prints, and photographs brawny workers with rolled-up sleeves and intelligent faces began to populate corporate publications (fig. 3.9). A. L. Townsend, in a 1920

FIG. 3.9. Lewis W. Hine, work portrait of Frank Vrastil, 1924. Hine's tele-
phone work portraits link their subjects to a longer craft tradition in which
independent artisans controlled their own work. ("Makers of the Nation's
Telephones," *Western Electric News* 13, no. 2 [Apr. 1924]: 2. Courtesy Baker
Old Class Collection, Baker Library, Harvard Business School.)

article detailing the managerial trend of using painting and illustra-
tion to heroicize the worker, described managerial goals as follows: "It
is believed that featuring the worker himself will stabilize him, make
him more contented on his job, give him the feeling that he is not
deep-hidden, far from the eyes of the ultimate consumer."[88] The visual

rhetoric refers to an earlier century's occupational portraiture celebrat-
ing the role of the skilled craftsman in maintaining a virtuous repub-
lic. Occupational portraits, often commissioned or made by artisans,
signified their belief in the relationship between productive labor and
republican ideals.[89] The portraits declare the relationship between skill,
whiteness, masculinity, and citizenship in what became formulaic terms
by the antebellum period: the artisan was usually depicted either at his
craft or displaying the product of his labor; rolled-up sleeves and a work
apron signaled his artisan status; and the subject's skilled hands held
either the tools of his trade or the skillfully wrought result.[90] Although
the best-known example of this genre is the painter John Singelton
Copley's portrait of Paul Revere (c. 1768–70), as Harry R. Rubenstein
has argued, the conventions of occupational portraiture, developed in
other media, carried over into photography after 1839. With the de-
cline of republican rhetoric and the triumph of wage labor in the late
nineteenth century, however, occupational portraits of workers of all
types declined dramatically until the genre was strategically revived in
the pages of the employee magazine.

Central to the visual rhetoric of artisanal republicanism is an em-
phasis on skilled craftsmanship and independent labor. The skilled
craftsmanship of Hine's industrial subjects is signaled both by the types
of employees represented and by the editor's captions. For example,
Hine's Western Electric portraits appeared as either full-page images
on page 2 or in a series grouped under a larger title, usually "Makers
of the Nation's Telephones." Despite the large numbers of production
workers at the Western Electric plants, most of Hine's portraits, or at
least the ones that Western Electric printed, showcase skilled work-
ers, the minority of employees whose work actually continued to fall
within an older craft tradition. For example, Frank Vrastil, of the Haw-
thorne works, was featured in 1924 as a cabinetmaker (see fig. 3.9).
The application of that craft tradition to the mechanized production
of 1920s telephone industry was left unexplored; instead Hine's staged
portrait shows the rolled-up sleeves, work apron, and hand plane of a
skilled craftsman.[91] The visual rhetoric of independent craftsmanship
is anchored by the portrait's caption, which explicitly links Vrastil to
a longer craft tradition: "Cabinetmaking is among the fine arts. What
names we can conjure up in that profession—Duncan Phyfe, Thomas
Sheraton, the Adam Brothers! The skill that comes of long experience

and study is apparent in the work of Frank Vrastil of Hawthorne, who now has some nineteen years to his credit."[92]

The independence of the artisanal republican is also signaled by Hine's consistent choice to make individual rather than group portraits of Western Electric workers. Hine's individualizing portraits contrast markedly with the group photographs of athletic teams, conventions, and company activities that also illustrate employee magazines.[93] The cabinetmaker Vrastil, for example, was one of nearly twenty-two thousand employees at the Hawthorne works in 1924, but the intimacy of Hine's portrait leaves the routinized claustrophobia of mass production outside the frame. Even Hine's portraits of women workers, which are more numerous than one might expect given the masculinist rhetoric of the occupational portrait genre, follow a similar individualizing logic. Mae Birkholtz, whom Hine photographed working on an automatic winding machine in 1925, fills most of the frame (fig. 3.10); the receding line of machinery and a few dim figures only hint at the massive scale of Hawthorne's production, which is suggested by a 1925 photograph of Hawthorne's Relay Assembly Department (fig. 3.11).

From Progressive Reform to Corporate Liberalism

Hine's work with Western Electric began in March 1923, when he spent a week at Western Electric's Hawthorne works, outside of Chicago.[94] By this point, under the direction of Henry F. Albright, an engineer and Hawthorne supervisor from 1908 to 1923, Western Electric's production had been fully rationalized. Whereas previously each product department had had its own machines and work force, under Albright's management each worker was, as Richard Gillespie has written, "confined to working in a department of drill presses, or lathes, or punch presses, assigned to a task that had been designed, timed, and priced according to precise measurements by a force of engineers and managers."[95] By 1922 the complexity of standardizing the piece rates for the thousands of parts necessary to make Western Electric's machine-switching equipment and automatic telephone exchanges led to the creation of the Time Standards Department, which by 1929 employed sixty workers who used both the stopwatch and the motion-picture camera to time workers' movements. Hawthorne established an Employment Department as early as 1896, and by 1913 a superintendent of employment and welfare directed the type of rationalized personnel

FIG. 3.10. Lewis W. Hine, work portrait of Mae Birkholtz, 1925. ("Makers of the Nation's Telephones," *Western Electric News* 14, no. 1 [Mar. 1925]: 2. Courtesy Baker Old Class Collection, Baker Library, Harvard Business School.)

management that would soon render Katherine Blackford's character-analysis methodologies obsolete.

Western Electric was at the forefront of progressive managerial policy in the early 1920s. The shift from Taylor's hard-driving approach to an emphasis on the "human element" in managing the large industrial work force was exemplified at Western Electric, where personnel managers were installed in each major department and, in 1922, reported

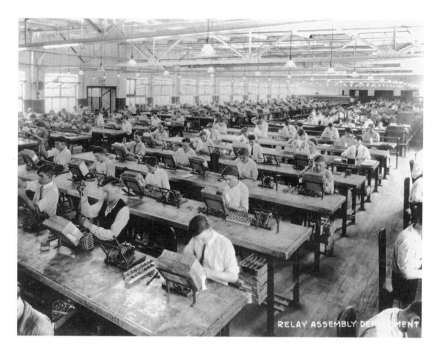

RELAY ASSEMBLY DEPARTMENT

FIG. 3.11. Lewis W. Hine, Relay Assembly Department at Western Electric's suburban Chicago Hawthorne works, 1925. (Property of AT&T Archives. Reprinted with permission of AT&T.)

to a General Personnel Committee at the head office in New York. By 1923 personnel management had become a cornerstone of Western Electric's corporate political philosophy.[96] Engineering the subjective, a key element of personnel management, became essential in a rationalized work environment where workers' control had been eradicated and production had been transformed into a series of repetitive tasks. Increased productivity also remained paramount, and the personnel-management movement gradually developed an appreciation for the importance of scientific research, especially in the social and behavioral sciences, in merging a longstanding interest in rationalizing industrial production with a newer, post-Taylor sensitivity to the "human element."

Hine's motivational portraiture of Hawthorne and other Western Electric workers, published in *Western Electric News* from 1923 through 1929, overlapped with the most famous set of social-science investigations in the history of American industry, the Hawthorne experi-

ments. The experiments began at Western Electric's suburban Chicago Hawthorne plant in November 1924 as an effort to study the effects of industrial lighting on the productive efficiency of six women relay assemblers. The lighting tests were completed in the spring of 1927, but by this point Western Electric had decided to embark on a new set of experiments to test the effect of rest periods and varied work schedules on the efficiency of relay-assembly workers. Elton Mayo and Clair Turner, of the Harvard Business School, and later Fritz Roethlisberger were invited to interpret and direct research in 1928, making Western Electric the first industrial site for sustained social-science research in the United States. In the years 1929–33 Hawthorne researchers produced three books and thirty-three articles describing the experiments and their implications for social science in industry. By the time the experiments concluded in 1933, they had been funded by the National Research Council, Western Electric, AT&T, and the Rockefeller philanthropies and represented a scientifically grounded American complement to the European investigations into the science of work.

Elton Mayo, a professor of industrial research at the Harvard Business School who joined the research in 1928, was a technocratic utopian, an advocate of the role of the professional managerial class in solving the problems of modern industrial society. "Civilization," he wrote his wife, "was progressive rationalization or nothing."[97] Mayo saw labor actions not as rational acts designed to gain benefits for workers but as symptoms of underlying reveries. Like his predecessor in the field of industrial psychiatry, E. E. Southard, Mayo understood industrial conflict as fundamentally rooted in personal maladjustment. The experience of repetitive motions, for example, was framed by the worker's subjective perception of these motions as monotonous; the solution was not to change the repetitive motions but to change the worker's perception of those motions.

The Hawthorne experiments became famous not for what they demonstrated, however, but for what they failed to demonstrate. The six young women relay assemblers had become "stars" of the experiments: they had regular access to the managerial offices in the Hawthorne tower; they escaped the loud anonymity of their one-hundred-person department; their wages were tied to their own productivity. In addition, they began to enjoy their work a bit: they talked and laughed while at their work stations and soon began to socialize even outside

of work, having slumber parties and attending the theater together.[98] Researchers, meanwhile, noted that the productivity of the six women relay assemblers increased as managers introduced more favorable working conditions, expressed in lighting, rest periods, varied shift hours, or other variables. Crucially, however, the women's productivity continued to rise in the twelfth test period, when managers removed all the special working conditions. It seemed that the social and working bonds that had developed among the six workers, combined with the heightened managerial attention they received, affected them more significantly than did changes in workplace lighting, rest periods, or other material changes. The workers' attitude toward their work, their motivation and moral, was more important than the changes in workplace conditions. The results of the Hawthorne experiments supported the direction that corporate managers had been moving since the war years, toward an engineering of the subjective on behalf of managerial goals. At the same time, the Hawthorne experiments confirmed what Hine himself had argued for some time: that workers played a central, unheralded role in industrial production and their contributions needed to be recognized, by the workers themselves as well as by management. After 1930 the new discipline of industrial sociology focused managerial attention on the manipulation of workers' group identities as a means of disrupting soldiering, increasing productivity, and manufacturing that elusive subjective state, job satisfaction. Hine's motivational portraiture, instrumental in building employee good will at Western Electric in the 1920s, proved a logical choice for Robert Hoppock's 1935 survey of economic life during the Depression, *Job Satisfaction* (fig. 3.12).

Hine's postwar work portraits sought to illustrate to the public, as well as to the workers themselves, the importance of workers' contributions to American industrial productivity. Although Hine's work for major corporations might seem an abandonment of his progressivism, in fact his postwar collaborations very much represent a continuation of his prewar reform politics. Although his emphasis may have changed from a critical to a more celebratory rhetoric, his politics continued to be marked by a liberal, rather than a radical, impulse. Like the corporate progressives who were steering big business to a safe channel between socialists and industrial unionists on the left and conservative, antilabor businessmen on the right (perhaps best represented by those organized in the National Association of Manufacturers), Hine sought

FIG. 3.12. Lewis W. Hine, portrait of "Smitty," an employed gas-station attendant. (Robert Hoppock, *Job Satisfaction* [New York: Harper and Brothers, 1935], 83).

to smooth industry's raw edges, to regulate capitalism, but not to overthrow it altogether. The question, for an understanding of Hine's work, however, is what Progressivism looked like after the war and what ends this Progressive legacy served in the greatly changed political climate of 1920s, probusiness America.

From the perspective of business history, the companies for whom Hine worked in the 1920s had in fact been at the forefront of Progressivism before the war, and after the war they helped steer governmen-

tal and business policy toward the new rapprochement between big business and the state that we now understand as corporate liberalism. For these "progressive" companies, to paraphrase Elton Mayo, rationalization *was* Progressivism. Western Electric and the Pennsylvania Railroad, for example, were among the earliest to adopt rationalizing production, corporate training programs, new managerial structures, and the hiring of university-trained experts. They pioneered modern forms of employee representation schemes, welfare-capitalist benefits, personnel-management departments, and collaboration between business, the academy, and the state in the furtherance of increased efficiency. These innovations, antiunion and proprofit to be sure, were nonetheless Progressive reforms within a rapidly changing business climate in the 1920s. Hine's Progressive employers, in other words, were key to the elaboration of a new relationship between the state, the corporation, and labor in the 1920s, a relationship that came to be known as corporate liberalism.[99]

Corporate liberalism stressed cooperation and responsibility rather than blatant competition and conspicuous profit taking as a means of maintaining hegemony in the explosive context of early-twentieth-century labor relations. Whereas liberalism in the eighteenth and early nineteenth centuries had represented a political philosophy of individual rights and unregulated markets, by the Progressive Era, liberals understood that the corporation was a fact of modern life. Progressive reformers, especially those outside of corporate environments, such as Hine and the Kelloggs, advocated state intervention to supervise corporate activity rather than the removal of state control over private enterprise. At the same time, Progressive business leaders had come to the conclusion that unless corporations became more "responsible" to labor and to the public, the very stability of capitalism as a system would remain under threat from a growing Socialist Party and from labor radicals, such as the IWW. They therefore sought to direct and manage the reform from within the corporation rather than have changes dictated by federal legislation or trade-union demands.

The new corporate liberalism was epitomized in the Progressive Era by the National Civic Federation (NCF) and, during and after the war, by the close relationship between business leaders and the Wilson administration.[100] The NCF was founded in 1900 as a big-business-dominated organization of progressive business leaders, organized labor leaders (including Samuel Gompers, of the AFL), and the "public"

(usually more businessmen). The NCF emphasized mediation and co-operation and sought to broker solutions to labor-management conflict independently of federal regulation. In antiunion contexts the NCF encouraged the development of corporate welfare initiatives and even state-legislated minimum-wage laws as an alternative to trade union-ism. It sought to anticipate the more radical class-based demands by sponsoring reforms that represented a compromise between labor and capital. Importantly, the NCF also functioned as the main educator about progressive business "best practices" to the business commu-nity. The war proved decisive in moving progressive business concerns squarely into the center of liberal politics. Wilson successfully dem-onstrated, especially through the War Industries Board, that a Demo-cratic administration could be sensitive to business concerns without being antilabor.

By the 1920s, then, it was certainly possible to be interested in the dignity of labor and an enlightened relationship between labor and management, as well as a corporate booster, and still be a Progressive, in the rather slippery yet historically specific sense of the term. In the context of this shift from middle-class progressive reform politics to middle-class corporate liberalism, it is a mistake to understand the re-formist work of, for example, Hine's NCLC work as necessarily anti-capitalist or even anti–big business. Progressive reformers' efforts to pass government regulations to monitor corporate excess represented precisely the type of state-business "cooperation" that progressive lead-ers began to craft after the war. Hine's reformist rhetoric both before and after the war was decidedly progressive; however, after the war the category "liberal" had swollen to include not only some of the prewar socialists but also a class of big business leaders who had once eschewed the "enlightened" labor-management policies that after the war came to define corporate liberalism. While Hine's reformist dedication to showcasing the worker in industrial capitalism may have remained rela-tively unchanged between 1904, when he made his first work portrait, and 1927, when he was replaced at Western Electric by the commercial photographer Morris Rosenfeld, the relationship between business, the state, and Progressive reform had changed greatly. Middle-class Pro-gressive reformers were now part of the corporate state.

RATIONALIZING
CONSUMPTION

Photography and
Commercial Illustration

Although the main audience for Hine's work in employee magazines was corporate managers and workers, by the mid-1920s his corporate photography had won him a broader commercial audience. In 1924 the jury for the Art Directors Club's annual exhibition of advertising art awarded Hine the medal for photographs in recognition for his work portrait of a Pennsylvania Railroad engineer that the railroad, directed by public-relations consultant Ivy Lee, had chosen for its dining-car menu insert.[1] As Hine wrote Paul Kellogg in 1924, the exhibition featured an additional five work portraits, some of which Kellogg had used in the *Survey* "before they got into advertising."[2] One of the work portraits was the 1904 portrait of the Ethical Culture School's printing instructor, which Hine referred to as his first "bull's eye" with a camera and which he submitted for an advertising award exactly twenty years later. Hine's work was represented again in 1925, when his work portrait of a man welding with an acetylene torch was submitted by the well-known advertising firm Barton, Durstine and Osborn on behalf of their client Prest-o-lite.[3]

By 1923 Hine's corporate photography was lauded in the commercial-art community as exemplary in the field of institutional advertising. Hine's work in corporate photography was exhibited alongside another rapidly evolving genre of photographic production, the advertising photograph designed for the consumer rather than for the production worker. By the second decade of the century the rationalization of the American economy threatened to founder not on the shoals of produc-

tion or distribution, where mechanization and national transportation systems had successfully vanquished challenges to middle-class material abundance, but upon consumption. Advertising matured as a profession in response to a new problem for American business: how to stimulate demand among consumers for the machined cornucopia of standardized products filling the shelves of American retail establishments. Whereas earlier advocates of American productive efficiency, such as the Gilbreths, had championed the use of photography in rationalizing the working body in production, by the 1920s the influence of applied psychology had reoriented managers toward an appreciation of the mind as the critical element of rationalized consumption. Greater sales in an increasingly competitive and national marketplace required persuading reticent consumers that individual difference and personal meaning could be theirs despite a regularized landscape of standardized goods. Corporations increasingly hired advertising agencies and their creative staffs to, in Jackson Lears's phrase, "surround mass-produced goods with an aura of uniqueness" designed to stimulate consumption through the promise of individuality.[4]

As the profile of the implied consumer shifted from that of "rational man" to "irrational woman" in the years 1908–15, photography's realist tendencies became a problem for a new school of advertisers seeking to harness the subjective for the benefit of corporate sales. By World War I, however, an art-school-trained illustrator, Lejaren à Hiller, successfully introduced fine-art principles into his commercial photographs, creating for the first time a national market for photograph-based advertising illustrations. Hiller, whose work was exhibited alongside Hine's corporate work portraits in the Art Directors Club's annual exhibitions in the 1920s, had an impact on the emerging profession of photograph-based advertising illustration that cannot be overstated. His complex photographs, created for national brand manufacturers from the middle of the second decade of the century through the 1950s, mixed a constructed studio realism with theatrical idealism to create a powerful landscape of commodity longing.

Rationalizing Consumption: The Emergence of Modern Advertising

Although the first advertising agency was founded in 1843, mid-nineteenth-century advertisers worked as media wholesalers, selling newspaper space to manufacturers at an inflated price, rather than writing

and illustrating copy on behalf of manufacturers. The 1870s brought various reforms to the Barnumesque industry, including the publication of reliable newspaper-circulation figures and the important innovation of N. W. Ayer and Son, which Francis Wayland Ayer began in 1869 with a new premise. Ayer's "open contract" set a fixed commission as payment for the advertiser's work, a percentage paid by the manufacturer; with this innovation, advertising agencies began working on behalf of manufacturers rather than the press.[5] Ads were, for the most part, heavy with text provided by the product's maker; as late as 1892 no agency had a regular employee dedicated to writing copy full time. After 1902, when the advertising pioneer Ernest Elmo Calkins and his partner Ralph Holden started their influential agency, leading agencies had creative staffs dedicated to writing copy, specifying type and layout, and soliciting increasingly sophisticated artwork.[6] Most new products, such as the Kodak camera or Uneeda biscuits, were introduced to the public through national advertising campaigns produced and directed by independent advertising agencies.[7]

The growth of national advertising in the 1890s dovetailed with the growth of magazine circulation, which increasingly relied upon advertising revenues to cut newsstand prices. The ten-cent magazine revolution came about as printing technologies, such as the rotary press, increased production capacity and as innovative publishers recognized new markets underserved by genteel standards such as *Century*, *Harper's*, or *Scribner's*.[8] A new group of enterprising publishers, such as Frank Munsey, S. S. McClure, Cyrus H. K. Curtis, and George Horace Lorimer, recognizing the growing audience for low-cost magazines, slashed the prices of the journals from the standard twenty-five cents to ten cents per copy. Circulation soared: the circulation of John Brisben Walker's *Cosmopolitan* jumped from sixteen thousand to four hundred thousand in just five years, while by 1893, despite the Panic, the *Ladies' Home Journal* readership stood at seven hundred thousand.[9] By World War I several magazines, including the *Ladies' Home Journal*, *Cosmopolitan*, and the *Saturday Evening Post*, each boasted circulations greater than 1 million.[10] As publishers turned to advertising for increased revenue, both the amount of overall advertising and the placement of the ads within the magazines shifted. As early as 1897, in Frank Presbrey's estimation, *Cosmopolitan* ran as many as 103 pages of advertising in a single issue.[11] Formerly bunched together in the back of the magazine, ads, growing in visual sophistication, migrated to the front as well. By

early in the second decade of the century, increasing numbers of ads were quarter-, half-, or full-page size, placed throughout the text; stories began with two or three pages of text and illustration in the front part of the journal before continuing in the back third, where fiction competed with advertisements for the reader's attention.[12]

The maturation of modern advertising and the growth of ten-cent magazines coincided with increased attention to both readership and consumers. Much of the fiction that dominated magazines such as the *Ladies' Home Journal* and *Cosmopolitan* spoke to an implied female reader. Even the *Saturday Evening Post*, which Cyrus Curtis had bought and reinvented as a "man's magazine" in 1897, attracted enough of a female readership to eventually become a symbol of middle-brow American taste.[13] While business and trade journals, such as *System* and *Printers' Ink*, spoke to a primarily male readership, both the fiction and the nonfiction material of the ten-cent magazines acknowledged a mixed readership of both men and women, often directed to different audiences within the same magazine. As advertising matured as a profession, executives also began to recognize the advertising audience as female.[14] In 1920 the home economist and advertising adviser Christine Frederick attached percentage figures to a general portrait with which advertisers had been familiar for some time: "Women buy 48 per cent of all drugs, 96 per cent of all dry goods, 87 percent of raw and market foods, 48.5 per cent of hardware and house furnishings."[15] As the purchasers of most products, women were the advertisers' target audience. As the twenties unfolded, new audiences came into view, such as the massive working-class female readership of Bernarr Macfadden's *True Story* magazine. But as Roland Marchand has convincingly argued, admen tended to collapse class distinctions into a composite portrait: the typical consumer was not only a woman but a lazy, emotional, and stupid one at that.[16]

Advertising Illustration and the Problem of Photographic Realism

The ten-cent magazine revolution also ushered in a new technology that was destined to redefine magazine illustration. The halftone screen process, gradually perfected in the years 1881–93, enabled printers to reproduce photographic images with a full range of tonal gradients upon a sheet of paper also receiving typeset copy.[17] The new process allowed magazines to consider using photographs as illustrations for both

advertising and fiction, as well as for cover art. *Munsey's*, the first magazine to sell for ten cents at the newsstand, in 1893, featured halftones as a means of reducing engraving costs as well as building a mass-market audience enthralled with the new photo essays of the rich and famous.[18] By 1900 the halftone process was "firmly established as a major reproductive method for publishers of mass illustrated materials."[19] Despite *Munsey's* success and the financial incentive to shift to halftones, however, it was some time before most national advertisers were willing to abandon their pen-and-brush artists in favor of commercial photography.

The problem, from the perspective of advertisers soliciting artwork before 1920, was simply that most commercial photography failed to meet the complex requirements of first-class advertising illustration. This is not to say, however, that commercial photographers were unaware of the growth of visual imagery in print advertising; many professionals, especially those who had made their living as commercial portrait photographers, eagerly solicited new business from manufacturers and merchants (fig. 4.1).

Throughout the 1890–1910 period, photography invaded the small ads found in the back of popular magazines. In 1892, according to the contemporary observer Walter Scot, "photography is seen to have expanded over more than one-half of the advertising space, crowding out stipple work entirely and throwing carefully executed woodcuts into the shade."[20] Advertisements for canned food, cameras, corsets, and carriages increasingly used photography to show a product's selling points in realist detail. Products were displayed with the crisp insistence of edge-to-edge focus; advertisers assumed that photography's ability to reproduce the detail formerly lost in, for example, wood engravings or pen-and-ink drawings would sell the customer on the product's fine workmanship. Eventually, stiff product still lifes were infused with "human interest": babies and pretty female faces accessorized machine tools and breakfast foods, and inventors' faces, in halftone, smiled warmly over busy factories (fig. 4.2). Yet as figure 4.2 suggests, despite the inclusion of an alluring young woman, the formal aspects of this type of advertising photography stayed safely within the confines of what generations of photographic critics had understood as photography's privileged relationship to the real, defined as the facticity of the material world. These portrait-based photographs, with their faithful if not tedious recording of each and every tooth (both human and metallic), told "everything about the facts of nature and left out the mystery."[21]

PHOTOGRAPHS for advertising purposes is our specialty.
We supply the highest type of photographic work in
mailing cards, monthly calendars, hangers, catalogues, box
covers, etc. Suppose you write for samples and prices.

The Photograph Company of America
Suite 830, Chicago Opera House Block
CHICAGO, ILL.

FIG. 4.1. Photograph-based advertisements such as this one gained in popular-
ity among advertisers in the 1890s. (The Photograph Company of America,
advertising postcard, c. 1901–7, Andreas Brown Collection, box 1, Advertising.
Courtesy Research Library, The Getty Research Institute, Los Angeles CA.)

So long as advertising photography worked within a model of rational
rather than emotional appeal, this lack of mystery (referred to else-
where as "art") was unproblematic; sharply focused, barely composed,
and blandly presented photographic records were considered superior
instruments of visual persuasion for many products.

McCAFFREY
FILE CO.
PHILADELPHIA.

Copyright 1909
McCaffrey File Co.
Philadelphia

"Good Teeth and
Good Character"

FIG. 4.2. Early commercial photographers relied on photography's capacity for detail, as well as the "human element" of the female figure, to sell products. (McCaffrey File Company, Philadelphia, advertising postcard, 1909, Andreas Brown Collection, box 1, Advertising. Courtesy Research Library, The Getty Research Institute, Los Angeles, CA.)

Early mass-circulation advertising photography corresponded with advertisers' belief that consumers made purchases based on rationality. The period before roughly 1908 was the era of advertising as "salesmanship in print": the advertisement was a stand-in for the missing salesman, whose selling pitch had been based upon the reason why the consumer should purchase one product and not others. A good ad was a

logical, persuasive argument concerning the product's superior merits; as one adman argued, "True 'Reason-Why' Copy is Logic, plus persuasion, plus conviction, all woven into a certain simplicity of thought—pre-digested for the average mind, so that it is easier to *understand* than to *misunderstand* it."[22]

Photography was an ideal medium for selling to an assumed "rational man." The faithful reproduction of detail offered by halftone technology provided the visual analogue for reason-why copy. The photograph is unique among representations in that the image relies on a photochemical event in which a light-sensitive material records patterns of light particles structured by matter. The early advertising photograph's indexical relationship to the product's material reality convincingly overwhelmed the image, saturating it with what Roland Barthes has called the "denotative message."[23] A plenitude of detail, crisp focus, a straightforward shooting style, and a centered composition shrouded the photographic image's connotative meanings; the viewer was encouraged to see the halftone as a transparent stand-in for the product itself, in all its superior workmanship.[24] Photography's peculiar ability to replicate appearance, sometimes discussed in terms of photographic realism, can work to collapse the interpretive space between image and material object, further obscuring the ideological space in which connotative meaning works.[25]

In an era of reason-why copy and efficiency mania, advertisers offered photography as providing an unmediated access to the real, defined as the product's material reality. Photographs denoted the superior product through the image's immediate quality, while photography as a medium implicitly connoted the efficiency of American business culture. Photography was the preferred medium in advertising copy directed to an implied rational consumer, who was usually male. Especially in product advertising in which the selling argument was based upon efficiency, photography emerged as a favored medium, remaining popular long after advertisers had abandoned reason-why copy for most household products (fig. 4.3).[26] Even in product advertising directed toward female consumers, if the copy was based upon logical argument (e.g., the small size, low price, and portability of a Western Electric sewing machine), then the preferred illustration medium was often, if not usually, the halftone. By the second decade of the century, photography was widely understood by advertisers, art directors, and consumers to connote the logical rationality of reason-why copy.

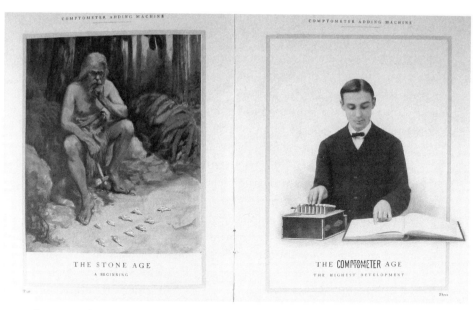

FIG. 4.3. Photography remained the preferred medium for trying to reach the implied rational consumer. (*Rapid Mechanical Calculation*, 1907, Felt and Tarrant Manufacturing Company, Business Machinery Box, Warshaw Collection of Business Americana—Business Machines, Archives Center, National Museum of American History, Behring Center Smithsonian Institution.)

For this reason, photographic illustration continued to dominate trade publications directed to business and professional men, such as *System*, in which the selling pitch was based upon rational appeals of price, efficiency, or quality.

But while photography offered realism, defined here as the faithful reproduction of precise detail, for many years it failed to offer art—and art was becoming increasingly indispensable to advertising. Photography's value as the preferred medium of efficient rationality became a distinct problem when advertisers and psychologists began to shift their model of the typical consumer from "rational man" to "emotional woman" in the first decade of the century. As the pioneering advertising psychologist Walter Dill Scott noted, "We have been taught by tradition that man is inherently logical, that he weighs evidence . . . and then reaches the conclusion on which he bases his action. The more modern conception of man is that he is a creature who rarely reasons at all."[27] By 1910, as Merle Curti has noted, the advertising-trade press had re-

placed the dominant image of man as rationalistic with a new conception of human nature based upon nonrational impulses. Advertising's role shifted from education concerning the product's merits to creating desire through the stimulation of impulses, instincts, and emotions. Although advertising never abandoned "rational man" nor reason-why copy completely, the shift to emotion and to a recognition of the retail consumer as "she" sparked a new style in advertising, called "impressionistic copy" or "atmosphere advertising."[28]

The new advertising style featured a heavy emphasis on illustration as a means of connoting the style, high quality, and class upon which most advertising of these years depended. Pioneer advertising psychologists such as Scott emphasized the role of mental imagery in awakening the senses, and as "the printed page cannot appeal directly to any of the senses except the eye," the role of visual imagery within the advertisement grew in importance.[29] Advertising men such as Ernest Elmo Calkins wore down illustrators' resistance to advertising work by helping to position commercial artwork within the larger spectrum of art practice. In the period 1880–1930, known as the golden age of mass-market magazine illustration, artists such as Winslow Homer, Frederic Remington, Charles Dana Gibson, Maxfield Parrish, and J. C. Leyendecker turned their art training to commercial ends.[30] While in 1906 the adman Albert D. Lasker could assert that "ninety per cent of the thought, energy, and cost of running our agency goes into copy," by the late 1920s the illustration clearly trumped the written word. Advertisers for breakfast cereal, soap, and soft drinks reproduced original paintings, drawings, and sketches, often signed by the artist, as a way of building brand recognition and associating the product with the cultured aesthetic connoted by the featured illustration (fig. 4.4). Some of these illustrations, such as Harrison Fisher's "Fisher Girl" or Charles Dana Gibson's "Gibson Girl," proved popular enough to be sold directly to consumers as independent works of art ready for home framing. The point of the illustrations was not to persuade the consumer through logical argument but to associate the product with the positive emotional responses triggered by what Roland Marchand has described as the "visual clichés" of American advertising: the lovely bloom of American (WASP) girlhood, the warm security of the family circle, or the comforts of the settled village.[31]

Painting and drawing became preferred media for illustration since advertising is a symbolic language that deals less with things as they are

FIG. 4.4. Coles Phillips, illustration for the Holeproof Hosiery Company, 1923. Companies selling to the female consumer continued to prefer nonphotographic media long after halftone technology had made photographic reproduction available inexpensively. (*Cosmopolitan*, May 1923, inside front cover.)

than with how (advertisers think) we would like things to be. Advertisers assumed that consumers preferred an idealized reflection of the social world rather than an image of literal reality. Michael Schudson has described this tendency within advertising as a drive for abstraction, understood not as a loss of figuration but as the articulation of an idea without reference to the specificities of concrete existence. Advertisers constructed a pictorial universe peopled by abstract types (e.g., the elegant society lady, the earnest breadwinner) performing predictable,

recognizable tasks (enjoying the club, working at the office) in abstract places. Like the socialist realism of the 1930s, Schudson argues, American advertising simplifies and typifies. Abstraction is central to this process: individual idiosyncrasies of specific grandmothers (e.g., standing, yelling nonwhite grandmothers) are smoothed over into an abstracted "type" (seated, knitting, smiling white grandmothers) that consumers recognize instantaneously, thereby expediting the sales message or product association.[32]

Pen-and-brush illustrations, with their signatures and distinctive brush marks and lines, clearly signaled the individual interpretation that provided one avenue to advertising's preferred goal of abstraction. Consumers implicitly recognized the illustrations of James Montgomery Flagg or Harrison Fisher—images that occupied the powerful emotional borderlands between the mundane specificity of the known and the alluring abstraction of fantasy—as ideal representations of American types. Illustrations acted as psychological handmaidens to consumer desire: they announced their status as idealized abstractions while simultaneously licensing subjective flights of consumer longing. Photography, however, seemed hamstrung as a medium: its faithful reporting of material fact and its overwhelming enthusiasm for endless, superfluous detail seemed to suggest its unsuitability for idealist representation. As one article stated in 1918, summarizing the field's pre-Hiller shortcomings, the "almost unavoidable realism of photographic illustrations as usually made killed the effective impression demanded of the picture used to illustrate a story. . . . An illustration must get away from this very definite thing and give to all classes of readers an idealistic vision of the hero or heroine of the book or story."[33]

Advertising photography in 1910, after the shift to "emotional" or "impressionistic" copy, remained a singularly unsophisticated, if not invisible, component of commercial photography, especially in light of the lush sophistication of contemporary illustration art. Most of the few advertising photographers continued to follow Harvey S. Lewis's suggestion in 1905 that the primary requirement of a photograph for reproduction was sharp detail.[34] This requirement made sense as long as the most advertising photography was produced for catalog illustration, which Lewis reported was the case in 1905.[35] Just a few years later, however, advertisers sought something more than the accurate presentation of the product; the shift to impressionistic copy required the merchandising not so much of the product itself but of the benefit

the product offered. In the case of soap, for example, cleanliness or domestic warmth, rather than the soap itself, being the focus of the advertising illustration. To borrow Roland Barthes's terminology once again, the advertisement's emphasis had shifted from the *denotative* to the *connotative* meaning.

Despite Lewis's attention to the newly developing field of advertising illustration, however, many articles on commercial photography through the prewar period failed even to mention advertising as a possible venue.[36] The invisibility of this new photographic field, as well as the naive approach of its few practitioners, sparked the Eastman Kodak Company to intervene. Recognizing the increased market for film and equipment represented by an industry-wide shift to photographic advertising illustration, Kodak sought to encourage more sophisticated work by professional photographers. In a 1913 booklet directed to professional photographers, Kodak announced, "There's a demand among magazine publishers for photographs that combine interest and art." Regrettably, however, most photographers "need training" in order to meet these new demands. *Human Appeal*, Kodak's booklet, spelled out what was missing from most advertising photography, recounting not only the company's own experience with its sophisticated photograph-based advertising campaign but also the experience of magazine editors from around the country, whose letters were excerpted in the booklet.[37]

Most photographic advertisements lacked what Kodak and other advertising writers throughout the twenties called "human interest." Human interest in advertising required a story about the product, usually depicted by human figures shown using or benefiting from the product. As ad copy for the well-known New York commercial photography firm Winemiller and Miller announced in 1922, "Where Human interest is an essential, a picture of real people doing natural things has a compelling quality which engages attention and establishes interest because it interprets a HUMAN motive in a HUMAN way."[38] In 1913 Kodak sought to move photographers toward the making of "pictures that gracefully and effectively tell a story." To meet this goal, photographers needed to move past the straightforward depiction of products required for catalog illustration to the artistic suggestion of narrative within the still image of the advertisement. As one magazine editor remarked, "Where most photographers are capable of producing satisfactory individual portraits, they have not yet had sufficient experience in the general make-up of illustrating work to secure the best results. . . . if

photographers will make some of their studies from the standpoint of pictorial composition, they will be able to see for themselves, through the experience so obtained, what the necessary features of successful pictures of this kind must be."[39]

By 1913, then, it was clear what advertisers wanted of illustrations, even if most photographers seemed unable to meet the demand. As advertisers increasingly emphasized the importance of the image within the overall composition of the advertisement, they sought dynamic images marked by both formal and conceptual clarity. Images needed to tell a "striking or interesting story" through dramatic lighting, harmonious composition, balanced use of lines and contrast, and other formal elements considered more the province of the artist than that of the photographer. For unlike art-school-trained illustrators such as Howard Pyle or N. C. Wyeth, few photographers could boast any formal art training; as a rule, they lacked the knowledge of composition, line, and chiaroscuro learned through academic study in the fine arts. The problem of how to introduce a more sophisticated photographic practice to advertising illustration was addressed, however, by a Milwaukee resident who moved to New York in 1907. Lejaren à Hiller, a young photographer with three years of formal art training at the School of the Art Institute of Chicago behind him, saw himself as an artist, illustrator, and photographer—in that order. Through his innovative use of the camera in both fiction and advertising Hiller essentially invented modern photographic illustration.

From Milwaukee to Chicago: Lejaren à Hiller's Early Years

Lejaren à Hiller was born in Milwaukee, Wisconsin, on 3 July 1880, one of four sons.[40] His father, John W. Hiller, was a Milwaukee probate judge and possibly a Mason and Civil War veteran as well.[41] Hiller's middle-class childhood and adolescence at 2731 State Street were enlivened by a rich imagination that, as in many artistically inclined young men in the 1890s, signaled a fascination with ritual, the exotic, and the Orient. His 1894 notebook announces his position as "Grand Inquisitor" of his own secret society; his brothers Edwin and Walter were enlisted, along with the "Grand Money Hoarder," his childhood friend Ned Sylvester. Hiller's pen-and-ink drawings and occasional watercolors illustrate his poetry (about an Abyssinian maiden in distress) or essays (concerning, for example, a favorite Symbolist icon, the Egyptian Sphinx). Hiller's

aesthetic earnestness, though clearly marked, is leavened by a sense of playfulness and humor that he retained throughout his later work.

At fifteen Hiller left public school and, with the help of his father, began a four-year apprenticeship at the American Lithograph Company in Milwaukee. The company specialized in designing and printing trade literature for commercial clients, providing Hiller with an early example of the sometimes profitable relationship between art and commerce. Serving an apprenticeship at the same company, during the same years, was another young Milwaukee resident, Edourd (later Edward) Steichen, who had begun taking drawing courses and teaching himself photography during his free time.[42] During Hiller's second year, however, after achieving the wage of two dollars weekly, he "lost his job" at American Lithograph and began work for another Milwaukee concern, the Gugler Lithograph Company.[43] In the period 1897–1900 Hiller designed pen-and-ink advertising illustrations and covers for theater and club programs; he also began experimenting with a box camera that he found in his parents' home.[44] The owner of the company, Mr. Gugler, took a personal interest in Hiller's accomplishments and talent and encouraged him to enroll in the school of the Art Institute of Chicago. In the fall of 1900 Hiller left home "with $75.00, my winter underwear, and my Elk bicycle" for the Masonic Temple on Chicago's North Side, where he became a boarder in the household of a family friend.[45]

The Art Institute of Chicago was an ideal setting for a young illustrator simultaneously enthralled with bohemian ideals and beset by financial pressures. In 1900 the school was enjoying a lengthy period of expansion under Director William M. R. French, who had recently helped move the school into an imposing Italian Renaissance building built for the World's Columbian Exposition with the Art Institute's long-term use in view. The number of day students enrolled jumped from 359 in 1883 to 815, mostly women, in 1905; enrollment in the Evening School (for working, mostly male adults) and the Saturday School (for children and student teachers) brought the total number of students to 2,580 by 1902–3.[46] The curriculum was also undergoing significant changes. The Art Institute had long been known as a school dedicated to a strong drawing foundation, with figure drawing from life (both costumed and nude models) holding a central place in the curriculum by 1896. By the 1890s the influence of the Arts and Crafts Movement had led to the introduction of several applied courses of study, in addition to traditional academic figure and anatomy studies.

Architecture classes were offered beginning in 1889, and by the 1890s a Department of Decorative Design offered study in the design of stained glass, rugs, book covers, capitals, and other utilitarian objects; graduates of the three-year course of study were prepared to go directly into professional design work for manufacturing or mercantile concerns. Illustration was added in the 1890s, with a course taught by the *Chicago Daily News* illustrator Frederick Richardson. Richardson emphasized drawing from memory rather than from life, an emphasis that suited Hiller's tastes for the fantastic and the imaginary.[47]

By the time Hiller arrived at the Art Institute in 1900, then, the school was clearly on its way to a practical rapprochement between the sometimes competing claims of fine and applied, or commercial, art. As the painting instructor Lawton S. Parker noted in 1902, after a stay in Paris, "The great mistake made in America has been the insistence that the student work at art for art's sake alone."[48] Increasingly, the school sought to train artists to meet not only the craftsman ideals of limited-production functional objects but also the design demands of a nation shifting to mass consumption. By 1909 the school's curriculum had successfully incorporated these new demands.

Hiller, who came to the Art Institute with experience in commercial art and a thirst for fine art, threw himself into both types of studies. In his first year he took the standard academy antique class, which included academic drawing studies as well as painting of the full figure in watercolor, oil, and ink. The following year, Hiller enrolled in the illustration class, supplemented by coursework in anatomy, life drawing (including from the nude), oil painting from life, and subjects.[49] His illustrations and drawing work, based upon examples in his notebooks and reproduced in the student journal, were competent and promising, if not superior. His strengths lay in imagination, color, and composition rather than in line; he did, however, win a special prize in the Art Institute League Exhibit of 1903 for a poster advertising the Art Students League annual ball.[50] When he was not in class Hiller, like most students at the school, worked at a variety of jobs to pay expenses: he worked for the school washing electric light bulbs; sold his own bookplates, sketches, and posters; and even began making small photographic portraits, which he sold to fellow students for twenty-five cents each.[51]

Hiller was a popular and colorful figure whose exotic theatricality and adventuresome nature generated considerable student commentary. In addition to his class work, Hiller was deeply involved with

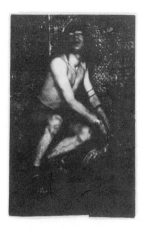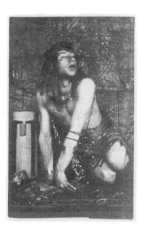

FIG. 4.5. Lejaren à Hiller, self-portrait as Buzzard of Buzz. (Courtesy Hiller Archive, Visual Studies Workshop, Rochester, NY.)

the student journal, the *Sketch Book*, to which he regularly contributed both pen-and-ink illustrations (including cover art) and a column titled "The Ghetto," a picaresque narrative of student adventures exploring the street life of Chicago's new immigrant communities.[52] Earthenware vessels, brass candlesticks, furniture, ossified fish, and exotic fabrics, bought from immigrant peddlers, became both home furnishings and props for Hiller's fanciful theater pieces and photographs. A *Sketch Book* profile of "Buzzy" Hiller, the first subject of a series of articles on "prominent" students, good-naturedly emphasizes Hiller's affect as the dreamy "artiste" transported by flights of creative imagination.[53] For the spring 1903 production of the life-drawing class's costume event, "The Buzzard of Buzz," Hiller both designed the sets for the second act and played the lead role of the good-natured genie, an Orientalist hybrid of "cannibal, wizard, oracle" (fig. 4.5).[54] A reviewer described Hiller's sets as "artistic" and "beautiful" and the colors as "weird and harmonious—sort of à la Jaren," perhaps coining Hiller's new name, which he changed from Jaren Hiller to Lejaren à Hiller at about this time.[55] Perfected during his Chicago years, the role of the creative genius/fine artist would prove invaluable capital in his later commercial work, in which the imprimatur "artist" successfully commanded high fees and creative autonomy.

As the self-portraits in figure 4.5 suggest, by this period Hiller was photographing regularly with a view camera. He recorded his own an-

tics, as well as those of his friends, in a series of photograph albums maintained from his art school years through the early years of the second decade of the century. Some of the earlier, art school images are humorous vignettes; for example, one series of three images tells the story of Hiller and two male friends dressing a chicken, cooking dinner, and then lying on the floor, presumably dead, from misguided culinary enthusiasm.[56] Hiller may have begun using the camera to document the life-drawing models in order to return to a pose after class.[57] Some early photographic figure studies, from about 1903, support this possibility. Yet his soft-focus, ethereal portraits suggest a pictorialist rather than a documentary impulse. Additional small studies of an old woman at a washstand, of a lake and trees, and of a barnyard signal Hiller's shift toward art photography, where beauty was defined not by the edge-to-edge sharpness depicting recognizable subject matter but by the compositional sophistication and picturesque subjects of the Barbizon and impressionist painters.

Although the School of the Art Institute of Chicago did not offer its first photography class until 1935, Chicago—and the Art Institute in particular—was an important center for the fine-art movement in photography. The Art Institute sponsored the important Chicago Salon in April 1900, the city's first photographic salon; on view at the Art Institute from 3 to 18 April 1900, it featured works by the well-known pictorialists Clarence White, Alice Austen, Gertrude Kasebier, Alfred Stieglitz, and a young Edward Steichen.[58] Hiller, who arrived at the Art Institute the following fall, would likely have visited the later salons, such as the second salon, held from 1 to 22 October 1901 at the Art Institute, which featured 129 photographs by a number of pictorialists, including F. Holland Day and Arnold Genthe. The third salon, on view during the winter of 1903, moved away from the doleful tones of the Eastern School and the earlier salons' emphasis on "fuzzy," or differentially focused, photographs.[59] Hiller would also have been introduced to fine-art photography through the head of the department of figure drawing and painting, J. H. Vanderpoel, who felt strongly that "a photographer, in the highest sense of the term, is an artist." In a series of articles published in the *Photo-Beacon* throughout 1901 Vanderpoel introduced to amateur photographers fine-art principles of posing, lighting, and composition, as well as other design essentials, using both photographs and old masters' paintings as examples.[60] Hiller, who was studying under Vanderpoel during this time, proved an avid student; by

1901 he had not only learned how to use a camera but also absorbed pictorialist ideals concerning technique and subject matter.

Decades of historiography on Stieglitz's Photo-Secession pressure the modern student to associate pictorialism with an antimarket, anti-commercial emphasis. Yet as recent scholarship reminds us, pictorialism's aesthetic ideals were not inherently antithetical to commercial considerations. Rather, pictorialism's emphasis on design and composition, as well as the hand-intensive processes of the new printing techniques, suggests an affinity for the Arts and Crafts Movement's critique of the divide between commercial and fine art. Some of the most influential of American pictorialists, such as Gertrude Kasebier and Clarence H. White, supported themselves through commercial work (portraiture in Kasebier's case and magazine illustration and teaching in White's).[61] While an art student at Chicago, Hiller was exposed to both fine-art photography and commercial illustration. Within four months of each other, two articles in Hiller's student publication, the *Sketch Book*, signaled his exposure to these two modern movements. A March 1903 article on art photography was followed in July by a pragmatic article entitled "Commercialism in Art," which asked the student reader to consider "what line of work will give the best return for the money invested in an art education?" The answer, the author suggested, was commercial illustration. "This may be the age of the poor art student," the author concluded, "but should not be the age of the poor artist."[62] Advertisers especially demanded the skills of the academically trained artist. It was Hiller's contribution to combine both of these developments, art photography and commercial illustration, into a middle-brow hybrid: photographic illustration for fiction and for advertising.

In late 1905, after a series of trips to California and the Southwest, Hiller returned to Chicago and began working as a commercial artist for J. T. H. Mitchell, who later became known as a partner in the well-known advertising firm Lennen and Mitchell.[63] Examples of Hiller's work during the year or so that he stayed with Mitchell are limited to a series of direct-mail advertising flyers aimed at retailers, illustrated in pen and ink with the mailer covers printed in two colors. One illustration, however, is unusual for its use of photography. A male figure with the bowler hat and cane of an upscale consumer perches rather awkwardly on a small bench; the lack of ground and awkward perspective seem to tilt the figure uncomfortably toward the viewer. Beneath the image, in small type, Mitchell announces a patent pending for the

use of photography, which, though innovative, hardly seems to draw the viewer into the advertisement. After working his way up to a salary of thirty-five dollars a week, Hiller apparently decided that he had had enough of Chicago and moved to New York.[64]

New York and the Ten-Cent Magazines: Hiller's Early Magazine Work

Upon arriving in New York in 1907, Hiller looked up an old friend from art school, possibly Ned Stevens, and became his roommate at 151 W. Twenty-third Street.[65] Hiller began his new career as a free-lance illustrator immediately. Although there is some record of pen-and-ink illustrations for advertising, through 1913 Hiller supported himself primarily through nonphotographic illustration of fiction in magazines.[66] In the years 1908–13, before he turned to photography, his pen-and-ink drawings illustrated fiction and poetry in *Good House-keeping, Cosmopolitan, Harper's Bazaar, Country Life in America*, and other magazines. From 1908 on, his paintings, which ranged in style from exotic Orientalism to sentimental genre scenes, were featured on the covers of a variety of mass-market magazines, including *Munsey's, Life, American Magazine, Pearson's*, and *World's Work*, as well as the *Cavalier, Short Stories, Adventure Magazine*, and *The All Story*. Hiller's cover illustrations proved immensely lucrative. Although he rarely chose to publicize this aspect of his career, from 1923 through 1934, long after he had given up his other cover-art contracts, he provided weekly covers for pulp detective weeklies, especially *Flynn's Weekly Detective Fiction* (later *Detective Weekly*). These highly dramatic and colorful illustrations, though painted, were photograph-based; like the true crime stories they illustrated, the images prowled the mysterious terrain between fact and fiction (fig. 4.6).

As figure 4.7, a self-portrait with beret and artist's smock, suggests, Hiller's self-presentation was very much that of the creative bohemian. "All my life," he stated in one of his autobiographical fragments, "I wanted to be an artist"; and once in New York, as he had in Chicago, he headed for the artists' haunts.[67] When he was not drumming up commissions or executing drawings, he immersed himself in the explosive cultural life that was New York before the war. New York's bohemia was not yet synonymous with Greenwich Village; instead, the elusive and increasingly sought-after spirit occupied shifting sites of leisure,

Fɪɢ. 4.6. Lejaren à Hiller, "Absinthe," illustration for *Flynn's Weekly Detective Fiction* and photo, c. 1925. Hiller's pulp-fiction covers were based on photographs. (Courtesy Hiller Archive, Visual Studies Workshop, Rochester, NY.)

including the dance-hall strip between Sixth Avenue and Broadway, on Twenty-ninth Street, just six blocks from Hiller's apartment.[68] He frequented cafes and especially dance halls, enjoying performances ranging from the Ziegfeld Follies to Ruth St. Denis.[69] He was involved with the annual Artists' Ball Masque at the Kit Kat Club, designing their poster invitation on the theme "A Dream of the Orient" in 1912. In 1909, identifying himself as an artist-illustrator rather than a photographer—photography's claims to art status were still heavily contested despite the best efforts of the Photo-Secession—Hiller joined the Society of Illustrators.

The Society of Illustrators was founded in 1901 as a type of artists' guild to professionalize, and masculinize, the work of mass-market magazine illustrators. Frustrated with the art directors' complete control over their work, illustrators sought increased creative autonomy, as well as a more systematic approach to commissions, deadlines, and fees. To bolster their image as artists, the organization sponsored annual exhibitions of illustration work, presented not in its final form as advertisement but instead as original drawings. Since most art-school-

FIG. 4.7. Lejaren à Hiller self-portrait, c. 1910. Hiller considered himself both an artist and a bohemian. (Courtesy Hiller Archive, Visual Studies Workshop, Rochester, NY.)

trained illustrators in 1901 were women, the Society of Illustrators sought to masculinize the field by barring women altogether from membership; in 1906, however, the fraternity relented, admitting five women as "associate members," while the male membership numbered seventy-three. The society also sponsored monthly dinners, annual costume balls, and theatrical performances that were attended by illustrators, art directors, artists, dancers, models, and others. These events were highly elaborate productions, with members and guests attending and/or performing in costume (often drag and/or blackface).[70] As other business organizations were discovering during the same years, the carnivalesque performance of a marginal identity worked to reinforce professional associations based upon dominant ideals even if the per-

FIG. 4.8. Sales Smoker, Safe Cabinet Sales Company, Remington Rand, c. 1920. The performance of marginal or alternative identities was a familiar ritual in early-twentieth-century organizational cultures, especially at sales convention "smokers." (Courtesy Hagley Museum and Library, Wilmington DE.)

formers were, in their nonprofessional lives, outside the defined norm (fig. 4.8).

Hiller remained an active member of the Society of Illustrators throughout his professional career, even after he had become a well-known advertising photographer. He was a member of the entertainment committee as early as 1910, and he was known for years for hosting boisterous all-night parties, often following society dinners or other events.[71] These events were extraordinarily important to Hiller, both professionally and personally. His friendships with well-known illustrators and artists such as Charles Dana Gibson, Walt Kuhn, and John Sloan legitimized his own practice as that of an artist, a prerequisite for his later success in advertising photography. Society of Illustrators events, exhibitions, and informal parties brought Hiller into contact

with the creative staffs of the major advertising agencies, as well as with the editors of mass-market magazines for whom many of the illustrators worked.[72]

At some point during his work as a freelance commercial illustrator Hiller began to badger magazine editors to allow him to illustrate his commissions with the camera rather than the brush. Hiller himself gives varying accounts of his motivation, citing laziness and the reduced expenses associating with modeling fees, for by this point he had begun photographing his subjects and then drawing or painting the illustrations from the photographs. Yet numerous pictorialist nude studies in his photographic scrapbooks from these years document his ongoing commitment to fine-art photography despite his day-to-day work churning out pen-and-brush illustrations for the major magazines (fig. 4.9). It is quite possible that despite his success in the highly competitive world of magazine illustration, he recognized his work as merely accomplished rather than outstanding, especially given the superior drawing skills of his better-known colleagues. Hiller developed a portfolio of photograph-based illustrations and made the rounds of the New York publishers, many of whom he already knew. Yet the magazine editors, recognizing the existing limits of the camera's flat, mechanical approach to illustration, initially refused to consider a photograph-based fiction illustration. Finally, however, Hiller succeeded in persuading W. G. Gibson, the editor of *Cosmopolitan* and a prior client, to give him a story to illustrate.[73]

Anna Katherine Green's short story "The Grotto Specter" appeared in the June 1913 issue of *Cosmopolitan*, along with a Jack London short story illustrated by Howard Chandler Christy, a Robert W. Chambers story with images by Charles Dana Gibson, and numerous other pieces.[74] The story, about a mysterious murder in a grotto, was illustrated by six signed photographic illustrations by Lejaren à Hiller, the only images reproduced in duotone, with a blue-green tint as the second ink. Unfamiliar with a suitable cave to photograph in New York, Hiller photographed a street excavation pit as a background for his fictionalized tableau. The camera suggested a documentary truth, which Hiller softened through dramatic chiaroscuro: deep, dark tonalities frame the figures, who emerge, hazily, from dense backgrounds whose contours and contents, though photographically rendered, remain nonetheless suggestive (fig. 4.10).

The resulting images made a dramatic impact on contemporary

FIG. 4.9. Lejaren à Hiller, pictorialist study of Agnes Boulton, c. 1908–14. (Courtesy Hiller Archive, Visual Studies Workshop, Rochester, NY.)

readers. The editors of *McClure's Magazine* spotted it and offered Hiller an exclusive contract. *Cosmopolitan* made a counteroffer, however, and Hiller signed a contract with Hearst Publications for $7,500 for a year's work.[75] Photography was hardly new to magazine illustration, but up to this point, outside advertising matter, all photographic illustration had described nonfiction features, whether news, social issues, celebrity happenings, theater performances, or bathing beauties. Within magazine illustration the camera image connoted the documentary: photographs recorded actual events, persons, or places. Hiller's practice of using the camera to "document" fiction, then, threw the assumed re-

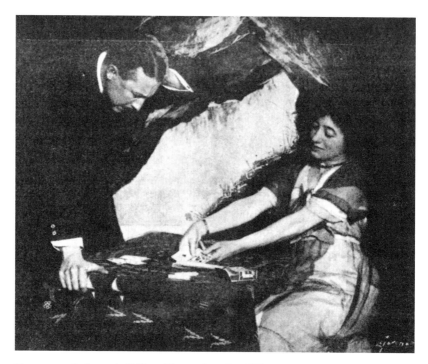

FIG. 4.10. Lejaren à Hiller, illustration for "The Grotto Specter," by Anna Katherine Green. (*Cosmopolitan*, June 1913, 93.)

lationship between photographic realism and social fact into question. Through the photography of fiction, especially the use of posed models rather than geographic place-marking, Hiller continued a tradition developed by Julia Margaret Cameron in her illustrations for Tennyson's *Idylls of the King and Other Poems* (1874–75), as well as more contemporaneous projects such as Adelaide Hanscom's photographic illustrations for *The Rubaiyat of Omar Khayyam* (1905).[76] Projects such as Cameron's, however, produced before the diffusion of halftone technology, reached only minimal audiences. Hiller's photographic illustrations for fiction, appearing in mass-market magazines, reached a circulation in the millions; their ideological effect was to complicate the assumed relationship not only between fact and fiction but also between photography and realism for a mass audience.

The *Cosmopolitan* work enabled Hiller to leave the country on a two-month trip to Paris by way of Portugal and Spain. In Paris Hiller spent most of his time in Montmartre and the Latin Quarter; his note-

books are filled with sketches and watercolors of dancers and scenes from the Folies Bergère, the Moulin Rouge, and the red-light district of Place Pigalle. Although he later claimed that this trip provided him an opportunity to study the old masters, the surviving sketchbooks record no museum visits and suggest instead Hiller's complete immersion in the bohemian culture of prewar Paris.[77] When he returned to New York on 6 September 1913, he took a new apartment at 23 West Thirty-first Street, in an area of New York known in 1909 as the "photographer's metropolis." Hiller's new studio was a few buildings down from Clarence H. White's studio, located at 5 West Thirty-first Street, in a townhouse recently occupied by the Camera Club of New York. Around the corner, two blocks away, were Stieglitz's Little Galleries of the Photo-Secession and Edward Steichen's studio, both at 291 Fifth Avenue. Gertrude Kasebier's studio was three blocks north, and the well-known portrait photographer Arnold Genthe had relocated to the corner of Fifth Avenue and Forty-sixth Street in 1911. The area was also home to the city's art galleries.[78]

Art Photography and the Fictions of Magazine Illustration, 1913–1919

Although halftone technology made the use of photographs possible in illustrations for mass-market magazines as early as the 1890s, it was some time before editors and advertisers considered photography a suitable medium for the "capitalist realism" required of nationally distributed advertising illustration. The few historians who have noted this cultural lag between technological innovation and aesthetic response credit the breakthrough to Edward Steichen and Clarence White and date this development to a later period, usually the early to middle 1920s. This interpretation follows the groundbreaking work of Patricia Johnston, whose research on Edward Steichen has helped to complicate historians' understandings of the relationship between art and commerce during the post–World War I era. Michele Bogart, following Johnston's lead, argues convincingly that the rise of advertising photography can be attributed to the moment when the aesthetic approaches of the pictorialist photographers converged with the needs of advertisers, a development she traces to the mid-1920s. Bonnie Yochelson, in her work on Clarence White, has furthered our understanding of this relationship by documenting White's role in training the second generation of American modernist advertising photographers, includ-

ing Paul Outerbridge Jr., Ralph Steiner, and Margaret Watkins. White, though he supplemented his modest teaching income with commercial work, recognized his neighbor Hiller as the senior statesman of commercial photographic illustration, inviting him to lecture on commercial work at the Clarence H. White School of Photography. The recent historiographic focus on Steichen and White, though a much-needed corrective to generations of scholarship on Stieglitz and the Photo-Secession, understates the degree to which fine-art aesthetics had become part of advertising photography well before Steichen's and White's students transformed the field in the 1920s.

Steichen and Hiller, born within a year of each other and in the same city, embarked on somewhat different paths after their stints as apprentice lithographers. About the time Hiller went to the Art Institute of Chicago, Steichen went directly to Paris, where he studied figure drawing and continued his experiments in art photography. In late 1902 he opened a portrait studio in New York that catered to the wealthy and famous, and in late 1905 he began his involvement with Stieglitz's Little Galleries (which Stieglitz opened in Steichen's building in November 1905). The following year, however, Steichen moved back to France, where he stayed until 1914, exhibiting his pictorialist photographs and supplying Stieglitz with the latest information concerning European developments in both photography and, increasingly, modern art. At the outbreak of war Steichen returned to New York and the Stieglitz circle, remaining until 1917, when he enlisted in the U.S. Army. During the war Steichen worked for the Photographic Section as a supervisor of aerial photography. He stayed in the air service for nearly a year after the armistice, until October 1919, followed by another three years in France. It was not until 1923 that he considered returning to the United States. Pessimistic about the chances of high-end portrait work in New York after such a long absence, he considered settling near his family in Chicago, but a meeting with Frank Crownin-shield landed him a position as chief photographer for *Vogue* and *Vanity Fair*. A few months later Steichen began his long association with the J. Walter Thompson advertising agency.[79]

By the time Steichen returned to New York in 1923, then, Hiller had been working as a New York–based photographic illustrator for ten years. It was Hiller's work, in both fiction and advertising, that persuaded art directors that photography had an important role in modern advertising. Along with the fashion photographer Baron Adolphe de

Meyer, who was hired by Condé Nast in 1913 to take fashion photographs for *Vogue*, Hiller was one of the most accomplished commercial photographers in pre–World War I America. The aesthetic foundation for Hiller's incursion into commercial illustration was pictorial, or artistic, photography. Pictorialism, a popular movement in American photography from the mid-1890s through World War I, built upon nineteenth-century English models in arguing for the creative possibilities of the camera. Though the movement is often associated with Alfred Stieglitz and his anticommercial, exclusive Photo-Secession (1902–17), pictorialism was in fact a broad aesthetic among "amateur" photographers who exhibited their work in local camera clubs and discussed technique and exhibitions in the photographic press. In the effort to elevate photography to the status of fine art, in both its subject matter and its formal strategies, many pictorialists emulated the effects of late-nineteenth-century European painters. The goal was to move photography away from the tyranny of fact: since a definition of artistic seeing included the ability to select certain details for creative expression at the expense of others, pictorialist photographers needed to deflect the camera's utilitarian leanings. Unlike mechanical or scientific photographs, aesthetic photographs required different means toward different ends.[80] As the American critic C. H. Caffin argued in 1901, the aesthetic photograph "will record facts, but not as facts; it will even ignore facts if they interfere with the conception that is kept in view; just as Corot in his paintings certainly recorded the phenomena of morning and twilight skies and just as certainly left out a number of facts as he sat before the scene, his object being not to get at facts, but to express the emotions with which the facts affected him."[81] The pictorialist photographer sought emotional expression rather than indexical verisimilitude; the camera, like the brush, was to be considered as yet another tool toward aesthetic ends.

Since the goal of American pictorialists was to make works of art rather than "mere" photographs, advocates emphasized the need for training in the fine arts in order to understand the elements of design and composition fundamental to exemplary creative expression. The best-known nineteenth-century popularizer of fine-art principles among photographers was Henry Peach Robinson, an English commercial photographer who published a series of popular studio manuals introducing design concepts such as balance (of lines and mass), composition (of figures and lines), and chiaroscuro to both American

and European photographers. His most popular guide, *The Pictorial Effect in Photography*, was originally published in America and reprinted numerous times.[82] Though Hiller may also have been familiar with Arthur Wesley Dow's influential composition manuals, Robinson's books, especially his use of models and combination printing, may also have been sources for Hiller's later work.[83]

Like the pictorialist commentators who followed him, Robinson differentiated between the "fact" of the photograph and the "truth" of the work of art. "A fact," Robinson wrote, "is anything done or that exists—a reality. Truth is conformity to fact or reality—absence of falsehood. So that truth in art may exist without an absolute observance of facts." Robinson's distinction between fact and truth expanded the subject matter available to creative photographers. The privileging of "truth" over the facticity of material reality acknowledged the subjective, spiritual dimension of artistic expression; the camera became a tool to render visible the invisible, to communicate the inexpressible. Deeply influenced by the simplicity of natural beauty, by European Symbolists, and by Japanese aesthetics, pictorialists photographing early in the century sought to infuse their work with an emotional and spiritual intensity. The preference for classical tableaux, as well as the allegorical dimensions of the natural landscape, pushed the camera image beyond the mechanical recording of social fact to express intimacy, ecstasy, ambiguity, and revelation, abstractions that prior generations had considered beyond the capability of photographic representation.

Most of Hiller's assignments following "The Grotto Specter" were for illustrations of pieces whose subject matter went beyond the limits of the known world. Models dressed in classical garb gesture theatrically in the margins of poetry by Dr. Frank Crane or a utopian essay by the British sexologist Havelock Ellis.[84] In 1914 Hiller began illustrating a series of four articles by the Belgian playwright and Symbolist Maurice Maeterlinck. The articles, which appeared from 1914 to 1916, covered a variety of questions relevant to contemporary interest in psychical research, including the ability to foresee the future; the temporal relationship of the present to both past and future; the ability to communicate through mediums; and the idealist assertion of the ongoing presence of loved ones despite their physical death.[85] Maeterlinck's antipositivist idealism had been introduced to American photographers, as well as to the general public, as early as 1902; one critic noted cynically that the writer was especially popular with "long hair females" who digressed

FIG. 4.11. Lejaren à Hiller, illustration for "Penetrating Another World," by Maurice Maeterlinck. (*Cosmopolitan*, 1914, 474–75.)

in lyceums on "the Comprehensibility of what is commonly called the incomprehensible in Maeterlinck."[86]

Hiller's illustrations for this series, as well as for other work during the 1914–18 period, matched Maeterlinck's interest in nonmaterial realities. While some photographs worked as somewhat straightforward illustrations of, for example, a woman examining tea leaves as a form of fortunetelling, most images were more complex. The double-page illustration for "Penetrating Another World," for example, features a draped woman staring pensively into a divining globe while ghoulish figures half emerge from the future's "intolerable darkness" (fig. 4.11). The image forcefully suggests life on the other side of the veil, while leaving the specifics of Hiller's technique shrouded in mystery. A 1915 article about James H. Hyslop, president of the American Society of Psychical Research, was illustrated by two photographic "spiritgrams," one of which depicted a floating William James appearing as an apparition after his death in 1910.[87]

Hiller's work in fiction and in imaging the nonmaterial world of psychic reality proved an ideal preparation for advertising illustration.

As he alone among commercial photographers seemed to recognize, selling no longer depended upon the verisimilitude of material reality; sales required the motivation of subjective realms of emotion and psychology. Advertisers had begun to recognize that "the same people who thrill and suffer and cry and grow hot-tempered over the tempests and joys of fiction, further ahead in the same magazines, are touched and influenced by that heart which is put into advertising."[88] The visual strategies used to motivate the reader's engagement with the work of fiction were soon to become indistinguishable from the visual strategies used to spark the consumer's desire to purchase.

A 1917 ad for the Aeolian Company suggests how Hiller's work in illustrating the subjective held direct relevance for advertising work (fig. 4.12). In this tableau an old man wears a "rapt expression, sad but very tender" as the phonograph, memory's handmaiden, returns the vision of his lost love, hovering in ghostly lavender and chestnut curls outside the open doorway. As this image suggests, the lines between fiction and advertising, between the material and nonmaterial worlds, and between truth and reality grew increasingly indistinct. Aesthetic innovations made in pursuit of the irrational became yoked, through advertising, to the rationalization of consumption. As Hiller pointed out in 1920, "Modern advertising, as it is exemplified in the higher class of periodicals, must often possess qualities that appeal to the reader with infinitely more subtlety than a mere statement of such material facts as widths, lengths, weights, colors, and prices . . . there are luxuries of the mind which must be hammered out no less than those for the body."[89] Hiller's visual strategies relied upon illustrating the mind's fictions, whether via the short story or by showing the emotional benefit promised by the consumption of mass-produced goods.

Advertising art directors immediately recognized Hiller's photographic breakthrough in fiction illustration, and as early as 1913 he was approached by N. W. Ayer to produce an ad for a silk company (fig. 4.13). Compared with his work of just four years later, the image he produced for Ayer is crude: the model perches precariously, and the eye is drawn not to the silk but instead to the intriguing clutter in the top left part of the photograph. There is no selection of detail through lighting, masking, retouching, framing choices, or the use of a soft-focus lens, all of which would become integral to his work in just a few years. Hiller made the photograph in his home, and in order to get the model and the silk in the picture without cutting the fabric he had to

FIG. 4.12. Lejaren à Hiller, ad for the Aeolian Company, 1917. Hiller's work in illustrating fiction proved useful in his later advertising work, where the line between fact and fiction was rendered intentionally indistinct. (*Saturday Evening Post*, 24 Nov. 1917, 46, detail.)

run the bolt into the adjoining kitchen. Hiller reminisced in 1936 that the image "wouldn't be worth five dollars today . . . but it was good then. And it was new. In those days, advertisers were satisfied to get a clear picture."[90] As Hiller continued to introduce pictorial technique to his fiction and feature illustrations, however, he emerged as the leading photographic illustrator of national advertising campaigns, producing photographic advertisements for Corning, Johns-Manville, Steinway, Winchester Arms, Senreco toothpaste, Hammermill paper, S. D. Warren paper, General Electric, and Armstrong's linoleum, among others,

FIG. 4.13. first ad for N. W. Ayer, c. 1913. (Courtesy Hiller Archive, Visual
Studies Workshop, Rochester, NY.)

all before 1920.[91] Success in both lines of work required the adaptation
of pictorialist aesthetics to the formerly static and mechanical photo-
graphic illustration.

In 1914, soon after his breakthrough with *Cosmopolitan* and Ayer,
Hiller began work on his most ambitious fine-art photographic proj-
ect. The skills in composition, lighting, costuming, and model posing,
refined in this project, established Hiller's reputation as an artist while
providing him with essential technical and aesthetic solutions to the
problems posed by advertising photography. The project, *Bypaths in
Arcady*, was a handsomely produced art book of love poems by Ken-
dall Banning, beautifully illustrated with twenty-four photographs re-

Fɪɢ. 4.14. Lejaren à Hiller, photographs from *Bypaths in Arcady*, a book of love poems by Kendall Banning illustrated with twenty-four photographs reproduced in photogravure by Hiller, published in 1915. Hiller's identity as an artist and a pictorialist helped legitimize his work as a commercial photographer. (Courtesy Hiller Archive, Visual Studies Workshop, Rochester, NY.)

produced in photogravure by Hiller (fig. 4.14). Appearing in 1915, at the end of the Arts and Crafts Movement's revival of fine-art printing, the poems and images described many of the Greek myths favored by classical and European pastoral writers, as well as early-twentieth-century aesthetes.[92] The photogravure process, widely available to fine-art printers and photographers after 1886, had become the ultimate photomechanical process for fine-art photographers because it could reproduce details and provide rich, velvety tones without reworking by hand. In Hiller's photographs, partly clad nymphs and gods pursue one another with poetic abandon, their shimmering limbs stretched in graceful spontaneity. Hiller worked in darkness, illuminating the models by flashlight just at the moment when the sought-after expression and attitude had been achieved. As a result, in the view of a critic who saw the photographs on exhibit in a Chicago gallery, "there is a night quality about his work . . . which distinguishes so much of the best artistic effort in literary lines, the feeling of soul isolation and the unreality of everything save dreams."[93] Pictorialist representation of Arcadian myth and longing provided ideal training for representing the dreamscape of modern advertising.

Disciplining the Eye: Pictorialism's Formal Strategies in the Service of Commerce

Hiller's working methods and techniques drew upon pictorialist aesthetics, but directed toward a mass audience. Since he relied upon the figure to provide "human interest" for the story or advertisement, all of his illustrations required models. The use of models for fine art was, of course, hardly new to painting or even to photography. Henry Peach Robinson, for example, preferred hiring trained models for his pastoral compositions, as the peasants themselves often looked as "frightened as a hunted hare." Since the peasant clothing was essential to the pictorial effect, however, Robinson would sometimes buy the clothes right off the peasant wearer. These staged compositions, Robinson realized, might open him to the "charge of masquerading." In his defense, he argued that art was a series of compromises whose value lay not in the means but in the overall effect achieved. "My models may be called to some extent artificial," he argued, "but they are so near the real thing as to be taken for it by the real natives, just as the trout does not seem to notice the difference between the natural and the artificial fly."[94]

Hiller, however, pioneered the use of photographic models for commercial illustration. Facial expression, gesture, costume, and placement were all carefully staged in order to illustrate a story that would spark an emotional response in the viewer.[95] The "authenticity" of the model's representation of type was subordinated to the more compelling necessity of securing a specific visual effect. At first Hiller used his friends and even himself as models; Sara Anita Plummer, a Ziegfeld Follies performer, later secretary to Charles Dana Gibson, and eventually Hiller's wife, can be spotted in many pre-1920 photographs.[96] By 1916, however, Hiller's commissions had begun to expand, and he went into partnership with the former art editor Henry Guy Fangel. "We study the composition of the photograph as an artist would plan the composition of a drawing," Fangel told the *New York Times* in 1918. "We work often like stage directors to get the right expression on a model."[97]

By 1918 Hiller and Fangel had moved into a studio at 135 West Forty-fourth Street and employed a staff of artists and photographers, in addition to Jenkins Dolive, whose sole job was to scout for models. The New York and photographic press reported that by 1918 Hiller had compiled a photograph-based card index representing the faces

Fig. 4.15. Models for Hiller illustrations, c. 1917–24. Hiller pioneered the use of models for photograph-based print advertisements. (Courtesy Hiller Archive, Visual Studies Workshop, Rochester, NY.)

and physical measurements of two thousand to three thousand working models. Each card featured two photographs, one frontal and one in profile, as well as height, age, weight, and other pertinent information (fig. 4.15). Many of the models were known to movie and theater patrons, while others were everyday New Yorkers whom Hiller or Dolive decided represented ideal "character types" and subsequently persuaded to pose.[98] Eventually, in fact, Hiller stopped working with well-known figures (such as "Billie" Scott or Marion Davies, whom he claimed to have introduced to Hearst) because, he argued, fiction and advertising required the subordination of the model's personality to the narrative.[99] Unlike in motion pictures, in which the audience expects the personality of a Mary Pickford to "show through the part," Hiller argued, in print illustration the models "must be a character in the story and nothing else."[100] The forward movement of the narrative, whether in fiction or advertising, was threatened by the star quality of the well-known actress.[101] As a writer for *Printers' Ink Monthly* explained in 1922, "The too-much-photographed face is unproductive of results."[102] The models assembled for Hiller's studio included artists' models, working-

class men and women seeking a little extra cash, occupational "types" spotted in the city's streets and immigrant neighborhoods, as well as middle-class women who modeled for the excitement and pleasure of "being photographed with exceptional care in their best clothes." While some models were contacted through the location scout, who would find the "real east side tradesmen, real farmers," or other authentic "types," others came to the studios on their own.[103]

Here, then, is a different sort of photographic archive, one that indexes the physiognomic capital of an emerging mass-culture industry. Unlike Blackford's physiognomic archive, in which the face's static features were intended to reveal, transparently, aspects of inner character, the models in Hiller's card index were valued precisely to the extent that their faces and expressions could shift to communicate new identities, new characters. In the visual landscape of modern mass culture, the charm of "personality" triumphed over immutable character, which in the context of commercial work would quickly limit a model's work prospects. A successful model was one who could appear in a variety of illustrations in different poses and situations while remaining simply a character in a story "and nothing else." As in the stage, cosmetics helped create these new characters, who inhabited the model's physiognomy as long as the photo shoot lasted. As Kathy Peiss has discussed, the growing acceptance of makeup promised personal transformation, the ability to change the self by changing one's external appearance.[104] Hiller took this transformation one step further, using models and makeup to communicate the transformative possibilities of consumption: ephemeral physiognomies sold the promise of authentic selfhood through the acquisition of goods.[105] The implication of Hiller's extensive model archive, which drew on both professionals and everyday New York residents, was an erasure of the boundary separating the public and the private selves: performance of self might become an ongoing condition. As one critic remarked with regard to Hiller's work, "From all indications about every other person in New York must be posing from time to time for something." This critic suggested, with tongue in cheek, that readers go down to Hiller's studio and "get mugged. Leave your picture . . . and one day you will be called upon to take the part that represents your real character."[106] Blackford's "real character" is here revealed as nothing more than the playful and knowing performance of type.

The atmospheric effects of Hiller's early advertising work, especially his inventive use of background, drew upon the controversial pic-

torialist legacy of combination printing. This technique, popularized by Oscar G. Rejlander and Henry Peach Robinson in the nineteenth century but written out of most twentieth-century photographic history, involved combining a number of separate negatives or prints into one image, touching up the seams with paint or ink, and then rephotographing the whole.[107] Hiller would have encountered this technique not only in Robinson's popular studio manuals, which covered the process thoroughly, but also in the photographic constructions that illustrated Alan Dale's reviews of contemporary stage productions, which appeared monthly in *Cosmopolitan* during the early years of the second decade of the century.[108] Like Robinson, Hiller usually began with a sketch of the final composition, a practice he continued throughout his later advertising work. With an idea of the necessary figures and backgrounds, as well as their relative scale, Hiller would then photograph each model or element individually at the correct scale, darkening the white lines of the edge cuts with spotting color.

One of Hiller's first commissions for which he relied upon combination printing was an illustration for Ella Wheeler Wilcox's World War I–era poem "It May Be." The poem asked the reader to pause in stillness, listening for echoes of curious "folk of the fourth dimension" seeking to reach a closed people bent upon war and financial gain (fig. 4.16). Hiller met the difficulties of photographing ghosts by photographing twelve models, each dressed in ethereal garb and hoisted from the studio floor in a harness contrived for the purpose. With each exposure Hiller reduced the focus, and the end result was a series of prints of progressively diminishing size. Hiller's raw print material comprised a variety of different figures, in various sizes, who seemed to be floating in space. He superimposed these images one onto another on board and retouched the seams with black and gray paint; the result was simultaneously photographic and fantastic.[109]

The shift to "straight photography" after about 1917, when Paul Strand published his manifesto rejecting the painterly influence on photographic practice, had little initial impact upon the commercial landscape of advertising photography.[110] Combination printing, a primary technique in the photomontage practice of European and Russian avant-garde art, continued to be important in commercial work, especially when the product was large and the costs and logistics of location shooting seemed prohibitive to the young professional. But whereas the Soviet and European artists' radical photomontage figured modernity's

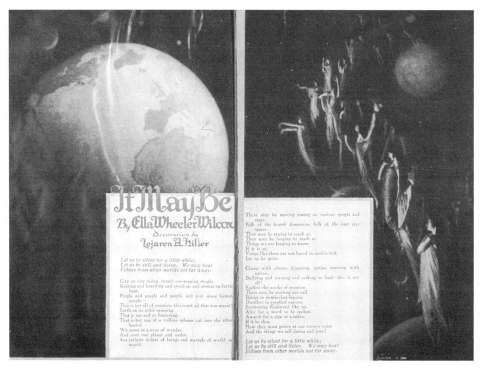

FIG. 4.16. Lejaren à Hiller, collage for the poem "It May Be," by Ella Wheeler Wilcox, c. 1914–17. Twelve models were photographed at various scales to construct this illustration. (Courtesy Hiller Archive, Visual Studies Workshop, Rochester, NY.)

breaks and discontinuities as a means of inserting revolutionary politics and aesthetics, American advertising montage practice before the late 1920s rendered the breaks between figures and objects invisible.[111] In American advertising, combination printing was used not as a means of radical critique but to provide what Temple Scott called "implied opinion": the "utilization of taste in presenting the article itself to the best advantage." Combination printing was one of the techniques available to the advertising photographer, but the erasure of disjuncture was necessary in order to provide advertising photographs characterized by the requisite "realism with just that touch of idealism."[112] As figure 4.17 suggests, Hiller used this strategy throughout his later advertising work, though he grew to prefer the manipulation of effect by the use of stage sets over the manipulation of image by means of combination printing.

FIG. 4.17. An article in the N. W. Ayer house organ details how the Hiller studios used combination printing to create advertising illustrations. ("Building an Advertising Photograph," *The Next Step*, November 1921, 12, series 6, box 15, N. W. Ayer Advertising Agency Records, Archives Center, National Museum of American History, Behring Center, Smithsonian Institution.)

Combination printing, though important to Hiller's early work, diminished in significance as Hiller became more adept at staging social tableaux within the studio. As his ability to make use of set construction, props, models, and other components of the interior studio set grew, the image's lighting and composition became the key elements

FIG. 4.18. Lejaren à Hiller, early painted image with three figures in Pierrot costume, *Good Housekeeping*, c. 1914. (Courtesy Hiller Archive, Visual Studies Workshop, Rochester, NY.)

in communicating the dramatic narrative required of both advertising and fiction illustrations. Again, Robinson's works, as well as his own background in the study of European painting, provided Hiller with the basic elements of chiaroscuro.[113] In early compositions, Hiller photographed his models at night with candlelight as his main illumination source; the candle threw dramatic shadows, which Hiller exaggerated with paint on the final board. In figure 4.18, for example, the three figures are posed together without the use of combination printing or image assembly. The shadows, painted in shades of black, gray, and white, provide the photograph with the sense of depth missing from most contemporary photographic illustrations, which were presented awkwardly on the printed page as flat, two-dimensional cutouts.

In the illustration shown in figure 4.19, a much more sophisticated composition with a full set, Hiller used lighting to highlight the enraptured features of "John Smith, merchant, by day" but "artist, dreamer, poet" while playing the Pianola. The edges of the composition are thrown into darkness, while the image's pyramidal composition and selective illumination guide the viewer's eye along two diagonal lines leading to points of illumination, one commencing at the left arm of the sofa and ending at the spot of light on the windowpane, the other

FIG. 4.19. Lejaren à Hiller, ad for the Aeolian Company, 1917 Hiller's skill in lighting and composition helped discipline the eye's movements through the advertisement. (*Saturday Evening Post*, 22 Sept. 1917, 78, detail.)

beginning with Hiller's own signature and continuing through Smith's hand (where another triangle is formed with the face, hands, and sheet music), to his face, and then back to the windowpane. The eye then returns to the two dramatically lit faces, moving restlessly between the two without resolution. The compositional tension is held by the absent center: the distance between the two figures is a little too great, the angle of sofa and piano a bit too severe. In search of resolution, the eye moves downward to the text, which both anchors the pyramid visually and works to resolve, through narrative, the image's subtle tensions.

 In these sophisticated images lighting, composition, and other formal strategies work together, leading the eye from the image to the product or narrative suggested by the gathered figures. Lighting directs the viewer's attention to certain points in the photograph, disciplining the eye's movements on behalf of the product's selling point. "As a human-interest agent," argued the *Printers' Ink* columnist C. B. Larrabee, "light is supreme."[114] Larrabee's fellow columnist W. Livingston Larned agreed: "Light is perhaps the most potent of all directing and guiding visual influences," he wrote in 1925. "It can signpost anything. It compels attention."[115] Lighting, composition, cropping, background, accessories, use of white space, the suggestion of human interest—all

were formal strategies used to focus viewers' attention on the product or its benefit while keeping "the eye from wandering from the edges of the picture."[116]

Hiller's compositions relied upon the aesthetics of pictorialist photography and painting to spark in the viewer a yearning of the spirit that the product promised to satisfy. As Hiller remarked, "If the maker of a great piano desires to demonstrate the wonders of that instrument to the cultured ones for whom it is specially designed, he does not exhibit a mere photograph of the piano, with a detail of its structure and a statement of its price; he obtains a picture that cannot fail to arouse deep and truly aesthetic emotions in the soul of any clod who may chance to see it." While this effect was not especially difficult for the charcoal or pen-and-ink artist to achieve, the photographer needed to manipulate his tools to achieve the same effect. "It is obvious that work of this sort possessed more abstract qualities than mere photography," remarked Hiller. These qualities could only be achieved by "a real artist, a painter understanding the technique as well as being possessed of splendid taste and dramatic ideas and feeling."[117] In the shift to emotional copy and advertisers' appeal to the subjective, pictorialism provided Hiller with the necessary tools to move photography away from its "almost unavoidable realism" to the abstracted idealism necessary in modern advertising.[118]

Photographic Advertising Illustration: Studio Realism and the "Psychological Moment"

Because of the increasing elaborateness of his studio compositions, Hiller required a larger space in which to construct sets. Location work in commercial photography, also known as "outdoor photographs," did not become a trend in the business until the late 1920s; during the twenty years before that, the set for the advertisement's narrative was constructed in the studio. For grand-scale environments, such as the Egyptian pyramids or a schooner at sea, Hiller would construct toy models, photograph the objects at a comparatively large scale, and then cut in smaller figures made by photographing models in the studio (a methodology shared by early cinema). For smaller settings, such as depictions of an evening at home by the piano or a group of bathing beauties, Hiller would have the set constructed in the studio (fig. 4.20). At his new barn-size studio on Forty-fourth Street, Hiller could construct larger sets, such as the five-foot-high mound of plaster dusted with

FIG. 4.20. Swimming models and constructed water set, Hiller Studios, c. 1920. (Courtesy Hiller Archive, Visual Studies Workshop, Rochester, NY.)

flour in order to simulate the Alps that provided the snowy background for a 1921 calendar illustration entitled "Switzerland—Europe's Playground."[119]

By 1920 Hiller's advertising work attracted the most sophisticated of clients and continued to garner national recognition. He collaborated with Walter Dorwin Teague, famous for his decorative "Teague borders" and later a founder of the new field of industrial design, in a series of advertisements for the upscale men's clothing manufacturer Adler-Rochester;[120] and he was the photographer for an elaborate, multipage booklet advertising the benefits of "electrical housekeeping."[121] Nearly every issue of "quality" magazines such as the *Saturday Evening Post* and the *Ladies' Home Journal* featured Hiller's distinctive photographic tableaux, usually signed by the artist. His work was selected for each of the Art Directors Club's annual exhibitions of advertising art: his nocturnal portrait of a nude nymph holding a luminous globe, for "Moon-Glo" Silk, was exhibited in 1921, as was his candlelit illustration for Pierrette Silk; in 1922 his photographs for Royal Typewriter and Fatima

FIG. 4.21. Lejaren à Hiller, illustration for Fatima Cigarettes, 1922. Hiller's work, such as this photographic illustration, was exhibited in the annual exhibitions of the Art Directors Club of New York. (Courtesy Hiller Archive, Visual Studies Workshop, Rochester, NY.)

Cigarettes (fig. 4.21) joined sophisticated photographic illustrations by Winemiller and Miller, H. W. Scandlin, and Grancel Fitz.[122] By 1923, art directors were seeking untouched photographs marked by "good composition" and the proper selection of material. After years of skepticism about photography's role in advertising illustration, the editor of the 1924 *Annual of Advertising Art* confidently asserted, "The place of the photograph in advertising is unquestioned. It can accomplish things which no drawing or painting can possibly do."[123] Hiller's work, characterized in this period more by studio realism than by combination printing, was prominently featured in the 1924 *Annual*, with photographic illustrations for the Grinnel Company (which manufactured hot-water installation) and for Western Electric, which hired Lewis Hine during the same period to make work portraits for its employee magazines.[124]

Following Hiller's lead, successful advertising photographers became the center of a complex business devoted to the manufacture of constructed realities, designed to create an air of "sincere naturalness" in the service of sales. This complex process often, though not always,

began with the art director. Before World War I, entrepreneurial pho-
tographers would often approach manufacturers directly with sample
ads tailored to the manufacturers' current advertising campaigns.[125] Af-
ter the war, with the increasing prominence of visual imagery in adver-
tising and the founding of the Art Directors Club in 1920, art directors
became the creative brokers between clients and artists.[126] Nonetheless,
throughout the 1920s the advertising photographer enjoyed substantial
creative autonomy. Photography was a relatively new medium for ad-
vertisers, and the most sought after commercial photographers, such
as Hiller, were artists in their own right. The well-known advertising
photographer Anton Breuhl recalled that in the mid-1920s art directors
had given him "a pretty free hand." "Later on, it became much more
cut and dried. The agency would come in with a complete layout and
you had to pretty much stick to it. That's when the fun went out of
things."[127]

But before the Depression, nationally famous advertising photogra-
phers such as Hiller enjoyed substantial autonomy, not necessarily in the
conceptualization of the campaign but certainly in its execution.[128] Initial
ideas were usually sketched in rough drawings indicating the placement
of models and a generalized set. While sometimes these drawings were
presented to Hiller by the art director, just as often he would sketch out
ideas based upon conversations with the advertising agency's creative
staff. Once Hiller had the general idea and the contract, he would turn
his attention to directing the studio work. The studio's casting director
was asked to begin the model-selection process; in a 1928 campaign for
Air-Way vacuum cleaners, for example, more than two hundred mod-
els were considered before a cast of ten was chosen, with Miss Pansy
Graham, the "Air-Way Girl," as the star.[129] After discussions with the
lighting expert and the property director, Hiller would consider the
advertisement's set. Hiller employed staffs of carpenters, painters, and
electricians to install and strike complex interior sets for each advertis-
ing campaign. Working within the space requirements of the camera's
viewfinder, architects and interior designers specified plans, and set
builders created bathrooms, drawing rooms, beach scenes, cathedral
interiors, snow-covered mountains, tropical forests—whatever the ad-
vertisement called for. A well-appointed drawing room, for example,
would be constructed by inserting moveable walls into a suspended
ceiling that was invisible to the camera and useful for future wall con-
figurations. Molding, doors, windows, fireplaces, and cabinetry, kept in

stock or available from theatrical and film-property merchants, were added to the walls, and the required finishes were applied by painters or masons. By 1931 Underwood and Underwood Illustration had in stock more than eight thousand props and accessories for a set decorator to use to create the perfect advertising setting.[130]

At Underwood and Underwood, where Hiller moved in 1924 as vice president and photographic director, the studios were large enough to accommodate three photographers working simultaneously. A wall fifty-eight feet long could serve as the background for other fashion shoots, which might include as many as three different scenes. Painted backdrops needed to be enough out of focus to be read as the real thing yet not so closely detailed that their painted construction would be transferred to the photographic plate. Underwood and Underwood's commercial division maintained as many as four furnished rooms at once, used mostly for illustrations rather than fashion shoots; favorite semipermanent installations included a French boudoir and an English drawing room. The on-site set department used the studio carpentry shop to construct additional rooms, backgrounds, or props as needed.[131]

Finally, the models, chosen by the casting director for their face, figure, bearing, and style, were introduced to the set. Hiller, working with a draper (especially in fashion shoots) and the lighting director, posed the models.[132] In about 1928 the *Air-Way Indicator* described Hiller's style as follows:

> And then Lejaren à Hiller—the master photographer of them all—mounts his little ladder back of the big camera with which the scene is to be "shot." Quick glances to the right and left. His highly trained eye takes in every-thing at a glance, so it seems to the casual onlooker. "Jones—head to the left. Graham—step back two inches. Flood light back right. Spot back of Jones' head. Move that chair right forward. That's it"—and so on, the or-ders pop like a machine gun. "Everybody ready? Camera? Get your poses. Now, Graham, tell her about it. TELL her about it. Action! Eyes open—more. You've never heard this before. It's NEW! That's it. Ready—hold it!" Click—and the first photograph has been taken.[133]

Hiller, working as a stage director, literally rehearsed the team of mod-els for as long as a week, searching for what one commentator called "the psychological moment," the point at which the sales story was suc-cessfully carried by the models' expressions and gestures in a perfect whole, telling the story more effectively than written words.[134]

FIG. 4.22. Lejaren à Hiller, montage image, c. 1928–30. American commercial photographers, including Hiller, appropriated modernist montage strategies in the late 1920s. (Courtesy Hiller Archive, Visual Studies Workshop, Rochester, NY.)

During the early and mid-1920s, before the camera (briefly) "went modern" with distortion and other "trick" effects (fig. 4.22), advertisers turned to photography for the realism the camera offered.[135] The finished print needed to appear as convincing as possible; the viewer needed to be shielded from the obviously constructed nature of the advertisement's setting. C. B. Larrabee, discussing Kodak's superior photographic advertisements, described what advertisers were looking

for as "sincere naturalness." Kodak's ads "seldom suggest the photographic studio, which is the big secret that the successful commercial photographers have learned. As soon as the floating rib begins to appear somewhere near the third button of the waistcoat, the consumer becomes aware of the skeleton underneath. But in the Kodak advertising there is never a sign of the floating rib. Which means that the illustrations are natural and unaffected—-and, biggest of all, convincing."[136] Hiller himself called this ability to suggest sincerity and mobilize purchasing through the twin vehicles of theatrical idealism and photographic realism "studio realism." As the *Printers' Ink* columnist W. Livingston Larned pointed out in his important book *Illustration in Advertising* in 1925, "Professional photographers smile at the thought that the camera does not lie," given the highly constructed nature of these illustrations. The general public at the time appeared much more naive: Larned noted that the "intensive realism" of the photographic image "comes to the aid of the advertiser, as a bringer of verities and realities. The public, many advertisers believe, treats the illustration [as] obviously a slice of real life."[137]

The complex mixture of realism and idealism achieved in these advertising illustrations sparked the viewer's imaginative longings, suspending desire in what Garry Wills has called the "borderland of invented time."[138] This potent combination of manipulated time, photographic realism, and constructed sets was made familiar to early-twentieth-century consumers through cinema. Advertisers quickly recognized the importance of telling a visual story in order to "appeal to the 'movie minded,'" which one commentator described as the equivalent in 1922 of the "average American."[139] In the view of many contemporary commentators, including Hiller, moving pictures, which were widely appreciated, whetted the public's appetite for photographic advertising illustration.[140] As Winemiller and Miller advertising photographers argued in a 1922 ad, "The note of Human appeal which interests the public in motion pictures . . . attracts it correspondingly in a photographic illustration for advertising."[141] *Photoplay* magazine, advertising its journal to potential advertisers in *Printers' Ink Monthly*, directly linked the viewers' subjectivity to both the cinema and consumption. "One secret of the far-flung fascination of the motion picture is that not only are pictures of the actors thrown on the screen, but there is also projected *the personalities of the spectators*," the ad proclaimed. "Every woman lives herself on the screen, finding there material for the surroundings of the

home she longs to build. If your product in anyway enters into the making of the American Home, no better background for its message may be found than PHOTOPLAY."[142] Print advertisers turned to photographic images, sometimes sequenced, to tell sales stories. As early as 1911, corporations such as International Harvester had begun making their own motion pictures as advertisements for heavy machinery, showing the pictures to county agricultural firms.[143] By 1927, enough commercial photographers had introduced the making of motion pictures to their work to warrant a dedicated column entitled "Screenology: Motion Picture Views and News" in the *Commercial Photographer*.[144]

Hiller was also deeply interested in film, but the links between the new medium and sales were more complex than the dreary didacticism of an animated harvester. For Hiller, film was an ideal vehicle for acquainting the broader public with the spiritual transcendence sparked by one's encounter with fine art. Around 1921 Hiller cofounded a film company, Triarts Productions, with the goal of bringing "Art with a capital A, to the masses." The idea behind the production company was to make a series of photoplays with great paintings as their inspiration: the films were animated *tableaux vivants* conjoining two popular middle-class pastimes—parlor theatricals and fine-art appreciation—with a mass audience in view.[145] At least three two-reel films were made with Hiller as art director and Herbert Blache as dramatic director; all three were based on well-known, frequently reproduced paintings in the allegorical vein. A committee of artists and art patrons, including Robert W. de Forest, president of the Metropolitan Museum of Art, and the illustrator Charles Dana Gibson, reportedly endorsed the idea and helped select the paintings.[146] The *New York Times* hailed the first film, *The Beggar Maid*, after Edward Burne-Jones's immensely popular 1883 painting *King Cophetua and the Beggar Maid*, as "one of the most inspiriting experiments that has been made for a long time." The reviewer singled out Hiller's skills in visual composition, which gave the picture a pictorial unity "far ahead of the average photoplay."[147]

A reviewer of Triarts's second film, *The Bashful Suitor*, based upon a painting by Josef Israels, also emphasized the film's visual sophistication. While the narrative was "too self-consciously sentimental," "the pictures by Herbert Blache and Lejaren à Hiller make the eyes feel good . . . by its photographic excellence, 'The Bashful Suitor' achieves high rank as a motion picture."[148] The third Triarts film, based upon the well-known eponymous painting *Hope*, by George Frederick Watts,

FIG. 4.23. George Frederick Watts, *Hope*, 1886. This popular painting became the basis for one of Hiller's films, designed to bring "Art with a capital A, to the masses." (Reproduced in Sir Wyke Bayliss, *Five Great Painters of the Victorian Era: Leighton, Millais, Burne-Jones, Watts, Holman Hunt* [London: Sampson Low, Marston, 1902], 93.)

featured Mary Astor in the title role. Watts's turn to allegorical works in the 1880s brought him international fame; the widely reproduced 1886 *Hope* was at the center of what one critic has called "the Cult of Watts" (fig. 4.23).[149] In Watts's depiction, Hope sits on a globe with bandaged eyes, playing on a lyre on which all of the strings but one are broken, to which she listens with plaintive determination. Hiller's version of the same image is decidedly more cheery: a movie still shows Mary Astor playing happily on a four-string lyre, gazing contentedly at her instrument (fig. 4.24). In a 1921 advertisement for International Business Machines (IBM) the spirit of individual, transcendent "hope"

FIG. 4.24. Still from the film version of *Hope*, Triarts Productions, 1922, directed by Lejaren à Hiller and Herbert Blache. (Newspaper clipping, c. 1922, courtesy Hiller Archive, Visual Studies Workshop, Rochester, NY.)

is translated into the corporate promise of progress and prosperity with IBM's "man-saving minute-saving, business machines" (fig. 4.25). Here, the allegorical figure of hope confidently tethers the globe, the lyre strings of musical flight transformed into the retaining wires of global communication. Aesthetic uplift and corporate growth present themselves, in Hiller's commercial imagination, as twin elements of modern hope and progress. Spirituality and sales fed into each other, as Hiller harnessed the power of the aesthetic response before the work of art on behalf of the corporation, which used advertising illustration to transform emotional intensity into commodity longing.

Triarts apparently failed as a business venture, however, and may also have cut into Hiller's independent work as an advertising photographer. For whatever reason, by 1924 Hiller had accepted an offer from Underwood and Underwood to head up the creative side of their commercial division. Underwood and Underwood is known to historians of both stereography and news journalism, but the story of the firm's commercial and advertising work has yet to be written. The parent company, Underwood and Underwood, was founded in 1882 by two

FIG. 4.25. Lejaren à Hiller, ad for International Business Machines, 1921. Here *Hope*'s visual iconography is redirected toward corporate advertising. (Courtesy Hiller Archive, Visual Studies Workshop, Rochester, NY.)

brothers, Bert and Elmer Underwood, as a house-to-house distributor of stereographic views. By 1901 Bert Underwood had begun making his own views; the firm soon outstripped all competition and was publishing twenty-five thousand stereographs per day, which were sold in boxed sets for middle-class "stereographic libraries."[150] In 1896 Bert Underwood became one of the first to sense the possibilities of photojournalism, selling photographs of the Greco-Turkish War to the *Illustrated London News* and to *Harper's Weekly*.[151] By 1912 the firm's news division had grown, while the stereo craze had waned, and in 1920 Underwood and Underwood ceased production of stereo views and sold the negatives to the Keystone View Company.[152] On the eve of World

War I the Underwood brothers had also founded a commercial division, including portraiture and possibly advertising photography.[153] In 1924, both brothers retired turning the business over to their sons, C. Thomas Underwood and E. Roy Underwood. In 1931 the business was reorganized into four separate companies, with Tom Underwood heading up the commercial division.[154]

By the late 1920s and certainly throughout the thirties, Underwood and Underwood Illustration Studios was the largest, most prominent commercial photography company in New York, if not in the country. In 1931, with the Depression spurring increased advertising expenditures, the company's sales volume exceeded half a million dollars; Hiller alone needed to do eight hundred dollars' worth of work per day in order for the firm to show a profit of 7–9 percent of sales.[155] By 1939 the company had branch offices in Chicago, Pittsburgh, Boston, and Detroit and had employed several well-known commercial photographers, including Valentino Sarra, John A. Funk Jr., Arthur d'Arazien, Eugene Hutchinson, and John Paul Pennebaker. The firm offered what had become a full range of specialties within commercial photography, including automobile photography (hence the Detroit office), industrial photography, product still lifes, and Hiller's specialty, "human interest" and "style" illustrations for print advertising. Company publicity material showcased award-winning illustrations, such as Hiller's direct color ad for the Scripps-Howard Newspapers, which won the Art Directors Club gold medal.[156]

The late 1920s and 1930s saw the full flowering of Hiller's commercial career. Although a full discussion of this important period lies beyond the scope of this chapter, the complexity of his commercial work can be glimpsed through his extraordinarily successful campaigns for Davis and Geck.[157] Davis and Geck, a medical supply company, hired Hiller to create a series of eighty-seven photographic tableaux representing great moments in surgical and medical history. The series, produced between 1927 and 1950, proved tremendously popular: the histrionic, semipornographic images masquerading as art appeared in all the major medical journals; special sepia print sets were presented to surgeons upon request; and in 1941 Hastings House reproduced seventy of the illustrations in their book *Surgery through the Ages* (fig. 4.26).[158] Underwood and Underwood used the images to sell their business to potential advertisers, emphasizing their research of historical details,

FIG. 4.26. Lejaren à Hiller, Etienne Gourmelen (Paris Plague of 1581), for
Davis and Geck advertisement, 1934. (Courtesy Hiller Archive, Visual Studies
Workshop, Rochester, NY.)

set-building capacity, model casting, and costumes. Their images, the
advertisement concluded, "tell *your* story, sell *your* goods."[159]

By 1929 advertising photography had come of age, with established
figures such as Victor Keppler, Edward Steichen, and Nickolas Muray
producing sophisticated photographic imagery for a fully developed
Madison Avenue advertising industry. The Depression spurred adver-
tisers' move toward photographic illustration, especially in the wake of
J. Stirling Getchell's meteoric rise within the industry.[160] As both pho-
tographic illustration and advertising matured as professions, the divi-
sion of labor intensified; by the late 1930s, photographers were more
likely to be technical wizards under the precise creative direction of the
advertising agency's art director. Hiller, never one to fetishize the tech-
nical aspects of commercial photography, retained creative autonomy

3. "I *confess*, I was scared—too scared even to run. But I managed, somehow, to uproot my feet and dive behind a tree just as the beast thundered by. Then one of the natives side-tracked him with a spear. I'll never forget how almighty *good* Canadian Club tasted after that escape. I'm through with zoos in the rough, but this fine old whisky and I have been faster friends than ever, ever since!"

IN 87 LANDS
NO OTHER WHISKY

FIG. 4.27. Lejaren à Hiller, Canadian Club ad, c. 1940–43. The elaborate studio realism of this advertisement came to an end in the late 1940s, to be replaced by location shooting. (Courtesy Hiller Archive, Visual Studies Workshop, Rochester, NY.)

longer than most of his peers. By the 1930s, however, he had begun migrating to the other side of the camera, indulging in his long love of the theatrical to model for his own photographic illustrations.[161] At the same time, the industry continued to shift toward location work and smaller, 35 mm camera formats; in 1943 Canadian Club ended its studio illustrations for the "87 lands" campaign, marking the endpoint for Hiller's pioneering approach to studio realism (fig. 4.27).

Hiller's quiet fade from professional work in the early 1950s shrouds, even today, his pivotal role in the history of advertising photography.[162] Drawing upon his training in fine art, Hiller applied pictorialist principles to commercial work, creating a new market for photograph-based advertising illustrations. His sensitivity to late-nineteenth-century Symbolist and pictorialist aesthetics allowed him to represent, photographically, the subjective and the ideal, exactly the aspects of the self being charted by applied psychologists and advertisers. Hiller's aesthetic solutions to the problems of photographic realism dovetailed with advertisers' shift to the subjective as the mainspring of consumerism

in the twentieth century. Through the rational design and planning of the viewer's emotional response, photographic advertising illustration promised the rationalization of American consumption. This equation remains a working assumption even today.

The emergence of modern, photograph-based illustration in American consumer advertising complements the shift to the subjective represented by Hine's corporate public-relations work. Whereas Hine's photographic practice can be understood as a type of institutional advertising designed for an internal, corporate audience, Hiller's work brought the indexical aspects of photographic realism to the representation of commodities via modern advertising. Although Hine and Hiller worked within different aesthetic traditions, they both used photography to represent a new emphasis on the subjective and the emotional as a key element of rationalization. Their work was integral to a corporate visual rhetoric that borrowed from the realist promise of the photographic image to render the utopian claims of a meaningful work environment or a transformational consumer product a real possibility, one that nonetheless remained permanently out of reach for most Americans.

CONCLUSION

This book charts the emergence of photography as a tool of persuasion in early-twentieth-century American commercial culture, beginning at the doorstep of the pre–World War I workplace, in the office of the employment manager. Despite Katherine Blackford's best efforts to legitimize her methods through an appeal to science, her visually based character analysis represented an increasingly outmoded reliance on a misplaced faith in the indexicality of photographic truth. Although the character analysts met with initial business success, their neophysiognomic assumptions were challenged, and eventually displaced, by the competing methodologies of applied psychologists, who successfully took over the market in employment-management consulting. Industrial psychologists remained very interested in the role of photography and perception, but their use of photographic technologies shifted during the 1920s from an instrumental realism to using the photograph as a tool in the mapping of subjective perception.

Once past the Blackford employment office, we followed, so to speak, a successful job applicant onto the prewar factory floor, where she was increasingly likely to be subject to time and motion study, especially in the industries that hired post-Taylor efficiency experts seeking to rationalize hand-intensive labor. The Gilbreths' photographic work, engineering primarily by Frank Gilbreth and lacking, as a result, some of the psychological sophistication of Lillian Gilbreth's managerial expertise, sought to industrialize the working body through the documentation, analysis, and reconfiguration of discrete motions. The Gilbreths

pioneered the use of visual technologies in the American workplace, a practice whose instrumentalist legacy continues today both in motion study and in the current managerial interest in employee webcams and other forms of workplace surveillance.

Still inside the walls of the factory, we shifted perspective to explore another use of corporate image making that emerged most fully after the war: public-relations photography directed toward the crucial internal audience of the employees themselves. The influence of applied psychology on management practice shifted photography's applications from a near-exclusive focus on the body to an increasing interest in the mind. This shift to the use of photographic technology to rationalize the subjective is evident in the final two chapters. Lewis W. Hine's 1920s employee work portraits were intended, and used, as a type of motivational portraiture, designed to engineer employee loyalty. Hine's work portraits can be understood as a type of early institutional advertising, produced and marketed to an internal, employee audience. In the final chapter, we moved out of the worksite to consider a more well researched form of advertising, one directed toward the end user of commodities. Here, managers' shift to the subjective is most thoroughly evident in the work of the advertising photographer Lejaren à Hiller. Hiller's advertising compositions relied heavily on the human body to spark an aesthetic response on the part of the viewer, an emotional and psychological event that Hiller, and the advertisers for whom he worked, sought to harness on behalf of corporate sales.

Photography emerged in this period as a critical methodology in rationalizing American capitalism. Over the course of the first two decades of the twentieth century, managers, consultants, art directors, and other brokers of managerial capitalism came to recognize, understand, and activate the powerful ideological capacities of the photographic medium. In the earlier years covered by this study, managers and consultants exemplified by Katherine Blackford and Frank Gilbreth seemed at times to believe in photography's alleged ability to reveal objective truths about the efficiencies and capacities of the working body. But as applied psychology began to complicate the Taylorite model of the "human machine," more fully elaborated in the European science of work, managers' understanding of photography's role in the corporate workplace also became more nuanced. Both personnel and advertising managers began to explore the ideological potential of photographic imagery in constructing, through representational strategies, an ideal-

ized landscape that nonetheless was anchored by the persistent truth claims of the photographic medium. By the early 1920s the corporate use of photographic representation had become an important element in managerial strategies to build employee loyalty, reduce labor turnover, manage public opinion, and sell more goods.

In the present era of global commerce, dot-com bubbles, and "flexible capitalism," rationalization has come to be equated with a hostile rigidity that threatened to destroy some of the twentieth century's largest, and hitherto most successful, corporations. But in the early twentieth century, *rationalization* captured the utopian aspirations of progressive managers and technocratic visionaries, experts who sought to replace haphazard methods with managerial control, much of it legitimized through the rhetoric of science. Rationalization, both the term and the process, was used to describe not only the material reorganization of industrial production but also the mental reorganization of the employee and the consumer. Photography emerged in the early twentieth century as a potentially powerful tool in rendering industrial production, distribution, and consumption a more efficient, rational process. Paradoxically, the engineering of the irrational, of the subjective desires for belonging and transformation, became one important route to this end goal of economic rationalization.

This book examines the uneven experiments of early-century managers as they used photography to rationalize both the corporeal and the subjective. Viewed from a contemporary perspective, since 1929 the instrumental efforts to remap worker motions or to decipher ability through photographic representations have waned in importance, whereas corporate image making has increased in importance. As Maren Stange, Lili Corbus Bezer, and others focusing on New Deal photography have shown, capitalism's crisis following the 1929 stock market crash was resolved in part through photography's emerging role in corporate or state-sponsored public relations.[1] From this perspective, Frank Gilbreth's use of photography can be seen to stand for a larger shift in the 1930s toward corporate public relations, which remains a key aspect of contemporary business culture. Gilbreth started out with the expectation that his use of photographic technologies would physically reengineer the industrial workplace. This may indeed have been the case while he was on the job, but as his clients quickly realized, Gilbreth's rationalization efforts quickly dissipated during his frequent absences. Over time, Gilbreth understood what his clients did not: that

photography's promise lay in its role in corporate publicity rather than in its positivist role in corporeal engineering. This was a lesson that Katherine Blackford failed to learn, at her peril, but one that other managers, influenced by applied psychology, understood when they hired Lewis Hine to "document" job satisfaction in the 1920s. By the time art directors turned to photography, the distinction between photographic "fact" and the rhetoric of persuasion had become profitably blurred, allowing corporate managers to use photography as a powerful tool in the ongoing effort to naturalize American consumer capitalism.

Although uneven, as a group these photographic interventions into the rationalization of industrial capitalism make up the prehistory of the triumphant emergence of photographic visual culture in 1930s commercial and public culture, a development that has been detailed in the histories of New Deal America, of advertising and consumption, and of American business culture more generally. As I hope this book shows, the visual sophistication and persuasive force of photographic representation in the Farm Security Administration and other New Deal programs, of *Fortune* magazine, and of the numerous advertising campaigns that relied on photography as an instrument of persuasion had their roots in pre–World War I commercial and visual culture. As even a cursory glance at an annual report, a newsstand magazine, or television advertisement will attest, the more successful of these managerial efforts to influence behavior through strategies of instrumental image making continue to flourish today.

Notes

Introduction

1. Slosson, "Science Remaking the World," 401.

2. Alan Trachtenberg, *The Incorporation of America: Culture and Society in the Gilded Age* (New York: Hill and Wang, 1980), 4–5.

3. Alfred D. Chandler Jr., *The Visible Hand: The Managerial Revolution in American Business* (Cambridge: Harvard University Press, Belknap Press, 1977); see also Chandler's earlier *Strategy and Structure: Chapters in the History of Industrial Enterprise* (Cambridge: MIT Press, 1962). For a more recent discussion of the rise of big business during these years, see Glenn Porter, *The Rise of Big Business, 1860–1920*, 2d ed. (Arlington Heights, IL: Harlan Davidson, 1992).

4. Philip Scranton, *Endless Novelty: Specialty Production and American Industrialization, 1865–1925* (Princeton, NJ: Princeton University Press, 1997), 17.

5. Dan Clawson, *Bureaucracy and the Labor Process: The Transformation of U.S. Industry, 1860–1920* (New York: Monthly Review Press, 1980); Sanford M. Jacoby, *Employing Bureaucracy: Managers, Unions, and the Transformation of Work in American Industry, 1900–1945* (New York: Columbia University Press, 1985); Susan Porter Benson, *Counter Cultures: Saleswomen, Managers, and Customers in American Department Stores, 1890–1940* (Urbana: University of Illinois Press, 1986); Olivier Zunz, *Making America Corporate, 1870–1920* (Chicago: University of Chicago Press, 1990); Lisa M. Fine, *The Souls of the Skyscraper: Female Clerical Workers in Chicago, 1870–1930* (Philadelphia: Temple University Press, 1990); Angel Kwolek-Folland, *Engendering Business: Men and Women in the Corporate Office, 1870–1930* (Baltimore: Johns Hopkins University Press, 1994); Daniel Nelson, *Managers and Workers: Origins of the Twentieth-Century Factory System in the United States, 1880–1920*, 2d ed. (Madison: University of Wisconsin Press, 1995).

6. Scranton, *Endless Novelty*, 7.

7. For recent work in this vein, see Wendy Gamber, *The Female Economy: The Millinery and Dressmaking Trades, 1860–1930* (Urbana: University of Illinois Press, 1997); Angel Kwolek-Folland, *Incorporating Women: A History of Women and Business in the United States* (New York: Twayne, 1998); Juliet E. K. Walker, *The History of Black Business in America: Capitalism, Race, Entrepreneurship* (New York: Macmillan, 1998); and Philip Scranton, ed., *Beauty and Business: Commerce, Gender, and Culture in Modern America* (New York: Routledge, 2001).

8. Wendy Gamber, "A Gendered Enterprise: Placing Nineteenth Century Businesswomen in History," *Business History Review* 72 (Summer 1998): 192.

See also the other essays in this issue, including Kathy Peiss, "'Vital Industry' and Women's Ventures: Conceptualizing Gender in Twentieth Century Business History," 219–41, and Joan Scott, "Comment: Conceptualizing Gender in American Business History," 242–49.

9. Kenneth Lipartito, "Culture and the Practice of Business History," *Business and Economic History* 24 (Winter 1995): 141; Kevin S. Reilly, "Dilettantes at the Gate: *Fortune* Magazine and the Cultural Politics of Business Journalism in the 1930s," ibid. 28 (Winter 1999): 213–22.

10. Roland Marchand, *Advertising the American Dream: Making Way for Modernity, 1920–1940* (Berkeley and Los Angeles: University of California Press, 1985); William Leach, *Land of Desire: Merchants, Power, and the Rise of a New American Culture* (New York: Vintage Books, 1993); T. J. Jackson Lears, *Fables of Abundance: A Cultural History of Advertising in America* (New York: Basic Books, 1994).

11. For Fordism, see Antonio Gramsci, *Selections from the Prison Notebooks of Antonio Gramsci*, ed. and trans. Quintin Hoare and Geoffrey Nowell Smith (New York: International Publishers, 1971). For the classic social history of American efficiency, see Samuel Haber, *Efficiency and Uplift: Scientific Management in the Progressive Era, 1890–1920* (Chicago: University of Chicago Press, 1964). For the impact of efficiency on American culture more generally during this period, see Mark Seltzer, *Bodies and Machines* (New York: Routledge, 1992); Martha Banta, *Taylored Lives: Narrative Productions in the Age of Taylor, Veblen, and Ford* (Berkeley and Los Angeles: University of California Press, 1993); and Cecelia Tichi, *Shifting Gears: Technology, Literature, Culture in Modernist America* (Chapel Hill: University of North Carolina Press, 1987).

12. Anson Rabinbach, *The Human Motor: Energy, Fatigue, and the Origins of Modernity* (New York: Basic Books, 1990); Terry Smith, *Making the Modern: Industry, Art, and Design in America* (Chicago: University of Chicago Press, 1993).

13. Daniel Nelson, *Frederick W. Taylor and the Rise of Scientific Management* (Madison: University of Wisconsin Press, 1980), 115.

14. Frederick Winslow Taylor, *Shop Management* (New York: Harper, 1911), 32–33.

15. David Montgomery, *Workers' Control in America: Studies in the History of Work, Technology, and Labor Struggles* (New York: Cambridge University Press, 1979).

16. Frederick Winslow Taylor, *The Principles of Scientific Management* (1911; reprint, New York: Norton, 1967), 49. Taylor attributes his success in the Midvale battle to the fact that he "was not the son of a working man": the superintendent backed Taylor over the machinists' competing claims, and since Taylor did not live among the workmen, he was therefore more resistant to informal pressure from his coworkers to maintain the shop's collective work culture.

17. Ibid., 49–50.

18. Nelson, *Frederick W. Taylor*, 42.

19. These experiments, which Taylor continued at Bethlehem Steel in 1898, resulted in the important discovery of high-speed tool steel. Taylor discovered that by heating metal-cutting tools to their melting point, a temperature well above the recommended level, these chromium alloy steel tools would harden to such an extent that they could be used at twice the speed of traditional tools. With the machine and feed speeds thus increased, productivity could rise as well. This discovery cemented Taylor's reputation as an engineer, and the proceeds from his various patents enabled him to devote his energies to promoting scientific management (See Nelson, *Frederick W. Taylor*, 86–87; and Frederick Winslow Taylor, *On the Art of Cutting Metals*).

20. Frederick Winslow Taylor, *On the Art of Cutting Metals*, 5.

21. Ibid., 4–11, 246–47. For further information about Barth, see Florence M. Manning, "Carl G. Barth, 1860–1939: A Sketch," *Norwegian-American Studies and Records* 13 (1943); and Haber, *Efficiency and Uplift*, 35–37.

22. Frederick Winslow Taylor, *On the Art of Cutting Metals*, 11–12.

23. Ibid., 4.

24. Siegfried Kracaeur, "Photography," in *The Mass Ornament: Weimar Essays*, trans. Thomas Y. Levin (Cambridge: Harvard University Press, 1995), 61.

25. In the Kinematoscope a series of static poses of, for example, Sellers's son hammering a nail, were mounted on a rotating drum. The photographs were glimpsed through slots in a band of steel that encircled the drum, giving the viewer a sense of motion based upon the persistence of vision (see Anita Ventura Mozley's introduction to Eadweard Muybridge, *Muybridge's Complete Human and Animal Locomotion*, 3 vols. [New York: Dover, 1979], 1:xii; see also Charles Musser, *The Emergence of Cinema: The American Scene to 1907* [Berkeley and Los Angeles: University of California Press, 1990], 43). Frederick Taylor had become friendly with Sellers's son, Coleman Sellers Jr., in the late 1870s through the Engineer's Club of Philadelphia. Coleman Sellers Sr. worked as the chief engineer of the family machine-tool company that bore his name; a relative, William Sellers, had bought a controlling interest in Midvale in the early 1870s (Robert Kanigel, *The One Best Way: Frederick Winslow Taylor and the Enigma of Efficiency* [New York: Viking, 1997], 146).

26. Frederick Winslow Taylor, *Scientific Management*, 83. Taylor's ideas about management had been introduced to the engineering community in 1895 with his address "A Piece Rate System: A Step toward Partial Solution of the Labor Problem." His 1903 address on shop management more fully introduced the elements of the Taylor System and helped map Taylor's move from engineering to managerial innovation (see Frederick Winslow Taylor, "Shop Management"). As Daniel Nelson notes, by 1901 Taylor had turned most of his energy to promoting

his management system, emphasizing it as a solution to what managers called "the labor problem" (Nelson, *Managers and Workers*, 60).

27. Taylor's text, which relies on passive verb construction, serves to draw the reader's attention away from those who are performing work to an appreciation of the object of the work: the tool.

28. This work by Muybridge was published in San Francisco in May 1881 as *The Attitudes of Animals in Motion: A Series of Photographs Illustrating the Consecutive Positions Assumed by Animals in Performing Various Movements.*

29. Mozley, introduction to Muybridge, *Muybridge's Complete Human and Animal Locomotion*, 1:xiv.

30. Gordon Hendricks, *Eadweard Muybridge: The Father of the Motion Picture* (New York: Grossman, 1975); William I. Homer and John Talbot, "Eakins, Muybridge, and the Motion Picture Process," *Art Quarterly*, Summer 1963, 194–216; Linda Williams, *Hard Core: Power, Pleasure, and the "Frenzy of the Visible"* (Berkeley and Los Angeles: University of California Press, 1989).

31. Marta Braun, "Muybridge's Scientific Fictions," *Studies in Visual Communication* 10, no. 3 (Summer 1984): 2–21; idem, *Picturing Time: The Work of Etienne-Jules Marey, 1830–1904* (Chicago: University of Chicago Press, 1992).

32. Marta Braun and Elizabeth Whitcombe, "Marey, Muybridge, and Londe: The Photography of Pathological Locomotion," *History of Photography* 23 (Autumn 1999): 218–24; see also Rachelle A. Dermer, "Photographic Objectivity and the Construction of the Medical Subject in the United States" (Ph.D. diss., Boston University, 2002).

33. See Rabinbach, *Human Motor.*

34. Braun, *Picturing Time*, 320–24.

35. Roland Barthes, "The Photographic Message," in *Image/Music/Text*, trans. Stephen Heath (New York: Hill and Wang, 1977), 17, 21.

36. Alison Griffiths, *Wondrous Difference: Cinema, Anthropology, and Turn-of-the-Century Visual Culture* (New York: Columbia University Press, 2002), 88–93.

37. Barthes, "Photographic Message," 27.

38. John Tagg, *The Burden of Representation: Essays on Photographies and Histories* (Amherst: University of Massachusetts Press, 1988), 4; see also idem, "Power and Photography; Part One, A Means of Surveillance: The Photograph as Evidence in Law," *Screen Education*, no. 36 (Autumn 1980): 17–27.

39. Allan Sekula, "Photography between Labour and Capital," in *Mining Photographs and Other Pictures, 1948–1968: A Selection from the Negative Archives of Shedden Studio, Glace Bay, Cape Breton*, photographs by Leslie Shedden, essays by Don Macgillivray and Allan Sekula, intro. Robert Wilkie, ed. Benjamin H. D. Buchloch and Robert Wilkie (Halifax: Press of the Nova Scotia College of Art and Design, 1983), 193–94. See also idem, "The Body and the Archive,"

October, 1986, 3–65; and idem, *Photography against the Grain: Essays and Photo Works, 1973–1983* (Halifax: Press of the Nova Scotia College of Art and Design, 1984).

40. Abigail Solomon-Godeau, *Photography at the Dock: Essays on Photographic History, Institutions, and Practices* (Minneapolis: University of Minnesota Press, 1991), xxviii. A classic collection of essays in postmodern photographic criticism is Victor Burgin's *Thinking Photography* (London: Macmillan, 1982). For a recent rapprochement between postmodern photographic criticism and modernism's allegiance to the object, see Geoffrey Batchen, *Burning with Desire: The Conception of Photography* (Cambridge: MIT Press, 1997), 4–21. For recent work on instrumental images, see Sarah Bassnett, "Photography, Instrumental Discourse, and City Planning in Early Twentieth Century Toronto and Montreal" (Ph.D. diss., Binghamton University, 2004).

41. Alan Trachtenberg, *Reading American Photographs: Images as History, Mathew Brady to Walker Evans* (New York: Hill and Wang, 1989).

42. Urwick, *Meaning of Rationalisation*, viii.

43. Ibid., 154–55.

44. Ibid., 18–19.

45. On the impact of scientific management on the German, French, English, and Russian economies, see Judith Merkle, *Management and Ideology: The Legacy of the International Scientific Management Movement* (Berkeley and Los Angeles: University of California Press, 1980).

46. Urwick, *Meaning of Rationalisation*, 33.

47. Siegfried Kracauer, *The Salaried Masses: Duty and Distraction in Weimar Germany*, trans. Quintin Hoare (London: Verso, 1998), 39.

48. On the relationship between precision dance and mechanization in the United States, see Joel Dinerstein, *Swinging the Machine: Modernity, Technology, and African American Culture between the Wars* (Boston: University of Massachusetts Press, 2003). Dinerstein's discussion of the Ziegfeld Girls and Busby Berkeley draws on Martin Rubin, *Showstoppers: Busby Berkeley and the Tradition of Spectacle* (New York: Columbia University Press, 1993); and Linda Mizejewski, *Ziegfeld Girl: Image and Icon in American Cinema* (Durham, NC: Duke University Press, 1999). See also Kracauer's essay on the Tiller Girls in *Mass Ornament*.

49. David E. Nye, *Image Worlds: Corporate Identities at General Electric, 1890–1930* (Cambridge: MIT Press, 1985); Roland Marchand, *Creating the Corporate Soul: The Rise of Public Relations and Corporate Imagery in American Big Business* (Berkeley and Los Angeles: University of California Press, 1998). On the value of investigating the cultural work of corporate America, see Thomas Frank, *The Conquest of Cool: Business Culture, Counterculture, and the Rise of Hip Consumerism* (Chicago: University of Chicago Press, 1997), x.

50. Hugh Aitkin, *Taylorism at Watertown Arsenal* (Cambridge: Harvard University Press, 1960); Daniel Nelson, ed., *A Mental Revolution: Scientific Management since Taylor* (Columbus: Ohio State University Press, 1992); David Montgomery, *The Fall of the House of Labor: The Workplace, the State, and American Labor Activism, 1865–1925* (New York: Cambridge University Press, 1991).

51. See Allen Davis, *Spearheads for Reform: The Social Settlements and the Progressive Movement, 1890–1914* (New York: Oxford University Press, 1967); Peggy Pascoe, *Relations of Rescue: The Search for Female Moral Authority in the American West, 1887–1930* (New York: Oxford University Press, 1990); Louise Michele Newman, *White Women's Rights: The Racial Origins of Feminism in the United States* (New York: Oxford University Press, 1999); Laura Wexler, *Tender Violence: Domestic Visions in an Age of U.S. Imperialism* (Chapel Hill: University of North Carolina Press, 2000).

Chapter 1. The Physiognomy of American Labor

1. Labor turnover is the ratio of the number of employees engaged in a year to the total number of employees on its payroll. For a discussion of labor turnover from the perspective of management, see Magnus W. Alexander, "Waste in Hiring and Discharging Men," address before the annual meeting of the National Machine Tool Builders Association, 1914, "N" File (hereafter cited as NF) 19/0043-1, Gilbreth Papers, Frank and Lillian Gilbreth Collection, Purdue University Libraries Special Collections, Purdue University, Lafayette, IN (hereafter cited as GPP); R. C. Clothier, "The Function of the Employment Department," *Bulletin of the United States Bureau of Labor Statistics* 196 (1916): 11; and "Discussion," Proceedings of Employment Managers' Conference, ibid., 73. The Ford Motor Company was a much-discussed example, as it had determined in 1913 that it needed to hire fifty-six thousand workers annually to maintain a work force of thirteen thousand (see "Enormous Labor Turnover"; "Labor Turnover Costs $1,250,000,000 Yearly"; and Arnold, "Ford Methods and the Ford Shops." For the transformation of production at Ford more generally, including employment policies, see Stephen Meyer III, *The Five Dollar Day: Labor Management and Social Control in the Ford Motor Company, 1908–1921* [Albany: State University of New York Press, 1981]).

2. Newton, "The Scientific Employment of Men," 68; see also "To Pick Workers Scientifically."

3. The quotation is from Frank Gilbreth, typescript, 28 Dec. 1915, folder on standardization, NF Container "O," GPP.

4. For strike activity during these years, see David Montgomery, *The Fall of the House of Labor: The Workplace, the State, and American Labor Activism, 1865–1925* (New York: Cambridge University Press, 1991), 332, 370.

5. The leader of the field was Meyer Bloomfield, head of Boston's Vocation

Bureau, who in 1911 called together fifty men who were in charge of hiring at their respective companies and formed the Employment Managers' Association (see the following by Bloomfield: "New Professional of Handling Men"; "Aim and Work of Employment Managers' Associations"; and "Labor Problems in Scientific Management"). The Employment Managers' Association was formally organized as a national association in 1918, when it opened its membership to women (see Fitch, "Employment Managers in Conference").

6. See Oscar W. Nestor, *A History of Personnel Administration, 1890–1910* (New York: Garland, 1986), 133–34; and Daniel Nelson, *Managers and Workers: Origins of the Twentieth-Century Factory System in the United States, 1880–1920*, 2d ed. (Madison: University of Wisconsin Press, 1995), 161–68. The name "Personnel Department" was suggested during the 1917 National Conference of Employment Managers, held in Philadelphia (see "Labor Turnover Costs $1,250,000,000 Yearly").

7. On modern interviewing strategies, see R. T. Fennell, "The Art of Interviewing," reprint from *Industrial Management* (1920), in NF 19/1043-1, GPP; Masterson, "Art of Interviewing"; and Kelly, "Hiring the Worker."

8. The eugenicist E. E. Southard, a supporter of Frank and Lillian Gilbreth's motion-study work and a pioneer in the field of industrial psychiatry, argued that strikers by definition "had something wrong with them from a nervous or mental standpoint" (see Southard, "Mental Hygiene of Industry"; see also Southard, "Modern Specialist in Unrest").

9. Sharon Hartman Strom, *Beyond the Typewriter: Gender, Class, and the Origins of Modern American Office Work, 1900–1930* (Urbana: University of Illinois Press, 1992), 109–54. See also Andrea Tone, *The Business of Benevolence: Industrial Paternalism in Progressive America* (Ithaca, NY: Cornell University Press, 1997); and Nikki Mandell, *The Corporation as Family: The Gendering of Corporate Welfare, 1890–1930* (Chapel Hill: University of North Carolina Press, 2002).

10. Dana, *Human Machine in Industry*, 3. For other discussions of the human machine in American industry, see Frederic S. Lee, *Human Machine and Industrial Efficiency;* and "Testing the Human Machine in the Man Testing Laboratory." The classic study on this question is Anson Rabinbach, *The Human Motor: Energy, Fatigue, and the Origins of Modernity* (New York: Basic Books, 1990).

11. Floyd Taylor, "What Do Your Hands Tell?"

12. James Parrin Quigel Jr., "The Business of Selling Efficiency: Harrington Emerson and the Emerson Efficiency Engineers, 1900–1930" (Ph.D. diss., Pennsylvania State University, 1992), 279. See also Samuel Haber's discussion of Emerson's role in popularizing efficiency, especially in relation to the Eastern Rate Case of 1910–11 and Taylor's rather unsympathetic public affect in *Efficiency and Uplift: Scientific Management in the Progressive Era, 1890–1920* (Chicago: University of Chicago Press, 1964), 55–57. For representative

examples of Emerson's enthusiastic popularizing of the "gospel of efficiency" (the term is his), see the following by Harrington Emerson: "Philosophy of Efficiency"; *Twelve Principles of Efficiency*; and *Efficiency as a Basis for Operation and Wages.*

13. Blackford, *The Job, the Man, the Boss*, 31–39; Blackford and Newcomb, *Analyzing Character*, 334–36.

14. *Welfare work* was a contemporary term used to describe the programs and amenities that some progressive companies had begun to provide employees, such as dining, health, and wash facilities, as well as programs in civic education, fitness, athletics, and singing, among others. For further discussion, see chapter 3. For two early discussions of the movement, see Beeks (head of the National Civic Foundation's Welfare Department), "Employees' Welfare Work"; and "Some Practical Principles of Welfare Work." For a company promotional brochure describing such programs, see United Shoe Machinery Corporation, *The Story of Three Partners*, United Shoe Machinery Corporation Papers, Box 277, Archives Center, National Museum of American History, Behring Center, Smithsonian Institution, Washington, DC (hereafter cited as NMAH). Labor activists often saw these activities as management's (successful) effort to convince workers of the "identification of their interests with those of management" (see, e.g., Epstein, "Industrial Welfare Movement Sapping American Trade Unions." The classic discussion remains Stuart Brandeis, *American Welfare Capitalism* [Chicago: University of Chicago Press, 1976], but see also Tone, *Business of Benevolence;* and Mandell, *Corporation as Family*).

15. Blackford, *The Job, the Man, the Boss*, 69–75. Because Blackford's plan meant that she was appropriating tasks and authority formerly reserved for supervisors and foremen, she encountered the same sort of internal resistance other scientific managers had faced when seeking to centralize other aspects of industrial management, such as ordering of materials, tool storage, and piece rates.

16. For Blackford's discussion of the vocational misfit, see Blackford and Newcomb, *Analyzing Character*, 17–110. See also "Refitting Human Misfits"; Parsons, "Putting Round Pegs in Square Holes"; and Harrington Emerson, *Twelve Principles of Efficiency*, 154–55.

17. Ellis, *Task of Social Hygiene*, 29.

18. Blank No. 2 Application for Position, in Blackford, *The Job, the Man, the Boss*, 82–83. This form does not differ in any significant way from the scores of related forms being published in journal such as *System* and *Industrial Engineering* as examples of "progressive" employee management.

19. Blackford, *The Job, the Man, the Boss*, 84–85 and figure on 86. I borrow the term *visual detection* from Ardis Cameron's excellent essay "Modern Types: Visual Detection in Everyday Life," unpublished manuscript in author's possession.

20. Blackford, *The Job, the Man, the Boss,* 105–6; see also Blackford, *Blondes and Brunets,* esp. 17–18.

21. Blackford, *The Job, the Man, the Boss,* 115–80; Blackford, *Character Analysis by the Observational Method,* 4–5. The following discussion is drawn from several of Blackford's works, including (in addition to those otherwise cited) Blackford, *The Man and His Job;* Blackford and Newcomb, *Analyzing Character;* Blackford, *Character Analysis by the Observational Method;* and Blackford and Newcomb, *The Right Job.*

22. Blackford, *Blondes and Brunets,* 18, 52.

23. Blackford, *The Job, the Man, the Boss,* 143.

24. Ibid., 144.

25. Nancy Stepan, *The Idea of Race in Science: Great Britain, 1800–1960* (Hamden, CT: Archon Books, 1982), 88; see also George W. Stocking Jr., *Race, Culture, and Evolution: Essays in the History of Anthropology* (London: Macmillan, 1976), 42–68.

26. Hendricks, "Scientific Employment Plan," 570.

27. Blackford and Newcomb, *The Right Job,* 1:22.

28. Other physical variables too numerous to recount fully here revisit classifications long familiar to practitioners of somatic interpretation. On some of these other variables, such as eye formation or physiological "type" (mental, motive, or vital), see any of Blackford's work.

29. Blackford, *The Job, the Man, the Boss,* 195, 113.

30. By the late nineteenth and early twentieth centuries, however, the distinctions between the two "sciences" had broken down, especially in popular treatments, with phrenologists examining faces and physiognomists examining heads shapes. See, e.g., Mary Olmstead Stanton, *A System of Practical and Scientific Physiognomy,* 2 vols. (London: F. A. Davis, 1890).

31. Darwin, *Expression of the Emotions in Man and Animals,* 1, my emphasis.

32. Elizabeth C. Evans, "Physiognomics in the Ancient World," *Transactions of the American Philosophical Society* 59 (1969): 6. According to Siegfried Frey, when physiognomy's reputation suffered one of its periodic declines in the 1790s, the practice's first modern historian, Georg Gustav Fulleborn, salvaged Aristotle's reputation by severing the hitherto assumed link between Aristotle and the *Phsyiognominica* (Frey, "Lavater, Lichtenberg, and the Suggestive Power of the Human Face," in *The Faces of Physiognomy: Interdisciplinary Approaches to Johann Caspar Lavater,* ed. Ellis Shookman [Columbia, SC: Camden House, 1993], 102).

33. John Graham, *Lavater's Essays on Physiognomy: A Study in the History of Ideas* (Bern: Peter Lang, 1979), 86. Among the recent book-length studies, see esp. Christopher Rivers, *Face Value: Physiognomic Thought and the Legible Body in Marivaux, Lavater, Balzac, Gautier, and Zola* (Madison: University of Wisconsin Press, 1994); Graeme Tytler, *Physiognomy in the European Novel: Faces*

and Fortunes (Princeton, NJ: Princeton University Press, 1982); and Juliet Mc-Master, *The Index of the Mind: Physiognomy in the Novel* (Lethbridge, AB: University of Lethbridge Press, 1990). For a further, more extensive bibliography, see Graeme Tytler, "Lavater and the Nineteenth-Century English Novel," in Shookman, *Faces of Physiognomy*, 161–81.

34. Carsten Zelle, "Soul Semiology: On Lavater's Physiognomic Principles," in Shookman, *Faces of Physiognomy*, 44.

35. Wells, *How to Read Character*, 14.

36. See Madeleine B. Stern, *Heads and Headlines: The Phrenological Fowlers* (Norman: University of Oklahoma Press, 1971), for a fuller discussion of the Fowlers and nineteenth-century phrenology.

37. Phrenologists used their skill to dispense advice concerning marriage and choice of occupation, sometimes using photographs sent through the mails as a basis for examination. The phrenologist Charlotte Fowler Wells, for example, established an employment bureau for household help at the turn of the century; in 1904 she established a National Vocation Bureau.

38. Blackford and Newcomb, *Analyzing Character*, 53.

39. Roland Barthes, "The Reality Effect," in *The Rustle of Language*, trans. Richard Howard (Oxford: Basil Blackwell, 1986), 148.

40. On Lavater, see Rivers, *Face Value*, 75.

41. Robert A. Sobieszek and Odette M. Appel, *The Daguerreotypes of Southworth and Hawes* (1976; reprint, New York: Dover, 1980), xvii. On the aesthetics of portraiture and nineteenth-century photography, see Alan Trachtenberg, *Reading American Photographs: Images as History, Mathew Brady to Walker Evans* (New York: Hill and Wang, 1989), 45–52; and Mary Panzer, *Mathew Brady and the Image of History* (Washington, DC: Smithsonian Institution Press, 1997), 46–53.

42. Benjamin H. D. Buchloh, "Residual Resemblance: Three Notes on the Ends of Portraiture," in *Face-Off: The Portrait in Recent Art*, ed. Melissa E. Feldman (Philadelphia: Institute of Contemporary Architecture, University of Pennsylvania, 1994), 65.

43. Lavater, *Essays on Physiognomy*, 1:218, 214.

44. Sabine Hake, "Faces of Weimar Germany," in *The Image in Dispute: Art and Cinema in the Age of Photography*, ed. Dudley Andrew (Austin: University of Texas Press, 1997), 117–50.

45. Some recent critics have offered a presentist reading of phrenology as "unscientific," failing to acknowledge the complexity of nineteenth-century scientific thought concerning the relationship between the mind and body or phrenology's lingering influence (see, e.g., Sandra Phillips, "Identifying the Criminal," in *Police Pictures: The Photograph as Evidence*, ed. Sandra Phillips, Mark Haworth Booth, and Carol Squiers [San Francisco: San Francisco Museum of Modern Art / Chronicle Books, 1997], 15, arguing that "in the early

part of the nineteenth century, the concepts of physiognomy were applied to the new study of phrenology, which quickly became a popular—and unscientific—fad").

46. F. H. Pike, "Defense of the New Phrenology," *Science*, 19 Apr. 1912, 619. For late-nineteenth-century expressions of the rapprochement between modern brain physiology and phrenology, see Clevenger, "Cerebrology and the Possible Something in Phrenology"; Wilson, "Old Phrenology and the New"; and Starr, "The Old and the New Phrenology."

47. Stepan, *Idea of Race in Science*, 20.

48. The leader in this area was Samuel Morton, who had collected more than a thousand skulls by the time of his death in 1851; Morton used his collection, composed mainly of specimens from Native American tribes, to win worldwide respect for the "American school" of polygeny. Polygenesis held that racial types were static, rather than evolutionary, and that the races of mankind had been separately created as distinct and unequal species. This theory, widely accepted in some quarters during the mid-nineteenth century, departed from both biblical and, later, Darwinian theories concerning the unitary origins of mankind. For further information about Morton, as well as Morton's relationship to phrenology, see William Stanton, *The Leopard's Spots: Scientific Attitudes toward Race in America, 1815–59* (Chicago: University of Chicago Press, 1960), 25–35.

49. Steven Jay Gould, *The Mismeasure of Man* (1981; reprint, New York: Norton, 1996), 85. Through a thorough reanalysis of Morton's data, Gould concludes that Morton's calculations were "a patchwork of fudging and finagling"; there is, in other words, no substantial difference in cranial capacity among races. For further discussions of nineteenth-century measurement practices, especially regarding racial typologies, see Reginald Horsman, *Race and Manifest Destiny: The Origins of American Racial Anglo-Saxonism* (Cambridge: Harvard University Press, 1981), 54–56; Robert W. Rydell, *All the World's a Fair: Visions of Empire at American International Expositions, 1876–1916* (Chicago: University of Chicago Press, 1984), 57, 160–67; and George W. Stocking Jr., *Victorian Anthropology* (New York: Free Press, 1987), esp. 62–69 (physical anthropology). On craniology, gender, and nineteenth-century cultural production, see Bram Dijkstra, *Idols of Perversity: Fantasies of Feminine Evil in Fin-de-Siècle Culture* (New York: Oxford University Press, 1986), 164–68.

50. Blackford, *Reading Character at Sight*, esp. lesson 5, "The Meaning of Race"; Wells, *How to Read Character*, vii–viii. See also Merton, *Descriptive Mentality*, 3, 25, for a substitution of cranial measurement and facial angles for the phrenologists' symbolic head (the illustrations are almost identical).

51. Stepan, *Idea of Race in Science*, 83, 94. The sociologist was William Z. Ripley, whose well-known summary of anthropological and biological ideas on race, *The Races of Europe*, appeared in 1899.

52. Davenport, *Guide to Physical Anthropometry and Androscopy*, 7. Anthropological measurement practices began their route to becoming international standards in 1874 with the publication of *Notes and Queries on Anthropology* by the British Association for the Advancement of Science, a traveler's guide designed to promote standardized measurements of the human form. The more generalized study of body proportions, especially for the purposes of art, has a much older history (see, e.g., Albrecht Dürer's four books on human proportion [1532–34]; Johann Bergmuller's *Anthropometria* [1723]; and Jacob de Wit's *Teekenboek der proportien* [1747]).

53. John S. Haller Jr., *Outcasts from Evolution: Scientific Attitudes of Racial Inferiority, 1859–1900* (Urbana: University of Illinois Press, 1971), esp. 3–40. Haller is unusual in dating modern anthropometry to the American Civil War. Most other accounts cite the 1874 *Notes and Queries* (see above, n. 52) or Francis Galton's 1884 anthropometric lab at the International Heath Exhibition in South Kensington, England.

54. This partial list of measurements is drawn from Sullivan, "Anthropometry of the Siouan Tribes." The book is a compilation of anthropometrical measurements made by Sullivan of 1,431 individuals from various Sioux tribes at the Columbian Exposition in Chicago in 1893. See also Sullivan's well-known guide *Essentials of Anthropology*. Anthropologists were most likely to study either institutionalized or nonwhite populations, such as the "feebleminded," schoolchildren, Native Americans, blacks, or colonized subjects.

55. This work continued through the 1920s among eugenicist scientists (see, e.g., Estabrooks, "Relation between Cranial Capacity, Relative Cranial Capacity, and Intelligence"). As Estabrooks concluded, "The reason for using the stature-capacity index is fairly clear. The brain very evidently has something to do with intelligence and it would seem only reasonable to suppose the larger the brain relative to the size of the individual, the greater would be his or her intelligence" (529). For the relationship between eugenics, racism, and the 1924 Immigration Act, see Daniel Kevles, *In the Name of Eugenics: Genetics and the Uses of Human Heredity* (New York: Knopf, 1985), 96–112.

56. Pearson, *Life, Letters, and Labour of Francis Galton*, 283. Pearson's chapter on Galton's various photographic projects is the fullest account of Galton's methods and inventions, but see also David Green's discussion in "Veins of Resemblance: Photography and Eugenics," *Oxford Art Journal* 7, no. 2 (1985): 3–16.

57. For Bertillion's work, see Edmund R. Spearman, "French Police Photography," *Nature* 42 (30 Oct. 1890): 642–44; and Jacques Boyer, "Bertillion's New System of Anthropometry," *Scientific American*, 29 June 1907, 534–35. Allan Sekula's discussion in "The Body and the Archive," *October* (1986): 36–39, remains the classic exploration in English. For more recent treatments, see Phillips, "Identifying the Criminal," 19–21; Eugenia Parry Janis, "They Say

I and I: and Mean: Anybody," in *Harm's Way: Lust and Madness, Murder and Mayhem*, ed. Joel-Peter Witkin (Santa Fe, NM: Twin Palms, 1994); and Shawn Michelle Smith, *American Archives: Gender, Race, and Class in Visual Culture* (Princeton, NJ: Princeton University Press, 1999).

58. Lombroso, who was heavily influenced by both the French anthropologist and surgeon Paul Broca and Darwin, published his investigations into the biological roots of criminal behavior, *L'Uomo deliquente*, in 1876; a second volume, on the female offender, following in 1889 (English translations of Lombroso's work appeared in 1911 and 1920). Lombroso's idea that criminals were atavistic throwbacks to an earlier evolutionary stage whose bodies bore stigmata (e.g., crania and facial asymmetry, tatooing, left-handedness) indicating their actual or potential criminality was extremely influential in Europe and the United States. Havelock Ellis argued that Lombroso's influence in Italy, France, and Germany was immediate, though controversial, and "as decisive as that of the *Origin of Species*" (see Ellis's 1890 compilation of eugenics thinking on criminality, *The Criminal* [New York: Scribner and Welford, 1890], 39. For an especially virulent American eugenics tract that focuses on the physiognomy of the criminal and the disabled, see Woods Hutchinson, "Our Human Misfits," *Everybody's Magazine*, 25 Oct. 1911, 519–29. For recent treatments of Lombroso's work, see Gould, *Mismeasure of Man*, 142–75; and Daniel Pick, *Faces of Degeneration: A European Disorder, c. 1848–1918* [Cambridge: Cambridge University Press, 1989], 109–52).

59. Blackford, "Afternoon with Bertillion," 428. On the tensions between the "type" and the "individual" in relationship to criminal photography, especially Bertillion's work, see Tom Gunning, "Tracing the Individual Body: Photography, Detectives, and Early Cinema," in *Cinema and the Invention of Modern Life*, ed. Leo Charney and Vanessa B. Schwartz (Berkeley and Los Angeles: University of California Press, 1995), 15–45.

60. "Reading the Human Countenance." The facial angles used by Matthews do not match Camper's precisely, but it can be argued that as far as a popular or business audience was concerned, this discrepancy hardly mattered: after 150 years of scientific physiognomic measurement, especially in profile, Matthews's drawings connoted a scientific validity, however unwarranted.

61. Not coincidentally, as I discuss later in this chapter, streetcar operators were one of the first occupational groups to be tested by industrial psychologists. On the Merton System, see "Story Told by Jaws, Noses, Brows, and Other Facial Features"; Merton, *Vocational Counseling and Employee Selection;* and Merton, *Descriptive Mentality*. See also Wagner, *Characterology*. By 1917 Merton had updated his title to "vocational counselor" and "Director and Lecturer Vocational Counseling Courses, Pace Institutes, NYC." His 1917 book *How to Choose the Right Vocation*, which argued that choosing the right vocation was essential for efficiency, offered a series of self-tests to determine "vocational

fitness." In many regards, his discussion in this book has less in common with Blackford's work than with later vocational-guidance literature.

62. On Kibby's system, see Barton, "What Your Mirror Will Tell about Your Character"; and Kibby, *Layman's Home Study Course*. On Barton, see Warren I. Susman, *Culture as History: The Transformation of American Society in the Twentieth Century* (New York: Pantheon, 1984), 122–31.

63. Payne, "Scientific Selection of Men."

64. For representative positive assessments, see Myron A. Lee, "Character Analysis by the Observational Method"; Hendricks, "Fitting the Man to His Job"; Hendricks, "Scientific Employment Plan"; and "Applying Psychology in Business."

65. Dunlap, "Reading of Character from External Signs," 160.

66. Cleeton, "Estimating Human Character." Ironically, Cleeton's suggested methodology, John B. Watson's mechanistic school of behaviorism, was later criticized as being equally monstrous. Watson's 1913 behaviorist manifesto sought to jettison psychologists' traditional (pre-Freudian) focus on consciousness in favor of the study of stimulus and response, or behavior.

67. On the growth of big business in the late nineteenth and early twentieth centuries, see Walter Licht, *Industrializing America: The Nineteenth Century* (Baltimore: Johns Hopkins University Press, 1995), 133–65. The classic discussion is Alfred D. Chandler Jr., *The Visible Hand: The Managerial Revolution in American Business* (Cambridge: Harvard University Press, Belknap Press, 1977), but for a recent corrective to Chandler's focus on big business during these years, see Philip Scranton, *Endless Novelty: Specialty Production and American Industrialization, 1865–1925* (Princeton, NJ: Princeton University Press, 1997).

68. As the historian Doug Baynton has argued, officials screened out undesirable immigrants, especially those perceived to be disabled, through visual detection as immigrants streamed past inspectors in single file ("The Inspection Line: Detecting Disabled Immigrants at the American Border, 1882–1924" [paper presented at the annual meeting of the Organization of American Historians, 1999]). In the spring of 1913 the American eugenicist H. H. Goddard sent two female assistants to Ellis Island to pick out the "feeble-minded" by sight (see Gould, *Mismeasure of Man*, 195). For immigration numbers, see Steven J. Diner, *A Very Different Age: Americans of the Progressive Era* (New York: Hill and Wang, 1998), 77.

69. Susman, *Culture as History*, 273–74; see also James Gilbert, *Work without Salvation: America's Intellectuals and Industrial Alienation, 1880–1910* (Baltimore: Johns Hopkins University Press, 1977).

70. Karen Haltunnen, *Confidence Men and Painted Women: A Study of Middle-Class Culture in America, 1830–1970* (New Haven: Yale University Press, 1982), 4–5, 40 (quotation), 48–49.

71. On the role of physiognomy in deciphering the crowd within the context of nineteenth-century urbanization, see Judith Wechsler, *A Human Comedy: Physiognomy and Caricature in 19th Century Paris* (Chicago: University of Chicago Press, 1982), 13–17; and Mary Cowling, *The Artist as Anthropologist: The Representation of Type and Character in Victorian Art* (Cambridge: Cambridge University Press, 1989), 1–6.

72. Warren I. Susman, "'Personality' and the Making of Twentieth Century Culture," in *Culture as History: The Transformation of American Culture in the Twentieth Century* (New York" Pantheon Books, 1984), 271–86; John Kasson, *Rudeness and Civility: Manners in Nineteenth-Century America* (New York: Hill and Wang, 1990), 70.

73. Munsterberg's work in applied psychology, though not in vocational testing, was anticipated by Walter Dill Scott, whose first book on the psychology of advertising had been published in 1903. Scott also turned to vocational testing, specializing in the scientific selection of salesmen, after World War I.

74. Frank J. Landy, "Hugo Munsterberg: Victim or Visionary?" *Journal of Applied Psychology* 77, no. 6 (Dec. 1992): 789.

75. Cattell, who met Galton while lecturing at Cambridge in the late 1880s, called him the "greatest man whom I have known" (see A. A. Roback, *History of American Psychology* [New York: Literary Publishers, 1952], 168). On the demise of Cattell's version of "mental anthropometry" in the 1890s see Michael M. Sokal, "James McKeen Cattell and Mental Anthropometry: Nineteenth Century Science and Reform and the Origins of Psychological Testing," in *Psychological Testing and American Society, 1890–1930*, ed. Sokal (New Brunswick, NJ: Rutgers University Press, 1987), 21–46. For a treatment of the intersection between professionalism, language, and intelligence testing in the United States, see JoAnne Brown, *The Definition of a Profession: The Authority of Metaphor in the History of U.S. Intelligence Testing, 1890–1930* (Princeton, NJ: Princeton University Press, 1992).

76. The standard compilation of such tests during these years was Whipple, *Manual of Mental and Physical Tests;* for anthropometric tests, see 1:65–88.

77. For accounts of Munsterberg's life and work, see Matthew Hale Jr., *Human Science and Social Order: Hugo Munsterberg and the Origins of Applied Psychology* (Philadelphia: Temple University Press, 1980); and Phyllis Keller, *States of Belonging: German-American Intellectuals and the First World War* (Cambridge: Harvard University Press, 1979), 7–120. On Munsterberg's background in experimental psychology, see Wolfgang Schonpflug, "The Road Not Taken: A False Start for Cognitive Psychology," *Psychological Review* 101 (1994): 237–42.

78. Munsterberg, *Psychology and Industrial Efficiency*, 51; Munsterberg, "A Laboratory Test for Workers," n.d., acc. 2457, Hugo Munsterberg Manuscript Collection, Rare Books and Manuscripts Department, Boston Public Library (hereafter cited as HMMC/BPL). See also Munsterberg, "Finding a Life's

Work"; and Donald Seymer Napoli, *The Architects of Adjustment: The History of the Psychological Profession in the United States* (Port Washington, NY: Kennikat, 1981).

79. This test, as well as other Munsterberg designed for ship captains, telephone operators, and others are discussed in more detail in Munsterberg, *Psychology and Industrial Efficiency*, 63–82; Muscio, *Lectures on Industrial Psychology*, 131–46; and Drever, *Psychology of Industry*, 37–44. For a history of the industrial-safety movement, see Mark Aldrich, *Safety First: Technology, Labor, and Business in the Building of American Work Safety, 1870–1939* (Baltimore: Johns Hopkins University Press, 1997).

80. Munsterberg, *Psychology and Industrial Efficiency*, 42–74.

81. For a criticism of the use of psychological testing to evaluate railway engineers on the grounds that the experiments fail to test for "character," see Dosch, "To Hire Men by Machinery."

82. Munsterberg argued that existing psychological studies that focused on the "mere process of seeing," especially the acuity of vision, were of limited usefulness since they failed to account for other subjective factors, especially attention. In a 1914 report to the National Electric Illuminating Society on streetlighting, for example, he argued against uniform illumination because of its failure to sustain attention. Such lighting "would produce a hypnoid state. Our attention is naturally fluctuating and will best be kept awake, if the illumination produces an alternation between tension and relaxation. This demands that there be darker regions between the lighted spots" (11 Apr. 1914, acc. 2442, HMMC/BPL. For more on the relationship between attention and vision, especially in relationship to psychology, see the following by Jonathan Crary: "Attention and Modernity in the Nineteenth Century," in *Picturing Science, Producing Art*, ed. Carolyn A. Jones and Peter Galison [New York: Routledge, 1998], 475–99; "Unbinding Vision," *October* 68 [Spring 1994]: 21–44; and *Suspensions of Perception: Attention, Spectacle, and Modern Culture* [Cambridge: MIT Press, 2001]).

83. Munsterberg, *Photoplay*; on attention, see 72–91, and on the emotions, see 112–31. Film theorists have explored this study at some length (see, e.g., Noel Carroll, "Film/Mind Analogies: The Case of Hugo Munsterberg," *Journal of Aesthetics and Art Criticism* 46 [Summer 1988]: 489–99; and Donald Fredericksen, *The Aesthetic of Isolation in Film Theory: Hugo Munsterberg* [New York: Arno, 1977]).

84. Despite Munsterberg's invention of the conductor viewfinder in 1912, he had a "deep aesthetic prejudice" against moving pictures until 1915, when he saw *Neptune's Daughter*, with Annette Kellerman. He became a contributing editor to *Paramount Pictograph* and wrote several screenplays, or "scenarios," which were produced by Paramount Pictures in 1916 under the series title "Testing the Mind" and viewed, he claimed, by 2 million people. Though

scholars have emphasized Munsterberg's aesthetic theory in *The Photoplay*, the content and purpose of the films, rarely discussed, reveal that his aesthetic concerns were closely allied with his work in vocational psychology. He became involved with Paramount in order to "stir up popular interest in the testing of minds for vocational guidance," he told an interviewer in 1916. At the time of his premature death in December 1916, Munsterberg was deeply involved in what he described as "an elaborate undertaking which has engaged my attention for the last four or five years," that is, mass vocational testing through, in part, film (see Munsterberg to Samuel McClintock [La Salle Extension University], 28 Sept. 1916; interview with Munsterberg by representatives of Paramount Pictures, 25 Apr. 1916, acc. 2461; Wallace Thompson [director of publications and advertising, Paramount Pictures] to Munsterberg, 16, 19 May, 20 June 1916, acc. 2182; and Munsterberg to McClintock, 28 Sept., 1, 16 Nov. 1916, acc. 2357A, all in HMMC/BPL).

85. Murphy, "Man for the Job," with illustrations by Edward Hopper.

86. Burtt, *Principles of Employment Psychology*, 16.

87. Loren Baritz, *The Servants of Power: A History of the Use of Social Science in American Industry* (Middletown, CT: Wesleyan University Press, 1960), 74–75.

88. Laird and Remmers, "Study of Intelligence from Photographs," 429; W. B. Johns and Worchester, "Value of the Photograph in the Selection of Teachers."

89. Burtt, *Principles of Employment Psychology*, 24; Burtt's remarks are part of his discussion of physiognomy as "pseudo-psychology." See also Ling, *Management of Personnel Relations*, 232.

90. Laird and Remmers, "Study of Intelligence from Photographs," 429. Laird and Remmers lump Freud in with Blackford as one of the masters of judging mental qualities from external appearances.

91. See Napoli, *Architects of Adjustment*, 92–93. Sokal argues that in Cattell's view, "the Psychological Corporation was to be the most important tool for protecting the public from the quacks."

92. For the study of blondes and brunettes, see Paterson and Ludgate, "Blond and Brunette Traits," 122. Another study on the relationship between anatomical traits, such as coloring and head shape, and academic aptitude can be found in Hull, *Aptitude Testing*. For the executive study, see Harry Hollingworth's review in his *Vocational Psychology and Character Analysis*, 41.

93. Harry Hollingworth, an associate professor of psychology at Columbia and a well-known pioneer of advertising psychology, led the textbook-based discussion of vocational physiognomy. His book *Vocational Psychology: Its Problems and Methods* covered a series of topics destined to become standard concerns for the tide of employee-psychology textbooks that appeared after the war, including job analysis, employee selection, vocational success, psy-

chological testing, and physiognomy. See, for example, the chapter entitled "The Search for Phrenological and Physiognomical Principles." The first book-length treatment of vocational psychology, it was the result of a course Hollingsworth had taught at Columbia on the use of psychological tests in vocational guidance. Another popular text was Harold Ernest Burtt's *Principles of Employment Psychology*, first published in 1926. The second chapter in the 1942 revised edition, entitled "Pseudo-Psychology," discusses the use of photography in the analysis of intelligence and character at some length.

94. Hollingworth, *Vocational Psychology and Character Analysis*, 70, 78. Other employment psychologists, though skeptical of the character analysts' methodology, remained unwilling to dismiss their work out of hand. Walter Van Dyke Bingham and Max Freyd, for example, noted in their 1926 textbook, *Procedures in Employment Psychology*, that "the investigator may try, if disposed, either directly or from photographs, some of the determinants in the Blackford system, the Merton system, or any other system of inferring abilities from facial or bodily features. He should be warned in advance, however, that sincere attempts of scientific investigators have hitherto uniformly failed to disclose statistically significant and rewarding correlations between these phrenological and physiognomic signs and valid criteria of character and ability" (63). Blackford's 1915 *The Job, the Man, the Boss* is included in the book's reference section.

95. Binet, director of the Sorbonne's psychology laboratory, began his studies of intelligence with craniometry, believing with the rest of the scientific community that "intellectual superiority is tied to superiority of cerebral volume." In 1900, however, finding no significant correlation, Binet abandoned this line of inquiry; he recommended in 1904 with the new approach of mental testing, thus severing the link between physical stigmata and mental processes. The 1908 version of his test forms the foundation of the modern IQ test and represents the first time that diverse faculties of mind were brought together under one index of mental ability (even though Binet had argued that intelligence was too complex to be indexed by a simply number). Lewis M. Terman, whose interest in intelligence was sparked by a childhood visit with a phrenologist, was one of Binet's main popularizers; the revisions he made while based at Stanford (resulting in the Stanford-Binet scale) launched the era of mass intelligence testing, especially in the schools (Gould, *Mismeasure of Man*, 176–78, 206–7; see also Lewis M. Terman, *The Measurement of Intelligence* [Boston: Houghton Mifflin, 1916]). The other important popularizer was H. H. Goddard, who encountered Binet's work on a 1908 visit to France and who used Binet's intelligence tests to help diagnose the mentally disabled (see Leila Zenderland, "The Debate over Diagnosis: Henry Herbert Goddard and the Medical Acceptance of Intelligence Testing," in Sokal, *Psychological Testing and American Society*, 46–75). On the first mass administration of intelligence tests,

during World War I, see Daniel Kevles, "Testing the Army's Intelligence: Psychologists and the Military in W.W.I," *Journal of American History* 55 (1968): 565–81; and David Kennedy, *Over Here: The First World War and American Society* (New York: Oxford University Press, 1980), 187–88.

96. Pintner's study was modified ten years later by a team of experimenters seeking to control for photographic variables: whereas Pintner's study utilized a range of portraits, in which some children were seated and others were standing, for example, the children in the later study were all photographed from the same distance, with the same camera, at a 45° angle, from each side of the child's face. Because of the subjects' IQ range (18–171), the authors concluded that "this experiment does not answer the question whether a group of persons can judge the intelligence of children in a classroom or elsewhere by their photographs alone to any extent better than chance" (Peter C. Gaskill, Norman Fenton, and James P. Porter, "Judging the Intelligence of Boys from Their Photographs," *Journal of Applied Psychology* 11, no. 5 [1928]: 394–404).

97. Pintner tested the students using the Yerkes-Bridges scale, a 1913 intelligence test popular through 1916 (see Yerkes and Bridges, *Point Scale for Measuring Mental Ability*).

98. Pintner, "Intelligence as Estimated from Photographs," 293. Pintner, another student of Wundt's, received his doctoral degree from the University of Leipzig in 1913. His early work focused on intelligence tests for the deaf, the handicapped, and nonnative English speakers; many of the army's beta tests (for non-English speakers or the illiterate) were based on his work. As a pioneer in the mental-test movement (centered, due to James McKeen Cattell's work in "mental anthropometry," at Columbia, where Pintner worked from 1921 until his death in 1942), Pintner was also a leader in the scientific study of individual differences (see Leonard Zusne, *Biographical Dictionary of Psychology* [Westport, CT: Greenwood, 1984], 339–40. On Cattell's Galtonian work concerning mental and physical differences, predating the introduction of Binet's intelligence scale in the United States, see Sokal, "James McKeen Cattell and Mental Anthropometry").

99. For a sampling of these studies, see Anderson, "Estimating Intelligence by Means of Printed Photographs"; Pope, *Interpretation of the Human Face from Photographs*, 3–17; Glen U. Cleeton and F. B. Knight, "Validity of Character Judgments Based upon External Criteria," *Journal of Applied Psychology* 8, no. 1 (1924): 216–31; Laird and Remmers, "Study of Intelligence from Photographs"; "Can We Read Human Character?"; Snow, "Can We Read Human Character?"; Omwake, "Value of Photographs and Handwriting in Estimating Intelligence"; and Viteles and Smith, "Prediction of Vocational Aptitude and Success from Photographs."

100. Landis and Phelps, "Prediction from Photographs of Success and of Vocational Aptitude," 324.

101. See Watson, "Psychology as the Behaviorist Views It"; and Watson, "Attempted Formulation of the Scope of Behavior Psychology."

102. Cleeton, "What You Can't Tell about People from Their Faces," 27. The photographs in this article showing the expression of emotion match one of the unidentified sets in the NMAH collections.

103. Darwin, *Expression of the Emotions in Man and Animals;* Duchenne, *Mecanisme de la physiognomie humaine* (1862), illustrated photographically (1852–56) by Adrien Tournachon (the brother of the great French photographer Nadar). Duchenne distinguishes the static features, "la physionomie proprement dite," from the expression of emotions, which he calls the "symptomatologie des passions" (1). On this project, see Darwin Marable, "Photography and Human Behavior in the Nineteenth Century," *History of Photography* 9 (Apr.–June 1985): 142–43; and Françoise Heilbrun, "Nadar and the Art of Portrait Photography," in *Nadar*, ed. Maria Morris Hambourg et al. (New York: Metropolitan Museum of Art, 1995), 40–41. See also Mantegazza, *Physiognomy and Expression*, esp. 1–23 for a historical sketch of the science of physiognomy and of human expression. On the distinction between pathognomy and physiognomy in Lavater's work, see Michael Shortland, "The Power of a Thousand Eyes: Johann Caspar Lavater's Science of Physiognomical Perception," *Criticism* 27 (Fall 1986): 389; and idem, "Skin Deep: Barthes, Lavater, and the Legible Body," *Economy and Society* 14 (Aug. 1985): 273–312.

104. Feleky, "Expression of the Emotions"; Feleky, *Feelings and Emotions*, 79. See also Leo Kanner, *Judging Emotions from Facial Expressions* (Princeton, NJ: Psychological Review, 1931): 5–7. Carney Landis, who also worked on facial expressions and photography, as well as the physiology of emotion more generally in the 1920s, agreed with Kanner that few studies followed Darwin's, but he did mention a 1912 study by Rudolf Schulze in Schulze, *Experimental Psychology and Pedagogy*, trans. R. Pintner (London: G. Allen, 1912) (see Landis, "Studies of Emotional Reactions. I," 326). The earliest post-Darwin use of photographs in relation to emotional expression was H. Rudolf's 1903 use of posed photographic portraits of an actor's emotional expression. Because of the exaggeration possible in posing conventional emotions, however, the approach introduced by Feleky and later experimenters was considered more authentic (see Rudolph, *Der Ausdruck der Gemutsbewegungen des Menchen*).

105. Feleky, *Feelings and Emotions*, 109.

106. The NMAH has three sets of expression-of-emotion photographs in its mathematics collections. One is the Feleky set, and two others, also of a young woman, are a related set of images mailed to Dr. Linus W. Kline, of Skidmore College, probably from the 1920s as well (Kline arrived at Skidmore in 1920). See also C. H. Stoelting, *Apparatus, Tests, and Supplies for Psychology, Psychometry, Psychotechnology*, catalog, 1937, p. 167, Mathematics Collections,

Division of the History of Science, NMAH. My thanks to Peggy Kidwell, Museum Specialist, for making these materials available to me.

107. Ruckmick, "Preliminary Study of the Emotions," 31 and figure on 33; see also Stoelting, *Apparatus*, entry 36246, p. 167.

108. Landis, "Studies of Emotional Reactions. I." See also Landis, "Studies of Emotional Reactions. II," 447; and Landis, "Interpretation of Facial Expression in Emotion," 59.

109. Landis, "Studies in Emotional Reactions. I," 336.

110. Hunt, "What Social Intelligence Is and Where to Find It"; see also Hunt, "Measurement of Social Intelligence." For a popular discussion of this work, see Wiggam, "Sizing Up the Other Fellow," reporting that the tests had "already proven highly successful in hundreds of business houses, where they are used as a basis for selecting and promoting employees, and in more than fifty colleges and universities, where they are employed in determining the qualifications of students and in advising them in the choice of a vocation" (40).

111. References to psychology in advertising and sales literature were endemic during the postwar years. For sales material, see, e.g., Hayes, "Psychology and Salesmanship"; "Greatest Ginger Talk Ever Written," excerpted from William James and retitled; "Three Natural Fields of Salesmanship," a discussion of the role of attention, interest, desire, and conviction; and Brasefield, "Psychology and What It Has for the Salesman." Most of the book-length studies on salesmanship include at least one chapter on psychology. On the subconscious, nonrational mind and the role of "suggestion" in "handling and influencing men," see the classic discussion in Walter Dill Scott, *Influencing Men in Business*; see also Bruce, "Psychology and Business," 32–33.

112. Knox, *The Science of Applied Salesmanship*, 28.

113. Ibid., 14–15. On the changing interpretations of "human nature" in business literature, esp. *Printers' Ink*, see Merle Curti, "The Changing Concept of 'Human Nature' in the Literature of American Advertising," *Business History Review* 41 (Winter 1967): 335–57.

114. See, e.g., Larson, "How to Read a Customer"; Esesarte, "Sizing Up the Prospective Customer I"; Larson, "Sizing Up the Prospective Customer II"; Elbon, "Studying the Buyer"; "Development of the Art of Selling"; "Duties and Characteristics of Salespeople"; and Knox, *Salesmanship and Business Efficiency* (1915), 254.

115. Knox, "Personality and How to Develop It"; Knox, Horner, and Ray, *Personality in Action*, 2. See also Tate, "Personality in Salesmanship."

116. Knox, Horner, and Ray, *Personality in Action*, 2.

117. "The Psychology of Salesmanship," *Salesmanship* 1 (June 1903); "An Example of the Power of Suggestion"; "How to Study Salesmanship"; Knox, *Science and Art of Selling*, 59–61, 173–89. See also T. J. Jackson Lears, *Fables of*

Abundance: A Cultural History of Advertising in America (New York: Basic Books, 1994): 208; and Stuart Ewen, *Captains of Consciousness* (New York: McGraw-Hill, 1976): 31–48.

118. "Selling Value of a Smiling Face." Concerning emotion and salesmanship, see also Susan Strasser, "The Smile That Pays," in *The Mythmaking Frame of Mind: Social Imagination and American Culture*, ed. James Gilbert (Belmont, CA: Wadsworth, 1993), 155–77.

119. Carnegie, *How to Win Friends and Influence People*, 98, 101. Carnegie states that he read James, among other psychologists, to prepare the course (20–21).

120. On smiles, see "Selling Value of a Smiling Face"; and Hirschler, "Dress Manner, Poise, Language, and Voice." On James and emotion, see Knox, *Science and Art of Selling*, 59–60. On Carnegie, see Giles Kemp and Edward Caflin, *Dale Carnegie: The Man Who Influenced Millions* (New York: St. Martin's, 1989); William Longwood, *Talking Your Way to Success: The Story of the Dale Carnegie Course* (New York: Associated Press, 1962); and Carnegie's own *How to Win Friends and Influence People*.

121. Blackford and Newcomb, *Analyzing Character*, 353–54.

122. Blackford and Newcomb, *The Right Job.* The copy I consulted was from the UCLA research (graduate) library. For a very humorous parody of Blackford's work, see Ratti, "Secrets of the Psyche."

Chapter 2. Industrial Choreography

1. Adam Smith, *Wealth of Nations* (New York: Modern Library, 1937), 423.

2. Frederick Winslow Taylor, for example, argued that "there was no 'invisible hand' in the factory to bring order out of the complexity. This order was to be discovered and realized by the systematizer" (Taylor, *Principles of Scientific Management* [1911; reprint, New York: Norton, 1967], 86, 140–41).

3. Rexford Tugwell, *The Battle for Democracy* (1935), 14, 245, quoted in John M. Jordan, *Machine-Age Ideology: Social Engineering and American Democracy* (Chapel Hill: University of North Carolina Press, 1994), 250. On Tugwell's relationship to the Resettlement Administration / Farm Security Administration (RA/FSA) photographic project, see Maren Stange, *Symbols of Ideal Life: Social Documentary Photography in America, 1890–1950* (New York: Cambridge University Press, 1989), 89–133.

4. Alfred D. Chandler Jr., *The Visible Hand: The Managerial Revolution in American Business* (Cambridge: Harvard University Press, Belknap Press, 1977).

5. David R. Roediger, *The Wages of Whiteness: Race and the Making of the American Working Class* (New York: Verso, 1991), 43–64.

6. On the relationship between union representation and scientific management, see Hoxie, *Scientific Management and Labor;* and Milton J. Nadworny,

Scientific Management and the Unions (Cambridge: Harvard University Press, 1955). See also David Montgomery, *Workers' Control in America: Studies in the History of Work, Technology, and Labor Struggles* (New York: Cambridge University Press, 1979).

7. Edna Yost, *Frank and Lillian Gilbreth: Partners for Life* (New Brunswick, NJ: Rutgers University Press, 1949), 155.

8. Brian Price, "One Best Way: Frank and Lillian Gilbreth's Transformation of Scientific Management, 1885–1940" (Ph.D. diss., Purdue University, 1987), 91. Price's treatment remains the most detailed investigation of the Gilbreths' career, especially their relationship to labor. On the pervasive appeal of efficiency in American culture more broadly during these years, see Cecelia Tichi, *Shifting Gears: Technology, Literature, Culture in Modernist America* (Chapel Hill: University of North Carolina Press, 1987), 75–97.

9. A full treatment of Lillian Gilbreth's important career as an industrial psychologist, consultant, and author is beyond the scope of this discussion. She had a tremendous influence on her husband, especially concerning management questions, but was not as centrally involved with the photographing and filming of work. Unless otherwise indicated, my use of the name Gilbreth refers to Frank rather than Lillian. For more information about Lillian, see Sherry E. Sullivan, "Management's Unsung Theorist: An Examination of the Works of Lillian Gilbreth," *Biography: An Interdisciplinary Quarterly* 18 (1995): 31–41; Martha M. Trescott, "Women Engineers in History: Profiles in Holism and Persistence," in *Women in Scientific and Engineering Professions*, ed. Viplet B. Haas and Carolyn C. Perrucci (Ann Arbor: University of Michigan Press, 1984), 181–204; Laurel Graham, *Managing on Her Own: Dr. Lillian Gilbreth and Women's Work in the Interwar Era* (Norcross, GA: Engineering and Management Press, 1998); and Jane Lancaster, "Wasn't She the Mother in *Cheaper by the Dozen?* The Life of Dr. Lillian Moller Gilbreth, 1878–1972" (Ph.D. diss., Brown University, 1998).

10. Lillian M. Gilbreth, *Quest of the One Best Way*, 15. Frank Gilbreth was not much of a student, and he was anxious to make money right away.

11. Work in the building trades was more highly paid than any other industrial work besides shipbuilding. Even though builders worked only twenty-four weeks a year, by 1885 they were earning three dollars a day. Gilbreth was fortunate to apprentice at a time when he could learn the trade without being bound as rigidly as he would have been five years earlier; changes in the apprentice system were accompanied by volatility in the labor market resulting from labor organizing, especially through the Knights of Labor. But, by 1891 labor, through the American Federation of Labor, had tightened its grip on the apprentice system enough to force Boston builders into an agreement modeled after the Philadelphia apprentice agreements of 1881, calling for a four- to five-year apprenticeship (Yost, *Frank and Lillian Gilbreth*, 35–37).

12. Ibid., 119–20, 213.

13. On the important role that progressive women had in applied psychology, as well as analysis of the professional limitations this generation of women faced as a result of their sex and gender, see Sharon Hartman Strom, *Beyond the Typewriter: Gender, Class, and the Origins of Modern Office Work, 1900–1930* (Urbana: University of Illinois Press, 1992), 109–61.

14. For the classic discussions, see Robert H. Wiebe, *The Search for Order, 1877–1920* (New York: Hill and Wang, 1967); and Samuel Haber, *Efficiency and Uplift: Scientific Management in the Progressive Era, 1890–1920* (Chicago: University of Chicago Press, 1964). See also Tichi, *Shifting Gears*, 75–97; Martha Banta, *Taylored Lives: Narrative Productions in the Age of Taylor, Veblen, and Ford* (Berkeley and Los Angeles: University of California Press, 1993); and Mark Seltzer, *Bodies and Machines* (New York: Routledge, 1992).

15. See Joseph A. Litterer, "Systematic Management: The Search for Order and Integration," *Business History Review* 35 (Winter 1961): 461–77; and idem, "Systematic Management: Design for Organizational Recoupling in American Manufacturing Firms," ibid. 37 (Winter 1963): 369–92.

16. For a representative statement of this sentiment, see Harrington Emerson, "Efficiency and the New Tariff." *Efficiency* was hardly a value-neutral term; what is possible is not necessarily what is desirable, and the conflict over the two was at the core of labor opposition to scientific management during these years (see Hugh Aitkin, *Taylorism at Watertown Arsenal* [Cambridge: Harvard University Press, 1960], 20–21).

17. Daniel Nelson, *Managers and Workers: Origins of the Twentieth-Century Factory System in the United States, 1880–1920*, 2d ed. (Madison: University of Wisconsin Press, 1995), 46–51; idem, "Scientific Management, Systematic Management, and Labor, 1880–1915," *Business History Review* 48 (Winter 1974): 480. On the shift from limited to flexible mass production in the United States during these years, see David A. Hounshell, *From the American System to Mass Production, 1800–1932: The Development of Manufacturing Technology in the United States* (Baltimore: Johns Hopkins University Press, 1984); and Philip Scranton, *Endless Novelty: Specialty Production and American Industrialization, 1865–1925* (Princeton, NJ: Princeton University Press, 1997). For a discussion of this transformation from the perspective of labor and management relations, see David Montgomery, *The Fall of the House of Labor: The Workplace, the State, and American Labor Activism, 1865–1925* (New York: Cambridge University Press, 1991), 9–58, 214–57.

18. The simultaneous professionalization of engineering was critical to the diffusion of the ideas of systematic management. The American Society of Mechanical Engineers, which increasingly engaged managerial concerns, was founded in 1880; engineering journals such as the ASME's *Transactions, Engineering Magazine*, and *American Machinist* were critical to the dissemination

of managerial innovations. On the professionalization of the field, see Ruth Oldenziel, *Making Technology Masculine: Men, Women, and Modern Machines in America, 1870–1945* (Amsterdam: Amsterdam University Press, 1999).

19. Yost, *Frank and Lillian Gilbreth*, 155; Nelson, *Managers and Workers*, 66–68.

20. Gilbreth had started to become familiar with the circle of Progressive businessmen and managers in the Philadelphia area who were also charting the direction of the ASME, including Horace K. Hathaway and Charles Day. It was James Dodge, president of the Link Belt Company as well as successor to Taylor in the ASME, who introduced Gilbreth and Taylor at the December 1907 meeting of the ASME (Lillian M. Gilbreth, *Quest of the One Best Way*, 31; Yost, *Frank and Lillian Gilbreth*, 155–56).

21. Frederick Winslow Taylor and S. E. Thompson, *A Treatise on Concrete, Plain and Reinforced* (New York: John Wiley and Sons, 1906). As early as 1895 Taylor had developed the idea of publishing a series of handbooks on the time necessary to accomplish tasks in various building trades; he hired Sanford Thompson to prepare manuscripts and undertake time study, which is why Thompson visited Gilbreth's construction site in 1898.

22. For Gilbreth, the advantages of collaboration included advertising and standing within the management community; disadvantages included the production of a book rather than a system, as well as delays to Gilbreth's project, already under way. Gilbreth wanted a book on bricklaying efficiency that he could use in his own contracting work and that would establish him as a systematizer in his own right (Frank B. Gilbreth diary [hereafter cited as FBG diary], 28 Jan. 1908, "N" File [hereafter cited as NF] 109/808-3, Gilbreth Papers, Frank and Lillian Gilbreth Collection, Purdue University Libraries Special Collections, Purdue University, Lafayette, IN [hereafter cited as GPP]).

23. Taylor and Gilbreth had thought that the bricklaying time-study data that Thompson had put together for his manuscript would be sufficient for setting rates for Gilbreth's bricklayers, but instead Thompson sent his stopwatch person, William O. Lichtner, to undertake new time studies of the bricklayers. In addition to other snags, the bricklayers, members of the Bricklayers Local Union No. 44, a Massachusetts local, successfully struck the job, objecting to time study and to the differential pay rate (see Price, "One Best Way," 51–57).

24. As industrial engineering professionalized, the time-study experts were increasingly likely to be recent college graduates whose knowledge had been gained in the classroom rather than on the shop floor ("white shirts"); as a result, these so-called experts were often ill-equipped to understand the complexities of specific (especially skilled) jobs and therefore had difficulty in understanding exactly how to break down a job into component parts suitable for timing.

25. Ironically, as the camera replaced the stopwatch as an instrument of time study, time study itself became mechanized, a microcosm of the transformation taking place in industry as a whole, as more and more hand-intensive jobs were replaced by mechanization.

26. Taylor's interest in visual technology may have stemmed in part from his relationship with Coleman Sellers Sr., the chief engineer for his cousin's Philadelphia-based machine-tool concern, William Sellers & Company, as well as a brilliant inventor with an abiding interest in moving pictures. In 1861 Sellers patented the Kinematoscope, a device designed to "exhibit stereoscopic pictures [so] as to make them represent objects in motion such as the revolving wheels of machinery, and various motions of the human body, adding to the wonders of that marvelous invention 'the stereoscope' a semblance of life that can only come from motion" (Charles Musser, *The Emergence of Cinema: The American Screen to 1907*, 2d ed. (Berkeley and Los Angeles: University of California Press, 1994], 43–45).

27. Horace K. Hathaway to Margaret Ellen Hawley, 14 Oct. 1927, NF 111/0812-1, GPP.

28. Yost, *Frank and Lillian Gilbreth*, ch. 15; Brian Price, "Frank and Lillian Gilbreth and the Manufacture and Marketing of Motion Study, 1908–1924," *Business and Economic History* 18 (1989): 88–99. The concern with standardization was pervasive during these years, as the efficiency and the elimination of waste central to the American system of mass production were predicated on standardized parts, tools, and systems (see, e.g., Hounshell, *From the American System to Mass Production*).

29. Frank B. Gilbreth, "Motion Study as an Increase of National Wealth," NF 5/0030-27, GPP, reprinted in Gilbreth and Gilbreth, *Applied Motion Study*, 41–56.

30. Frank B. Gilbreth, *Bricklaying System*, 140.

31. Gilbreth had his own version of Taylor's differential piece rate, tied to the worker's adherence to Gilbreth's bricklaying methods. Those who followed the system received a "substantial increase over the minimum rate of pay"; those who could partly follow it received "more money than the minimum rate"; those who made a good-faith effort but were nonetheless unable to learn the system received the minimum wage; and those who refused to make even a good-faith effort would not be hired unless no other bricklayers were available (ibid., 142–43).

32. Ibid., 140–64. According to L. W. Peck, "At times individual records at the rate of 3,000 brick were made, and on the last two days of the contract the entire bricklaying gang averaged 2,600 bricks per day per man" (Peck, "High Record in Bricklaying Attained").

33. See esp. the series of images A49-111, 113, and 114, all made on 22 Dec. 1908, in NF 10/0031-1, GPP. Here, the hand of a well-dressed man dem-

onstrates the proper way to reach for and pick up a brick. Most of the other images in this group of photographs record Gilbreth's site innovations designed to increase production speed, such as the conveyor belt, Gilbreth's patented scaffolding system, and a pulley system for hauling bricks, among others.

34. Frank B. Gilbreth, *Bricklaying System*, 140–41. Gilbreth, looking ahead to a time when he would seek to apply motion study in "all branches of the mechanical trades," also solicited photographs from readers illustrating "the best methods used by the best mechanics in working their trade."

35. FBG diary, typescript, 23 Nov. 1908, 2:26, NF 109/808-3, GPP.

36. Gilbreth used these images again in *Motion Study*, published in 1911.

37. Frank B. Gilbreth, *Bricklaying System*, 145.

38. For distinctions between a group, a series, and a sequence, see Keith A. Smith, *Structure of the Visual Book*, expanded 4th ed. (Rochester, NY: K. Smith Books, 2003). Smith, drawing on Nathan Lyons's work at the Visual Studies Workshop, among other sources, defines a group as a topical cluster of images, for which there is no set order of viewing; a series as a linear progression based upon forward movement, both visually and conceptually; and a sequence as not necessarily based on forward movement but instead determined more by cause and effect, resulting in more of a conceptual montage, with meaning flowing more freely among layers.

39. Indeed, the bricklayers had walked off Gilbreth's previous job over a time-study dispute, while in a heated address to the strikers Gilbreth claimed legitimacy as a "union man." He more than likely undercut his efforts at solidarity, however, by exclaiming, "I will raise the pay of the bricklaying mechanics throughout the United States in spite of the interference of pig headed, ignorant men in Gardner" (FBG diary, typescript, 23 Nov. 1908, 2:26, NF 109/808-3, GPP). The unionized bricklayers struck Gilbreth's 1911 job at Glens Falls, New York as well, objecting to having their output measured and to Gilbreth's differential pay scale. Gilbreth capitulated on this job: he stopped measuring output, paid a uniform sixty-five cents per hour to all bricklayers, and stopped insisting on his bricklaying system (Price, "One Best Way," 84).

40. Allan Sekula, "Photography between Labour and Capital," in *Mining Photographs and Other Pictures, 1948–1968: A Selection from the Negative Archives of Shedden Studio, Glace Bay, Cape Breton*, photographs by Leslie Shedden, essays by Don Macgillivray and Allan Sekula, intro. Robert Wilkie, ed. Benjamin H. D. Buchloch and Robert Wilkie (Halifax: Press of the Nova Scotia College of Art and Design, 1983), 234.

41. Milton J. Nadworny, "Frederick Taylor and Frank Gilbreth: Competition in Scientific Management," *Business History Review* 31 (Spring 1957): 23–34.

42. Waste was the product of inefficiency, and Progressive Era reformers concerned with increasing any type of industrial or social efficiency identified

and exhibited waste as a rhetorical strategy in numerous social and cultural debates (see, e.g., Cronau, *Our Wasteful Nation;* Committee on Elimination of Waste in Industry of the Federated American Engineering Societies, *Waste in Industry* [New York: McGraw-Hill, 1921]; and Stuart Chase, *The Tragedy of Waste* [New York: Macmillan, 1925]). For a discussion of the widespread use, as well as varying conceptualizations of the term, see Tichi, *Shifting Gears,* 63–75.

43. Frank B. Gilbreth, "Economic Value of Motion Study in Standardizing the Trades," 265, NF 42/0265-2, GPP. On the relationship between Progressive Era efficiency ideals and the early conservation movement, see Samuel Hays, *Conservation and the Gospel of Efficiency: The Progressive Conservation Movement, 1890–1920* (Cambridge: Harvard University Press, 1959).

44. Frank B. Gilbreth, *Motion Study,* 76.

45. Anson Rabinbach has discussed how nineteenth-century European scientists, borrowing from earlier discoveries in thermodynamics, reconceptualized work from an organic process connected to a discrete individual to "labor power," a distinct force that scientists could "objectively" identify, study, and control. The structuring metaphor for this conceptual shift became that of the human motor (Rabinbach, *The Human Motor: Energy, Fatigue, and the Origins of Modernity* [New York: Basic Books, 1990]).

46. In his discussion of the working environment, Gilbreth clearly benefited from Lillian's contributions, as he did in all of his work after their 1904 marriage (see Jane Lancaster, "Wasn't She the Mother in Cheaper by the Dozen?"). Lillian's interest—and later training—in psychology is clear in the 1911 motion-study publications. Their discussions of such topics as workers' health, the role of music and other forms of entertainment at work, and the use of light and color in the workplace reflect contemporary concerns of welfare secretaries and anticipate the emphases of applied psychologists and industrial sociologists after World War I.

47. Frank B. Gilbreth, *Motion Study,* 65–70.

48. Ibid., 72–73. Cost reduction was a key component of systematic management, as well as an important selling device for industrial-engineering consultants seeking to attract new clients (see also Frank B. Gilbreth, "Motion Study as an Increase of National Wealth").

49. Frank B. Gilbreth, *Motion Study,* 90–91. Throughout his career, Gilbreth continued to write on standardization and to collect articles about it. He advocated a U.S. bureau of standardization of mechanical trades with federally sponsored experiment stations similar to those run by the Department of Agriculture. In a typewritten manuscript dated 1915, for example, he exclaimed, "I say, 'Standardize everything under the sun" (NF 0, GPP. See also in this folder W. E. Freeland, "Standardization of Products as a Plant Economy," *Lewis Bulletin,* 19 Nov. 1921, which reprinted an address given before the Taylor Society on 4 December 1920; A. A. Stevenson, "Significance of Standardization

to American Industry and the Federal Government," *Mechanical Engineering* 44:185–86; and H. Campbell and Alex Taub, "Waste Elimination through Standardization," *American Machinist*, 9 Mar. 1922, 363).

50. See, e.g., "Decline of Brickwork," *Waterbury Republican*, 2 Aug. 1908, and Frank B. Gilbreth, "Systematizing a Contractor's Office," *Construction News*, 7 Nov. 1908, both on microfilm, roll 1, GPP.

51. Frank B. Gilbreth, "Economic Value of Motion Study in Standardizing the Trades," 266, in NF 42/0265-2, GPP.

52. Frank B. Gilbreth, *Motion Study*, 103.

53. Price, "One Best Way," 153–55; see this same source for a fuller discussion of Gilbreth's installation at the New England Butt Company. The name Betterment Room reflects the Gilbreths' increasing focus on post-Taylor modifications to scientific management, as they sought to introduce ideas of worker education and participation as a means of defusing worker antipathy. At New England Butt, for example, the Gilbreths sought to institutionalize labor's involvement in the installation of scientific management by sponsoring weekly lectures in which scientific management was discussed by management and operatives; setting up a home reading system; arranging for a branch library to open in the factory; and setting up a suggestion system, with monthly prizes. Gilbreth began his motion-study work in the company offices, rather than in the shop, in order to demonstrate that white-collar work could also be made more efficient. For more on this shift to "welfare work," in which the Gilbreths were important early figures, see Stuart D. Brandes, *American Welfare Capitalism, 1880–1940* (Chicago: University of Chicago Press, 1976); Sanford M. Jacoby, *Employing Bureaucracy: Managers, Unions, and the Transformation of Work in American Industry, 1900–1945* (New York: Columbia University Press, 1985); and Nikki Mandell, *The Corporation as Family: The Gendering of Corporate Welfare, 1890–1930* (Chapel Hill: University of North Carolina Press, 2002).

54. This is especially true given that the specific reforms instituted by the Gilbreths began to unravel soon after they were introduced at the factory; according to Brian Price, this installation, "which Gilbreth intended as a monument to Taylorism began to crumble almost as quickly as it had been erected" (Price, "One Best Way," 156).

55. Caption to photo 610-1028, New England Butt Company album, Gilbreth microfilm, roll 2, GPP.

56. On 1 and 4 March 1912 Gilbreth wrote his English contacts Anna G. Cross and James F. Butterworth that he had developed a new process for making motion studies (Frank B. Gilbreth [hereafter cited as FBG in references to correspondence] to Anna G. Cross, 1 Mar. 1912, NF 117/0816-37, GPP, and FBG to James F. Butterworth, 4 Mar. 1912, NF 118/0816-76, GPP).

57. British patent application, received by FBG, 7 Apr. 1912, NF 117/0816-44, GPP.

58. Whitaker's first daily report to Gilbreth, dated 19 June 1912, is a three-page memo detailing the savings to be realized from more efficient window washing (S. E. Whitaker to FBG, 19 June 1912, NF 159/0952-2, GPP).

59. The term *motion study* is ambiguous since it can reference to either a noun (a document) or a verb (a process), neither of which necessarily implies photographic study, although increasingly motion study grew to be synonymous with the use of photographic technology. In the earlier bricklaying work, Gilbreth had used the term to refer to both still photographs and charts. In the present context the term, used in conjunction with time study, seems to describe the physical process of observing the work with an eye to analyzing motion, a process that can be (and was) accomplished without the use of a camera. In other words, *motion study* can describe both the process and the resulting record.

60. Whitaker to FBG, 15 July 1912, NF 159/0952-2, GPP.

61. See Whitaker to FBG, 25 June, 15, 18, 19 July 1912, ibid. There are no film positive strips from earlier than 6 August 1912 in the NF material. The work under observation in the Betterment Room involved the assembly of various types of braiding machines. One of Gilbreth's early efficiency innovations—implemented before motion-picture filming—was to have the necessary component machine parts laid out ahead of time on a "vertical packet" near the assembly site. This work, performed by a lesser-paid assistant, saved the assembler time since he did not have to hunt about for parts stored in boxes, many of which had not been properly machined to begin with and therefore required additional filing and cleaning prior to assembly. The packet was a Taylor idea that Gilbreth had previously adapted to his construction work, especially bricklaying.

62. Whitaker to FBG, 25, 27 July, 19 Aug. 1912, ibid.

63. Gilbreth continued to redesign these clocks; the one in use on 6 August 1912, built by Mr. Winter, had one hundred divisions (Whitaker to FBG, 22 July 1912, ibid.). Winter left the company on 23 October 1912 in order to join the drafting room of a tool company in preparation for going into business with his brothers (Whitaker to FBG, 23 Oct. 1912, ibid.). Eventually Gilbreth used a clock that revolved twenty times per minute; with one hundred divisions on its face, the micromotion analyst could distinguish motions to the one two-thousandth of a minute, what Gilbreth called a "wink" (see "Making a Micromotion Study," Gilbreth microfilm, roll 2, GPP).

64. Robert Thurston Kent, "Micro-motion Study: A New Development in Efficiency Engineering," *Scientific American*, 25 Jan. 1913, 84, NF 5/0030-25, GPP. The word *cinematograph* was first used in 1892 in a French camera patent (Anthony R. Michaelis, *Research Films in Biology, Anthropology, Psychology, and Medicine* [New York: Academic Press, 1955], 1).

65. Frank B. Gilbreth, "Description of Photographs sent to Mr. Robert Moulton," caption to photo 1109, NF 01/0019, vol. 3, GPP. Gilbreth began telling colleagues of this technique, which he called micromotion study, in early March 1912; by April he had filed patent claims. He wrote James F. Butterworth, his English agent and a possible source for the technological information necessary for the project, "I know that you will be pleased to learn that I have perfected a device for taking motion study and time study down to one thousandth of a minute with no variation whatsoever due to human element or lack of human precision" (FBG to Butterworth, 4 Mar. 1912, NF 118/0816-54, GPP; for patent claims, see NF 117/0816-44).

66. Kent, "Micro-motion Study in Industry"; see also Kent, "Micro-motion Study: A New Development in the Art of Time Study."

67. When the Industrial Workers of the World tried to organize the shop in August 1912, they did not meet with much success, perhaps because Gilbreth had taken several steps to avert the problems that had plagued his earlier contracting work. One of these steps was paying the workers double the rate of normal pay when they were under observation in the Betterment Room (Whitaker to FBG, 2 Aug. 1912, NF 159/0952-2, GPP).

68. On the use of film to teach new workers the most efficient way to perform the assigned task, Gilbreth commented, "The only way to teach at demonstration speed the real motions and real methods of the expert is to take the picture very fast and project them very slow, thus slowing down the expert operator with his real motions to a speed that can be seen by the learner" (NF 01/0019, vol. 3, "Captions for Photographs and Glass Diapositives," GL-428, GPP). Gilbreth claimed that his use of film for motion study "enabled the worker to do over three times as much work as formerly with less fatigue." Film was critical to the transfer of skill, he argued, since the motions used by an expert to teach the beginner were not the same as the motions used by the expert when performing most efficiently. The expert worker was not necessarily even aware of the precise nature of these most efficient motions; film, Gilbreth argued, captured these mysterious efficiency hieroglyphs for the benefit of both the experienced and the apprentice worker (caption to photo 610-331, n.d. [c. 1917], NF 01/9919, vol. 3, GPP). Meyer Bloomfield, head commissioner of Vocational Guidance in the Boston public schools and a prominent early advocate for vocational education, visited the "laboratory" (Gilbreth's synonym for the Betterment Room) "to see exactly our method of transference of skill from the experienced worker to the inexperienced worker" (caption to photo 1069, NF 01/0019, vol. 1, GPP).

69. Kent, "Micro-motion Study: A New Development in Efficiency Engineering," 84.

70. See captions in NF 01/0019, vol. 1, GPP.

71. Recipients of these images included the American reformer Jane Addams, the Viennese financier and economist Georg Schlesinger, and numerous others.

72. For a selected example of the Gilbreths' discussion of the use of film in micromotion study, see Frank B. Gilbreth, "Motion Study as an Increase of National Wealth"; and Frank B. Gilbreth and Lillian M. Gilbreth, "Motion Study and Time-Study Instruments of Precision," in NF 42/0265-4, pp. 4–7, GPP.

73. The application of film to motion study generated considerable positive publicity for the Gilbreths (see, e.g., "The New Equipment for Motion Study," *Bulletin of the Efficiency Society*, n.d. [Jan. 1913?], clipping, NF 5/0030-28A, GPP).

74. Price, "One Best Way," 207. The Gilbreths subscribed to a clipping service, and their files contain numerous articles announcing the use of film in motion study (see, e.g., "Silver Seconds in Model Industry," *Outlook* [July 1914], in NF 5/0030-26, GPP; Kent, "Micro-Motion Study: A New Development in Efficiency Engineering"; and "Use Moving Pictures to Promote Business Efficiency," *New York Tribune*, Feb. 1913, in NF 5/0030-25, GPP).

75. As a generation of labor historians have shown, women's industrial labor was more likely to be mechanized and also nonunionized. Employers requiring labor-intensive handwork, such as packing, sorting, canning, folding, and sewing, as well as machine tending, were in general more likely to hire lower-paid women workers. The historiography of this shift is voluminous; for an overview, see Alice Kessler-Harris, *Out to Work: A History of Wage-Earning Women in the United States* (New York: Oxford University Press, 1982), 142–79.

76. While the Hawthorne experiments of 1924–27 built upon the psychological insights of the Gilbreths, the result of these later investigations was to shift the focus of study from the observation of individual operatives or machines (the Gilbreths' focus in 1913) to groups of workers and the elusive element of individual and group psychology. Stuart Chase summed up the importance of the Hawthorne findings as follows: "Some day, factory managers are going to realize that workers are not governed primarily by economic motives. . . . Underneath the stop-watches and bonus plans of the efficiency experts, the worker is driven by a desperate inner urge to find an environment where he can take root, where he belongs and has a function; where he sees the purpose of his work and feels important in achieving it" (quoted in J. A. C. Brown, *The Social Psychology of Industry* [London: Penguin, 1954], 73. See also Richard Gillespie's *Manufacturing Knowledge: A History of the Hawthorne Experiments* [Cambridge: Cambridge University Press, 1991]).

77. Kathy Peiss, *Cheap Amusements: Working Women and Leisure in Turn-of-the-Century New York* (Philadelphia: Temple University Press, 1986), 148.

78. John Collier, "Moving Pictures: Their Function and Regulation," *Playground* 4 (Oct. 1910): 232, quoted in Roy Rosenzweig, *Eight Hours for What We Will: Workers and Leisure in an Industrial City, 1870–1920* (New York: Cambridge University Press, 1983), 194.

79. Eileen Bowser, *The Transformation of Cinema, 1907–1915* (Berkeley and Los Angeles: University of California Press, 1990), 103–21.

80. Robert Sklar, *Movie Made America: A Cultural History of American Movies* (New York: Vintage Books, 1994), 40.

81. For Frank Gilbreth's use of the term *star*, see the caption to image 18306, NF 01/0019, vol. 1, GPP. On this point, see also Richard Lindstrom's excellent article, "They All Believe They Are Undiscovered Mary Pickfords: Workers, Photography, and Scientific Management," *Technology and Culture* 41 (Oct. 2000): 725–51, which appeared after I had completed my research.

82. The Gilbreths' systems seem to have been successfully maintained so long as Frank Gilbreth was directly involved with the installation. As soon as he turned his attentions elsewhere, however, workers and managers reverted to their former patterns. As a result, none of the Gilbreths' installations lasted much longer than the duration of the contract, and some fell apart even before; this was a problem that plagued other installations of scientific management as well. On the denouement of representative Gilbreth contracts, see Price, "One Best Way," 216 (New England Butt Company) and 256 (Hermann, Aukam).

83. On the relationship between early film and changing ideas of time, see Michael O'Malley, *Keeping Watch: A History of American Time* (New York: Viking, 1990), 210–11. As O'Malley and others discuss, the period 1908–15 marked the rise of feature films (esp. after 1912), a growing middle-class audience (esp. after the National Board of Censorship was organized in 1908 to oversee film content), and the introduction of new narrative techniques, such as crosscutting, the use of multiple camera angles, and closeups. O'Malley argues that by 1915 these changes had reintegrated early films into the framework of standard time.

84. Lillian Gilbreth, who continued the family business after her husband's death, was forced by sex discrimination to limit her consulting to "women's work." Film remained an important element of that work, however. For example, as a consultant to Macy's New York store (1925–28) Lillian Gilbreth helped the head of the Planning Department at Macy's, B. Eugenia Lies, to film cashiers and typists as part of a larger program designed to make sales work more efficient (see Laurel Diane Graham, "Lillian Moller Gilbreth's Extensions of Scientific Management into Women's Work, 1924–1935" [Ph.D. diss., University of Illinois at Urbana-Champaign, 1992], 37–73).

85. Walter Benjamin discusses this process in relationship to film reception, arguing that modern technology's various haptic and optical "shocks" have newly "subjected the human sensorium to a complex kind of training."

Film is a logical medium for this new sensorial training, since "in a film, perception in the form of shocks was established as a formal principle." As he argued, "That which determines the rhythm of production on a conveyor belt is the basis of the rhythm of reception in the film" (Walter Benjamin, "On Some Motifs in Baudelaire," in *Illuminations: Essays and Reflections*, ed. Hannah Arendt [New York: Schocken Books, 1968], 175).

86. Scholars of mass culture and early cinema have described how late-nineteenth-century spectacles of realism (e.g., tabloid journalism, expositions, and wax museums), combined with decades of optical amusements such as the zoopraxiscope, formulated a type of "cinematic spectatorship" even before the advent of cinema, which was a widespread form of urban entertainment by 1908. For cinematic modes of viewing, see Vanessa R. Schwartz, "Cinematic Spectatorship before the Apparatus: The Public Taste for Reality in Fin-de-Siècle Paris," in *Cinema and the Invention of Modern Life*, ed. Leo Charney and Vanessa Schwartz (Berkeley and Los Angeles: University of California Press, 1995), 297–319, as well as the other essays in this collection; see also Schwartz's *Spectacular Realities: Early Mass Culture in Fin-de-Siècle Paris* (Berkeley and Los Angeles: University of California Press, 1998).

87. On 2 April 1913 Whitaker wrote Frank Gilbreth that on "Tuesday afternoon, at 71 Brown Street, the first trial of the Orbit method of motion study was made; the second study was made at the New England Butt Co. on the third floor later in the afternoon." The Brown Street address was the Gilbreth residence, where some of the photographic work was being experimented with; the third floor of the New England Butt Company was the Betterment Room (NF 159/0952-2, GPP).

88. For an early description of the cyclegraph process, see "Cymography: The New Efficiency Science," clipping from *Coal Age*, NF 5/0030-28A, GPP. This article reprinted two cyclegraph images from the *American Machinist*, which had also covered the story. Almost all of the Gilbreths' published writings and business correspondence highlight the development of cyclegraphy after April 1913. For a representative discussion of the technology and its applications, see Gilbreth and Gilbreth, "Motion Study and Time-Study Instruments of Precision."

89. Later, the pace of pulsations was increased to as high as three thousand per minute (see, e.g., caption to image 1028, a chronocyclegraph of a turret-lathe operator, NF 01/0019, vol. 1, GPP).

90. The caption to one image of the cyclegraph describes it as showing "intermittent electric lights with the filament and the current so proportioned that the light brightens quickly and dies out slowly. This gives us a photograph of time in that the number of flashes per second is known. Moreover, the point on the spot shows the direction of the motion" (caption to image 618-G68-2, NF 01/9919, vol. 3, GPP. See also Frank B. Gilbreth and Lillian M. Gilbreth,

"Chronocyclegraph Motion Devices for Measuring Achievement," reprinted in *Efficiency Society Journal* 5, no. 3 [Mar. 1916]: 137–49. The cross-screened background was accomplished by photographing chalk lines on a blackboard and then using the same plate to photograph a worker's motions. The resulting image was a double exposure. Muybridge used a cross-screened background (constructed using white threads) at the University of Pennsylvania as early as 1885; his approach was in turn borrowed from nineteenth-century English anthropometric photography.

91. Kent, "Micro-motion Study in Industry," 34.

92. Enoch B. Garey to Hawley, 14 Jan. 1929, NF 111/0812-1, GPP.

93. The Gilbreths saved and filed almost all documents relating to their work. There was so much material, in fact, that filing was one of the children's weekly chores, in addition to housekeeping and other activities (NF 111/0809-1, GPP).

94. In the United States, Coleman Sellers's Kinematoscope (1861) was intended, in part, to demonstrate the workings of his machinery in motion. And the first mutoscope pictures (1896) were pictures of loom-weaving machinery that the traveling salesman could use to show merchants what they were buying, as well as the machinery's working parts. Two of the original founders of the American Mutoscope Company had worked together in a Syracuse, New York, machine shop; a third partner, William Kennedy Laurie Dickson, was the photographic innovator behind Edison's motion-picture work (Anthony Slide, *Early American Cinema* [Metuchen, NJ: Scarecrow, 1994], 11–12; Musser, *Emergence of Cinema*, 43, 176). Edison's genius was, in part, his ability to apply the industrial and scientific innovations of Marey, Muybridge, and others to commercial entertainment.

95. During their sojourn in London, Frank wrote Lillian, who was visiting relatives in Germany while Frank stayed behind in London to attend to business, "Now I've searched the trunks for that copy of the micro-motion paper and can't find it, so I had better borrow Jimmy's [James F. Butterworth's]. I have got to go to Birmingham . . . and then I can meet you in Paris if there is any good in doing so, and I think there is—but I can't tell now. . . . I've dined with Butterworth or he with me every day, in fact twice every day since I returned. He is a bright chap and he knows that this thing is right. Too bad we have to worry once in a while but it seems good for a respite once in a while" (FBG to Lillian M. Gilbreth [hereafter cited as LMG in references to correspondence], 7 Aug. 1910, NF 111/0813-1, GPP).

96. LMG to Hawley, 30 Nov. 1928, NF 111/0812-2, GPP: "I am so sorry but I do not remember when Mr. Gilbreth became acquainted with Muybridge's work. I suppose I could trace the date in his diaries but not now. I do know that he had his work on the cyclegraph well underway and all complete but the refinements before Mr. James Butterworth, an English friend wrote

him that similar attempts to record work had been made by Muybridge and Marey." See also Margaret Ellen Hawley, "The Life of Frank B. Gilbreth and His Contributions to the Science of Management" (master's thesis, University of California at Berkeley, 1929), 126: "As for motion study, Mr. Gilbreth was by no means the originator of it. For instance, the pioneer work in motions and instantaneous photography by Muybridge in America and Marey in France antedates Gilbreth's work." Lillian Gilbreth was as anxious as her husband had been to construct and preserve his reputation as the originator of motion study. As Marta Braun has observed, in response to Hawley's assertion, above, Lillian Gilbreth wrote, "Omit!" (see Marta Braun, *Picturing Time: The Work of Etienne-Jules Marey, 1830–1904* [Chicago: University of Chicago Press, 1992], 423n96).

97. Charles Day was a Philadelphia-based engineer in the firm of Day and Zimmerman, successors to Dodge, Day, and Zimmerman. Day's letter of 7 December 1911 to Gilbreth reads: "Dear Frank:—I told Father of your interest in Muybridge's work on animal locomotion and during my absence I find that he has secured a copy for you. I am sending this to you under separate cover and hope that you have not secured one in the interim. Very truly yours, Charles Day" (NF 130/0828-8, GPP).

98. Braun, *Picturing Time*, 344.

99. Typescript, 11 Dec. 1915, NF 01/0019, vol. 1, pt. 2, GPP.

100. Marey, *Movement*, Gilbreth Library, Siegesmund Engineering Library, Purdue University, Lafayette, IN.

101. "We got direction. Marey never got direction, but the fundamental principal of the photography of short intervals we did not get. I have since visited his successor's work and we have become fast friends" (Gilbreth microfilm, roll 2, Misc., GPP).

102. Lillian Gilbreth had gone to Columbia to work toward a master's degree in English under Brander Matthews, but Matthews refused to teach women. Lillian took a number of other classes instead, including a psychology class with the noted applied psychologist Edward Thorndike. She began work toward a Ph.D. in English (with a minor in psychology) at the University of California, Berkeley in 1903, but after marrying Frank in 1904 and moving to the East Coast, she changed the main focus of her work to applied psychology. Berkeley, however, refused to grant her a Ph.D. in 1912, arguing that she had not met the residency requirement. Meanwhile, the Gilbreths had difficulty finding a publisher for Lillian's Ph.D. thesis on the psychology of management, since the work had been authored by a woman. Finally, Lillian entered Brown University's new program in applied management, receiving her Ph.D. in 1915; her dissertation was serialized in *Industrial Engineering* from May 1912 to 1913 and then published as *The Psychology of Management* by Sturgis and Walton in 1914 under the name "L. M. Gilbreth" (see Yost, *Frank and Lillian*

Gilbreth, 119–20, 213. For L. M. Gilbreth's work on fatigue, see Frank B. Gilbreth, "Production and Fatigue"; and Gilbreth and Gilbreth, *Fatigue Study*).

103. The museum was partially a result of discussions stemming from the Gilbreths' Summer School in Scientific Management, which they began in 1913 and which continued for several summers thereafter.

104. "Chairs Designed to Abolish All Unnecessary Fatigue in Factories," newspaper clipping, NF 5/0030-26, GPP. See also Frank B. Gilbreth and Lillian M. Gilbreth, "Museum of Devices for the Elimination of Unnecessary Fatigue in the Industries," *Scientific American*, 111 (14 Nov. 1914: 411, ibid.; "Unnecessary Fatigue of the Worker," *Iron Age* (2 Oct. 1913), ibid.; "Meeting the Human Phase of the Problem through Devices for Minimizing Fatigue and through Fostering the Habit of Reading," *Iron Age* (Apr. 1914), NF 5/0036-26, GPP.

105. The Gilbreths' interest in creating museums for their work continued well after their work at the New England Butt Company. In the winter of 1915 they tried, without success, to get the National Museum in Washington (now the National Museum of American History, Behring Center, Smithsonian Institution [hereafter cited as NMAH]) to start a national fatigue department. The National Museum did, however, collect several wire motion models that have since been lost. In 1917 they called for a government-sponsored museum that would include models of artificial limbs and appliances for the disabled (see the following by Gilbreth and Gilbreth: "The Engineer, the Cripple, and the New Education," Jane Morley files, Gilbreth Collection, Division of Engineering, History of Technology, NMAH [hereafter cited as Morley/NMAH]; Gilbreth and Gilbreth, *Fatigue Study;* and *Motion Study for the Handicapped*, 100). My thanks to Jane Morley, who donated her Xeroxes from the GPP to NMAH while I was finishing research on the Gilbreths' relationship to the study of fatigue.

106. Rabinbach, *Human Motor*, 172.

107. Although the concern with worker fatigue did not find a laboratory expression in the United States before the 1920s, American reformers were very much concerned with the relationship between industrial fatigue and protective labor legislation, especially concerning women (see, e.g., Josephine Goldmark's investigation into the relationship between fatigue and working conditions, *Fatigue and Efficiency: A Study in Industry* [New York: Charities Publication Committee, Russell Sage Foundation, 1912]).

108. As Reinhard Bendix has discussed, this period of American industrial history marked the first time that managers came together to forge a collective solution to the labor problem. Especially after World War I, a new management ideology emerged that emphasized the value of cooperation and industrial peace over the combat and struggle that had prevailed in 1910. Nonetheless, as Bendix notes, "it is also important to recognize that the new ideas were

frequently a mere rephrasing of the old 'stand-bys' of managerial ideology" (Reinhard Bendix, *Work and Authority in Industry: Ideologies of Management in the Course of Industrialization* [Berkeley and Los Angeles: University of California Press, 1956], 295).

109. Gilbreth's contract with Hermann, Aukam began in September 1912, while he was still setting up work at the New England Butt Company. The earliest Hermann, Aukam motion studies date from October 1912.

110. By 1914 Gilbreth was recording the work using simultaneously a Graflex camera, a verascope, and what he called the "English camera," probably a movie camera (drill-press captions, p. 6, NF 01/0019, vol. 1, pt. 1, GPP). The verascope, one of Gilbreth's favorite cameras, was a high-quality, popular French all-metal stereographic camera introduced in 1894, and the Graflex was an American-made camera that used 5 × 7 inch plates. There is considerable information about photographic equipment and processes in the Frank and Lillian Gilbreth Collection (see, e.g., NF 2/0021, GPP).

111. Drill-press captions p. 5, NF 01/0019, vol. 1, pt. 1, GPP; image 610–37, Gilbreth Collection, Division of Engineering, NMAH, stereocard 80.0785.017.

112. Typescript, 20 Sept. 1915, drill-press captions, NF 01/0019, vol. 1, pt. 1, GPP.

113. It would have been a simple matter, for example, to place the clocks a little further away from the machine, still within the view of the movie camera yet outside the range of the stereocamera's viewfinder. At this stage of the work, however, Gilbreth argued that the "blur of clock shown in picture measured time" (FBG diary, typescript [EP 2/6/41], 2 Apr. 1913, NF series 1, box 1, GPP).

114. The caption Gilbreth used for this image when sending it out to colleagues and potential clients read, "Chronocyclegraph path of the hands of an inexperienced girl, folding cloth in a textile factory" (Misc. captions, NF 01/9919, vol. 3, GPP).

115. Gilbreth argued that "habit" could only be seen three-dimensionally, through a stereoscope (Misc. captions, NF 01/9919, vol. 3, GPP). The folders and their motions were obsessively documented and analyzed; this woman (either Esther Lesley or Edna Wagner) was photographed simultaneously by at least three stereo cameras.

116. Cyclegraph book, 1 Nov. 1913, Gilbreth microfilm, roll 2, GPP.

117. For the showman P. T. Barnum's sophisticated manipulation of audience gullibility and skepticism, see Neil Harris, *Humbug* (Boston: Little, Brown, 1973).

118. Price, "One Best Way," 230–31, emphasis in the original.

119. Nadworny, "Frederick Taylor and Frank Gilbreth," 26.

120. FBG to LMG, 9 May 1914, NF 112/0813-6, GPP. There are many

conflicting stories about this break. Charles D. Wrege and Ronald G. Green-wood argue somewhat unconvincingly, for example, that Taylor turned on Gil-breth out of professional jealousy (see Wrege and Greenwood, *Frederick W. Taylor, the Father of Scientific Management: Myth and Reality* [Homewood, IL: Business One Irwin, 1991]. For additional accounts, see Yost, *Frank and Lil-lian Gilbreth*, 257; Price "One Best Way," 256–63; and Nadworny, "Frederick Taylor and Frank Gilbreth," 29).

121. Frederick Winslow Taylor, *Shop Management* (New York: Harper, 1911), 65, quoted in Nadworny, "Frederick Taylor and Frank Gilbreth," 27.

122. FBG to Frederick Winslow Taylor, 18 Apr. 1912, quoted in Nelson, *Managers and Workers*, 66.

123. Gilbreth and Gilbreth, "Motion Study and Time-Study Instruments of Precision." The Gilbreths eventually launched a frontal assault on time study in a paper published in 1921, six years after Taylor's death (see Gilbreth and Gilbreth, "Indictment of Time Stop Watch Time Study," 102). Needless to say, this paper, which was delivered before the Taylor Society, did not ingra-tiate the Gilbreths with those Taylor defenders still active in the society. The paper, along with its discussion the following April, marked a declaration of war between the advocates of time study and the advocates of motion study.

124. FBG to LMG, 2, 7 January 1914, NF 112/0813-6, GPP. By July the Social Democrats were indeed protesting Gilbreth's "Americanization" of the company (see *New York Times*, 14 July 1914, 3; for more on the German re-sponse to Taylorism, see Judith Merkle, *Management and Ideology: The Legacy of the International Scientific Management Movement* [Berkeley and Los Angeles: University of California Press, 1980], 172–99).

125. FBG to LMG, 2, 7 Jan. 1914, NF 112/0813-6, GPP.

126. FBG to LMG, 2, 5, 7, 8, 12, 14 Jan. 1914, ibid.

127. The classic discussion of workplace control is Montgomery, *Workers' Control in America*.

128. FBG to LMG, 2 Jan. 1914, Morley/NMAH.

129. Kessler-Harris, *Out to Work*, 146.

130. FBG to LMG, 2, 5, 7, 8, 12, 14 Jan. 1914, NF 112/0813-6, GPP. Frank wrote Lillian that after paying his manager and five assistants (pulled from Hermann, Aukam and the New England Butt Company), he would make a profit of twenty-five thousand dollars each year.

131. FBG to LMG, 7 Jan. 1914, ibid.

132. While at Auergellschaft, however, he discovered that the company manufactured superior incandescent bulbs, "very small lamps not bigger than grains of wheat," which he could use to great effect with his cyclegraphic work, especially for the tips of fingers. The new bulbs suggested the possibilities, never realized, of color cyclegraphy: "We can use many different colors at once if we so desire and have a different one on every finger, then by means of a col-

ored photograph reproduced by color process like those in *American Magazine* we could also put over the color photograph which is new in many phases. Color photography would add to the publicity feature also" (FBG to LMG, 5 Jan. 1914, Morley/NMAH).

133. FBG to LMG, 8 Jan. 1914, ibid.

134. FBG to Butterworth, 4 Mar., 10 Apr. 1912, ibid. Gilbreth's interest in applying scientific management to surgery and hospital work dated from at least as early as March 1912 and was explicitly related to the photographic possibilities he saw for his motion-study work. On 4 March 1912 he wrote his English agent, James F. Butterworth, that "among my present jobs is that of studying the possibilities of motion study, time study, and eventually scientific management as applied to the practice of surgeons in the hospitals." A month later Gilbreth wrote Butterworth, "There is no question but that my work on surgery and the doctors will make a much greater sensation than anything that has been done in Scientific Management to date and it is being backed by the right kind of people. I will show you in about two months publicity that will rival the remarkable work that you have done for Scientific Management in England. . . . I am not quite sure where the money making comes in and consequently am not working as many days at it as I should like to for it is the most pleasant, stimulating, and absorbing work that I have ever had and it is also more satisfactory to feel that I am doing something for my fellow man" (ibid.).

135. FBG to LMG, 2 Jan. 1914, ibid.

136. Dr. Kuckenstein was very enthusiastic about using the photographs and film, claiming, Gilbreth reported, that as a result he was able to save three seconds in tying each surgical knot (FBG to LMG, 12, 14 Jan. 1914, ibid.).

137. Gilbreth shot more than three hundred feet of film and made more than fifty chronocyclegraphs. He claimed that this was the first time that the point of a sword had ever been photographed (FBG to LMG, 16 Jan. 1914, ibid.).

138. Gilbreth's caption for image 1427-C, to the leading figure in French scientific management, was, "Chronocyclegraph of my best wishes for a Merry Christmas. Unfortunately we could not get these to you in time for Christmas but we hope that they will mark the beginning of a happy and most prosperous New Year to all of the De Freminvilles" (Misc. captions, NF 01/9919, vol. 3, GPP).

139. See also the image captioned "John the Olympic Champion," filmed at Providence on 22 Apr. 1913, NF 12/0031-15a, GPP.

140. "More Science in Running Ball Team Than a Trust," clipping from unidentified newspaper, c. 1913, NF 5/0030-28A, GPP. See also "'Movies' to Help Baseball Players Economize Force," *New York Tribune*, 15 June 1913, and "A Brand New Science of Baseball," *Providence Sunday Journal*, June 1913, both in NF 5/0030-25, GPP.

141. "'Movies' to Help Baseball Players Economize Force."

142. LMG to Walter Camp, 31 Oct. 1913, NF 51/0293, GPP.

143. The similarities to Etienne-Jules Marey's work in France are indisputable. As Marta Braun has written concerning Marey's work in filming the 1900 Olympics, "All his life he had tried to make images of the 'elite' subject, 'for example the prize-winners at athletic sports. These champions,' he wrote, 'will thus betray the secret of their success, perhaps unconsciously acquired, and which they would doubtless be incapable of defining themselves'" (Braun, *Picturing Time*, 205–6).

144. Camp to FBG, 3 Dec. 1915, and FBG to Camp, 6 Dec. 1915, both in NF 51/0293, GPP. I have found no evidence that this project was ever realized.

145. FBG to Camp, 12 Feb. 1916, ibid. For sports motion-study captions, see ibid.

146. For the golf captions, see ibid.; and NF 01/9919, vol. 3, GPP.

147. FBG to Camp, 11 Dec. 1916, NF 51/0293, GPP.

148. Rabinbach, *Human Motor*, 188, citing Jules Amar's *Le moteur humain et les bases scientifiques du travail professionel*, with a preface by Henri Le Chatelier (Paris: H. Dunod and E. Pinat, 1914), 469; and Amar, *Physiology of Industrial Organization*, 163.

149. Frank B. Gilbreth, "Motion Study for the Crippled Soldier," 671.

150. Ibid. By the end of the year Gilbreth had added a seventeenth motion, a second instance of "transport, loaded," and placed in position number seven (see Gilbreth and Gilbreth, "Motion Study for Crippled Soldiers," 4, Morley/NMAH).

151. Gilbreth and Gilbreth, "Applications of Motion Study," offprint in NF 53/0290, GPP. By 1915 Gilbreth was an avid moviegoer, attending one to two films daily while working in Berlin; he was probably familiar with Vachel Lindsay's *The Art of the Moving Picture* (1915), in which Lindsay compared moving images to Egyptian hierogylphs (see also O'Malley, *Keeping Watch*, 237–38).

152. SIMO chart of handkerchief folding, NF 52/0297-5, GPP.

153. Frank B. Gilbreth, "Motion Study for the Crippled Soldier," 672.

154. Gilbreth and Gilbreth, "Motion Study for Crippled Soldiers," 5; Gilbreth and Gilbreth "The Engineer, the Cripple, and the New Education."

155. "Crippled Soldiers Disheartened by Delays," *New York Times*, 24 Aug. 1919, 7; "Provision for Disabled Soldiers," *Monthly Review of the Bureau of Labor Statistics*, Oct. 1917, 683–94.

156. Recognizing that scientific management represented a radical appropriation of craft-based knowledge and control, workers and in some cases unions resisted its insidious encroachment throughout these years. By 1911, when workers at the Watertown Arsenal, in Watertown, Massachusetts, struck over the issue of time study, the Taylor System—and specifically the practice of

timing workers with a stopwatch—had become a national issue. Organized labor succeeded in getting Congress to investigate the impact of the Taylor System on labor practices, which resulted in time study's being banned in government installations. By 1912 the stopwatch had become the contested symbol of an increasingly embattled scientific-management movement. Gilbreth saw the use of the camera as an opportunity to retain managerial prerogatives while persuading critics and workers that the Gilbreths were what he called "the good exception." On scientific management and labor opposition, see Hoxie, *Scientific Management and Labor;* Montgomery, *Workers' Control in America;* and Merkle, *Management and Ideology,* 29. On the Watertown Arsenal strike, see Aitkin, *Taylorism at Watertown Arsenal.*

157. FBG to LMG, 1 May, 5 Apr. 1915, NF 112/813-4, GPP.

158. FBG to Prof. William Stewart Ayars, 28 Oct. 1915, NF 01/0019-5, GPP; FBG to LMG, 1 May 1915, NF 112/813-4, GPP.

159. See FBG to LMG, 6 Oct. 1915, NF 112/813-4, GPP, in which Frank Gilbreth describes a talk he gave on the crippled soldier before the Buffalo Society of Engineers.

160. FBG to LMG, 12 Oct. 1915, ibid. For Gilbreth's interest in Canadian rehabilitation efforts, see his correspondence with William Stewart Ayars (NF 01/0019-5, GPP), as well his extensive newspaper clipping files concerning Canadian, French, English, and German rehabilitation work (crippled soldier files, NF 28/0104-1, 28/0104-2, GPP).

161. Nancy Bristow, *Making Men Moral: Social Engineering during the Great War* (New York: New York University Press, 1996); Roxanne Panchasi, "Reconstructions: Prosthetics and the Rehabilitation of the Male Body in World War I France," *Differences* 7 (1995): 109–40. See also Elspeth H. Brown, "The Prosthetics of Management: Motion Study, Photography, and the Industrialized Body in World War I America," in *Artificial Parts, Practical Lives,* ed. Katherine Ott, David Serlin, and Stephen Minm (New York: New York University Press, 2002), 249–81.

162. This language is from Henry A. Whitmarsh, "Rehabilitation of the Crippled Soldier," *Journal of the American Institute of Homeopathy,* Oct. 1918, 397, but see also Douglas C. McMurtrie, *The War Cripple,* vol. 1 of *Columbia War Papers,* 1st ser. (New York: Columbia University, 1917), 5. For the strenuous life, see Theodore Roosevelt's influential essay "The Strenuous Life," as well as Gail Bederman's analysis of Roosevelt, in Bederman, *Manliness and Civilization: A Cultural History of Gender and Race in the United States, 1880–1917* (Chicago: University of Chicago Press, 1995).

163. Frank B. Gilbreth and Lillian M. Gilbreth, "Motion Study and the Mutilated Soldiers," typescript, p. 2, NF 78-3, GPP, copy in Morley/NMAH. See also idem, "Measurement of the Human Factor in Industry," 7, Seeley G. Mudd Library, Yale University, New Haven, CT.

164. Frank B. Gilbreth and Lillian M. Gilbreth, "First Steps toward Solving the Crippled Soldier Problem," typescript, p. 7, NF 78-1, GPP, copy in Morley/NMAH.

165. FBG to Lt. Col. James Bordley (director of the Red Cross Institute for the Blind in Baltimore), 24 Dec. 1918, NF 696-4, GPP, copy in Morley/NMAH.

166. On the gendered transformations of office work during these years see Angel Kwolek-Folland, *Engendering Business: Men and Women in the Corporate Office, 1870–1930* (Baltimore: Johns Hopkins University Press, 1994); and Strom, *Beyond the Typewriter*. On retail sales, see Susan Porter Benson, *Counter Cultures: Saleswomen, Managers, and Customers in American Department Stores, 1890–1940* (Urbana: University of Illinois Press, 1986). On dental-hygiene work, see Gilbreth and Gilbreth, "The Conservation of the World's Teeth: A New Occupation for Crippled Soldiers," reprinted from *Trained Nurse and Hospital Review*, July 1917, Morley/NMAH, "pamphlets."

167. Gilbreth and Gilbreth, "The Engineer, the Cripple, and the New Education," 6.

168. The experience of reintroducing disabled veterans to productive employment after the war served to join those working on behalf of the veterans with the Safety First, or industrial-safety, movement. On the movement to reduce industrial accidents and safeguard workers' health, see Mark Aldrich, *Safety First: Technology, Labor, and Business in the Building of American Work Safety, 1870–1939* (Baltimore: Johns Hopkins University Press, 1997).

169. Albert Jay Nock to LMG, 29 Jan., 7 Feb. 1916, NF 816-22, GPP, copy in Morley/NMAH.

170. LMG to Bradley Stoughton, 15 Feb., 1918, ibid., crippled soldier files.

171. On documentary photography, see Stange, *Symbols of Ideal Life*. On "capitalist realism" as an American advertising aesthetic that simplifies and typifies, see Michael Schudson, *Advertising, the Uneasy Persuasion: Its Dubious Impact on American Society* (New York: Basic Books, 1984), 209–33. And on *Fortune* magazine, founded in 1929, see Terry Smith, *Making the Modern: Industry, Art, and Design in America* (Chicago: University of Chicago Press, 1993), 159–98; and Kevin S. Reilly, "Dilettantes at the Gate: *Fortune* Magazine and the Cultural Politics of Business Journalism in the 1930s," *Business and Economic History* 28 (Winter 1999): 213–22.

172. The word *ergonomics*, from the Greek *ergos* (work) and *nomos* (natural law), was coined by Hywell Murrell after a meeting of a working party, held in the Admiralty Building at Queene Anne's Mansions, London, on 8 July 1949, at which it had been resolved to form a society for the "study of human beings in their working environment" (Stephen Pheasant, *Bodyspace: Anthropometry, Ergonomics, and the Design of Work*, 2d ed. [London: Taylor and Francis, 1996],

4; see also Amit Bhattacharya and James D. McGlothlin, eds., *Occupational Ergonomics: Theory and Applications* [New York: Marcel Dekker, 1996]).

173. Gilbreth and Gilbreth, "How to Put the Crippled Soldier on the Payroll," 5, reprinted in *Trained Nurse and Hospital Review* (May 1917), offprint in Morley/NMAH.

174. Frank B. Gilbreth, "Third Summer School of Scientific Management," typescript of discussions on 13 August 1915, in NF 104-2, GPP, copy in Morley/NMAH. For further discussion of the positive publicity generated by the work on the crippled soldier problem, see correspondence between the Gilbreths and Dr. Ing. Georg Schlesinger, Germany's foremost advocate of scientific management, from 6 June 1915 through 13 July 1916, esp. FBG to Schlesinger, 6 Dec. 1915, in NF 816-139, GPP, copy in Morley/NMAH.

175. Gilbreth and Gilbreth, "The Engineer, the Cripple, and the New Education," 6; Frank B. Gilbreth and Lillian M. Gilbreth, "How to Attack the Problem of the Crippled Soldier," typescript, NF 104-1, GPP, copy in Morley/NMAH, apparently a draft of "The Engineer, the Cripple, and the New Education."

176. Jules Amar, *La prothese et la travail des mutiles* (Paris: H. Dunod et E. Pinat, 1916), 8–10; Amar, *Physiology of Industrial Organization*, 66–73, in which Amar briefly refers to both Marey and the Gilbreths (73). The Gilbreths owned two editions of Amar's *Le moteur humain*, one from 1914 and a 1923 edition personally inscribed as follows: "a mes chers amis Fr. B et L. Gilbreth cordial hommage par Jules Amar Paris 7 Juin 1923 62 Blvd. St. Germain" (Gilbreth Library, Siegesmund Engineering Library, Purdue University, Lafayette, IN).

177. See also Amar, "La prothese et la travail des mutiles," figs. 2, "Bras de travail du Professeur Amar" (p. 11), and 3, "Bras avec main articulee Cauet" (p. 12). The latter image was reprinted in the Gilbreths' "How to Put the Crippled Soldier on the Payroll" and attributed to Amar.

178. Waldemar Kaempffert and A. M. Jungmann, "Crippled But Undaunted," *Popular Science Monthly*, Nov. 1918, 70–73.

179. FBG to LMG, 12 July 1917, NF 112/813-4, GPP.

180. The term *universal design* originated in the United States, where the Americans with Disabilities Act (1990) increased consciousness among designers about the rights of people with disabilities. The concept has grown to include designing with the needs of a varied population in view, not just the standardized "Joe and Josephine" of mid-twentieth-century industrial design (see James Mueller, "Towards Universal Design," *American Rehabilitation* 16 [Summer 1990]: 15–19; Abir Mullick and Edward Steinfeld, "Universal Design," *Innovation*, Spring 1997, 14–18; and Henry Dreyfuss, *Designing for People* [New York: Simon and Schuster, 1955]).

181. For another assessment, see Frank T. Lohrke, "Motion Study for the Blind: A Review of the Gilbreths' Work with the Visually Handicapped,"

International Journal of Public Administration 16 (1993): 667–782. After Frank Gilbreth's death in 1924, Lillian Gilbreth continued to work with the disabled (see Yost and Lillian M. Gilbreth, *Normal Lives for the Disabled*).

182. For later uses of motion study and film, see, e.g., Allan H. Mogensen, *Common Sense Applied to Motion and Time Study* (New York: McGraw-Hill, 1932); Ralph M. Barnes, *Practical and Theoretical Aspects of Micromotion Study* (Ithaca, NY, 1933); idem, *Motion and Time Study* (New York: J. Wiley and Sons, 1937); Ralph M. Barnes and Marvin E. Mundel, *A Study of Hand Motions Used in Small Assembly Work* (Iowa City: University of Iowa Press, 1939); Herbert C. Sampter, *Motion Study* (New York: Pitman, 1941), 118–33; and Marvin E. Mundel, *Motion and Time Study: Principles and Practice* (New York: Prentice-Hall, 1950). Articles about motion study appeared in the periodical press regularly through about 1957, and Sherry E. Sullivan argues in "Management's Unsung Theorist," 34, that the Gilbreths' process chart, flow diagrams, and principles of time and motion study are used today.

Chapter 3. Engineering the Subjective

1. Steven A. Gelb, Garland E. Allen, Andrew Futterman, and Barry A. Mehler, "Rewriting Mental Testing History: The View from the *American Psychologist*," *Sage Race Relations Abstracts* 11 (May 1986): 18–31. For a discussion of the 1924 Johnson Act, eugenics, and racial formation, see Matthew Frye Jacobson, *Whiteness of a Different Color: European Immigrants and the Alchemy of Race* (Cambridge: Harvard University Press, 1998), 39–90.

2. Judith Mara Gutman, *Lewis W. Hine and the American Social Conscience* (New York: Walker, 1967), 37. Unfortunately, Gutman did not provide sources for her information, so I have been unable to verify her assertion.

3. Daile Kaplan, ed., *Photo Story: Selected Letters and Photographs of Lewis W. Hine* (Washington, DC: Smithsonian Institution Press, 1992), xxiii–xxxiv.

4. Alan Trachtenberg, "Ever—the Human Document," in *America and Lewis Hine: Photographs, 1904–1940*, foreword by Walter Rosenblum, biographical notes by Naomi Rosenblum, essay by Alan Trachtenberg (New York: Aperture, 1977), 120; see also Francis W. Parker to Frank A. Manny, 7 Apr. 1900, in Kaplan, *Photo Story*, 2.

5. Kaplan, *Photo Story*, xxxiv; see also Daile Kaplan, "'The Fetish of Having a Unified Thread': Lewis W. Hine's Reaction to the Use of the Photo Story in *Life* Magazine," *exposure* 27 (1989): 9–20.

6. Maren Stange, *Symbols of Ideal Life: Social Documentary Photography in America, 1890–1950* (New York: Cambridge University Press, 1989), 53.

7. For Hine's photographs of child laborers, see Vicki Goldberg, "Lewis W. Hine, Child Labor, and the Camera," in *Lewis W. Hine: Children at Work* (Munich: Prestel, 1999), 7–20; Tom Beck, "Duality in Lewis Hine's Child Labor Photographs," in *Priceless Children: American Photographs, 1890–1925; or, Child*

Labor and the Pictorialist Ideal, by George Dimock, exhibition catalog (Greensboro, NC: Witherspoon Art Museum, 2001), 24–31; Verna Posever Curtis and Stanley Mallach, *Photography and Reform: Lewis Hine and the National Child Labor Committee* (Milwaukee: Milwaukee Art Museum, 1984); and George Dimock, "Children of the Mills: Re-Reading Lewis Hine's Child-Labour Photographs," *Oxford Art Journal* 16, no. 2 (1993): 37–54.

8. Goldberg, "Lewis W. Hine, Child Labor, and the Camera," 18.

9. Paul Strand, "Photography and the New God" (1917), reprinted in *Classic Essays on Photography,* ed. Alan Trachtenberg (New Haven: Leete's Island Books, 1980), 141–51.

10. Miles Orvell, "Lewis Hine and the Art of the Commonplace," in *After the Machine: Visual Arts and the Erasing of Cultural Boundaries* (Jackson: University Press of Mississippi, 1995), 48.

11. Lewis Hine to Paul Kellogg, Apr. 1924, reprinted in Kaplan, *Photo Story,* 29–30.

12. Alan Trachtenberg, *Reading American Photographs: Images as History, Mathew Brady to Walker Evans* (New York: Hill and Wang, 1989), 168.

13. Stange, *Symbols of Ideal Life,* 67–73; Robert Sink, "Children in the Library: Lewis Hine's Photographs for the Child Welfare Exhibit of 1911," *Biblion* 1 (1993): 12–24; Judith Mara Gutman, "Lewis Hine's Library Photographs: A Critic's View," ibid., 25–32.

14. Stange, *Symbols of Ideal Life,* 68–72.

15. Alan Trachtenberg, "Camera Work: Notes towards an Investigation," *Massachusetts Review* 19 (1978): 838.

16. Kaplan, *Photo Story,* xx–xxi; idem, "Fetish of Having a Unified Thread."

17. Daile Kaplan, *Lewis Hine in Europe: The Lost Photographs* (New York: Abbeville, 1988), 40–41.

18. Kaplan, "Fetish of Having a Unified Thread"; see also Michael L. Carlebach, *American Photojournalism Comes of Age* (Washington, DC: Smithsonian Institution Press, 1997), 128–35.

19. See, e.g., Naomi Rosenblum, *A World History of Photography,* 3d ed. (New York: Abbeville, 1997), 377–78. There are two important exceptions to this historiographic emphasis, however: Peter Seixas's persuasive reading of Hine's 1920s work in "Lewis Hine: From 'Social' to 'Interpretive' Photographer," *American Quarterly* 30 (Fall 1987): 381–409, and Susan Meyer's revisionist reading of Lewis Hine's Empire State Building series in relationship to leftist politics in the 1930s, "In Anxious Celebration: Lewis Hine's Men at Work," *Prospects* 17 (1992): 319–52.

20. For more about *Fortune* magazine, see Kevin S. Reilly, "Dilletantes at the Gate: *Fortune* Magazine and the Cultural Politics of Business Journalism in the 1930s," *Business and Economic History* 28 (Winter 1999): 213–22; and Terry

Smith, *Making the Modern: Industry, Art, and Design in America* (Chicago: University of Chicago Press, 1993).

21. Nancy F. Cott, *The Grounding of Modern Feminism* (New Haven: Yale University Press, 1987), 98; Sara M. Evans, *Born for Liberty: A History of Women in America* (New York: Free Press, 1989), 188.

22. Steven J. Diner, *A Very Different Age: Americans of the Progressive Era* (New York: Hill and Wang, 1998), 262–63; Lynn Dumenil, *The Modern Temper: American Culture and Society in the 1920s* (New York: Hill and Wang, 1995), 22–23; Daniel T. Rodgers, *Atlantic Crossings: Social Politics in a Progressive Age* (Cambridge: Harvard University Press, 1998).

23. Kaplan, *Lewis Hine in Europe*, 204.

24. Kaplan, *Photo Story*, 19; see also Gutman, *Lewis W. Hine and the American Social Conscience*, 37.

25. Roland Marchand, *Creating the Corporate Soul: The Rise of Public Relations and Corporate Imagery in American Big Business* (Berkeley and Los Angeles: University of California Press, 1998), 89.

26. Richard S. Tedlow, *Keeping the Corporate Image: Public Relations and Business, 1900–1950* (Greenwich, CT: JAI, 1979), xviii. See also Paul Burton, *Corporate Public Relations* (New York: Reinhold, 1966), 5; and Scott M. Cutlip, *Public Relations History: From the 17th to the 20th Century* (Hillsdale, NJ: Lawrence Erlbaum Associates, 1995), 187–209. For a discussion of the history of the term *publicity* in the late nineteenth and early twentieth centuries, see Alan R. Raucher, *Public Relations and Business, 1900–1929* (Baltimore: Johns Hopkins University Press, 1968), 1–16.

27. Edward Bernays, another key figure in the history of public relations, is also often called the father of the field as well. But as this account suggests, Bernays joined a field already shaped by Lee's prewar work. A nephew of Sigmund Freud, Bernays got his start in the propaganda field when he joined George Creel's Committee on Public Information in 1917. In 1923 Bernays taught the first college course on public relations at New York University, and his *Crystallizing Public Opinion* (New York: Boni and Liveright, 1923) was the first book devoted to the new field. For more on Bernays, see Larry Tye, *The Father of Spin: Edward L. Bernays and the Birth of Public Relations* (New York: Crown, 1998); and Stuart Ewen, *PR! A Social History of Spin* (New York: Perseus, 1998).

28. Merle Curti, "The Changing Concept of 'Human Nature' in the Literature of American Advertising," *Business History Review* 41 (Winter 1967): 335–57; Ray Eldon Hiebert, *Courtier to the Crowd: The Story of Ivy Lee and the Development of Public Relations* (Ames: Iowa State University Press, 1966), 5; Tedlow, *Keeping the Corporate Image*, 36–37; Scott M. Cutlip, *The Unseen Power: Public Relations, a History* (Hillsdale, NJ: Lawrence Erlbaum Associates, 1994), 57–61.

29. Hiebert, *Courtier to the Crowd*, 103.

30. *CF&I Industrial Bulletin* 1 (Oct. 1915): 7.

31. See, e.g., Walter Lippmann, *Public Opinion* (New York: Harcourt, Brace, 1922); Bernays, *Crystallizing Public Opinion*; Scott, *Psychology of Public Speaking* (1926). The European literature was deeply influenced by the much earlier work by Gustave Le Bon, *The Crowd: A Study of the Popular Mind* (1895), the second edition of which was published in London in 1897.

32. Ivy L. Lee, *Human Nature and Railroads* (Philadelphia: E. S. Nash, 1915), 14–18.

33. Lewis Hine, quoted in Kaplan, *Lewis Hine in Europe*, 59.

34. Hiebert, *Courtier to the Crowd*, 243–44.

35. Ibid., 240–51.

36. Ibid., 253; Eric Goldman, *Two-Way Street: The Emergence of the Public Relations Counsel* (Boston: Bellman, 1948). On the Committee on Public Information, see George Creel, *How We Advertised America: The First Telling of the Amazing Story of the Committee on Public Information That Carried the Gospel of Americanism to Every Corner of the Globe* (New York: Harper, 1920); Stephen Vaughan, *Holding Fast the Inner Lines: Democracy, Nationalism, and the Committee on Public Information* (Chapel Hill: University of North Carolina Press, 1980), esp. 141–92; and Ewen, *PR!* 103–29.

37. Kaplan, *Lewis Hine in Europe*, 113. Homer Folks was a lieutenant colonel working on behalf of the Red Cross; Hine was his assistant.

38. Kaplan, "Fetish of Having a Unified Thread," 12.

39. "Camera Interpretation of Labor."

40. David E. Nye, *Image Worlds: Corporate Identities at General Electric, 1890–1930* (Cambridge: MIT Press, 1985), 14–15.

41. Stephen B. Adams and Orville R. Butler, *Manufacturing the Future: A History of Western Electric* (Cambridge: Cambridge University Press, 1999), 109; see also Sam Kiley, ed., *Corporate Magazines in the U.S.* (Westport, CT: Greenwood, 1992), ix.

42. Adams and Butler, *Manufacturing the Future*, 112.

43. "Beginning Its Thirteenth Year, the *Western Electric News* Defies Superstition"; "Every Move a Picture: C. W. Barrell, Director of Our Motion Picture Bureau, Tells How and Why We Do It," *Western Electric News* 11 (June 1922): 24–25.

44. "Every Move a Picture."

45. Bigelow, "Just What Does the House Organ Do?"; Argyle, "Pop Ball on House-Organs"; Bigelow, "House Publications."

46. Peter Johansen argues, however, that the first employee magazine in North America was the short-lived *Trip Hammer*, of the Toronto-based Massey Manufacturing Company, an agricultural-implements manufacturer, first published in 1885 (Peter Johansen, "'For Better, Higher, and Nobler Things':

Massey's Pioneering Employee Publication," *Journalism History* 27 [Fall 2001]: 94–104).

47. As discussed in chapter 2, personnel management as a distinct field of managerial specialization flourished in the years after World War I as applied psychologists, working from their experience classifying U.S. Army personnel, began to work with employment managers to try to understand the complex relationship between psychological characteristics, individual personality, and job analysis. One of the first textbooks in the new field was written by the psychologist Walter Dill Scott and the Progressive employment manager Robert C. Clothier (see Walter Dill Scott and Robert C. Clothier, *Personnel Management: Principles, Practices, and Point of View* [Chicago: A. W. Shaw, 1923]; and Cyril Curtis Lang, *The Management of Personnel Relations: History and Origins* [Homewood, IL: Richard D. Irwin, 1965]). On the personnel-management movement in the World War I era, see Daniel Nelson, *Managers and Workers: Origins of the Twentieth-Century Factory System in the United States, 1880–1920*, 2d ed. (Madison: University of Wisconsin Press, 1995), 161–69; and Sanford M. Jacoby, *Employing Bureaucracy: Managers, Unions, and the Transformation of Work in American Industry, 1900–1945* (New York: Columbia University Press, 1985), 137–40. As Nikki Mandell argues, the shift from prewar "welfare managers" to postwar "personnel managers" was a gendered transformation: women professionals were pushed out of managerial positions by a professionalizing, male cohort (see Nikki Mandell, *The Corporation as Family: The Gendering of Corporate Welfare, 1890–1930* [Chapel Hill: University of North Carolina Press, 2002], 116–31).

48. Marchand, *Creating the Corporate Soul*, 101. See "Beginning Its Thirteenth Year, the *Western Electric News* Defies Superstition," for a classic statement of the "lament." The article explains how the magazine came about by contrasting contemporary life to life in the "days when manufacturing in this country was in its rudimentary stage," when "factories were small. Employees were not numerous. The head of the firm was continuously walking among the workers, chatting with them, complimenting them on a good piece of work, laying a friendly hand on the shoulder." But "today's [1924] employees find it increasingly difficult to know each other."

49. National Industrial Conference Board, *Employee Magazines in the United States*, 1, 3.

50. "Employees' Magazines as Distinguished from House-Organs," 41; see also Bigelow, "Cadillac Employees' Magazine."

51. Bigelow, "How Much Should a House Magazine Cost?"; see also Bigelow, "Putting Across the Employees' Magazine."

52. Marchand, *Creating the Corporate Soul*, 7–47.

53. Ibid., 272. See also Dickinson, "Making Welfare Copy Believable"; and Dickinson, "Selling the Job to Employees in Big Advertisements."

54. On good will, see the following articles by Clifford G. Bigelow: "Cashing in on 'Good Will'"; "House Publications and the 'Heart' of Business"; and "The House Publication's Chief Characteristic."

55. On emotion and the "psychological" as historically specific cultural categories, see Joel Pfister and Nancy Schnog, eds., *Inventing the Psychological: Towards a History of Cultural Life in America* (New Haven: Yale University Press, 1997).

56. Townsend, "Labor: A Gladiator of the Pictures," 117.

57. Bigelow, "Producing a Prize-Winning Employees' Magazine," 73.

58. Hungerford, "Over Half a Million Yearly for Employee Magazines," 491; see also Bigelow, "If the Boss Is Broad-Minded."

59. Irving Bernstein, *The Lean Years: A History of the American Worker, 1920–1933* (Baltimore: Penguin, 1960), 62; see also David Fairris, "From Exit to Voice in Shopfloor Governance: The Case of Company Unions," *Business History Review* 69 (Winter 1995): 501–3.

60. James R. Green, *The World of the Worker: Labor in 20th Century America* (New York: Hill and Wang, 1980), 102. On Fordism, see Gramsci, *Antonio Gramsci Reader,* 275–99; and Bernard Doray, *From Taylorism to Fordism: A Rational Madness,* trans. David Macey (London: Free Association, 1988).

61. David Brody, *Workers in Industrial America* (New York: Oxford University Press, 1980), 62. See also Lendol Calder, *Financing the American Dream: A Cultural History of Consumer Credit* (Princeton, NJ: Princeton University Press, 1999); Martha L. Olney, *Buy Now, Pay Later: Advertising, Credit, and Consumer Durables in the 1920s* (Chapel Hill: University of North Carolina Press, 1991); and Regina Lee Blaszczyk, *Imagining Consumers: Design and Innovation from Wedgwood to Corning* (Baltimore: Johns Hopkins University Press, 2000).

62. On the American standard of living, material culture, and scale among the middle class in the 1920s, see Marina Moskowitz, *The Standard of Living: Material Culture, Marketing, and Middle Class Communities* (Baltimore: Johns Hopkins University Press, 2004).

63. Lynn Dumenil, *Modern Temper,* 218–26. See also Robert K. Murray, *Red Scare: A Study in National Hysteria, 1919–1920* (Minneapolis: University of Minnesota Press, 1955); and Charles H. McCormick, *Seeing Reds: Federal Surveillance of Radicals in the Pittsburgh Mill District, 1917–1921* (Pittsburgh: University of Pittsburgh Press, 1997).

64. Bernstein *Lean Years,* 84.

65. Louis Galambos, *The Public Image of Big Business in America, 1880–1940* (Baltimore: Johns Hopkins University Press, 1975).

66. Green, *World of the Worker,* 102.

67. On the relationship between welfare capitalism and company size, see H. M. Gitelman, "Welfare Capitalism Reconsidered," *Labor History* 33 (1992): 5–31. The classic discussions of welfare capitalism are David Brody, "The Rise

and Decline of Welfare Capitalism," in *Change and Continuity in Twentieth Century America: The 1920s*, ed. John Braeman et al. (Columbus: Ohio State University Press, 1968), 147–78; and Stuart D. Brandes, *American Welfare Capitalism, 1880–1940* (Chicago: University of Chicago Press, 1976). For a recent study that contradicts the assumption that employer welfare capitalism was replaced by state initiatives before and during the New Deal, see Sanford M. Jacoby, *Modern Manors: Welfare Capitalism since the New Deal* (Princeton, NJ: Princeton University Press, 1997).

68. For the recent historiography on welfare capitalism, see Andrea Tone, *The Business of Benevolence: Industrial Paternalism in Progressive America* (Ithaca, NY: Cornell University Press, 1997); and Nikki Mandell, *The Corporation as Family: The Gendering of Corporate Welfare, 1890–1930* (Chapel Hill: University of North Carolina Press, 2002). See also Ardis Cameron, "In the Shadow of the Square Deal: Rethinking Workers, Managers, and Welfare Capitalism," *New York History* 62 (1990): 451–55. These studies complicate the classic discussions of welfare capitalism, which have heretofore focused on the relative success or failure of corporate welfare programs in inhibiting independent union organizing, by using gender as a category of analysis.

69. Venus Green, *Race on the Line: Gender, Labor, and Technology in the Bell System, 1880–1980* (Chapel Hill: University of North Carolina Press, 2001), 137. On the telephone industry's shift to marketing the personal touch of telephone communication during the early twentieth century, see Claude S. Fischer, "'Touch Someone': The Telephone Industry Discovers Sociability," in *Technology and American History*, ed. Stephen H. Cutliffe and Terry S. Reynolds (Chicago: University of Chicago Press, 1997), 271–300.

70. Adams and Butler, *Manufacturing the Future*, 92, 127; Richard Gillespie, *Manufacturing Knowledge: A History of the Hawthorne Experiments* (Cambridge: Cambridge University Press, 1991), 18. Although some of Western Electric's skilled workers had become union members in the 1880s and 1890s, the company generally was successful in resisting efforts at shop-floor organizing until the triumph of the International Brotherhood of Electrical Workers (IBEW) in the 1950s. Many of Western Electric's welfare-capitalist initiatives were introduced in the wake of labor actions, such as the employee-representation plan of 1919, introduced after the Massachusetts state arbitration board intervened in a 1917 Western Electric strike.

71. On unionization efforts in the telephone industry, see Green, *Race on the Line*; Stephen H. Norwood, *Labor's Flaming Youth: Telephone Operators and Worker Militancy, 1878–1923* (Urbana: University of Illinois Press, 1990); and Kenneth Lipartito, "When Women Were Switches: Technology, Work, and Gender in the Telephone Industry, 1890–1920," *American Historical Review* 99 (Oct. 1994): 1075–1111.

72. Paul Street, "A Company Newspaper: The Swift Arrow and Welfare

Capitalism in Chicago's Meatpacking Industry, 1917–1942," *Mid-America: An Historical Review* 78 (Winter 1996): 31–60.

73. See, e.g., "Whitin Machinist among the Picturesque," *Whitin Spindle* 1 (Aug. 1919); and O'Shea, "How Big Companies Are Using Employees' Magazines."

74. O'Shea, "How Big Companies are Using Employees' Magazines."

75. Providing photographs for the employee magazine was only one of the many duties of the company's photographic department, which also included progress photographs of plant architecture, industrial photography, engineering photography, portraits of company managers, and so on. In 1922 the Hawthorne photographic department alone had more than twenty-four thousand 8 × 10 inch glass negatives, five thousand 5 × 7 inch negatives, and more than twenty-eight hundred lantern slides for advertising products at trade shows (L. H. Myers, "How Hawthorne Gets Its Picture Took"). For a fuller discussion of the myriad uses to which photography was put in corporate environments, see Nye, *Image Worlds*, 10–31.

76. Don Slater, "Consuming Kodak," in *Family Snaps: The Meanings of Domestic Photography*, ed. Jo Spence and Patricia Holland (London: Virago, 1991), 49–59. For further discussion of Kodak and the marketing of roll film and snapshot cameras, see Nancy Martha West, *Kodak and the Lens of Nostalgia* (Charlottesville: University of Virginia Press, 2000); and Brian Coe and Paul Gates, *The Snapshot Photograph: The Rise of Popular Photography, 1888–1939* (London: Ash and Grant, 1977).

77. N. W. Ayer Collection, series 6, box 15, Ayer Publications, 1919–1926, Warshaw Collection of Business Americana, Archives Center, National Museum of American History, Behring Center, Smithsonian Institution (hereafter cited as NMAH). See esp. *The Next Step*, Aug. 1920 and Nov. 1921; with the November issue it moved to a larger size, 9 × 12 inches, on coated stock.

78. Bigelow, "Producing a Prize-Winning Employees' Magazine." For other examples of the use of employee vacation photographs in employee magazines, see Hungerford, "Over Half a Million Yearly for Employee Magazines"; Hahn, "Photographs—The House Organ Editor's Strongest Ally"; and Wingfield, "Pictures for the Employees' Magazine."

79. Mandell, *Corporation as Family*, 33, 132. See also Marchand, *Creating the Corporate Soul*, 103–18; and Angel Kwollek-Folland, *Engendering Business: Men and Women in the Corporate Office, 1870–1930* (Baltimore: Johns Hopkins University Press, 1994), 168–70.

80. Pierre Bourdieu, *Photography: A Middle-Brow Art* (London: Polity, 1990), 19. For an analysis of eugenics and the role of the family album, see Shawn Michelle Smith, *American Archives: Gender, Race, and Class in Visual Culture* (Princeton, NJ: Princeton University Press, 1999), 113–32; for an analysis of the discourse of domesticity and white supremacy in postbellum family pho-

tographs, see Laura Wexler, *Tender Violence: Domestic Visions in an Age of U.S. Imperialism* (Chapel Hill: University of North Carolina Press, 2000), 16–51. Of course, some snapshot practices, as well as many reading practices, work in opposition to these dominant narratives (see the essays collected in Marianne Hirsch, ed., *The Familial Gaze* [Hanover, NH: University Press of New England, 1999]; and Deborah Willis, *Picturing Us: African American Identity in Photography* [New York: New Press, 1994]).

81. Simon Watney, "Ordinary Boys," in Spence and Holland, *Family Snaps*, 27.

82. Dickinson, "Employees' Magazines More Essential Now Than Ever," 138.

83. An article describing Western Electric's use of photography explicitly links corporate photographic practice to the family album. The author begins an article on the West Street plant's use of photography by observing that "nearly everybody at some time or another has been inoculated with the camera germ. . . . If you're married you take the baby's picture when she gurgles her first gurg . . . also when she does her first one-step." Just as it is "natural . . . that parents should keep a permanent record of their children's babyhood," the author argues, so the company keeps a permanent photographic record of "itself and its offspring—its product." The author concludes, "So you will find a great variety of pictures in West Street's family album" ("How West Street Uses Photographs." See also the double-page-spread cartoon "Our Office Photo Album").

84. Dunn, *Americanization of Labor*, 250.

85. Ibid., 254.

86. Although Hine began focusing on his work portraits after World War I and his Red Cross assignments, he actually made his first such portrait in 1904. While working at the Ethical Culture School, he made what he called his "first bull's eye" with a camera, a portrait of the school's printing instructor. The medium-distance, angled portrait graciously allows the printer the space and solitude necessary to his craft, which Hine emphasizes through a crisp depiction of the hands, fingers skillfully adjusting paper on press. The overhead lighting lends a religious intensity to the figure, whose work is imbued with a sacred purpose. Hine retrieves the rhetoric of the sacred in his 1920s work portraits, which he intended to convince the workers themselves of the importance of their work in the modern, industrialized workplace (see Kaplan, *Lewis Hine in Europe*, 19).

87. Michael Schudson, *Advertising, the Uneasy Persuasion: Its Dubious Impact on American Society* (New York: Basic Books, 1984). This commercial visual culture prefigures the explosion of similar imagery in the 1930s, when American painters, sculptors, and illustrators, influenced by socialist realism and popular-front politics, began their collective "fanfare for the common man." On

the proliferation of representation of idealized forms of skilled labor in the post–World War I period, see Melissa Dabakis, *Visualizing Labor in American Sculpture: Monuments, Manliness, and the Work Ethic, 1880–1935* (New York: Cambridge University Press, 1999), 174–224; and Barbara Melosh, *Engendering Culture: Manhood and Womanhood in New Deal Public Art and Theatre* (Washington, DC: Smithsonian Institution Press, 1991), 83–110. On the popular front and cultural politics, see Michael Denning, *The Cultural Front: The Laboring of Culture in the Twentieth Century* (London: Verso, 1996).

88. Townsend, "Labor: A Gladiator of the Pictures."

89. On artisanal republicanism, see Sean Wilentz, "Artisanal Republican Festivals and the Rise of Class Conflict in New York City, 1788–1837," in *Working Class America: Essays on Labor, Community, and American Society*, ed. Michael H. Frisch and Daniel J. Walkowitz (Urbana: University of Illinois Press, 1983); and idem, *Chants Democratic: New York City and the Rise of the American Working Class, 1788–1850* (New York: Oxford University Press, 1984), 61–103. On occupational portraiture, see Harry R. Rubenstein, "With Hammer in Hand: Working Class Occupational Portraits," in *American Artisans: Crafting Social Identity, 1750–1850*, ed. Howard B. Rocke, Paul A. Gilge, and Robert Asher (Baltimore: Johns Hopkins University Press, 1995), 178–98.

90. David R. Roediger, *The Wages of Whiteness: Race and the Making of the American Working Class* (New York: Verso, 1991); Ava Baron, ed., *Work Engendered: Toward a New History of American Labor* (Ithaca, NY: Cornell University Press, 1990), 47–69.

91. The staged nature of the image is suggested by the cabinetmaker's left hand, which is directed—improbably—towards, rather than away from, the body. By the 1920s the mass production of wooden telephone equipment would likely have been accomplished with an electric, stationary planer, not a hand plane.

92. "Makers of the Nation's Telephones," *Western Electric News* 13 (Apr. 1924): 2.

93. On photography and the employee magazine more generally, see Nye, *Image Worlds*, 103–11; and Andrea Tone, *Business of Benevolence*, 108.

94. "Makers of the Nation's Telephones," *Western Electric News* 12 (Mar. 1923): 2.

95. Gillespie, *Manufacturing Knowledge*, 14. My summary of the Hawthorne experiments is drawn from Gillespie's excellent work.

96. Ibid., 26.

97. Ibid., 99.

98. Adams and Butler, *Manufacturing the Future*, 124–25.

99. David Noble, *America by Design: Science, Technology, and the Rise of Corporate Capitalism* (New York: Oxford University Press, 1977), 265.

100. My discussion of corporate liberalism and the NCF is indebted to

James Weinstein, *The Corporate Ideal in the Liberal State* (Boston: Beacon, 1968). For further discussions of corporate liberalism, see Martin J. Sklar, *The Corporate Reconstruction of American Capitalism, 1890–1916* (Cambridge: Cambridge University Press, 1988), 33–42; R. Jeffrey Lustig, *Corporate Liberalism: The Origins of Modern American Political Theory, 1890–1920* (Berkeley and Los Angeles: University of California Press, 1982); and David A. Horowitz, *Beyond Left and Right: Insurgency and Establishment* (Urbana: University of Illinois Press, 1997), esp. 1–42.

Chapter 4. Rationalizing Consumption

1. The Pennsylvania Railroad had been a client of Ivy Lee's since 1906, when the railroad's president, Alexander J. Cassatt, hired Lee to combat rising public resentment against railroad strikes and accidents. In 1922 the railroad, with the help of a federal injunction, broke a strike of four hundred thousand railroad workers. Lee devised a new publicity campaign in the midst of the strike that included the founding of an employee magazine in each of the railroad's four regions; the creation of the *Pennsylvania Standard*, a management mouthpiece; the adoption of a rhetoric of family to describe the company; the creation of an employee profit-sharing plan; and, importantly, the introduction of the Pennsylvania Railroad dining-car menu. The menu was seen by fifty-four thousand diners each week, and the inserts Lee designed featured a photograph of a Pennsylvania Railroad worker with an accompanying caption. Hine's work portrait of a Pennsylvania Railroad engineer was one of the photographs Lee used as part of this series (see Ray Eldon Hiebert, *Courtier to the Crowd: The Story of Ivy Lee and the Development of Public Relations* [Ames: Iowa State University Press, 1966], 86–88).

2. Daile Kaplan, ed., *Photo Story: Selected Letters and Photographs of Lewis W. Hine* (Washington, DC: Smithsonian Institution Press, 1992), 29.

3. Art Directors Club of New York, *Third Annual of Advertising Art* (New York, 1924); idem, *Fourth Annual of Advertising Art, 1925* (New York, 1925). For a discussion of the New York art directors' goals in creating these annual exhibitions of advertising art, see "Advertising Art Promoted by New York Art Center"; and "Art Directors' Club Holds First Annual Exhibition."

4. T. J. Jackson Lears, *Fables of Abundance: A Cultural History of Advertising in America* (New York: Basic Books, 1994), 270. On the role of trademark legislation and brand identity in developing mass markets, see Susan Strasser, *Satisfaction Guaranteed: The Making of the American Mass Market* (Washington, DC: Smithsonian Institution Press, 1989), 29–57; and Richard S. Tedlow, *New and Improved: The Story of Mass Marketing in America* (New York: Basic Books, 1990).

5. N. W. Ayer, *The Ayer Idea in Advertising* (Philadelphia, 1912), 15–16, in N. W. Ayer Collection, series 6, box 14, Ayer Publications, 1912–1916, War-

shaw Collection of Business Americana, Archives Center, National Museum of American History, Behring Center, Smithsonian Institution, Washington, DC (hereafter cited as NMAH).

6. On Calkins, see Stephen Fox, *The Mirror Makers: A History of American Advertising and Its Creators* (New York: William Morrow, 1984), 40–48. For further background in American advertising during these years, including the shift to full creative staffs, see Juliann Sivulka, *Soap, Sex, and Cigarettes: A Cultural History of American Advertising* (Belmont, CA: Wadsworth, 1998), 44–133.

7. The history of American advertising has been extensively researched. On advertising before 1920, see Pamela Walker Laird, *Advertising Progress: American Business and the Rise of Consumer Marketing* (Baltimore: Johns Hopkins University Press, 1998); Daniel Pope, *The Making of Modern Advertising* (New York: Basic Books, 1983); Fox, *Mirror Makers*, 13–39; Roland Marchand, *Advertising the American Dream: Making Way for Modernity, 1920–1940* (Berkeley and Los Angeles: University of California Press, 1985), 7–9; and Lears, *Fables of Abundance*.

8. Frank Luther Mott, *A History of American Magazines*, vol. 4, *1885–1905* (Cambridge: Harvard University Press, 1957), 3–10, 46–47.

9. Theodore Peterson, *Magazines in the Twentieth Century* (Urbana: University of Illinois Press, 1964), 6–7.

10. Ibid., 60.

11. Frank Presbrey, *The History and Development of Advertising* (Garden City, NY: Doubleday, 1929), 470.

12. In 1912, for example, all of the advertising in *McClure's* was grouped in the back of the journal; by November 1913, however, advertisements appeared throughout the magazine.

13. On the relationship between gender and reading in late-eighteenth- and early-nineteenth-century America, see Cathy Davidson, *Revolution and the Word: The Rise of the Novel in America* (New York: Oxford University Press, 1986). For an extended treatment of gender and magazine readership, see Jennifer Scanlon, *Inarticulate Longings: The Ladies' Home Journal, Gender, and the Promise of Consumer Culture* (New York: Routledge, 1995).

14. The *Printers' Ink* columnist James Wallen declared in 1921 that "ninety per cent of all advertising is addressed to woman" (Wallen, "Is Old Man 'Reason-Why' Dead?" 69; see also Wallen, "Emotion in Advertising Copy").

15. Frederick, "Teach Women What Advertising Does," 178. For other expressions of the consumer as female, see the ad for Strathmore Expressive Papers in *Printers' Ink*, 7 Oct. 1920, 151; and Elsie Johns, "What Kind of Advertising Do Women Read?" See also Ellen Gruber Garvey, *The Adman in the Parlor: Magazines and the Gendering of Consumer Culture, 1880s to 1910s* (New York: Oxford University Press, 1996), esp. 135–65; and James D. Norris, *Ad-*

vertising and the Transformation of American Society, 1865–1920 (Westport, CT: Greenwood, 1990), 71–94.

16. Marchand, *Advertising the American Dream*, 52–87. On consumer marketing and the *True Story* readership, see Shelley Nickles, "'Their Purchased Symbols': Household Appliances, Industrial Designers, and Blue-Collar Consumers in Postwar America" (paper presented at the annual meeting of the American Studies Association, Washington, DC, 1 Nov. 1997).

17. David Phillips, "Art for Industry's Sake: Halftone Technology, Mass Photography, and the Social Transformation of American Print Culture, 1880–1920" (Ph.D. diss., Yale University, 1996), 54–62. For a further discussion of the technologies and inventions relating to halftones, see Estelle Jussim, *Visual Communication and the Graphic Arts: Photographic Technologies in the Nineteenth Century* (New York: R. R. Bowker, 1983), 66–67.

18. Phillips, "Art for Industry's Sake," 61.

19. Neil Harris, "Iconography and Intellectual History: The Half-Tone Effect," in *New Dimensions in American Intellectual History*, ed. John Higham and Paul K. Conkin (Baltimore: Johns Hopkins University Press, 1979), 197.

20. Scot, "Photography in Commercial Illustration," reprinted in *Practical Photographer*, Feb. 1896, 53–54. On photography in relationship to news illustration, see Scot, "Photography in Newspaper Illustrating."

21. Henry Peach Robinson, *Elements of a Pictorial Photograph*, 70. The definition of *realism*, especially in relationship to photography, has never been static; the term's use to define photography's capacities and goals was contested throughout the nineteenth century and into the twentieth. For a review of some of the nineteenth-century debates, see Mary Warner Marien, *Photography and Its Critics: A Cultural History, 1839–1900* (Cambridge: Cambridge University Press, 1997). On realism in relationship to American culture more generally, see Miles Orvell, *The Real Thing: Imitation and Authenticity in American Culture, 1880–1940* (Chapel Hill: University of North Carolina Press, 1989); and David Shi, *Facing Facts: Realism in American Thought and Culture, 1850–1920* (New York: Oxford University Press, 1995).

22. Quoted in Fox, *Mirror Makers*, 50. Later, with the shift to emotion and atmospheric advertising, the notion of salesmanship in print was retooled to reflect the "human touch." "When you put salesmanship into print you are trying to make it take the place of a living salesman," argued Herbert N. Casson. "People do not care to read about facts . . . this is especially true of women, and most of our sales literature—fully eighty percent of it—is intended to influence women. Most goods are bought by women" (see Casson, "Human Touch in Printed Salesmanship"; see also Soule, "Silent Salesmen").

23. Roland Barthes, "The Photographic Message," in *Image/Music/Text*, trans. Stephen Heath (New York: Hill and Wang, 1977), 18.

24. This factual style of presentation was especially effective in industrial

photography (see David E. Nye, *Image Worlds: Corporate Identities at General Electric, 1890–1930* [Cambridge: MIT Press, 1985], 31–58).

25. See Jennifer Green-Lewis, *Framing the Victorians: Photography and the Culture of Realism* (Ithaca, NY: Cornell University Press, 1996), 26–27.

26. On the connection between photography, efficiency, and reason-why copy after World War I, see "Pictorial Demonstration Instead of the Superlative"; and White, "Old Man Specific Gets Direct Sales with Institutional Advertising."

27. Walter Dill Scott, *Influencing Men in Business*, 35. Scott's work on advertising psychology began appearing after 1901, when Thomas L. Banner, the western advertising manager for *The Delineator* and other Butterick magazines, asked Scott to give a talk on the psychology of advertising to a group of advertising men. Scott's numerous articles and books helped move advertisers away from reason-why copy to more suggestive methodologies. For more on Scott, see Leonard W. Ferguson, *Walter Dill Scott: First Industrial Psychologist* (Hartford, CT: Heritage of Industrial Psychology, 1962); and Edmund C. Lynch, "Walter Dill Scott: Pioneer Industrial Psychologist," *Business History Review* 42 (Summer 1968): 149–70.

28. Fox, *Mirror Makers*, 70; see also Martha L. Olney, *Buy Now, Pay Later: Advertising, Credit, and Consumer Durables in the 1920s* (Chapel Hill: University of North Carolina Press, 1991), 135.

29. Walter Dill Scott, "Psychology of Advertising"; see also Roberts, "What the Photograph Means to the Magazine."

30. Michele H. Bogart, *Artists, Advertising, and the Borders of Art* (Chicago: University of Chicago Press, 1995). See also Neil Harris, "Pictorial Perils: The Rise of American Illustration," in *The American Illustrated Book in the Nineteenth Century*, ed. Gerald W. R. Ward (Winterthur, DE: Winterthur Museum, 1987), 3–19.

31. Marchand, *Advertising the American Dream*, 153, 235–84. See also Ronald Berman, "Origins of the Art of Advertising," *Journal of Aesthetic Education* 17 (Fall 1983): 62. For a contemporary critique of advertisers' overreliance on visual clichés, see the following by Larned: "Finding the Theme for the Illustration"; "Peopling the Advertisements"; and "When Is an Illustration Unconventional?"

32. Michael Schudson, *Advertising, the Uneasy Persuasion: Its Dubious Impact on American Society* (New York: Basic Books, 1984), 209–33. Roland Marchand has described advertising as a *Zerrspiegel*, or fun-house mirror, which reflects back a distorted image—not wholly fictive but exaggerated in places (Marchand, *Advertising the American Dream*, xvii).

33. "Our Cover Portrait and Hall of Fame."

34. Harvey S. Lewis, "Commercial Photography, Lesson No. 7." See also his other articles in this series, esp. "Commercial Photography, Lesson No. 5,"

"Commercial Photography, Lesson No. 6," and "Commercial Photography, Lesson No. 19."

35. Lewis, "Commercial Photography, Lesson No. 5," 329. See also "Photographing Small Articles for Catalogues and Illustrative Purposes."

36. For example, H. S. Hood, in an article on commercial photography, defines the field as "all of the ground not covered by portrait and pictorial work," including x-rays, architectural photography, mechanical record pictures, and so on. He does not, however, mention advertising illustration (Hood, "Some Phases of Commercial Photography"). Other articles that included advertising applications within the field of commercial photography continued to focus on the details of product photography, to the exclusion of atmosphere (see, e.g., Radcliffe, "Commercial Photography"). By 1922, however, commercial photographers had begun to appreciate the value of sentiment, or the connotative meaning (see "Selling Human Sentiment Proves More Successful Than Selling the Product").

37. As historians of both photography and advertising have often discussed, Eastman Kodak was a pioneer in not only brand-name marketing but also the use of photography in advertising. Eastman's successful development of roll film in 1885 made possible the further expansion of the photography market. With slogans such as "You push the button, we do the rest" and brand images such as the "Kodak girl," the company especially targeted women and eventually children in its advertising for Kodak Model 1 and Brownie cameras (see Don Slater, "Consuming Kodak," in *Family Snaps: The Meanings of Domestic Photography*, ed. Jo Spence and Patricia Holland [London: Virago, 1991], 49–59; Brian Coe and Paul Gates, *The Snapshot Photograph: The Rise of Popular Photography, 1888–1939* [London: Ash and Grant, 1977], chs. 2 and 3; and Reese V. Jenkins, *Images and Enterprise: Technology and the American Photographic Industry, 1839–1925* [Baltimore: Johns Hopkins University Press, 1975], 172–258).

38. *Printers' Ink Monthly*, Dec. 1922, 97.

39. Eastman Kodak Company, *Human Appeal*, 12. Kodak sponsored a series of advertising contests in order to promote the fledging field; the 1913 contest offered three thousand dollars in cash prizes for winning prints.

40. For helping me to piece together Hiller's career I would like to thank first and foremost Arnold Sorvari, now deceased, who saved Hiller's photographs and other documents from the trash collectors in 1979. Many thanks as well to Nathan Lyons and Bill Johnson, of the Visual Studies Workshop, Rochester, NY; Michael Hargraves, of the Getty Museum; and Joe Struble, of the International Museum of Photography at George Eastman House.

41. Hiller's childhood name was Jaren, but by the time he was in art school he had begun signing his work "Le Jaren," which soon became "Lejaren à Hiller." His brothers were Raymond, Edwin, and Walter (Hiller correspond-

ence, Lejaren à Hiller Archive, Visual Studies Workshop, Rochester, NY [hereafter cited as Hiller Archive, VSW]. For Hiller's birthdate, see "Lejaren a. Hiller," autobiographical typescript, 2 Feb. 1950, ibid.). Hiller wrote that before he went to Chicago to study, his "father had communicated with a Civil War friend of his, whom he had not seen since those days, and I became a boarder in his household . . . built on top of the Northside Chicago Masonic Temple where ingress was possible only when there was no lodge meetings" (Hiller, autobiographical typescript, 28 Sept. 1945, p. 1, ibid.).

42. Patricia Johnston, *Real Fantasies: Edward Steichen's Advertising Photography* (Berkeley and Los Angeles: University of California Press, 1997): 7–8. In some of his autobiographical fragments Hiller mentions overlapping with Steichen while serving his apprenticeship (Steichen apprenticed from 1894 to 1898); Hiller also kept track of Steichen's career by clipping articles and other mentions of his more famous contemporary. At the same time, however, the names of the companies do not correspond: Johnston records Steichen's firm as the American Fine Art Company, while Hiller remembers his firm as the American Lithograph Company. I suspect, as Hiller's recollections are not always accurate, that although he did overlap with Steichen, it was at the American Fine Art Company.

43. Hiller was not much of a historian of his own life or work, and the various interviews he gave over the years report varying "facts" about his early (and later) years. Based upon 5 × 7 inch glass plate negatives in his archive, as well as other sources, however, I would date the beginning of his photographic work to 1898. For one version of his early use of the camera, see *Photographer's Showplace* 1, no. 2 (Dec. 1956): 4, Hiller Archive, VSW.

44. For examples of this early illustration work, see Hiller Archive, VSW. One theater program for the Carlton Minstrels dated December 1899 documents a Hiller cover illustration, as well as Hiller's performance in the final piece.

45. Lejaren à Hiller, autobiographical typescript, 28 Sept. 1945, p. 1, Hiller Archive, VSW. Another, not always reliable source reports, however, that "at the Art Institute he took a room on Michigan Avenue where most of the other art students lived" (John O. Emerson, "Lejaren à Hiller," 345).

46. M. D. R. French, "Art School of the Art Institute of Chicago," 7.

47. Roger Gilmore, ed., *Over a Century: A History of the School of the Art Institute of Chicago, 1866–1981* (Chicago: School of the Art Institute of Chicago, 1982), 69–73.

48. Ibid., 74.

49. Lori Daniels (registrar, School of the Art Institute of Chicago), personal communication with author, 1999. Hiller attended the school for three years, from September 1901 to mid-1903. During these years students received a diploma after a course of study that lasted three to four years, depending on their

progress in perspective, anatomy, and life drawing. While there is no record of Hiller's receiving a diploma, degrees in the fine arts were being discontinued at the school as of 1906, under the philosophy that the assumed possibility of graduation in art was a fallacy. During 1902–3 the school reorganized under the Parisian *atelier et concours* system, in which students chose their teachers and worked with them independently for a month before choosing to continue or seeking a new instructor; monthly competitive exams in the form of exhibitions determined class standing (see French, "Art School of the Art Institute of Chicago," 8; and Gilmore, *Over a Century*, 73).

50. "Honorable Mention," *Sketch Book* 2, no. 4 (Apr. 1903): 27–29.

51. On his washing light bulbs, see Hiller, autobiographical typescript, 28 Sept. 1945, Hiller Archive, VSW. For examples of his bookplates, see *Sketch Book* 1, no. 2 (Mar. 1902): 27 and 2 (May 1903): 12–14. For an account of Hiller's commercial work during school, see "Honorable Mention," 27. For an example of Hiller's portrait work, see the student portraits illustrating French, "Art School of the Art Institute of Chicago"; and for more on his portrait work, see John O. Emerson, "Lejaren à Hiller," 345.

52. See "The Ghetto"; and "The Ghetto As We Saw it," *Sketch Book* 1, no. 2 (Mar. 1902).

53. J.F.C., "Snide Talks with Art Students." For another description of Hiller, see the "typically Hilleresque" self-characterization of the inspired artist, subject to fits and starts of creative genius and "succeeding fits of idleness," in "Honorable Mention."

54. For a fuller description, see the clipping "Truly Bohemian Is the Life of Chicago's Art Students" in Hiller's photo album from the Art Institute years, Hiller Archive, VSW.

55. "Buzzard of Buzz," 32.

56. Hiller also used the camera to record his own drawings, pasting these photos in his album along with small portraits of school friends. He documented his various travel adventures, not only to the Chicago "Ghetto" but also to St. Louis, where in 1902 he painted murals for the world's fair; the Mississippi River, where he traveled for nine months on a houseboat with his art school buddy Harold Betts; and to the Southwest and San Francisco (April 1903). Hiller reports: "Worked at the St. Louis World Fair 1902–03, as an artist painting panoramas of the Galveston Flood, New York to the North Pole, and the Boer War Exhibits. Left St. Louis thereafter in a houseboat with the name of 'The Primeval Man' painted red. Drifted nine months down the Mississippi" (typescript signed "Lejaren a. Hiller," 2 Feb. 1950, Hiller Archive, VSW). Photographs in Hiller's 1909–33 scrapbook document the St. Louis work in 1902, as well as the boat trip. Other sources claim that it was in St. Louis that Hiller sold his first photographic illustration: "Hiller was assigned by a St. Louis newspaper to illustrate photographically the story of a Jay Hawker

visiting the World's Fair. Hiller scouted around and got a model, dressed him up in the proper fashion, and made a half dozen or so photographs" (see John O. Emerson, "Lejaren à Hiller," 346; and "Gallery").

57. John O. Emerson reported that while at the Art Institute, Hiller came into possession of a 4 × 5 camera, which he began taking to class. Despite some objections from instructors, "Hiller succeeded in creating opportunities to pose and photograph many groups, figure studies, nudes, etc. Several of the photographs made in this manner were later 'discovered' by an instructor at Chicago University. Their beauty and artistry won a sympathetic eye, and later, unknown to Hiller, enlargements of the photographs were made and three or four of them hung in one of the University halls for many years" (John O. Emerson, "Lejaren à Hiller," 345).

58. The entire issue of the June 1900 *Photo-Beacon* is devoted to reviews of the salon and reproductions from it. The jury was composed of Alfred Stieglitz, Joseph T. Keily, Clarence White, Ralph Clashron, and Eva L. Watson (see *Photo-Beacon*, June 1900, 4).

59. For reviews of the third salon, see *Photo-Beacon*, Jan. 1903, 12–13; and "Juror's Opinion of the Third Salon." See also Chicago Photographic Salon, *Photo-Beacon Souvenir*; and *Photo-Beacon*, Oct. 1901.

60. Vanderpoel, "Portrait Posing and Lighting." See also from the *Photo-Beacon*, for example, "Composition"; "Group Composition"; "Posing," both Apr. 1901 and May 1901; "Posing the Male Figure"; and "Child in Portraiture." In 1902 a similar set of articles on pictorial photography by Lucius W. Hitchcock was printed in the *Photo-Beacon*, such as "The Use of Accessories with One or More Figures," "Perspective," "Lighting and Values," and "Conventional Composition."

61. See, e.g., Yochelson, "Clarence H. White, Peaceful Warrior." During his early years (by 1904) in New York White was known as a photographic illustrator, having illustrated one story for *McClure's Magazine*, as well as several books.

62. "Photography as a Fine Art"; Hugh Stuart Campbell, "Commercialism in Art."

63. Hiller took his time moving from art school (which he appears to left in March 1903) to New York (where he moved in 1907). In the spring of 1903 Hiller took a trip to the American Southwest, like many other curious adventurers visiting the New Mexican "adobelands." At some point, perhaps in conjunction with this 1903 trip, Hiller got a job as a "traveling artist" for the Santa Fe Railroad, making numerous paintings and sketches for the railroad's advertising literature. By 12 April 1903 Hiller was in San Francisco making sketches and snapshots of Chinatown residents. Some sources, not necessarily reliable, suggest that Hiller was also in California in 1905, recovering from malaria and typhoid fever contracted during his Mississippi River boat trip.

Since Hiller had taken that trip years before, however, it seems more likely that if he fell ill, it was as a result of a trip to Panama in January 1905. Either way, by December 1905 Hiller had bought a ticket back to Chicago, arriving at the scene of his school days flat broke (see Thomas Wood Stevens, "San Domingo Days," *Garden of the Gods Magazine,* c. Spring 1903, 70–76, Hiller Archive, VSW). Hiller's sketchbooks contain sketches of the depot in Albuquerque, NM; the Grand Canyon; Las Vegas; Old Town New Mexico (both pencil and pen-and-ink drawings); adobes; Hotel Castaneda; Santa Fe; Santa Dominica New Mexico; Pipe Creek; Laguna; and Chinatown, San Francisco (see Hiller sketchbook; "Gallery"; and photograph album with canceled postage stamps, all in Hiller Archive, VSW).

64. The earliest date for these mailers, copies of which Hiller sent to his parents as a method of record keeping, is 11 July 1905; the latest is 5 March 1906 (Hiller Archive, VSW. See also John O. Emerson, "Lejaren à Hiller," 345; and "Gallery," Hiller Archive, VSW).

65. Because his own name was so often misspelled, Hiller kept a humorous record of the various name versions in the form of envelope addresses. These scraps of paper often include his home and studio addresses, as well as dates from postmarks (Hiller Archive, VSW).

66. See, e.g., his cartoonlike pen-and-ink drawings for the Tiny Tads Company, of New York City: an alphabet for children doubling as an ad campaign for a furniture store (1909–33 scrapbook, Hiller Archive, VSW).

67. Lejaren à Hiller, autobiographical typescript, 25 Sept. 1945, p. 2, Hiller Archive, VSW.

68. Albert Parry, *Garrets and Pretenders: A History of Bohemianism in America* (New York: Covici-Friede, 1933), 258; see also George Chauncey, *Gay New York: Gender, Urban Culture, and the Making of the Gay Male World, 1890–1940* (New York: Basic Books, 1994), 227–32. For further discussion of New York nightlife during these years, see M. Alison Kibler, *Rank Ladies: Gender and Cultural Hierarchy in American Vaudeville* (Chapel Hill: University of North Carolina Press, 1999); and David Nasaw, *Going Out: The Rise and Fall of Public Amusements* (New York: Basic Books, 1993).

69. *Sketch Book,* Sept. 1909–Aug. 1910, Hiller Archive, VSW.

70. Bogart, *Artists, Advertising, and the Borders of Art,* 32–39. Bogart discusses these events as "stag" parties, suggesting a consolidation of a normative heterosexual identity, yet they also gave license to nonnormative sex and gender roles, suggesting a broader range of sexual and gendered identities. These events, some of which were open to the larger artistic and theatrical community, were much anticipated in part because the costume requirement ensured the shedding of clothing in favor of "artistic," Orientalist, or Arcadian attire (Joe Leon [New York actor], conversation with author, 7 July 1999). Hiller was among the society members who performed in a 1914 play called *Plague* at the

Berkeley Theatre (see "Artists Preparing for Their Annual Splurge," *World*, Feb. 1914, clipping, Hiller Archive, VSW). Nonetheless, the sanctioned performance of an otherwise marginalized identity can also work to consolidate dominant norms (see Peter Stallybrass and Allon White, *The Politics and Poetics of Transgression* [Ithaca, NY: Cornell University Press, 1986]).

71. For a description of some of Hiller's parties, see Edward P. Harrison, "Lejaren Hiller, Photo Tycoon, Comes Next Monday to 'Shoot the Works,'" *Bumblebee* (Rochester Ad Club) 23 (9 Jan. 1936), Hiller Archive, VSW; Marks, "Portrait of Hiller," 153–54; and Katz, "Perfect Host."

72. For further documentation of Hiller's involvement with the Society of Illustrators, see the 1909–33 scrapbook, photographs of Society events, and membership certificates in the Hiller Archive, VSW.

73. To my knowledge, Hiller's only illustration for *Cosmopolitan* before his photographic work commenced in 1913 was a pen-and-ink drawing for Ella Wheeler Wilcox's poem "Lord Speaks Again" in the October 1909 issue. For brief narratives concerning this period of Hiller's career, see Katz, "Perfect Host," 54; and Lejaren à Hiller, autobiographical typescript, 2 Feb. 1950, Hiller Archive, VSW. Hiller claimed that he made his first photograph-based illustration for a St. Louis newspaper while working at the world's fair in 1902; the images illustrated a story of a farm family visiting the fair, and he was paid $1.50 for each (Lejaren à Hiller, autobiographical typescript, 25 Sept. 1945, p. 2, Hiller Archive, VSW).

74. *Cosmopolitan*, one of the nation's leading illustrated magazines, had been bought the by publishing entrepreneur William Randolph Hearst in 1905, his first venture into the general magazine market. In 1914 the magazine had a circulation of 1 million, with each issue averaging 144 pages. In 1912 the magazine dropped its muckraking emphasis and turned to a major reliance on fiction, with an increasing emphasis on sexual or romantic subjects (see Mott, *History of American Magazines*, 4:480–505).

75. Hiller, "Illustrating Magazine Articles," 17; "They Chose Photography," clipping about Hiller, Margaret Bourke-White, and George Platt Lynes, 1941, Hiller Archive, VSW. See also Katz, "Perfect Host," 54.

76. Tennyson, a family friend of Cameron's, had asked her to illustrate a "people's edition" of his popular epic poem. The 1874 King edition reproduced her photographs in the form of a few wood-engraved frontispieces. Disappointed with the project, she published a series of expensive albums, also with King, that, though commercial failures, generated extensive discussion in the photography journals (for more on this project, see Carol Armstrong, *Scenes in a Library: Reading the Photograph in the Book, 1843–1875* [Cambridge: MIT Press, 1998], 361–412).

77. See Hiller sketchbooks, Hiller Archive, VSW. The flyleaf of one sketchbook reads, "Left New York July 11th 4:30 pm. Steamer Madonna, Fabrian

line, via Providence Rhode Island Azores Islands, Lisbon Portugal . . . Barcelona, Marseilles." The dates suggest that Hiller's trip lasted about two months, from 11 July 1913 (after receiving payment for his *Cosmopolitan* work) through 6 September.

78. Yochelson, "Clarence H. White, Peaceful Warrior," 26; Jerry E. Patterson, "A Review of His Life and Work," in *Arnold Genthe, 1869–1942*, exhibition catalog (Staten Island: Staten Island Museum, 1975), 9.

79. Patricia Johnston, "Edward Steichen's Commercial Photography," *exposure* 26 (1989): 4–22; idem, *Real Fantasies*. For Steichen's World War I work, see also Allan Sekula, "The Instrumental Image: Steichen at War," *Artforum* 14 (Dec. 1975): 26–35.

80. Pictorialism has an extensive historiography. As an introduction, see Robert Doty *Photo-Secession: Stieglitz and the Fine-Art Movement in Photography* (1960; reprint, New York: Dover, 1978); William Innes Homer, *Alfred Stieglitz and the Photo-Secession* (Boston: Little, Brown, 1983); and Christian A. Peterson, "American Arts and Crafts: The Photograph Beautiful, 1895–1915," *History of Photography* 16 (Autumn 1992): 189–232.

81. Caffin, *Photography as a Fine Art*, 10; see also Louis A. Lamb, "The Broad Movement in Pictorial Photography," in *The American Annual of Photography and Photographic Times Almanac* (New York: Styles and Cash, 1906), 74–76. The fine-art movement in photography quickly led to a set of visual clichés; Stieglitz founded the Photo-Secession in part to protest "the antagonism of its founders to the existing spirit and standards that governed the larger photographic organizations of America in matters pertaining to pictorial photography" (see Alfred Stieglitz, "The Photo-Secession," in *The American Annual of Photography for 1904* [New York: Styles and Cash, 1904], 41–44).

82. F. Dundes Todd, the editor of the *Photo-Beacon*, Chicago's well-known amateur photography journal, regularly suggested Robinson's books to photographers seeking more information on artistic photography (see, e.g., letter to the editor, *Photo-Beacon*, Feb. 1900, 52; and "Pictorial Competition No. 21," ibid., Mar. 1900, 60).

83. The Montross Art Galleries, located on Fifth Avenue a few blocks from Hiller's studio, often showed Dow's work in the early years of the second decade of the century. Arthur Wesley Dow, chair of the Columbia University Teachers College's fine arts department, was a nationally prominent art educator whose students included White, Kasebier, and Alfred Langdon Coburn, among other pictorialist photographers. Dow was also an expert on Japanese prints, and his influential textbook *Composition*, first published in 1899, wed Eastern and Western art principles to assert the expressive qualities of formal design principles such as repetition, symmetry, and opposition (see Dow, *Composition;* and Yochelson, "Clarence H. White, Peaceful Warrior," 28. For a discussion of Dow's theories of composition in a source that was likely familiar to

Hiller, see Lucius W. Hitchcock, "Pictorial Photography," *Photo-Beacon*, Jan. 1902, 5–8).

84. See, e.g., Ellis, "Masculinism and Feminism"; Ella Wheeler Wilcox, "This Is My Task," *Cosmopolitan* 58 (Dec. 1914–May 1915): 500–501; Crane, "What's the Use?"; Crane, "The Cost"; Crane, "The Elect"; Crane, "Judgment"; and George J. Whelan, "Paying Up Oneself," *Cosmopolitan* 58 (Dec. 1914–May 1915): 699. Hiller even illustrated an article about the use of psychology in selecting employees: Child, "Man-Screen."

85. See the following by Maurice Maeterlinck: "Penetrating Another World," *Cosmopolitan* 57 (Sept. 1914): 474–83; "The Unknown Guest," ibid. 57 (Oct. 1914): 674–86; "Supernatural Communications in War-time," ibid. 60 (Mar. 1916): 568–72; "The Fallacy of Grief," ibid. 60 (May 1916): 816–18; and "The Will of Earth," ibid. 60 (Sept. 1916): 43, 130, 132.

86. Quoted in Lucy Bowditch, "Eduard Steichen and Maurice Maeterlinck: The Symbolist Connection," *History of Photography* 17 (Winter 1993): 334–42. See Bowditch's essay for a further discussion of the relationship between Maeterlinck and the *Camera Work* circle, especially Steichen and Sadakichi Hartmann.

87. Peter Clark Macfarlane, "Spiritgrams," *Cosmopolitan* 58 (Dec. 1914–May 1915): 254–58. Arnold Genthe, another well-known pictorialist, also produced some striking photographic illustrations for article describing psychical phenomenon after Hiller's work appeared (see, e.g., William Archer, "Can We Foretell the Future?" which was "illustrated with Imaginary Photographs by Arnold Genthe," *McClure's*, Dec. 1914, 78–91, and Jan. 1915, 79–87, as well as Genthe's photographs for Courtney, "His First Wife"). I have found no secondary sources that discuss the work of pictorialist photographers in illustrating fiction in mass-market magazines.

88. W. H. Heath, "Heart Throbs as the Pictorial Theme," *Printers' Ink*, 11 Nov. 1920, 157–58.

89. Lejaren à Hiller, "Combining Brush and Camera," *Printers' Ink Monthly*, June 1920, Hiller Archive, VSW.

90. Quoted in Jerre Bruce article in *Camera Craft*, Sept. 1936, 425–33, ibid.

91. The Steinway ad, for example, was the inaugural image for Steinway's famous "Instrument of the Immortals" campaign, a brainchild of copywriter Raymond Rubicam, later of Young and Rubicam but working for N. W. Ayer and Son in 1919. On the image and the campaign, see Julian Lewis Watkins, *The 100 Greatest Advertisements* (New York: Dover, 1959), 44–45.

92. For example, the idylls of the half man, half goat shepherd Pan. For a further discussion of the Arts and Crafts book movement in America, see Susan Otis Thompson, "The Arts and Crafts Book in America," in Ward, *American Illustrated Book in the Nineteenth Century*, 171–200; and John Harthan, *The His-*

tory of the Illustrated Book (London: Thames and Hudson, 1981), 227–69. The pioneer of modern fine-art publishing was the Boston pictorialist photographer Fred Holland Day, who began his press, Copeland and Day, soon after he met William Morris, who was just then establishing the Kelmscott Press, in the summer of 1890. Day's ethereal, spiritually wrought photographs, especially his crucifixion series, seem a likely influence on Hiller's extensively staged studio productions. Day exhibited his work at the Art Institute of Chicago while Hiller was a student there, as part of the second annual Chicago Photographic Salon, 1–22 Oct. 1901 (Verna Posever Curtis and Jane Van Nimmen, eds., *F. Holland Day: Selected Texts and Bibliography* [New York: G. K. Hall, 1995], 148. For Day's publishing work, see Estelle Jussim, *Slave to Beauty: The Eccentric Life and Controversial Career of F. Holland Day, Photographer, Publisher, Aesthete* [Boston: David R. Godine, 1981], 61–74).

93. The photographs were exhibited at the galleries of Moulton and Ricketts, Chicago (Agnes Richards, "A Genius in Art Photography," c. 1915, article in Hiller Archive, VSW; for a list of members of the Brothers of the Book, see newspaper clipping of unknown origin in ibid.).

94. Henry Peach Robinson, *Picture-Making by Photography*, 52–53. For further discussion of the model in pictorialist photography, see R. W. Shufeldt, "The Practical Use of the Nude," *American Annual of Photography for 1904*, 210–25; and idem, "The Art Photographer's Model," in *The American Annual of Photography and Photographic Times Almanac* (New York: Styles and Cash, 1907), 137–49.

95. On photography, models, and facial expression, see C. Frances Jenkins, "How to Secure Expression in Photography," *Cosmopolitan*, June 1899, 131–36; on the application of expression to advertising, see Garrett K. Brown, "Making Faces with People to Learn Their Minds."

96. Plummer and Hiller wed at the Little Church Around the Corner on 27 October 1921; afterwards, they moved to a new apartment at 332 West Twenty-eighth Street (*New York Tribune* clipping, Hiller Archive, VSW).

97. "Using the Camera to Illustrate Fiction: Models Pose for Photographs Showing Scenes in the Story—How Two Artists Originated the Plan," *New York Times Magazine*, 6 Jan. 1918, 13.

98. For a description of a well-known model's work, including work for Hiller, see Billie Scott, "The True Story of the Artist's Model: Conclusion of One Beautiful Model's Revelations of the Temptations, Pitfalls, and Rewards of Being a Pictured Beauty," 1916, clipping from unidentified New York tabloid, Hiller Archive, VSW. On the work of modeling more generally in relation to photography, see Phillips, "Art for Industry's Sake," 99–108.

99. Some of the models Hiller reportedly "discovered" or hired during these years include William S. Hart, Billie Dove, Mary Astor, and Mabel Normand (see Marks, "Portrait of Hiller," 153. On Hiller's work with models in

the 1930s, see George Bijur, "Underwood and Underwood Dig Up a Model," clipping from *Commercial Photographer*, c. 1937, 397–99, Hiller Archive, VSW).

100. Judson, "Illustrator Scouts the City to Get Suitable Models."

101. Testimonial ads often used well-known stars, including Mary Pickford (for Pompeiian Facial Cream), but these ads relied on the comparatively straightforward strategy of product endorsement.

102. Harrington, "Photographic Portrait-Study."

103. "Using the Camera to Illustrate Fiction." For an excellent study of the relationship between fashion, theater, and consumer culture in early-twentieth-century New York, see Marlis Schweitzer, "Becoming Fashionable: Actresses and Fashion in New York City, 1895–1919" (Ph.D. diss., University of Toronto, 2005).

104. Kathy Peiss, "Making Faces: The Cosmetics Industry and the Cultural Construction of Gender," *Genders*, Spring 1990, 143–69; idem, *Hope in a Jar: The Making of America's Beauty Culture* (New York: Henry Holt, 1998), 144.

105. John Powers, the founder, in 1923, of the first professional modeling agency in New York, pointed out that the shift to photography within advertising had created a demand for models, which his agency sought to fill (see John Robert Powers, *The Powers Girls: The Story of Models and Modeling and the Natural Steps by Which Attractive Girls Are Created* [New York: Dutton, 1941], 22–23. See also William Leach, *Land of Desire: Merchants, Power, and the Rise of a New American Culture* [New York: Vintage Books, 1993], 308).

106. Judson, "Illustrator Scouts the City to Get Suitable Models"; see also "Girls in Society Pose for Artists as Picture Models," clipping, c. 1918, Hiller Archive, VSW.

107. Historians have tended to take sides, along with some contemporary critics, against combination printing. Beaumont Newhall criticized the practice by emphasizing nineteenth-century critiques (see, e.g., Beaumont Newhall, *The History of Photography* [1938; New York: Museum of Modern Art, 1994], 74, 78). Robert Doty described Rejlander's work as "misguided" and characterized Robinson's combination prints as "sham means of producing tableaux" (see Doty, *Photo-Secession*, 11). More recent scholarship has provided a welcome historical corrective to what has often been an oddly moral objection to alternative, or "non-straight," photographic aesthetics (see, e.g., Ellen Handy, "Pictorial Beauties, Natural Truths, Photographic Practices," in *Pictorial Effect/Naturalistic Vision: The Photographs and Theories of Henry Peach Robinson and Peter Henry Emerson*, ed. Handy [Norfolk, VA: Chrysler Museum, 1994], 1–28).

108. See, e.g., Dale, "Tear-Drenched Drama," 210; or Dale, "Beauty with Winged Feet." For a theatrical photographer's complaint concerning salon photography's increasing bias against image manipulation, see Corydon G.

Snyder, "A Few Kicks and a Word about Theatrical Photography," in *The American Annual of Photography and Photographic Times Almanac* (New York: Styles and Cash, 1907), 261–66.

109. See Hiller, "One Thousand Ghosts." For other discussions of combination printing and commerce during this period, see Leonard Peake, "Giving the Photograph an 'Art Quality,'" *Printers' Ink*, 4 Aug. 1921, 123–27; Brodine, "Profitable Advertising and Pictorial Photography"; "Combination-Printing"; and William S. Davis, "Making of Composite Photographs."

110. As the photographer (and student of Clarence White) Margaret Watkins observed in 1926, "In the days of the Photo-Secession the artistic and commercial photographers were mutually unaware" (see Margaret Watkins, "Advertising and Photography," in *Pictorial Photography in America*, vol. 4 [New York: Pictorial Photographers of America, 1926]).

111. For a discussion of montage in American advertising, see Sally Stein, "'Good Fences Make Good Neighbors': American Resistance to Photomontage between the Wars," in *Montage and Modern Life, 1919–1942*, ed. Matthew Teitelbaum (Cambridge: MIT Press, 1992), 128–89. For the ongoing appreciation for what was sometimes called "mosaic photography" in commercial work, see L. V. Jolliffe, "A Mosaic Photograph and How It Was Made," *Printers' Ink Monthly*, Feb. 1928, 41–42.

112. Temple Scott, "The Use of Photography in Advertising," *Bulletin of the Art Center*, Mar. 1925, 176.

113. Henry Peach Robinson, *Picture-Making by Photography*, 26; see also Henry Peach Robinson, *Pictorial Effect in Photography*, 118–48.

114. Larrabee, "Human Interest and Light." For a review of Hiller's work that singles out his masterful sense of lighting, see clipping from *New York Tribune*, 14 Mar. 1920, Hiller Archive, VSW.

115. W. Livingston Larned, "A Little Light on Dark Pictorial Subjects," *Printers' Ink*, 16 Apr. 1925, 77–81; see also Larned's "Catching the Eye of the Lazy Reader," ibid., 18 Nov. 1920, 150–52.

116. Wilbur Perry, "How Much Should the Advertising Photograph Show?" *Printers' Ink Monthly*, Dec. 1922, 35–36. For a discussion of backgrounds and accessories in still-life advertising photography, see "Hats—and the Photographs That Sell Them"; and Foster, "Accessories That Make the Half-Tone Interesting."

117. Hiller, "Combining Brush and Camera." For additional articles from this era hailing Hiller as an artist-photographer pioneering in commercial work, see "The Work of the Lejaren à Hiller Studios," *Studio Light*, Apr. 1918, 8–12. Edouard C. Kopp, in an article stressing the importance of fine-art training for amateur photographers, reproduced a Hiller illustration for *Cosmopolitan* as an example of fine-art principles in photography (see Kopp, "Craft and Art in Amateur Photography").

118. "Our Cover Portrait and Hall of Fame." This article, which appeared in an Ansco Company house organ, appeared next to an article by Sadakichi Hartman detailing the compositional structures of works by master painters such as Botticelli, Raphael, and Boucher.

119. E. McKenna, "When Photography Borrows Effects from the Theatre," *Printers' Ink Monthly*, c. 1921, Hiller Archive, VSW. The firm of White and Wyckoff, based in Holyoke, Massachusetts, made "distinctive social stationery," among other products. Hiller made calendar illustrations for their Autocrat Stationery line between 1920 and 1937, with tableaux based upon "the Grand Canyon of Colorado," "Holland—Land of Dykes and Windmills," "Spain—Land of the Toreador," and so on. For further examples, see Hiller Archive, VSW.

120. For Teague's advertising work before 1925, see Clarence P. Hornung, *The Advertising Designs of Walter Dorwin Teague* (New York: Art Direction, 1991); Clarence P. Hornung and Fridolf Johnson, *200 Years of American Graphic Art* (New York: George Braziller, 1976), 164–65; and Charles Dalton Olson, "Sign of the Star: Walter Dorwin Teague and the Texas Company, 1934-1937" (master's thesis, Cornell University, 1987), 1–39. Teague worked for Phoenix Hosiery, as did Hiller; the borders on the White and Wyckoff calendars seem to be Teague's work as well. Teague worked for the high-quality illustration advocate Ernest Elmo Calkins in his advertising agency Calkins and Holden from 1908 to 1912, when he went out on his own as a freelance advertising artist specializing in decorative design and typography. For further information about Teague, see Jeffrey Meikle, *Twentieth Century Limited: Industrial Design in America, 1925-1939* (Philadelphia: Temple University Press, 1979).

121. *There Is More Leisure for the Housekeeper in Electrical Housekeeping*, Edison Company booklet, 1924, Hiller Archive, VSW. Hiller's clients were numerous but difficult to track down. At the time of my research Hiller's archive basically comprised seventy-five boxes of undated photographs, with no finding aid or cataloging system. Though I have sorted the photographs into rough decades, most of advertising photographs lack any information about date, client, advertising agency, or copy. I have been able to match some of the photos to ads through periodical research, but I have only accounted for a tiny minority of his output.

122. Additional research is needed on these early important commercial photographers. Hiller's 1921 photographs were loaned by J. A. Migel and exhibited by Street and Finney. The 1922 Royal Typewriter ad was exhibited by the H. K. McCann Company, while the Fatima photograph was loaned by Liggett and Meyers and exhibited by the Newell-Emmett advertising agency (see Art Directors Club of New York, *Annual of Advertising Art in the U.S., 1921* [New York, 1921], 5, 21; idem, *Annual of Advertising Art in the U.S., 1922*

[New York, 1922], 104, 109. For further information about these important exhibitions, see "Advertising Art Promoted by New York Art Center"; "Art Directors' Club Holds First Annual Exhibition"; "Awards at Art Directors' Club Exhibition," *Printers' Ink*, 30 Apr. 1925, 61–62; and Bogart, *Artists, Advertising, and the Borders of Art*, 128–32).

123. Art Directors Club of New York, *Third Annual of Advertising Art, 1924*, 122. W. Livingston Larned, noting the advances in photographic illustration, had declared as early as 1920 that "the artist can howl the winds down and the fact still remains that there are more photographic illustrations than ever—and they are superlatively better [than painted illustrations]" (W. Livingston Larned, "The Hidden Beauties of the Photographic Illustration," *Printers' Ink*, 25 Mar. 1920, 57).

124. Art Directors Club of New York, *Third Annual of Advertising Art, 1924*, 122, 123. The 1925 *Annual* also featured Hiller's work, including ads for Macy's men's clothing and for the Oshkosh Trunk Company, both exhibited by Barton, Durstine, and Osborn. Steichen's work for J. Walter Thompson was exhibited in this annual for the first time (see idem, *Fourth Annual of Advertising Art, 1925*).

125. See, e.g., Lewis, "Commercial Photography, Lesson No. 19," 180–81.

126. Bogart, *Artists, Advertising, and the Borders of Art*, 128.

127. On photographers' relationship to art directors, see Joseph V. Sloan, "How a Blind Man Originates Clever Advertising Photographs," *Commercial Photographer* 1 (Oct. 1926): 9–10; and Abel, "Putting Imagination into the Sales Picture," *The Commercial Photographer* 2 (Feb. 1927): 207–9. The Breuhl quotation is from Johnston, *Real Fantasies*, 319n24.

128. Winemiller and Miller, a strong competitor for Hiller's clients by 1922, advertised the following personnel for their photographic illustrations: a layout man, a director, and an operator (*Printers' Ink Monthly*, June 1922, 98).

129. "Converting Air-Way Advertising into Sales," *Air-Way Indicator*, c. 1928, 13–16, Hiller Archive, VSW.

130. Advertising photographers' working methods were described by a number of commentators in the 1920s, after the field had grown substantially (see, e.g., Charles Kaufmann, "Photographing Live Models Is an Art in Itself"; Flader, "Gone Is the Long-Haired Artist"; Ralph Young, "Human-Interest Illustrations," *Commercial Photographer*, Jan. 1928, 159–62; and Wilbur Perry, "'Making' the Photograph with the Proper Accessories," ibid., July 1928,: 461–66). For the Underwood figure, see Ben D. Jennings to Gordon Aymar, 16 Apr. 1931, Hiller Archive, VSW. On advertising photographers' working methods in a more recent era, see Barbara Rosenblum, *Photographers at Work: A Sociology of Photographic Styles* (New York: Holmes and Meier, 1978), 63–85.

131. Lejaren à Hiller, "Changing Styles in Fashion Photography," *Com-*

mercial Photographer, c. 1925, Hiller Archive, VSW. Although Hiller did some fashion work, he was best known for the elaborate social tableaux of contemporary advertising illustrations.

132. By the late 1920s only the most esteemed of advertising photographers, such as Hiller, posed their own models; otherwise, the art director was expected to have perfected the "ability to direct [the models] as a motion picture director handles the actors on the silver screen" (see David H. Colcord, "Tricks in Photography That Make for Better Engravings," *Printed Salesmanship,* Oct. 1927, 168–69).

133. "Converting Air-Way Advertising into Sales."

134. Ralph Young, "The Illustrative Photograph in Advertising," *Commercial Photographer,* Sept. 1928, 549.

135. A full discussion of the relationship between photography and modernism in advertising is beyond the scope of this essay, but see W. Livingston Larned, "When the Camera Goes Modern," *Printers' Ink,* 29 Aug. 1929, 52, 57–58, 60. Hiller's late-1920s work included a small number of striking modernist images and montages. On advertisers' general suspicion of modernism in advertising, see Gridley, "Statistical Glass Applied to Modernism," 133. For the decline of sentimentality and the rise of modernism among some sectors of amateur and commercial photography in 1929, see Frank Crowninshield, foreword to *Pictorial Photography in America,* vol. 5 (New York: Pictorial Photographers of America, 1929).

136. C. B. Larrabee, "How Kodak Chooses Its Advertising Illustrations," *Printers' Ink Monthly,* July 1922, 30–31.

137. W. Livingston Larned, *Illustration in Advertising* (New York: McGraw-Hill, 1925), 309. See also Claudy, "Honest Photographic Tricks"; and W. Livingston Larned, "What Can Be Done with Photographs," *Printers' Ink,* 12 Jan. 1922, 49–52. For a review of Larned's *Illustration in Advertising,* see B. F. Berfield, "What Must the Advertiser Know about Advertising Art?" ibid., 19 Mar. 1925, 77–80.

138. Garry Wills, "Message in a Bottle: Inventing Time," *Critical Inquiry* 15 (Spring 1989): 509.

139. Wilbur Perry, "The Movie Booklet," *Printers' Ink Monthly,* Sept. 1922, 20; see also "A Printing Idea Borrowed from Movies."

140. L. Earle Martin, "Photography in Advertising," in *The American Annual of Photography for 1930* (New York: Styles and Cash, 1930), 190–91.

141. Ad for Winemiller and Miller, *Printers' Ink Monthly,* Dec. 1922, 97. For commentary on the relationship between motion pictures and the advertising industry, see "Motion Picture Stunts Are Borrowed by Advertisers," *Printers' Ink,* 14 May 1925, 105–10.

142. *Printers' Ink Monthly,* Apr. 1922, 51.

143. *Back to the Old Farm* was created by International Harvester's advertis-

ing department in 1911, the first commercial movie ever made to sell a company's products (see Navistar International Corporate Archives, Chicago, IL. For further discussion of sponsored film in a slightly later period, see William L. Bird Jr., *Better Living: Advertising, Media, and the New Vocabulary of Business Leadership, 1935–1955* [Chicago: Northwestern University Press, 1999], 120–43).

144. The column, edited by Eugene J. Cour, the editorial representative for Pathé News, debuted in June 1927.

145. On *tableaux vivants* and middle-class gentility, see Karen Halttunen, *Confidence Men and Painted Women: A Study of Middle-Class Culture in America, 1830–1870* (New Haven: Yale University Press, 1982), 174–90. On the development of a middle-class audience for art appreciation, see Lawrence Levine, *Highbrow/Lowbrow: The Emergence of Cultural Hierarchy in America* (Cambridge: Harvard University Press, 1988), 151–68.

146. The *New York Times* reported that the idea for the project came from Miss Vera Ryer. The committee of artists and art patrons also included Edwin H. Blashfield, president of the National Academy of Design; Robert Aiken, president of the Sculptors' Society of America; Louis C. Tiffany; and Daniel Chester French (*New York Times Film Reviews*, 26 Sept. 1921, 103).

147. Burne-Jones's painting was based upon a Tennyson poem of sixteen lines, published in 1842, which in turn was based upon an Elizabethan story about a king who is indifferent to feminine graces until he falls in love with an impoverished "beggar" maid. Burne-Jones's painting illustrates a passage in which the maid sits awestruck in the royal palace as the king lays his crown before her. When the painting was exhibited at the Exposition Universelle in Paris in 1889, Burne-Jones was awarded the cross of the Légion d'honneur, and a vogue for his painting began that lasted well into the twentieth century. Hiller seems to have made a role in the film for a Burne-Jones character, who "subdues the fears of all concerned that love between persons in widely separated social classes may result unhappily" (ibid.). For further information about Burne-Jones, as well as his relationship to the Pre-Raphaelite Brotherhood and the Aesthetic, Symbolist, and Arts and Crafts movements, see Stephen Wildman and John Christian, *Edward Burne-Jones: Victorian Artist-Dreamer* (New York: Metropolitan Museum of Art, 1998).

148. *New York Times Film Reviews*, 12 Dec. 1921, 20. The leads were played by Mary Brandon and Pierre Gendron.

149. Chris Mullen, *G. F. Watts: A Nineteenth Century Phenomenon* (London: Whitechapel Art Gallery, 1974), 2. The Triarts film is briefly mentioned in *New York Times*, 15 Oct. 1922, 21–22.

150. The Underwood brothers had a standardized sales talk long before National Cash Register. For a fuller discussion of their sales techniques, see William Brey, "Ten Million Stereo Views a Year," *Stereo World*, Jan.–Feb. 1990,

7–12; see also John Dennis, "The Stereoscopic Photograph: The Only Magazine in the World in the Stereoscopic Field," ibid., Jan.–Feb. 1995, 4–11.

151. Obituaries for Bert Underwood, *New York Times*, 29 Dec. 1943, 17, and Elmer Underwood, ibid., 19 Aug. 1947, 23.

152. William Culp Darrah, *Stereo Views: A History of Stereographs in America and Their Collection* (Rochester, NY: Visual Studies Workshop, 1979), 113. For more recent work on the role of stereographs in American culture, see Laura Schiavo, "'A Collection of Endless Extent and Beauty': Stereographs, Vision, Taste, and the American Middle Class, 1850–1880" (Ph.D. diss., George Washington University, 2003).

153. Underwood and Underwood pioneered the "stock" photograph for advertising and selling (see Underwood and Underwood, *Reserve Illustrations by Underwood and Underwood* [1931], a catalog offering stock images in categories such as "Girls and Women—Portrait Heads and Action Pictures," "Home and Family Groups," "Boudoir Scenes," and "Sports Scenes and Travel Pictures").

154. Shortly before 1931 Elmer Underwood relinquished financial control of the business but retained a financial interest that he passed on to his son Tom (obituary for Elmer Underwood). Tom remained the head of Underwood and Underwood Illustration through 1947. The company seems to have closed about 1949, for reasons that Ed Scherck, a vice president at Underwood, was reluctant to put on tape (see transcript of Ed Scherck, interview by Arnold Sorvari, 4 October 1980, Hiller Archive, VSW. For another account, see "American Aces: Underwood and Underwood," an article about the company's role as official photographers for the 1939 world's fair, *U.S. Camera*, c. 1939, ibid.).

155. Gordon Aymar to Lejaren à Hiller, 9 Apr. 1931; Ben D. Jennings to Aymar, 16 Apr. 1931, Hiller Archive, VSW.

156. Underwood and Underwood brochure, c. 1937, ibid. Hiller's numerous awards included recognition from the Art Directors Club and the Photographers' Association of America, among others (see certificates and correspondence, ibid.). On the growth of color photography between the wars, which is too complex a story to tell here, see Sally Stein, "The Rhetoric of the Colorful and the Colorless: American Photography and Material Culture between the Wars" (Ph.D. diss., Yale University, 1991).

157. Another series worthy of further discussion elsewhere is Hiller's extensive work for Canadian Club whiskey.

158. *Histrionic* is Robert A. Sobieszek's apt term for the series (see Robert A. Sobieszek, *The Art of Persuasion* [New York: Abrams, 1988], 66). Only one of the eighty-seven tableaux was photographed in color, using the new color carbro process; all others were photographed in black and white, though eight subjects were then hand-colored at the Underwood studios. For more on the printing of this series, see Charles T. Riall to John Rudy, 19 Nov. 1985, Hiller Archive, VSW.

159. Advertisement, Underwood and Underwood, c. 1934, Hiller Archive, VSW.

160. Getchell, who started his own company in 1932, was a vocal advocate of photographic technology and was largely responsible for the industry-wide shift to tabloid formats, bold headlines, and photographic realism. "We believe people want realism today," he argued. "Products as they really are. Human interest. People. Places. Told in simple photographs that the eye can read and the mind can understand" (quoted in Fox, *Mirror Makers*, 166).

161. Although Hiller had modeled for his own illustrations as far back as his *Cosmopolitan* years, by the late 1920s Underwood and Underwood began to market Hiller's celebrity status as a model as well as a photographer. A calling card announces, for example, "Meet HILLER! Here he is, the rubber-faced model—equally expert on either side of the camera!" As his work behind the camera waned, Hiller's role as company salesman increased, and he was more frequently showcased, at professional talks, presentations, and banquets. For the card, as well as presentation and award certificates from the 1920s through the 1940s, see Hiller Archive, VSW.

162. The end of Underwood and Underwood, as well as Hiller's relationship with the company, remains somewhat unclear. Ed Scherck, who had worked with Hiller at Underwood and Underwood since 1927, eventually left the business in about 1948, taking many of the best clients with him. (Scherck declined to record the details of the end of Underwood, which closed about 1949.) George Greb, another Underwood employee, had left Underwood in about 1947 and started a complete photographic studio at 155 East Thirty-fifth Street called George Greb Studios (specializing perhaps in automobile photography). When Scherck left Underwood he established his own studio at 6 East Thirty-ninth Street and worked with Greb for about six months to a year; they later established a studio—Greb and Scherck, Inc.—at 240 East Forty-fifth Street. After the closing of Underwood and Underwood, Hiller considered himself officially retired but continued working on an exclusively freelance basis for Greb and Scherck; many of these later images are in the collection of the International Museum of Photography at George Eastman House (my source for the studio addresses). See also transcript Of Ed Scherck, interview by Arnold Sorvari, 1987, Hiller Archive, VSW.

Conclusion

1. Maren Stange, *Symbols of Ideal Life: Social Documentary Photography in America, 1890–1950* (New York: Cambridge University Press, 1989); see also Lili Corbus Bezer, *Photography and Politics in America: From the New Deal into the Cold War* (Baltimore: Johns Hopkins University Press, 1999).

Selected Bibliography

Using Photographs for Historical Analysis

In their efforts to understand and narrate the past, historians encounter and interpret a range of primary-source materials. Although it might be fair to say that historians have been most at ease with the written word, over the past several decades they have enlarged their interpretation of "text" to include a range of primary sources, including material-culture artifacts, moving pictures, the built environment, advertisements, and other historical artifacts that do not rely exclusively on the written word to communicate meaning. In writing this book, for example, I relied heavily upon the photograph, in addition to other primary sources such as periodical literature and personal papers. Historians seeking primary-source materials concerning Frank and Lillian Gilbreth should start with the voluminous records archived at the Purdue University Special Collections Library, Lafayette, Indiana, where the Gilbreths' photographic materials are located with their personal and professional papers, including correspondence, diaries, image captions, presentation scripts, offprints of articles, and other useful materials. Additional photographs and stereographs concerning the Gilbreths' study of motion can be found at the National Museum of American History, Behring Center, Division of the History of Technology, Washington, DC. Primary materials concerning Katherine Blackford and other character analysts were gleaned from their published works, including periodical literature. Lewis W. Hine's materials can be found at the International Museum of Photography, George Eastman House, Rochester, New York (photographs and some correspondence); in the Prints and Photographs Division of the Library of Congress, Washington, DC; and in numerous other archives. Hine's nonphotographic archival record is sparse, and many of his letters have been usefully collected in Daile Kaplan, ed., *Photo Story: Selected Letters and Photographs of Lewis W. Hine* (Washington, DC: Smithsonian Institution Press, 1992). Archival materials concerning Lejaren à Hiller, including photographs, autobiographical typescripts, advertising offprints, oral-history interviews, and negatives, are available at the Visual Studies Workshop, Rochester, New York. Additional Hiller materials are available at the International Museum of Photography, George Eastman House. Any researcher contemplating a project concerning American commercial or business history would be well advised to investigate the materials in the Hagley Museum and Library, Wilmington, Delaware; the Warshaw Collection of Business Americana, Archives Center, National Museum of American History; the Baker Library, Harvard Business School; and the John W. Hartman Center for Sales, Advertising, and Marketing History, Duke University.

For those embarking on their own research into the photographic record, the first challenge is to find an archive of historical photographs to analyze. The researcher's goal is to find a group of photographs that have a historical relationship to one another and whose number is not overwhelming. The collections of most historical societies, university special collections, government agencies, and museums include photographs. Historians can find these collections through published guides to photograph collections at specific archives and museums (such as the Smithsonian), through Web sites, or by contacting historical societies or other organizations directly. Many of these collections are very large, comprising tens of thousands, if not millions, of images. Students who encounter archives of this size will need to narrow their focus by choosing a specific time period or subject. In addition to being collected in museums and archives, of course, photographs appear regularly in periodical literature, in souvenir and museum shops, in printed ephemera, and on the Internet. The researcher should select a manageable group of images for his or her analysis.

Once the researcher has selected a photographic archive, the analysis might proceed on three levels. First, the historian should seek to analyze the image itself as a primary text, to determine how the image works in formal terms. The evidence, in this case the photograph, should be allowed to suggest directions for further research. Next, the historian should study the historical context in which the image was produced, focusing on accompanying text and the production and circulation of specific, historical meanings. Finally, the researcher might wish to examine the image, and its historical meanings, through the lens of a theoretical framework, such as those suggested by feminism or postcolonial theory, in order to produce a reading of the primary source that is informed equally by a close study of the image's formal vocabulary, by history, and by an analytical framework, however defined.

One should begin a formal analysis of the image simply by describing the image to an imagined, intelligent reader. One should not be afraid to state what might seem obvious; description consists, in part, in representing what is right in front of one's eyes, but in an artful manner. The historian reading the photographic record is basically translating the visual into the verbal, and since seeing is a subjective process, the historian is in fact creating the image for the reader. Without going into elaborate analyses, he or she should lead the reader through the image, describing its subject matter and focusing on elements that will support his or her argument concerning the image's meaning. The historian should consider questions such as, What does the photograph show? Are we looking at a landscape, a factory interior, a group of children selling newspapers? Looking closely at the image, is it possible to tell what time of day it is? Where is it set? If there is a human figure, what is the figure doing, wearing, and so on? How is the body positioned? The historian should be specific as to

expression, gesture, hair, color, background, and other details that, taken as a whole, communicate meaning. Also to be considered are the formal elements of the image, including the use of lines (vertical, horizontal, diagonal); the masses of lights and darks; the choice of focus, framing, and color. How is the eye led through the image, and how is this movement suggested by the image's formal qualities? After describing the image, the historian should move to an analysis of the image as a cultural form. What message is the document communicating, and how is the form of the document useful in communicating that message? One of the goals of the historical analysis is to understand *how* specific meanings are suggested through the photograph's formal qualities.

Photographs rarely appear in the world without some sort of context; they are always part of a discursive environment that works to direct and to anchor their otherwise elusive meanings. These various contexts can be thought of in relationship to scale and to the production, distribution, and consumption of photographic meaning. In relationship to scale, one should consider the following very local questions. Does the photograph have any accompanying text that seeks to direct how one interprets the image? This accompanying text might be a newspaper caption; a photographer's caption on the back side of the image (such as in Lewis Hine's *Dinner Pail Toters*); a narrative, such as that used by the efficiency expert Frank Gilbreth to explicate his motion studies; or advertising copy, such as that accompanying a Hiller photograph. In addition to accompanying text, often the photograph appears within a larger context, such as a book or a magazine. How can the historian characterize this medium? Here, the researcher asks who wrote or published the magazine or book, what the author's or editor's intentions were, and who the audience was. Often, historical studies are available to help in the interpretation of the photographic context, such as histories of magazines, specific museums, publishing houses, or reform organizations. In addition to secondary sources, other cognate primary sources, such as manuscripts, periodical literature, and other texts, can help the historian more fully interpret photographs.

Beyond the immediate context of accompanying caption and, perhaps, the magazine or book in which the photograph might be embedded, the photograph may appear in a still larger environment, such as the archive or an exhibition venue. Often, of course, photographs that were once part of an exhibition or a magazine story are recontextualized as part of a photographic archive. Here, one can ask how the implied viewer of the archival image or the exhibition is meant to understand the photograph's discursive meaning. Is the image presented as part of a historical category, an aesthetic category, a commercial category? One of Hiller's advertising photographs, for example, could be filed away under the heading "WWI," or "Pictorialism," or "Advertising"; what is implied by such archival or exhibition decisions?

Once we move from questions of production (who made the image, when

and why, etc.) to questions of reception (who viewed the image, where, etc.), questions of scale become more fluid. In what contexts and environments did viewers encounter the photographs at the time of their original circulation? Who was likely to view, for example, a 1909 Louis Hine photograph of a child working in a textile mill, and how? What meanings were specific viewers meant to take away from their encounters with the images, and can the researcher find evidence for those meanings? It should be kept in mind that different communities of viewers may interpret the same image differently. A middle-class reformer, for example, might interpret Lewis Hine's child-labor photograph differently than a South Carolina mill owner who employed the photograph's subjects in 1909.

Sometimes it can be relevant to consider how photographs have been appropriated and recontextualized to create new meanings, such as when Katherine Blackford reprinted a Jacob Riis portrait to make a claim about physiognomic truth in a 1918 book on character analysis. In the twenty-first century, photographs are increasingly unmoored from their original contexts and asked to carry meanings that were never part of their original circulation; this labor of symbolic meaning is especially pronounced in the circulation of commercial imagery, including on the Internet and in advertising. Historians will usually wish to ask how the photograph may have been read, or interpreted, at a specific historical moment rather than how a contemporary audience may understand the image and its meaning.

My final recommendation is to observe in one's reading how historians describe and analyze photographs as part of their historical analysis. In addition to the examples provided in this book, the reader might wish to explore the following: Ardis Cameron, ed., *Looking for America: The Visual Production of Nation and People* (Malden, MA: Blackwell, 2005); Laura Wexler, *Tender Violence: Domestic Visions in an Age of U.S. Imperialism* (Chapel Hill: University of North Carolina Press, 2000); and Alan Trachtenberg, *Reading American Photographs: Images as History, Mathew Brady to Walker Evans* (New York: Hill and Wang, 1989).

Primary Sources

Manuscript and Photograph Collections
Boston Public Library. Rare Books and Manuscripts Department.
 Munsterberg, Hugo, Manuscript Collection.
Getty Museum, Los Angeles. Photograph Collections.
Getty Research Institute, Los Angeles. Special Collections.
 Brown, Andreas, Collection.
Hagley Museum and Library, Wilmington, DE.
 Manuscripts and Archives. Remington Rand Division, Safe Cabinet
 Company Papers, Sperry Rand Corporation.

Pamphlet Collection.

Pictorial Collections. DuPont, Provident Mutual Life Insurance
Company, Remington Rand Collection, Safe Cabinet Company,
Westinghouse.

International Museum of Photography, George Eastman House, Roch-
ester, NY.

Hiller, Lejaren à, Collection.

Hine, Lewis W., Collection.

Muybridge, Eadweard, Manuscript Collection.

Kingston Museum, Kingston upon Thames, UK.

Muybridge Scrapbooks.

National Museum of American History, Behring Center, Smithsonian
Institution, Washington, DC.

Archives Center. United Shoe Machinery Corporation Papers.

Archives Center. Warshaw Collection of Business Americana. N. W. Ayer
Collection.

Division of Engineering, History of Technology. Gilbreth Collection,
Jane Morley files.

Division of the History of Science. Mathematics Collection.

Division of Photographic History. Eadweard Muybridge Collection.

Purdue University, Lafayette, IN.

Gilbreth Library. Siegesmund Engineering Library.

Purdue University Libraries Special Collections. Frank and Lillian Gil-
breth Collection.

Visual Studies Workshop, Rochester, NY.

Hiller, Lejaren à, Archive.

BOOKS AND ARTICLES

Abel, Charles. "Putting Imagination into the Sales Picture." *Commercial Pho-
tographer* 2, no. 5 (Feb. 1927): 207–9.

Achilles, Paul S. "Some Psychological Aspects of Scientific Management."
Society for the Advancement of Management Journal 13 (May 1936): 67–70.

Adams, Henry Foster. "The Mythology and Science of Character Analysis."
Scribner's Magazine, May 1921, 569–75.

———."Psychology Goldbricks: Character Analysis—'Applied Psychology.'"
Scribner's Magazine, July 1921, 101.

"Advertising Art Promoted by New York Art Center." *Printers' Ink*, 10 Nov.
1921, 50–52.

Amar, Jules. "The Care of the Wounded in France: Methods and Instruments
for Aiding Men Who Have Lost Hands or Arms." *Scientific American
Supplement* 82 (1916): 348–50.

———. *The Human Motor; or, The Scientific Foundations of Labour and Industry.*

Trans. Elsie P. Butterworth and George E. Wright. London: Routledge, 1920.

———. *Organisation physiologique du travail.* Paris: Dunod et Pinat, 1917.

———. *The Physiology of Industrial Organisation and the Reemployment of the Disabled.* Translated by Bernard Miall. New York: Macmillan, 1919.

———. *La prothese et la travail des mutiles.* Paris: Dunod et Pinat, 1916.

Anderson, L. Dewey. "Estimating Intelligence by Means of Printed Photographs." *Journal of Applied Psychology* 5, no. 2 (June 1921): 152–55.

"Applying Psychology in Business." *Current Opinion* 54 (July 1913): 6066.

Argyle, Donald. "Pop Ball on House-Organs." *Printers' Ink Monthly,* Feb. 1923, 34, 73.

Arnold, Horace L. "Ford Methods and the Ford Shops." *Engineering Magazine* 47 (1914): 179–203.

"Art Directors' Club Holds First Annual Exhibition." *Printers' Ink,* 10 Mar. 1921, 80–84.

Barton, Bruce. "What Your Mirror Will Tell about Your Character." *American Magazine* 93, no. 4 (Apr. 1922): 58–60, 136.

Beeks, Gertrude. "Employees' Welfare Work." *Independent* 55 (22 Oct. 1903): 2515–18.

"Beginning Its Thirteenth Year, the *Western Electric News* Defies Superstition and Talks about Itself." *Western Electric News* 13, no. 1 (Mar. 1924): 3–4.

Bergen, H. B. "What Personnel Men Don't Know about Judging Human Traits." *Industrial Psychology* 2 (1927): 80–83.

Bigelow, Clifford G. "The Cadillac Employees' Magazine." *Printed Salesmanship* 48, no. 5 (Jan. 1927): 455–60.

———. "Cashing In on 'Good Will.'" *Printed Salesmanship* 48, no. 4 (Dec. 1926): 359–63.

———. "The House Publication's Chief Characteristic." *Printed Salesmanship* 46, no. 2 (Oct. 1925): 177–84.

———. "House Publications." *Printed Salesmanship,* July 1925, 487–92.

———. "House Publications and the 'Heart' of Business." *Printed Salesmanship* 46 (Sept. 1925): 75–79.

———. "How Much Should a House Magazine Cost?" *Printed Salesmanship* 47 (May 1926): 269–75.

———. "If the Boss Is Broad-Minded, Have Him Read This." *Printed Salesmanship* 47, no. 6 (Aug. 1926): 559–62.

———. "Just What Does the House Organ Do?" *Printed Salesmanship* 46, no. 3 (Nov. 1925): 291–98.

———. "Producing a Prize-Winning Employees' Magazine." *Printed Salesmanship* 49, no. 1 (1927): 71–74.

———. "Putting Across the Employees' Magazine." *Printed Salesmanship* 47, no. 5 (July 1926): 461–65.

Bingham, Walter Van Dyke. "Cooperative Business Research." *Annals* 110 (Nov. 1923): 180–83.

———. "Psychology Applied." *Scientific Monthly*, Feb. 1923, 148–50, 153.

———. "What Industrial Psychology Asks of Management." *Bulletin of the Taylor Society* 9 (Dec. 1924): 243–48.

Bingham, Walter Van Dyke, and Max Freyd. *Procedures in Employment Psychology*. Chicago: A. W. Shaw, 1926.

Blackford, Katherine M. H. *Blondes and Brunets*. Edited by Arthur Newcomb. 3d ed. New York: Review of Reviews, 1916.

———. *Character Analysis by the Observational Method*. Edited by Arthur Newcomb. 3d ed. New York: Henry Alden, 1918.

———. *Employers' Manual*. New York: Emerson, 1912.

———. "An Afternoon with Bertillion." *Outlook* 24 (Feb. 1912): 424–28.

———. *The Job, the Man, the Boss*. Garden City, NY: Doubleday, Page, 1915.

———. *The Man and His Job*. Chicago: LaSalle Extension University, 1915.

———. *Reading Character at Sight*. Edited by Arthur Newcomb. New York: Blackford, 1922.

Blackford, Katherine M. H., and Arthur Newcomb. *Analyzing Character: The New Science of Judging Men; Misfits in Business, the Home, and Social Life*. New York: Review of Reviews, 1916.

———. *The Right Job: How to Choose, Prepare for, and Succeed in It*. New York: Review of Reviews, 1924.

Bloomfield, Meyer. "The Aim and Work of Employment Managers' Associations." *Annals of the American Academy* 65 (May 1916): 76–87.

———. "Labor Problems in Scientific Management." *Iron Age* 94 (10 Dec. 1914): 1371.

———. "The New Professional of Handling Men." *Annals of the American Academy* 25 (Sept. 1915): 121–26.

Brandeis, Louis D. *Scientific Management and Railroads: Being Part of a Brief Submitted to the Interstate Commerce Commission*. 1911. Reprint, Easton, PA: Hive, 1981.

Brasefield, H. D. "Psychology and What It Has for the Salesman." *Salesman*, July 1910, 136.

Brodine, Harry A. "Profitable Advertising and Pictorial Photography." *Photo-Era* 11 (July 1918): 3–5.

Brown, Garrett K. "Making Faces with People to Learn Their Minds." *Printers' Ink Monthly*, Jan. 1922, 30.

Bruce, H. Addington. "Psychology and Business." *Outlook* 99 (Sept. 1911): 32–36.

Burtt, Harold Ernest. *Principles of Employment Psychology*. Rev. ed. New York: Harper, 1942.

———. *Psychology and Industrial Efficiency*. New York: Appleton, 1929.

Butler, Nicholas Murray. "A Menace to Our Integrity as a People." *World's Work* 11 (Nov. 1905–Apr. 1906): 6817.

"The Buzzard of Buzz." *Sketch Book* 2, no. 4 (Apr. 1903): 30–33.

Caffin, Charles H. *Photography as a Fine Art.* 1901. Facsimile, New York: American Photographic Book, 1972.

"A Camera Interpretation of Labor," *Mentor,* Sept. 1926, 42–47.

Campbell, Hugh Stuart. "Commercialism in Art." *Sketch Book* 2, no. 6 (July 1903): 36–37.

Campbell, J. M. "People Have Become 'Standardized' by Advertising." *Printers' Ink,* 29 July 1920, 10–12.

"Can We Read Human Character?" *Literary Digest,* 20 June 1925, 22–23.

Carnegie, Dale. *How to Win Friends and Influence People.* New York: Simon and Schuster, 1936.

Casson, Herbert N. "The Human Touch in Printed Salesmanship." *Printed Salesmanship,* Sept. 1926, 27.

Chapman, J. C. *Trade Tests: The Scientific Measurement of Trade Proficiency.* New York: Holt, 1921.

"Character the Foundation of Success." *Salesmanship* 3, no. 5 (Nov. 1904): 140–44.

Chicago Photographic Salon. *The Photo-Beacon Souvenir.* Chicago: Photo-Beacon, 1901.

Child, Richard Washburn. "The Man-Screen." *Cosmopolitan,* Dec. 1914–May 1915, 647–49.

"The Child in Portraiture." *Photo-Beacon,* July 1901, 197–200.

Claudy, C. H. "Honest Photographic Tricks." *Printers' Ink,* 22 July 1920, 25–28.

Cleeton, Glen U. "Estimating Human Character." *Scientific Monthly,* Nov. 1926: 428–29.

———. "What You Can't Tell about People from Their Faces." *American Magazine* 101, no. 3 (Mar. 1926): 26–28.

Clevenger, S. V. "Cerebrology and the Possible Something in Phrenology." *American Naturalist* 22 (July 1888): 612–21.

"Combination-Printing." *Photo-Era* 20 (Jan. 1920): 8–10.

Compass Sales Corporation. *The Selling Compass.* Chicago, 1933.

"Composition." *Photo-Beacon,* Feb. 1901, 37–41.

Copley, Frank Barkley. *Frederick Winslow Taylor.* 2 vols. New York: Harper, 1923.

Courtney, W. L. "His First Wife: The Strange Case of Ralph Holderness." *McClure's,* Feb. 1915, 98–106.

Crane, Frank. "The Cost." *Cosmopolitan,* Nov. 1914, 721.

———. "The Elect." *Cosmopolitan,* Dec.–May 1915, 113.

———. "Judgement." *Cosmopolitan,* Dec.–May 1915, 353.

——. "What's the Use?" *Cosmopolitan*, Oct. 1914, 577.

Cronau, Rudolf. *Our Wasteful Nation*. New York: Mitchell Kennerly, 1908.

Dale, Alan. "A Beauty with Winged Feet." *Cosmopolitan*, 1915, 404–505.

——. "The Tear-Drenched Drama." *Cosmopolitan*, Jan. 1910, 199–212.

Dana, Richard. *The Human Machine in Industry*. New York: Codex, 1927.

Darwin, Charles. *The Expression of the Emotions in Man and Animals*. London: J. Murray, 1872.

Davenport, Charles. *A Guide to Physical Anthropometry and Androscopy*. New York: Cold Spring Harbor, 1927.

Davis, William S. "The Making of Composite Photographs." *Photo-Era* 25 (Mar. 1925): 132–39.

Dennis, Wayne. "The Background of Industrial Psychology." *Current Trends in Industrial Psychology*. Pittsburgh: University of Pittsburgh Press, 1949.

"The Development of the Art of Selling." *Salesmanship* 1, no. 2 (July 1903): 22.

Dickinson, Roy. "Employees' Magazines More Essential Now Than Ever." *Printers' Ink*, 31 Mar. 1921, 133–34, 136, 138, 141–42, 145–49.

——. "Making Welfare Copy Believable: Advertising That Sells the Community and Gets New Workers." *Printers' Ink*, 11 Mar. 1920, 169–79.

——. "Selling the Job to Employees in Big Advertisements." *Printers' Ink*, 6 May 1920, 125–26.

Doll, E. A. *Anthropometry as an Aid to Mental Diagnosis: A Simple Examination of Sub-Normals*. Baltimore: Williams and Wilkins, 1916.

Dosch, Arno. "To Hire Men by Machinery." *World's Work* 28 (Aug. 1914): 467–71.

Dow, Arthur Wesley. *Composition: A Series of Exercises from a New System of Art Education*. 3d ed. 1890. Reprint, New York: Baker and Taylor, 1990.

Drever, James. *The Psychology of Industry*. 1921. Reprint, London: Methuen, 1947.

Drury, Horace. *Scientific Management: A History and Criticism*. New York: Columbia University Press. 1915.

Duchenne, Guillaume Benjamin Amand. *Mecanisme de la physiognomie humaine ou analyse electro-physiologique de l'expression des passions*. Paris: V. J. Renouard, 1862.

Dunlap, Knight. "The Reading of Character from External Signs." *Scientific Monthly*, Aug. 1922, 153–65.

Dunn, Robert W. *The Americanization of Labor: The Employers' Offensive against the Trade Unions*. New York: International Publishers, 1927.

"Duties and Characteristics of Salespeople." *Salesmanship* 1, no. 2 (July 1903): 24.

Eastman Kodak Company. *The Human Appeal*. Rochester, NY, 1913.

Elbon, S. G. "Studying the Buyer." *Salesmanship* 6, no. 1 (Jan. 1906): 80.

Ellis, Havelock. "Masculinism and Feminism." *Cosmopolitan*, 1915, 316–17.

———. *My Life*. Boston: Houghton Mifflin, 1939.

———. *The Task of Social Hygiene*. Boston: Houghton Mifflin, 1912.

Emerson, Harrington. "Discipline and Efficiency: The Ruling of Great Or-
ganizations." *Scientific American Supplement* 24 (Dec. 1910): 415–16.

———. "Efficiency and the New Tariff: How Scientific Management Enables
America to Compete with Cheap European Labor." *Scientific American
Supplement*, 21 Feb. 1914, 122–23.

———. *Efficiency as a Basis for Operation and Wages*. New York: Engineering
Magazine, 1912.

———. "Philosophy of Efficiency." *Engineering Magazine* 41 (Apr. 1911):
23–26.

———. "Salient Features of the Düsseldorf Exposition." *Engineering Magazine*
24 (Oct. 1902): 17–32.

———. "Square Pegs in Round Holes." *Independent* 93 (16 Feb. 1918): 277.

———. *The Twelve Principles of Efficiency*. New York: Engineering Magazine,
1912.

Emerson, John O. "Lejaren à Hiller: The Artist Who Made an Art of Pho-
tography." *Camera*, May 1932, 344–53.

"Employees' Magazines as Distinguished from House-Organs." *Printers' Ink*,
19 Feb. 1920, 41–43.

"The Employer and the Employee." *System* 5, no. 5 (May 1904): 349–57.

"Enormous Labor Turnover." *National Association of Corporation Schools Bul-
letin* 4, no. 8 (Aug. 1917): 21–25.

Epstein, Abraham. "Industrial Welfare Movement Sapping American Trade
Unions." *Current History* 24 (4 July 1926): 516.

Esesarte, M. A. "Sizing Up the Prospective Customer I." *Salesmanship* 5, no.
3 (Sept. 1905): 121–24.

———. "Sizing Up the Prospective Customer II." Salesmanship 5 (Oct. 1905):
182–85.

Estabrooks, G. H. "The Relation between Cranial Capacity, Relative Cranial
Capacity, and Intelligence in School Children." *Journal of Applied Psychol-
ogy* 12, no. 5 (Oct. 1928): 524–29.

"Every Move a Picture: C. W. Barrell, Director of Our Motion Picture
Bureau, Tells How and Why We Do It." *Western Electric News* 11, no. 4
(June 1922): 24–25.

"An Example of the Power of Suggestion." *Salesmanship* 1, no. 2 (July
1903): 31.

Eyre, Edward, ed. *Scientific Management since Taylor: A Collection of Authorita-
tive Papers*. 1924. Reprint, Easton, PA: Hive, 1972.

Feleky, Antoinette M. "The Expression of the Emotions." *Psychological Review*
21 (1914): 33–41.

———. *Feelings and Emotions*. New York: Pioneer, 1922.

Fitch, John A. "Employment Managers in Conference." *Survey* 40 (18 May 1918): 189.

Flader, Louis. "Gone Is the Long-Haired Artist—Hail the Carpenter, Electrician, and Plumber!" *Commercial Photographer* 3, no. 3 (Dec. 1928): 115–23.

Fosbroke, Gerald Elton. *Character Reading through Analysis of the Features*. New York: Putnam's, 1914.

———. *Plus + Selling*. Minneapolis: Minneapolis Sales Engineering Institute, 1933.

Foster, D. P. "Accessories That Make the Half-tone Interesting." *Printers' Ink*, 15 Apr. 1920, 133–36.

Frederick, Christine. *Household Engineering: Scientific Engineering in the Home*. Chicago: American School in Home Economics, 1919.

———. *Selling Mrs. Consumer*. New York: Business Bourse, 1929.

———. "Teach Women What Advertising Does." *Printers' Ink*, 20 June 1920, 177–83.

French, M. D. R. "The Art School of the Art Institute of Chicago." *Sketch Book* 2, no. 6 (July 1903): 7–14.

"Gallery." *Advertising and Selling* 45 (23 May 1935): 29.

Galton, Frances. "Analytical Photography." *Photographic Journal*, 31 Dec. 1900, 133–35.

———. "The Bertillion System of Identification." *Nature* 54 (15 Oct. 1896): 569–70.

———. "Classification of Portraits." *Nature* 76 (17 Oct. 1907): 617–18.

———. "Composite Portraits." *Journal of the Anthropological Institute* 8 (1878): 132–42.

———. "Measurement of Resemblance." *Nature* 74 (4 Oct. 1906): 562–63.

———. "Photographic Measurement of Horses and Other Animals." *Nature* 57 (6 Jan. 1898): 230–32.

———. "Request for Prints of Photographic Portraits." *Nature* 73 (5 Apr. 1906): 534.

Gantt, Henry. *Work, Wages, and Profits*. New York: Engineering Magazine, 1913.

Gerhardt, P. W. "Scientific Selection of Employees." *Electric Railway Journal* 47, no. 7 (15 Feb. 1913): 171.

"The Ghetto." *Sketch Book* 1, no. 2 (Apr. 1902): 124–25.

Gilbreth, Frank B. "The Achievements of Motion Psychology." *Bulletin of the Taylor Society* 9 (Dec. 1924): 259, 283–85.

———. "The Application of Scientific Management to the Work of the Nurse." Paper presented at the eighteenth annual Convention of the

American Society of Superintendents of Training Schools for Nurses, Springfield, MA, 1912.

———. *Bricklaying System.* 1909. Reprint, Easton, PA: Hive, 1974.

———. *Concrete System.* 1908. Reprint, Easton, PA: Hive, 1974.

———. "Economic Value of Motion Study in Standardizing the Trades." *Industrial Engineering,* Apr. 1910, 265–69.

———. "The Effect of Motion Study upon the Workers." *Annals of the American Academy of Political and Social Science* 65 (May 1916): 272–76.

———. *Fatigue Study: The Elimination of Humanity's Greatest Unnecessary Waste.* New York: Sturgis and Walton, 1916.

———. *Field System.* 1908. Reprint, Easton, PA: Hive, 1973.

———. "An Indictment of Time Stop Watch Time Study." *Bulletin of the Taylor Society* 6 (June 1921).

———. "The Making and Use of Instruction Cards." *Industrial Engineering and Engineering Digest* 9 (May 1912): 380–92.

———. *Motion Study: A Method for Increasing the Efficiency of the Workman.* 1911. Reprint, Easton, PA: Hive, 1972.

———. "Motion Study as an Increase of National Wealth." *Annals of the American Academy of Political and Social Science* 59 (May 1915): 96–103.

———. "Motion Study for the Crippled Soldier." *Journal of the American Society of Mechanical Engineers,* Dec. 1915, 669–75.

———. "Motion Study in Surgery." *Canadian Journal of Medicine and Surgery* 40 (July 1916): 22–31.

———. *Primer of Scientific Management.* 1912. Reprint, Easton, PA: Hive, 1985.

———. "Principles of Scientific Management as applied to Highway Engineering." *Municipal Engineering* 40 (May 1914): 474–75.

———. "The Problem of the Crippled Soldier: What Shall Be Done with Him after the War?" *Scientific American Supplement* 83 (1915): 402–3.

———. "Production and Fatigue." *Iron Age* 94 (1 Oct. 1914): 776.

———. "Scientific Management in the Hospital." Speech delivered at a meeting of the American Hospital Association, St. Paul, MN, n.d. [after 1914].

———. "The Theory at Work." Address to the Civic Forum, New York, 28 Apr. 1911.

Gilbreth, Frank B., and Lillian M. Gilbreth. "Applications of Motion Study: Its Use in Developing the Best Methods of Work." *Management and Administration* 8, no. 3 (1924): 001–003.

———. *Applied Motion Study: A Collection of Papers on the Efficient Method to Industrial Preparedness.* New York: Sturgis and Walton, 1917.

———. "Chronocyclegraph Motion Devices for Measuring Achievement." Paper presented at the Second Pan-American Congress at Washington, DC, 3 Jan. 1916.

———. "The Engineer, the Cripple, and the New Education." Paper presented at the annual meeting of the American Society of Mechanical Engineers, 4–7 Dec. 1917.

———. *Fatigue Study; The Elimination of Humanity's Greatest Unnecessary Waste: A First Step in Motion Study.* 2d rev. ed. New York: Macmillan, 1919.

———. "How to Put the Crippled Soldier on the Payroll." Paper presented at the annual meeting of the Economic Psychology Association, New York, 26–27 Jan. 1917.

———. "Measurement of the Human Factor in Industry." Prepared for presentation at the National Conference of the Western Efficiency Society, 22–25 May 1917.

———. "Motion Models: Their Use in the Transference of Experience and the Presentation of Comparative Results in Educational Methods." Paper presented at a meeting of the American Association for the Advancement of Science, Columbus, OH, 27 Dec. 1915–1 Jan. 1916.

———. "Motion Study and Time-Study Instruments of Precision." Prepared for presentation at a meeting of the International Engineering Congress, San Francisco, CA, 20–25 Sept. 1915.

———. "Motion Study for Crippled Soldiers." Paper presented at a meeting of the American Association for the Advancement of Science, Columbus, OH, 27 Dec. 1915–1 Jan. 1916.

———. *Motion Study for the Handicapped.* London: Routledge, 1920.

———. "The One Best Way to Do Work: A Solution to the Problem of the High Cost of Living." Paper presented before several chapters of the Society of Industrial Engineers, May 1920.

———. "Three Position Plan of Promotion." *Iron Age* 96 (Nov. 1915): 1057–59.

———. "Unnecessary Fatigue—A Multi-Billion Dollar Enemy to America." *Journal of Industrial Hygiene* 1 (Mar. 1920): 542–845.

Gilbreth, Lillian M. "Discussion." *Bulletin of the Taylor Society* 10 (June 1925): 162.

———. "Monotony in Repetitive Operations." *Iron Age* 118 (11 Nov. 1926): 1344.

———. *Psychology of Management.* New York: Sturgis and Walton, 1914.

———. *The Quest of the One Best Way: A Sketch of the Life of Frank Bunker Gilbreth.* New York: Society of Industrial Engineers, 1925.

Gooding, E. F. "Camera as a Tool of Management." *Photo-Era* 39 (Dec. 1917): 24–28.

Gramsci, Antonio. *An Antonio Gramsci Reader: Selected Writings, 1916–1935.* Edited by David Forgacs. New York: Schocken Books, 1988.

"Greatest Ginger Talk Ever Written." *Salesmanship* 5, no. 3 (Sept. 1905): 115–20.

Gridley, Don. "A Statistical Glass Applied to Modernism." *Printers' Ink Monthly*, Dec. 1928, 44–47, 133.

"Group Composition." *Photo-Beacon*, Mar. 1901, 72–75.

Hahn, A. R. "Photographs—The House Organ Editor's Strongest Ally." *Printed Salesmanship*, Apr. 1928, 128–31.

Hapgood, Herbert J. "Engaging an Employee." *System* 5, no. 1 (Jan. 1904): 86–89.

———. "How to Secure Right Men." *System* 7, no. 1 (Jan. 1905): 65–69.

Harrington, R. G. "The Photographic Portrait-Study." *Printers' Ink Monthly*, Nov. 1922, 106.

Harrison, H. D. *Industrial Psychology and the Production of Wealth.* New York: Dodd, Mead, 1925.

Hartness, James. "The Human Element." *Iron Age* 94 (3 Dec. 1914): 1297.

"Hats—and the Photographs That Sell Them." *Commercial Photographer* 1, no. 2 (Nov. 1925): 43–47.

Hayes, Edgar M. "Psychology and Salesmanship." *Salesmanship* 2, no. 5 (May 1904): 167–69.

Health, W. H. "Heart Throbs as the Pictorial Theme." *Printers' Ink*, 11 Nov. 1920, 157–58.

Hendricks, Burton J. "Fitting the Man to His Job: A New Experiment in Scientific Management." *McClure's*, June 1913, 50–59.

———. "A Scientific Employment Plan." *American Review of Reviews*, 20 Nov. 1913, 567–76.

Hiller, Lejaren à. "Illustrating Magazine Articles and Advertising by the Use of the Camera." *Commercial Photographer* 3, no. 1 (Oct. 1927): 17–20.

———. "One Thousand Ghosts—Deliver Them Early Next Week." *Advertising and Selling Fortnightly*, 17 Dec. 1924, 36, 50–51.

Hirschler, Diana. "Dress Manner, Poise, Language, and Voice: The Importance of These Five Points in the Making of Sales." *Salesmanship* 2, no. 5 (May 1904): 163–67.

Hollingworth, Harry L. *Advertising and Selling.* New York: D. Appleton, 1912.

———. *Applied Psychology.* New York: D. Appleton, 1926.

———. *Judging Human Character.* New York: D. Appleton, 1922.

———. *Vocational Psychology: Its Problems and Methods.* New York: D. Appleton, 1916.

———. *Vocational Psychology and Character Analysis.* New York: D. Appleton, 1929.

Hollingworth, H. L., and A. T. Poffenberger. *Applied Psychology.* New York: 1917.

Hood, H. S. "Some Phases of Commercial Photography." In *The American Annual of Photography for 1909*, 45–50. New York: Styles and Cash, 1909.

"How to Study Salesmanship." *Salesmanship* 1, no. 4 (Oct. 1903): 83.

"How West Street Uses Photographs." *Western Electric News* 11, no. 14 (June 1922): 8–11.

Hoxie, Robert Franklin. *Scientific Management and Labor.* New York: D. Appleton, 1915. Reprint, A. M. Kelley, 1966.

Hubbard, Charles W. "Some Practical Principles of Welfare Work." *Journal of Social Science* 42 (Sept. 1904): 83–94.

Hull, C. L. *Aptitude Testing.* Yonkers, NY: World Book, 1928.

Hungerford, C. W. "Over Half a Million Yearly for Employee Magazines." *Printed Salesmanship,* Aug. 1928, 490–91.

Hunt, Thelma. "The Measurement of Social Intelligence." *Journal of Applied Psychology* 12, no. 3 (June 1928): 317–34.

———. "What Social Intelligence Is and Where to Find It." *Industrial Psychology* 2 (1927): 605–12.

"Is Business Psychology Becoming a Joke?" *Current Opinion* 58 (Oct. 1914): 279–81.

"Is Motion Study Scientific?" *Engineering Magazine* 45 (June 1913): 412–14.

James, William. *The Principles of Psychology.* 2 vols. New York: Henry Holt, 1890.

Jastrow, Joseph. "Relation of Phrenology to the Study of Character." *Scientific American Supplement,* 4 Dec. 1915, 354–55.

J.F.C. "Snide Talks with Art Students." *Sketch Book* 1, no. 3 (May 1902): 28.

Johns, Elsie B. "What Kind of Advertising Do Women Read?" *Printers' Ink,* 15 July 1920, 137–43.

Johns, W. B., and D. A. Worchester. "The Value of the Photograph in the Selection of Teachers." *Journal of Applied Psychology* 14 (1930): 54–62.

Johnson, Roy W. "How Advertising Affects Standardization." *Printers' Ink,* 16 June 1921, 81–88.

Jolliffe, L. V. "A Mosaic Photograph and How It Was Made." *Printers' Ink Monthly,* Feb. 1928, 41–42.

Jones, C. H. "Human Being Management." *Industrial Management* 52 (Dec. 1916): 398–400.

Judson, Jeanne. "Illustrator Scouts the City to Get Suitable Models: Lejaren à Hiller Has Developed Unusual Studio for Magazine Work and Card Indexes His Subjects' Faces." *New York Sun,* 4 Nov. 1917, 10.

"A Juror's Opinion of the Third Salon." *Photo-Beacon,* Feb. 1903, 44–45.

Katz, Joseph. "Perfect Host." *Advertising and Selling,* 23 May 1935, 29, 54–56.

Kaufmann, Charles. "Photographing Live Models Is an Art in Itself." *Printed Salesmanship,* Feb. 1928, 495–99.

Kelly, Roy Wilmarth. "Hiring the Worker." *Industrial Management* 52, no. 5 (Feb. 1917): 597–603.

Kemble, William Fretz. "Choosing Employees by Test." *Industrial Management* 52, no. 4 (Jan. 1917): 447–60.

———. "Standardizing the Characteristics of Men." *Industrial Management* 52, no. 3 (Dec. 1916): 30–323.

———. "Testing the Fitness of Your Employees." *Industrial Management* 52, no. 2 (Nov. 1916): 149–64.

Kent, Robert Thurston. "Micro-motion Study: A New Development in the Art of Time Study." *Industrial Engineering and Engineering Digest* 8 (Jan. 1913): 1–4.

———. "Micro-motion Study in Industry." *Iron Age* 91 (2 Jan. 1913): 34–37.

Kibby, William Judson. *The Layman's Home Study Course on Character Analysis by Observation.* N.p., 1915.

Knox, James Samuel. "Character Building." In *Salesmanship and Business Efficiency*, 45–61. Cleveland, OH: Knox Business Book, 1922.

———. "Personality and How to Develop It." In *Salesmanship and Business Efficiency*. Cleveland, OH: Knox Business Book, 1922.

———. *Salesmanship and Business Efficiency.* Cleveland, OH: Knox Business Book, 1915.

———. *The Science and Art of Selling.* Cleveland, OH: Knox Business Book, 1921.

———. *The Science of Applied Salesmanship.* Vol. 1. Des Moines, IA: Knox School of Applied Salesmanship, 1911.

Knox, James Samuel, Alice H. Horner, and Ruth Wade Ray. *Personality in Action.* Oak Park, IL: Knox Business Book, 1940.

Kopp, Edouard C. "Craft and Art in Amateur Photography." *Photo-Era* 13 (Oct. 1918): 171–77.

Kornhauser, A. W., and F. A. Kingsbury. *Psychological Tests in Business.* Chicago: University of Chicago Press, 1924.

Kornhauser, A. W., and R. N. McMurry. "Ratings from Photographs." *Personnel Journal* 17 (1938): 21–24.

"Labor Turnover Costs $1,250,000,000 Yearly." *National Association of Corporation Schools Bulletin* 4, no. 8 (Aug. 1917): 5.

Laird, Donald A., and Herman Remmers. "A Study of Intelligence from Photographs." *Journal of Experimental Psychology* 7 (1924): 429–46.

Landis, Carney. "The Interpretation of Facial Expression in Emotion." *Journal of General Psychology* 2 (1929): 59–72.

———. "Studies of Emotional Reactions. I. A Preliminary Study of Facial Expressions." *Journal of Experimental Psychology* 7 (Oct. 1924): 325–41.

———. "Studies of Emotional Reactions. II. General Behavior and Facial Expression." *Journal of Comparative Psychology* 4 (1924).

Landis, Carney, and L. W. Phelps. "The Prediction from Photographs of Success and of Vocational Aptitude." *Journal of Experimental Psychology* 11 (1928): 313–24.

Larned, W. Livingston. "Finding the Theme for the Illustration." *Printers' Ink*, 29 Oct. 1920, 105–9.

———. "Peopling the Advertisements with Characters That Really Live." *Printers' Ink*, 12 Feb. 1920, 59–64.

———. "When Is an Illustration Unconventional?" *Printers' Ink*, 7 Oct. 1920, 165–69.

Larrabee, C. B. "Human Interest and Light." *Printers' Ink Monthly*, Oct. 1922, 40–41.

Larson, J. Fred. "How to Read a Customer." *Salesmanship* 5, no. 1 (July 1905): 13–17.

Lavater, Johann Caspar. *Essays on Physiognomy*. 3 vols. in 5. London: J. Murray, 1789–98.

Lee, Frederic S. *The Human Machine and Industrial Efficiency*. New York: Longmans, Green, 1918.

Lee, Myron A. "Character Analysis by the Observational Method as Used in the Selection of Employees." *Sibley Journal of Engineering* 35, no. 2 (Feb. 1921): 22.

Lewis, Harvey S. "Commercial Photography, Lesson No. 7: Principal Requirements of Photo Illustration." *Western Camera Notes*, Jan. 1905, 16–18.

———. "Commercial Photography, Lesson No. 5: Photographic Illustrations and Their Adaptation." *Western Camera Notes*, Dec. 1904, 329–32.

———. "Commercial Photography, Lesson No. 6: The Photographing of Crockery, Canned and Bottled Goods." *Western Camera Notes*, Jan. 1905, 18–21.

———. "Commercial Photography, Lesson No. 19: Method of Obtaining Good Subjects for Advertising Purposes." *Western Camera Notes*, July 1905, 180–83.

Ling, Cyril Curtis. *The Management of Personnel Relations*. Homewood, IL: Richard D. Irwin, 1965.

Link, Henry C. *Employment Psychology: The Application of Scientific Methods to the Selection, Training, and Grading of Employees*. New York: Macmillan, 1919.

———. "An Experiment in Employment Psychology." *Psychological Review* 25 (1918): 116–27.

———. *The New Psychology of Selling and Advertising*. Foreword by John Broadus Watson. New York: Macmillan, 1932.

———. "Psychological Tests in Industry." *Annals* 110 (Nov. 1923): 180–83.

Logan, James. "Can Human Beings Be Standardized?" *Factory* 15 (July 1915): 11.

"Makers of the Nation's Telephones." *Western Electric News* 12 (Mar. 1923): 2; 13 (Apr. 1924): 2.

Mantegazza, Paolo. *Physiognomy and Expression*. London: Walter Scott, 1900.

Marey, E. J. *Movement*. Translated by Eric Pritchard. London: William Heinemann, 1895.

Marks, Robert S. "Portrait of Hiller." *Coronet*, Mar. 1939, 147–57.

Mason, J. K. "How to Study Factory Efficiency." *Engineering Magazine* 51 (Aug. 1916): 394–400.

Masterson, J. L. "The Art of Interviewing." *Employment and Labor Maintenance*, Sept. 1920, 247.

Merrick, Dwight V. *Time Studies*. New York: Engineering Magazine, 1919.

Merton, Holmes Whittier. *Descriptive Mentality from the Head, Face, and Hand*. Philadelphia: D. McKay, 1899.

———. *How to Choose the Right Vocation*. New York: Funk and Wagnalls, 1917.

———. *Vocational Counseling and Employee Selection: The Art of Judging People*. New York: Merton Institute, 1920.

Mogensen, Allan H. *Common Sense Applied to Motion and Time Study*. New York: McGraw-Hill, 1932.

Munsterberg, Hugo. "Finding a Life's Work." *McClure's*, Feb. 1910, 398–403.

———. *The Photoplay: A Psychological Study*. New York: D. Appleton, 1916.

———. *Psychology and Industrial Efficiency*. Boston: Houghton Mifflin, 1913.

Murphy, Carroll D. "The Man for the Job: How to Find Him and to Recognize Him When Found: The Methods Used by Successful Employers." *System* 23, no. 4 (Apr. 1913): 402–10.

Muscio, Bernard. *Lectures on Industrial Psychology*. 2d ed. London: Routledge, 1920.

Myers, Charles S. *Mind and Work: The Psychological Factors in Industry and Commerce*. London: University of London Press, 1920.

Myers, L. H. "How Hawthorne Gets Its Picture Took." *Western Electric News* 11, no. 4 (June 1922): 2–5.

National Industrial Conference Board. *Employee Magazines in the United States*. New York, 1925.

Newton, Herbert. "The Scientific Employment of Men." *Scientific American*, 26 July 1913, 68–69.

Omwake, K. "The Value of Photographs and Handwriting in Estimating Intelligence." *Public Personnel Studies* 3 (1925): 2–15.

O'Shea, Peter F. "How Big Companies Are Using Employees' Magazines." *Printers' Ink*, 3 Feb. 1921, 122.

"Our Cover Portrait and Hall of Fame." *Portrait* (Ansco Company) 9, no. 2 (June 1919): 11–15.

"Our Office Photo Album." *Western Electric News* 12, no. 9 (Nov. 1923): 26–27.

Parsons, K. "Putting Round Pegs in Square Holes." *Industrial Management* 56 (Oct. 1918): 330–31.

Paterson, Donald G., and Katherine E. Ludgate. "Blond and Brunette Traits: A Quantitative Study." *Journal of Personnel Research* 1, no. 3 (1922): 122–27.

Payne, Arthur Frank. "The Scientific Selection of Men." *Scientific Monthly,* Dec. 1920, 545.

Pearson, Karl. *The Life, Letters, and Labour of Francis Galton.* Vol. 2. Cambridge: Cambridge University Press, 1924.

Peck, L. W. "A High Record in Bricklaying Attained by Novel Methods." *Engineering News* 62 (5 Aug. 1909): 152.

Person, H. S., ed. *Scientific Management in American Industry.* New York: Harper, 1929. Reprint, Easton, PA: Hive, 1972.

"Photographing Small Articles for Catalogues and Illustrative Purposes." *Abel's Photographic Weekly,* 15 Mar. 1913, 248–51.

"Photographs Poor Character Guides." *Literary Digest,* 6 Oct. 1928, 21.

"Photography as a Fine Art." *Sketch Book* 2, no. 3 (Mar. 1903): 34–35.

"Pictorial Demonstration Instead of the Superlative." *Printers' Ink Monthly,* Jan. 1923, 65–66.

Pier, Arthur Stanwood. "Brawn and Character." *Atlantic Monthly,* Jan. 1907, 106–12.

Pintner, Rudolph. "Intelligence as Estimated from Photographs." *Psychological Review* 25 (1918): 286–96.

Poffenberger, Albert Theodor. *Applied Psychology.* New York: D. Appleton, 1927.

———. *Psychology in Advertising.* Chicago: Shaw, 1925.

Pope, D. V. *The Interpretation of the Human Face from Photographs.* Bulletin 8. Randolph, VA: Randolph-Macon Woman's College, 1922.

"Portrait of Hiller." *Coronet,* Mar. 1939, 147–57.

"Posing." *Photo-Beacon,* Apr. 1901, 110–13.

"Posing." *Photo-Beacon,* May 1901, 137–40.

"Posing the Male Figure." *Photo-Beacon,* June 1901, 170–73.

"Powermakers; Work Portraits by Lewis W. Hine: Photographs Taken in the Power Plants of the Pennsylvania System." *Survey* 47 (31 Dec. 1921): 511–18.

"A Printing Idea Borrowed from Movies." *Printed Salesmanship* 50, no. 2 (Oct. 1927): 170–71.

"Psychological Tests for Accident Prevention." *Electric Railway Journal* 39, no. 10 (9 Mar. 1912): 394.

Radcliffe, George. "Commercial Photography." In *The American Annual of Photography for 1910,* 280–82. New York: Styles and Cash, 1910.

Ratti, Arturo F. "Secrets of the Psyche." *American Mercury* 19, no. 74 (Feb. 1930): 235–41.

"Reading the Human Countenance." *Current Literature* 42 (Mar. 1907):
 329–31.

"Refitting Human Misfits." *Literary Digest*, 1 Jan. 1912, 1162–63.

Roberts, Mary Fenton. "What the Photograph Means to the Magazine."
 Photo-Era 20 (Sept. 1925): 121–26.

Robinson, Henry Peach. *The Elements of a Pictorial Photograph*. Bradford, UK:
 Percy Lund, 1896.

———. *Pictorial Effect in Photography*. New York: Scovill and Adams, 1892.

———. *Picture-Making by Photography*. London: Hazell, Watson, and Viney,
 1889.

Robinson, Louis. "Chins and Character." *Blackwood's Magazine* 181 (Jan.
 1907): 69–75.

Rocine, Victor Gabriel. *Correspondence Course in Character Reading by Sight*.
 Portland, OR: Rocine's Publishing and Efficiency Service, 1934.

Roosevelt, Theodore. "Character and Civilization." *Outlook* 105 (Nov. 1913):
 526–28.

Rosenstein, J. L. *The Scientific Selection of Salesmen*. New York: McGraw-Hill,
 1944.

Ruckmick, C. A. "A Preliminary Study of the Emotions." *Psychological Mono-
 graphs* 30, no. 3 (1921): 28–35.

Rudolph, H. *Der Ausdruck der Gemutsbewegungen des Menchen*. 2 vols. Dres-
 den: Kuhtmann, 1903.

Sampter, Herbert C. *Motion Study*. New York: Pitman, 1941.

Schulze, J. W. *Office Administration*. New York: McGraw-Hill, 1919.

"Scientific Selection of Workmen." *Engineering Record* 67 (15 Feb. 1913): 171.

Scot, Walter. "Photography in Commercial Illustration." *American Journal of
 Photography*, Nov. 1895, 501–4.

———. "Photography in Newspaper Illustrating." *American Journal of Photog-
 raphy*, Oct. 1895, 442–46.

Scott, Walter Dill. *Aids in Selecting Salesmen*. Pittsburgh: Bureau of Salesman-
 ship Research, 1916.

———. *Influencing Men in Business: The Psychology of Argument and Suggestion*.
 New York: Ronald, 1911.

———. "The Psychology of Advertising." *Atlantic Monthly*, Jan. 1904, 34.

———. *The Psychology of Advertising; a Simple Exposition of the Principles of Psychol-
 ogy in Their Relation to Successful Advertising* Boston: Small Maynard, 1908.

———. *The Psychology of Public Speaking*. Philadelphia: Pearson Bros., 1907.

———. *The Psychology of Public Speaking*. New York: Noble and Noble, 1926.

———. "The Scientific Selection of Salesman." *Advertising and Selling* 25
 (Dec. 1915): 11.

———. *The Theory of Advertising: A Simple Exposition of the Principles of Psychology
 in Their Relation to Successful Advertising*. Boston: Small, Maynard, 1903.

Scott, Walter Dill, and R. C. Clothier. *Personnel Management: Principles, Practices, and Point of View*. Chicago: A. W. Shaw, 1923.

"Selling Human Sentiment Proves More Successful Than Selling the Product." *Printers' Ink*, 13 July 1922, 106–8.

"The Selling Value of a Smiling Face." *Salesmanship* 2, no. 3 (Sept. 1915): 132–33.

Sheldon, William Herbert. *The Varieties of Human Physique*. New York: Harper, 1940.

Sizer, Nelson. *Study of Character by Photographs*. New York: Human Nature Library, 1891.

Slosson, Edwin E. "Science Remaking the World: The Influence of Photography on Modern Life." *World's Work* 45 (Feb. 1923): 399–416.

Snow, A. J. "Can We Read Human Character?" *Hygeia* 3, no. 4 (Apr. 1925): 185–89.

Soule, Karl Thayer. "Silent Salesmen." *Printed Salesmanship*, Sept. 1926, 32–33.

Southard, E. E. "The Mental Hygiene of Industry: A Movement That Particularly Concerns Employment Managers." *Industrial Management* 59, no. 2 (Feb. 1920): 103–4.

———. "The Modern Specialist in Unrest: Place of the Psychiatrist in Industry." *Industrial Management* 59, no. 6 (1920): 462–66.

Starbuck, Edwin D. "Character and Science." *Journal of the National Education Association* 15 (1926): 213–14.

———. "Tests and Measurements of Character." *Journal of the National Education Association* 62 (1924): 357–61.

Starr, Allen. "The Old and the New Phrenology." *Popular Science Monthly*, Oct. 1889, 730–48.

"The Story Told by Jaws, Noses, Brows, and Other Facial Features." *Literary Digest*, 22 May 1920, 71–72.

Strand, Paul. "Photography and the New God." In *Classic Essays on Photography*, ed. Alan Trachtenberg, 141–51. New Haven, CT: Leete's Island Books, 1980.

Sullivan, Louis. "Anthropometry of the Siouan Tribes." *Anthropological Papers of the American Museum of Natural History* 23, pt. 3 (1920).

———. *Essentials of Anthropology: A Handbook for Explorers and Museum Collectors*. New York: American Museum of Natural History, 1923.

Talbot, Winthrop. "The Human Element in Industry." *Iron Age* 91 (3 Feb. 1913): 366.

Tate, A. N. "Personality in Salesmanship." *Salesmanship* 7, no. 3 (Sept. 1906): 146.

Taylor, Floyd. "What Do Your Hands Tell?" *Popular Mechanics* 47, no. 1 (Jan. 1927): 20.

Taylor, Frederick Winslow. "A New System for the Manufacture of Steel Balls." *American Machinist* 23 (1 Nov. 1900): 1035–39.

———. *On the Art of Cutting Metals.* New York: American Society of Mechanical Engineers, 1906.

———. "A Piece Rate System: A Step toward Partial Solution of the Labor Problem." *ASME [American Society of Mechanical Engineers] Transactions* 16 (1895): 856–93.

———. "Shop Management." *ASME Transactions* 24 (1903): 1369–71.

"Testing the Human Machine in the Man Testing Laboratory." *Scientific American*, 10 Sept. 1921, 187.

Thompson, Clarence Bertrand. *Theory and Practice of Scientific Management.* Boston: Houghton Mifflin, 1917.

———, ed. *Scientific Management: A Collection of the More Significant Articles Describing the Taylor System of Management.* Cambridge: Harvard University Press, 1914.

Thorndike, Edward. "Fundamental Theorems in Judging Men." *Journal of Applied Psychology* 2, no. 1 (Mar. 1918): 67–76.

"Three Natural Fields of Salesmanship." *Salesmanship* 2, no. 1 (Jan. 1904): 12–15.

"To Pick Workers Scientifically." *Literary Digest*, 29 Mar. 1913, 703–4.

Townsend, A. L. "Labor: A Gladiator of the Pictures." *Printers' Ink*, 8 July 1920, 117–21.

Urwick, Lyndall. *The Meaning of Rationalisation.* 3d ed. London: Nisbet, 1930.

Vanderpoel, J. H. "Portrait Posing and Lighting." *Photo-Beacon*, Jan. 1901, 5–8.

Vernon, H. M. *Industrial Fatigue and Efficiency.* London: Routledge, 1921.

Viteles, Morris S., and Kinsley R. Smith. "The Prediction of Vocational Aptitude and Success from Photographs." *Journal of Experimental Psychology* 40 (Dec. 1932): 615–29, 619.

Wagner, Carl E., Jr. *Characterology: The Art and Science of Character Analysis.* York Beach, ME: Samuel Weiser, 1986.

Wallen, James. "Emotion in Advertising Copy: A Well That Will Never Run Dry." *Printers' Ink*, 29 July 1920, 34–36.

———. "Is Old Man 'Reason-Why' Dead? Long Live Mistress Emotion!" *Printers' Ink*, 17 Nov. 1921, 69–70.

Watson, John B. "An Attempted Formulation of the Scope of Behavior Psychology." *Psychological Review* 24 (1917): 329–52.

———. "Psychology as the Behaviorist Views It." *Psychological Review* 20 (1913): 158–77.

Watts, Frank. *An Introduction to the Psychological Problems of Industry.* London: George Allen and Unwin, 1921.

Wells, Samuel R. *How to Read Character: A New Illustrated Hand-Book of Phrenology and Physiognomy for Students and Examiners; with a Descriptive Chart.* 1868. New York: Fowler and Wells, 1883.

Whipple, Guy Montrose. *Manual of Mental and Physical Tests.* 2 vols. 1910. 2d rev. and enl. ed. Baltimore: Warwick and York, 1914.

White, K. B. "Old Man Specific Gets Direct Sales with Institutional Advertising." *Printers' Ink Monthly,* Jan. 1922, 31–32.

Wiggam, Albert Edward. "Science Measures Morals: Its Aim Is to Eliminate the Liar and the Cheat." *World's Work* 56 (1928): 86–94.

———. "Sizing Up the Other Fellow." *Everybody's Magazine* 110, no. 1 (July 1930): 40–41.

Wilson, Andrew. "The Old Phrenology and the New." *Popular Science Monthly,* Feb. 1879, 475–91.

Wingfield, S. G. "Pictures for the Employees' Magazine." *Printers' Ink,* 7 Oct. 1920, 125–26.

Yates, Dorothy Hazeltine. *Psychological Racketeers.* Boston: Gorham, 1932.

Yerkes, Robert M., and James W. Bridges. *A Point Scale for Measuring Mental Ability.* Baltimore: Warwick and York, 1915.

Yoakum, C. S. "Experimental Psychology in Personnel Problems." *Bulletin of the Taylor Society* 10 (June 1925): 154–63.

Yost, Edna, and Lillian Gilbreth. *Normal Lives for the Disabled.* New York: Macmillan, 1944.

———. *Straight Talk for the Disabled Veteran.* New York: Public Affairs Committee, 1945.

Index